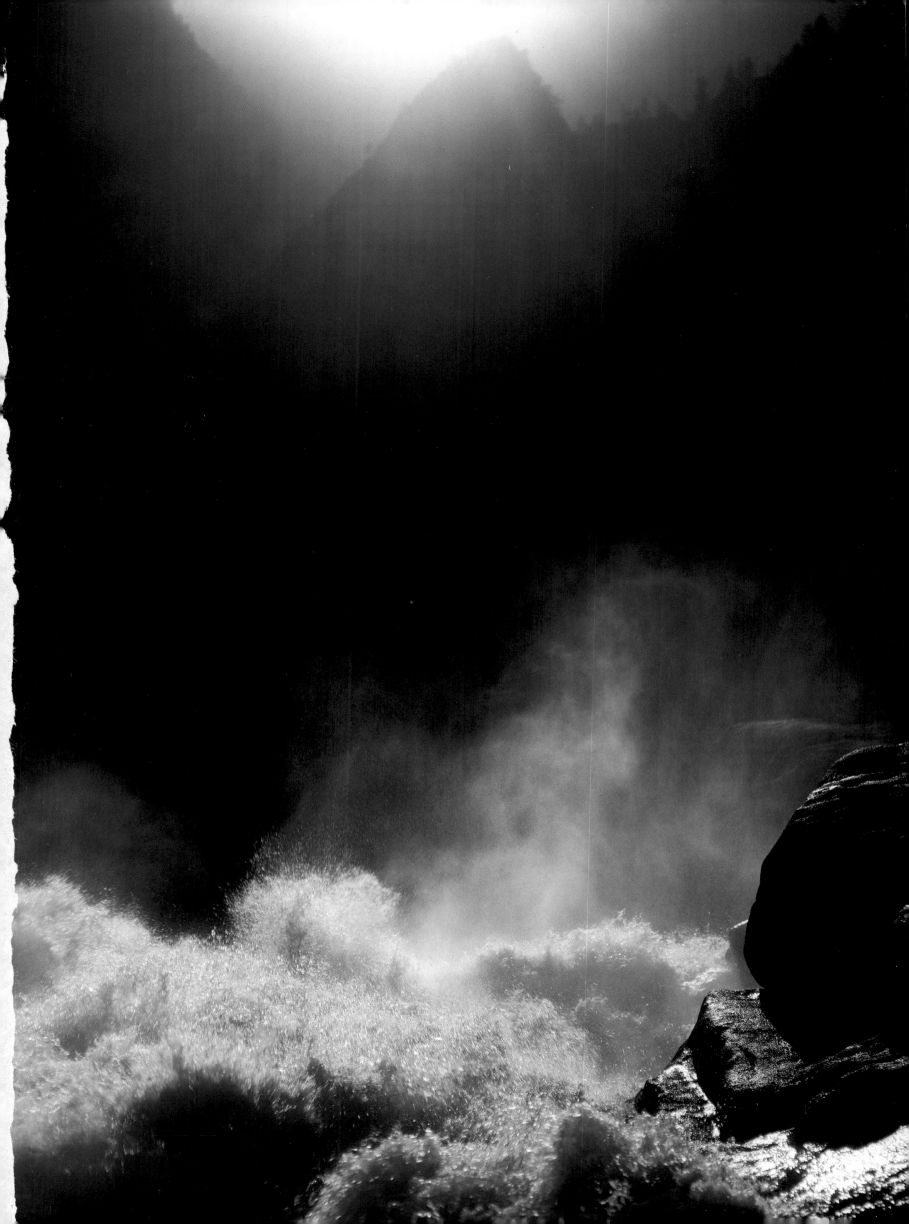

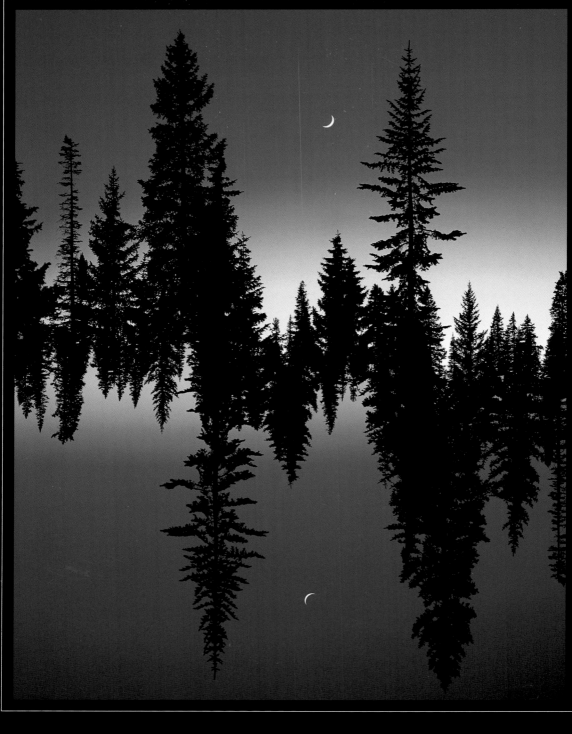

MARC MUENCH

PRIMAL FORCES

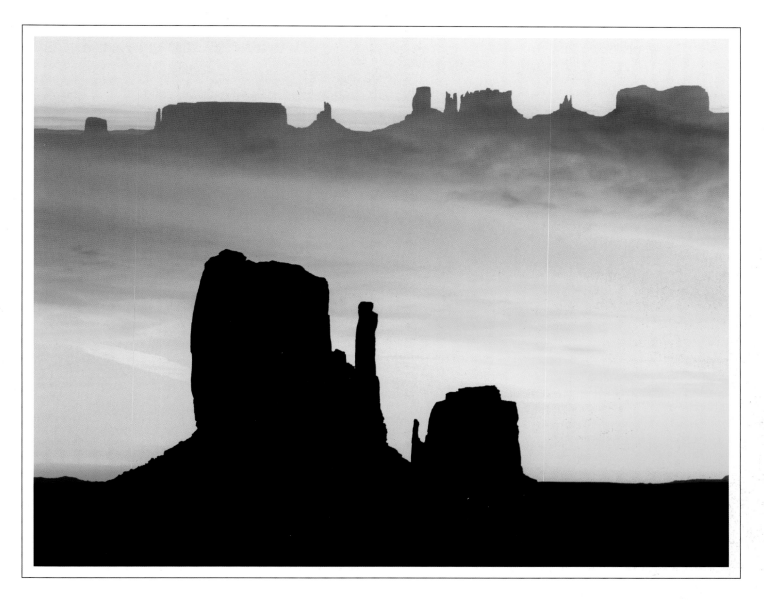

DAVID MUENCH

GRAPHIC ARTS CENTER PUBLISHING ®

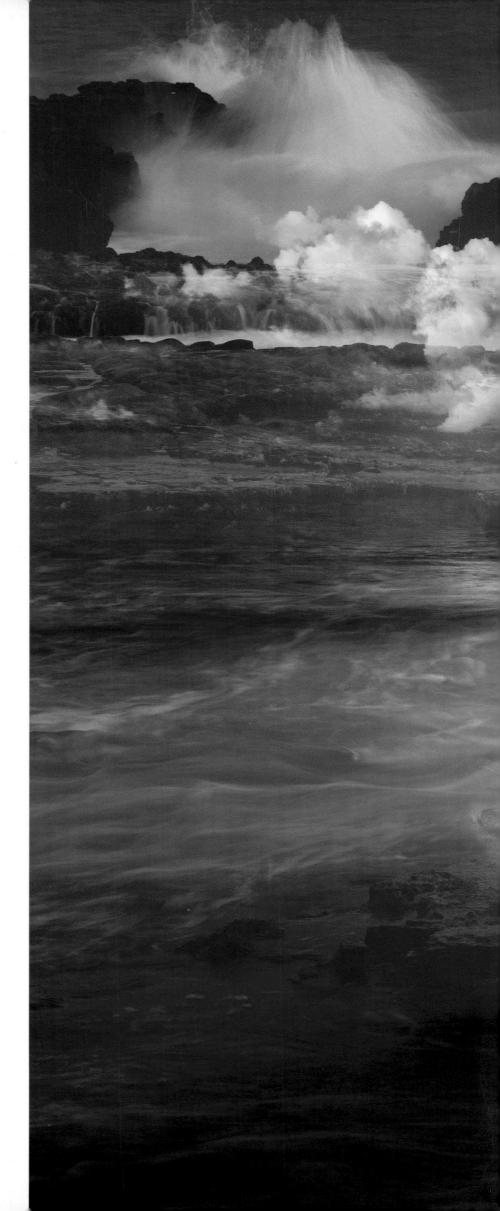

For Joyce

David Muench © MM: all photographs except those noted below.

Marc Muench © MM: photographs front cover (right), pages 2, 6 (inset), 7, 7 (inset), 8–9, 10, 12–13, 20, 22, 28–29, 32, 39, 40–41, 46 (left inset), 46 (right inset), 52–53, 55, 62, 63, 70, 72 (inset), 79, 82, 84–85, 88–89, 90, 92–93, 106, 107, 115, 117, 126, 127, 142, 151, 159, 164–165, 166, 174, 176, 177, 179, 184 (left inset), 185 (left inset), 186, 187, 188–189, and 191.

Michelle Gilders © MM: all text and photograph page 148.

G. Brad Lewis © MM: photographs pages 118, 128, and 154.

Bonnie Muench © MM: photograph page 112.

Book compilation © MM by Graphic Arts Center Publishing®
An imprint of Graphic Arts Center Publishing Company
P.O. Box 10306, Portland, Oregon 97296-0306
503/226-2402
www.gacpc.com

Library of Congress Cataloging-in-Publication Data
Muench, David.
 Primal forces / photography by David Muench and
Marc Muench ; text by Michelle Gilders.
 p. cm.
Includes index.
 ISBN 1-55868-522-7
 1. Nature—Pictorial works. 2. Landscape—Pictorial
works. I. Muench, Marc. II. Gilders, Michelle A., 1966–
III. Title.
 TR721 .M84 2000
 779'.3—dc21 00-037181

Second Printing

President: Charles M. Hopkins

Editorial Staff: Douglas A. Pfeiffer, Ellen Harkins Wheat,
Timothy W. Frew, Tricia Brown, Jean Andrews,
Alicia I. Paulson, Jean Bond-Slaughter

Production Staff: Richard L. Owsiany, Joanna Goebel

Designer: Bonnie Muench

Digital Pre-Press: Tom Dietrich of DMPI

Freelance Editor: Linda Gunnarson

Printing: Haagen Printing

Binding: Lincoln & Allen

Printed and bound in the United States of America

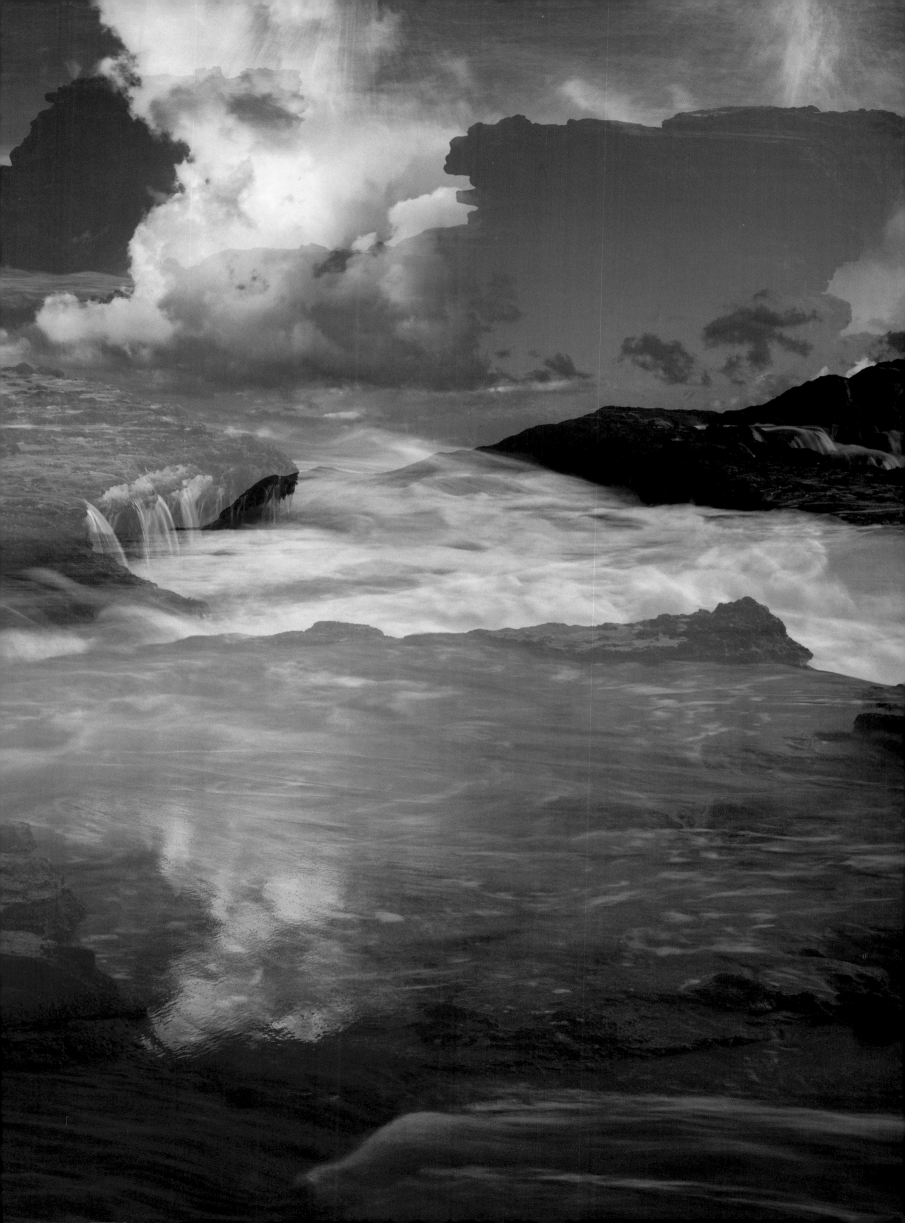

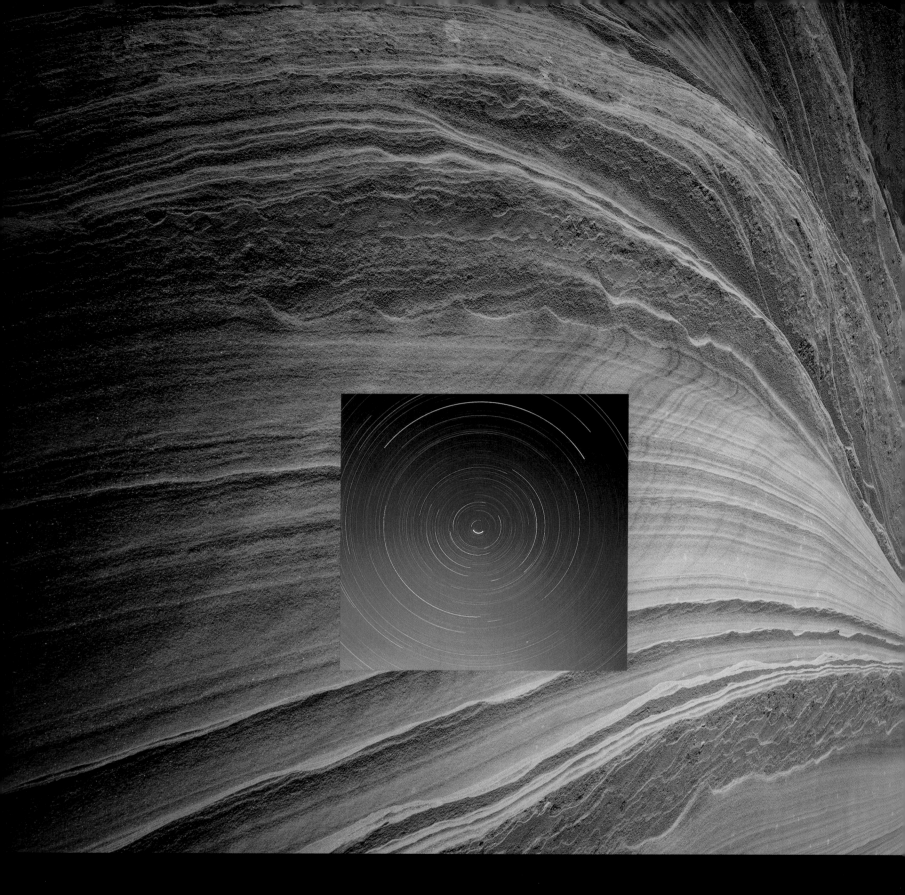

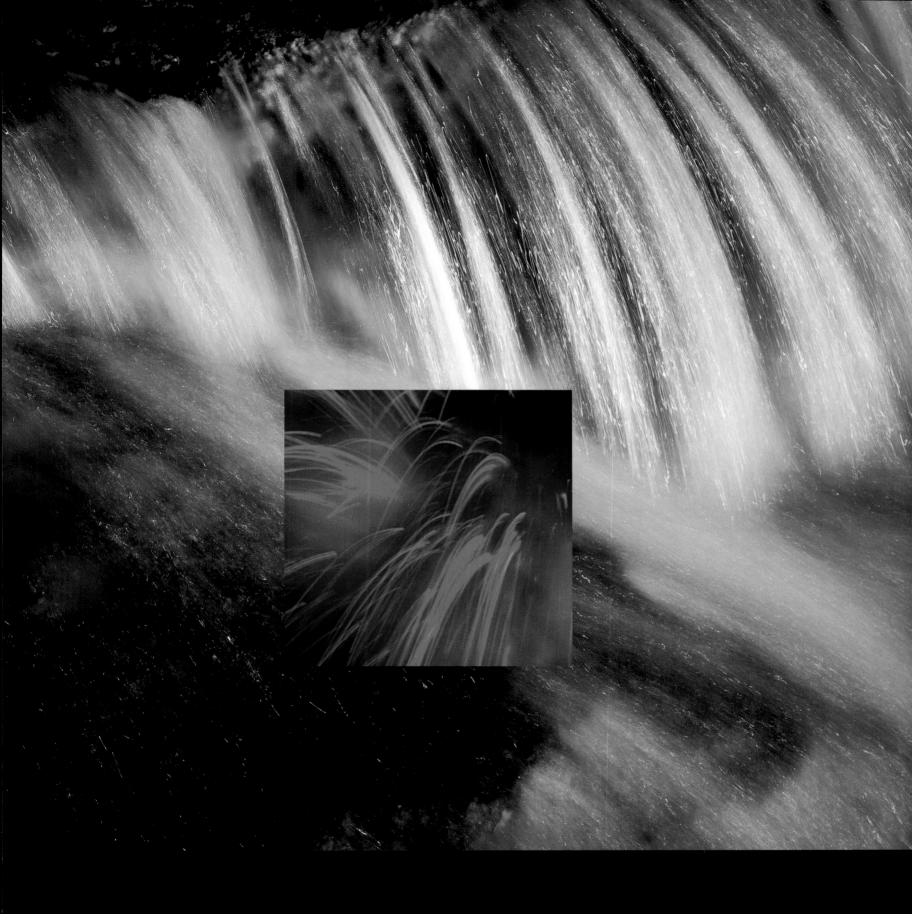

FIRE

WATER

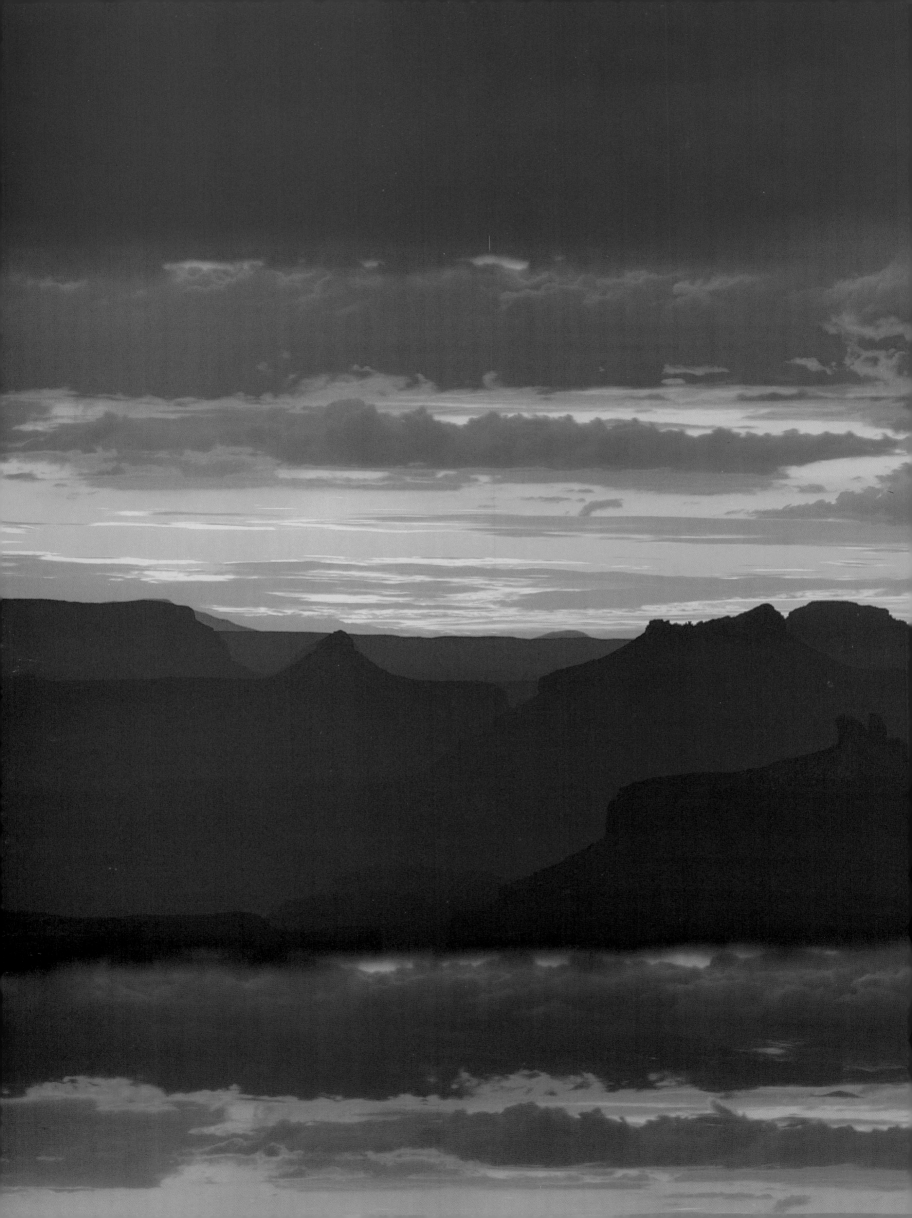

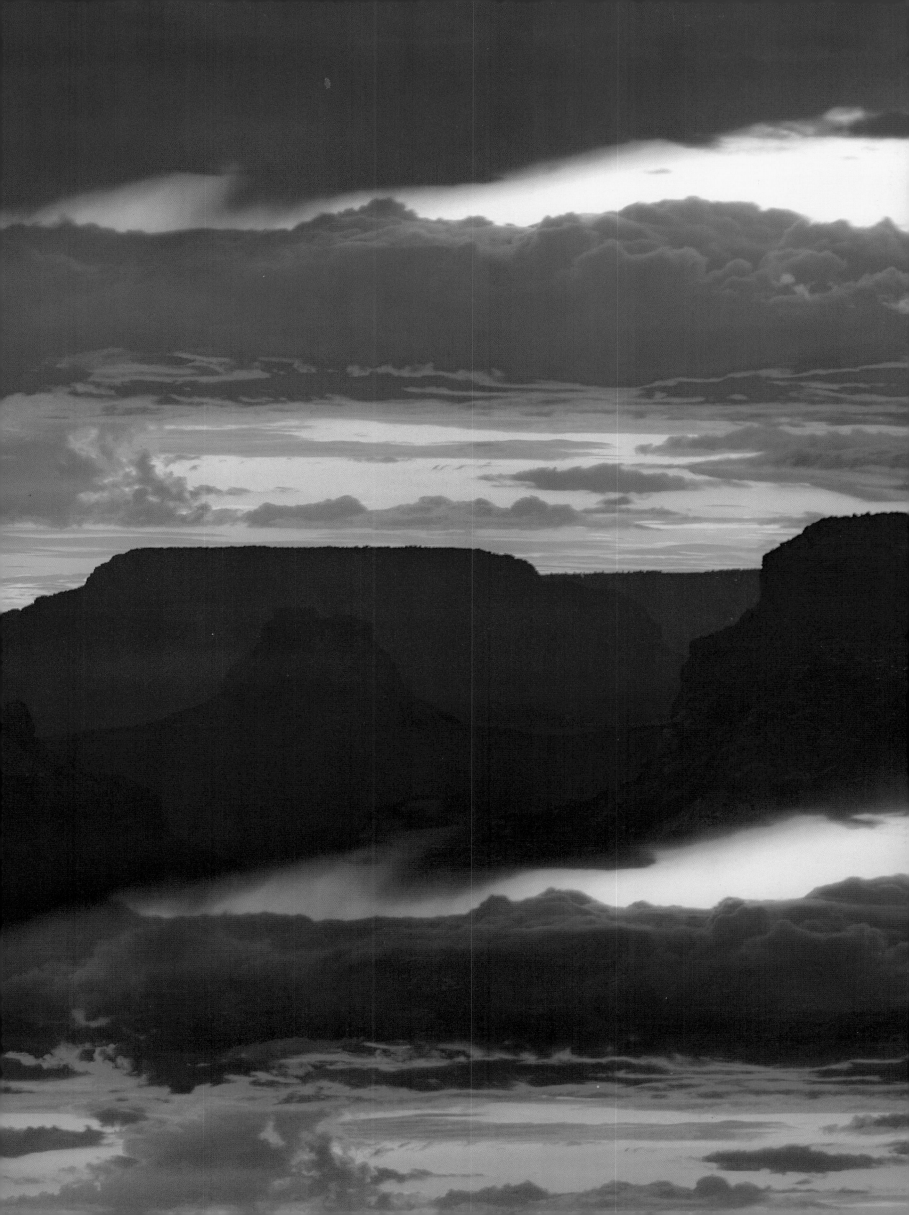

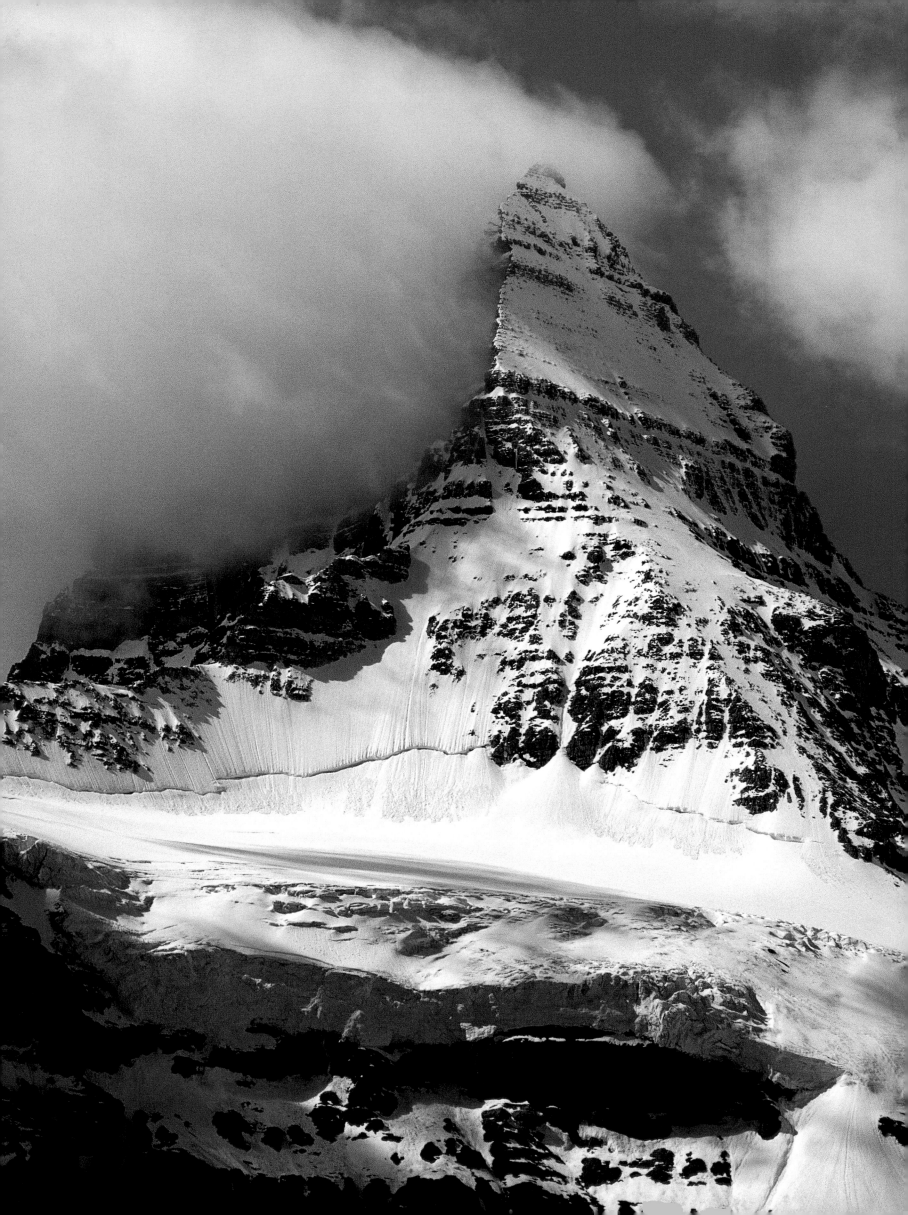

"Focusing on EARTH, AIR, FIRE, and WATER
I was inspired to create these multiple exposures in camera
to emphasize the interaction and evolving mystery
of the Primal Forces." —David Muench

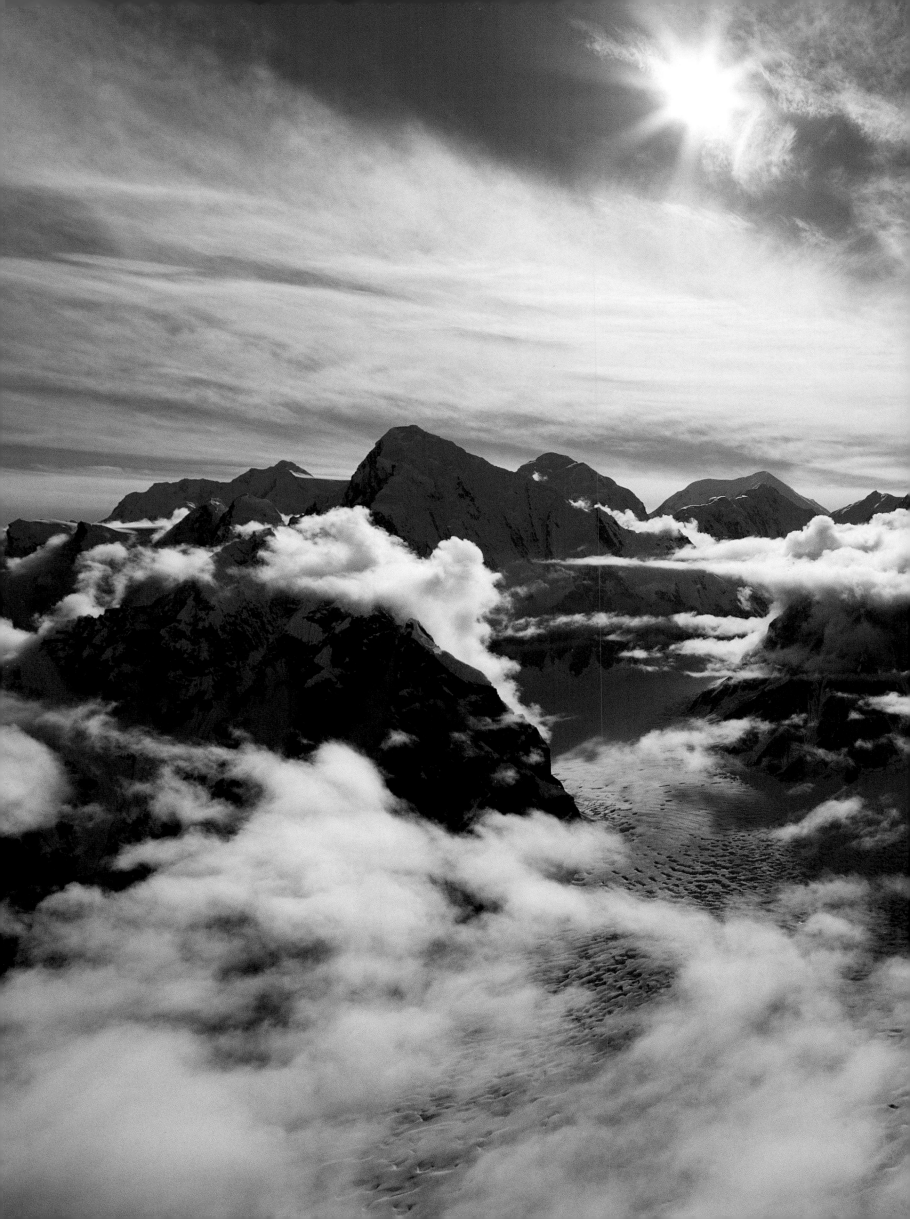

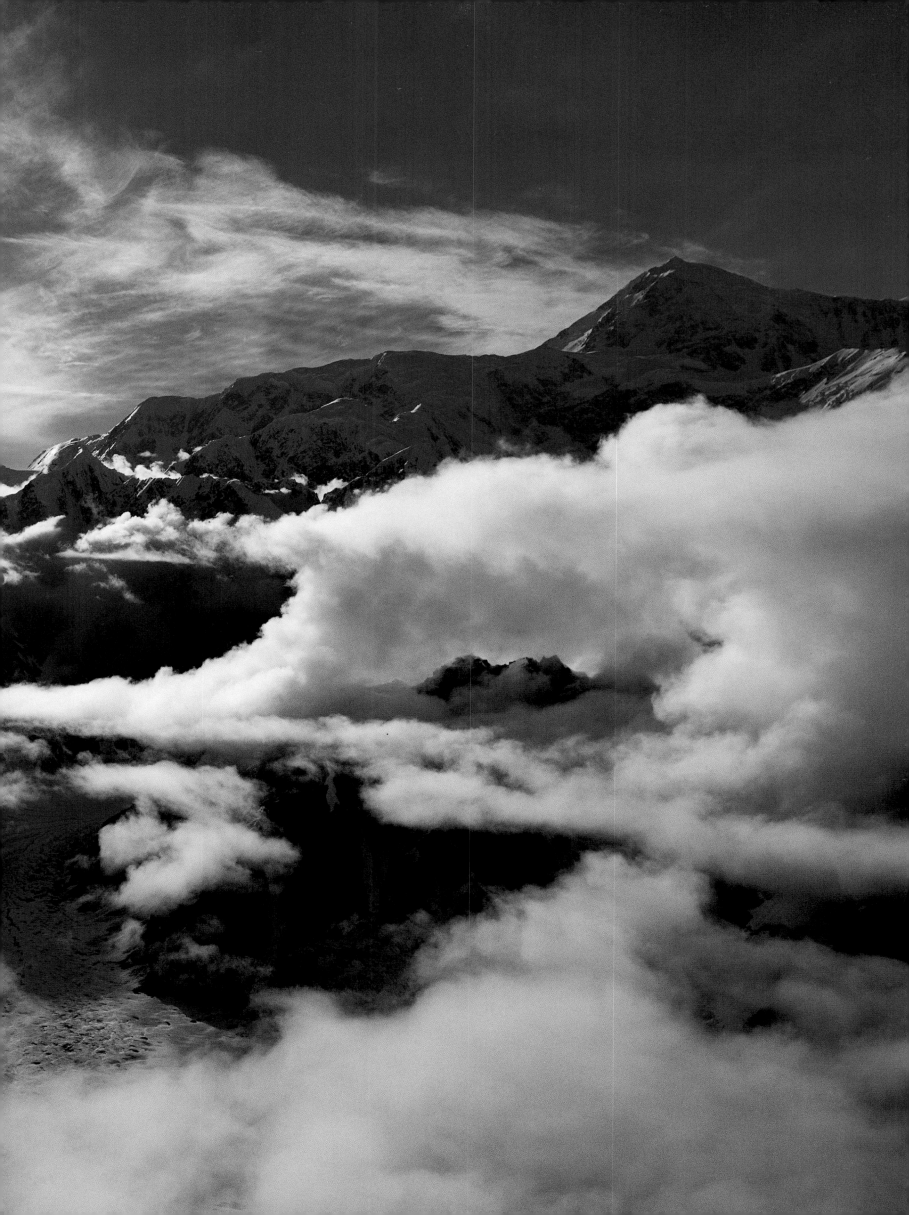

FORCES IN MOTION

At times the Earth can appear to be a static thing—immovable, immobile, unchanging, unyielding. This deception is born of the Earth's longevity and of our mortality. A closer look, however, reveals that all is in motion. Clouds shift and shimmer across the sky. Wind moves grass and trees. Water cascades, trickles, or seeps. Ice flows and grinds, sliding over bedrock. Waves gently lap shorelines or pummel them with the weight of entire oceans behind them. Fire licks at vegetation, turning whole forests to ash. Mountains rise and are worn down by water and wind. Tectonic plates slide up against each other, releasing tensions in undulating waves that make solid rock as fluid as ocean swells. Volcanoes spew gas and rock in violent eruptions, transforming land-scapes that formed over millennia into something distinctly alien, all in a matter of seconds.

This solid Earth of ours is no static rock adrift in the void of space. It is a dynamic planet that moves and breathes, not as a living thing, but as one that sustains living things. If there were no motion, there would be no life.

We are connected to the four primal forces: earth, air, fire, and water. We breathe air deep into our lungs. Water fills our veins and tissues. Earth supports us, fulfills us, sustains us, and ultimately recycles us. Fire burns, in our cells, within the tiny mitochondria that turn food into energy. The fire of the sun warms our faces just as it drives the cycle of life from plant to animal and back again. Earth, air, fire, and water were the four "elements" on which so many cultures founded their philosophies. To Aristotle, the elements circled one another. Earth was at the center. Water lay above the earth. Air lay above the water. And fire encircled them all.

Our connection to the Earth's primal forces can seem distant in a modern, technological age. We can usually avoid the extremes, or so we think. We live and work in air-conditioned buildings and drive air-conditioned vehicles. Tinted windows filter the sun's light. Gas, coal, and oil give us fuel to hold frigid winters at bay. Light is provided at the flick of a switch. Water flows from a tap and is whisked away by drains and sewers. Food appears in our supermarkets, cleaned and wrapped. This has become our daily world—at least for those of us in developed countries. When things change, sometimes dramatically and often unexpectedly, we speak of "acts of God" and "natural disasters," as though we expect the *status quo* to continue forever.

There is no *status quo* in nature. "Men argue; Nature acts," said Voltaire. Things change—that is nature's only constant. Storms move heat from the equator to the poles, volcanoes create new land out of molten rock, fires revitalize as much as they destroy, glaciers carve valleys, and water moves mountains. Without the "natural disasters" that we have come to fear—earthquake, volcanic eruption, hurricane, tornado, forest fire, flood—the Earth would have a very different landscape from the one we have come to know.

Goethe once said of nature: "She loves illusion. She shrouds man in mist, and she spurs him toward the light. Those who will not partake of her illusions

she punishes as a tyrant would punish. Those who accept her illusions she presses to her heart. To love her is the only way to approach her."

I have been fortunate to experience some of the most potent expressions of nature's primal forces. In October 1987, a great storm roared across southern England. Although technically not a hurricane since the winds were just shy of official hurricane force, the storm still flattened 15 million trees in the southern counties and prevented me from attending a job interview in London, although it also prevented my interviewer—and most other Londoners—from showing up at work as well. Despite the storm, I got the job, and eventually it led me to Alaska, where I experienced my first earthquakes, the strongest of which registered 6.6 on the Richter scale; a volcanic eruption, when Mount Spur coated Anchorage in several inches of gray ash (a film canister of which still graces one of my bookshelves); "white-out" conditions, in which the landscape disappears amidst a disorienting uniformity; and an absolute temperature of –60°F (–51°C) with a wind chill of –97°F (–72°C), sufficient to freeze exposed flesh in less than three minutes. I have also baked in temperatures above 106°F (41°C) in the tropics of South America, the atolls of the South Pacific, and the deserts of the American Southwest. Personally, I prefer the risk of frostbite over that of heat exhaustion.

A few months after Hurricane Andrew hit southern Florida in August 1992, I drove through Homestead and was at once horrified and entranced by the utter destruction brought by the wind. Two years later I had my own close encounter with the "big wind" as the remnants of a hurricane slammed into Costa Rica while I was on my way to Monteverde, high in the mountains. Though downgraded to a tropical storm, the hurricane washed out the road I was on in a mudslide 10 feet (3 meters) thick, missing my truck by a matter of seconds. Also in 1994, while I was in the South Atlantic, a storm with winds of 70 miles per hour (112 kilometers per hour) sent waves crashing over the top of the ship taking me from the Falklands to South Georgia Island. Paradoxically, the infamous Drake Passage was as calm as a mill pond on that voyage and a subsequent one.

Today, I call the Canadian Rockies home. I am surrounded by towering peaks more than 9,900 feet (3,000 meters) high that even in midsummer can be sprinkled with snow. This is a landscape born of each of the four primal forces. The mountains owe their existence to the collision of continental plates—the combined force of earth and fire. The individual shapes of the mountains reflect their silent battle with wind and water. As I sit on my deck, taking in this vista of ice, mountains, clouds, and trees, I know the true meaning of inspiration.

The elemental forces of nature entwine us. They merge, working in concert, becoming stronger as the powers of one are combined with the powers of another. Earth and fire rend the surface and deliver molten rock to the air. Air and earth exchange heat and dust. Water erodes earth and extinguishes fire. Air and water exchange material between them, each feeding off the other. These are the powerful, mysterious forces that gave rise to the myths and legends that defined early civilizations. That which could not be predicted or understood became the breath of gods or the savage blows of titans. A modern understanding of much of the physics behind the forces of nature does not diminish their majesty, power, or ability to fire the imagination. Knowledge is a precious commodity, for it allows us to comprehend so many of the glories of our world.

There is a saying among South American Indians: "To become human, one must make room in oneself for the wonders of the universe." The primal forces of our world are wondrous indeed, and we should make room in ourselves to experience, understand, and appreciate them.

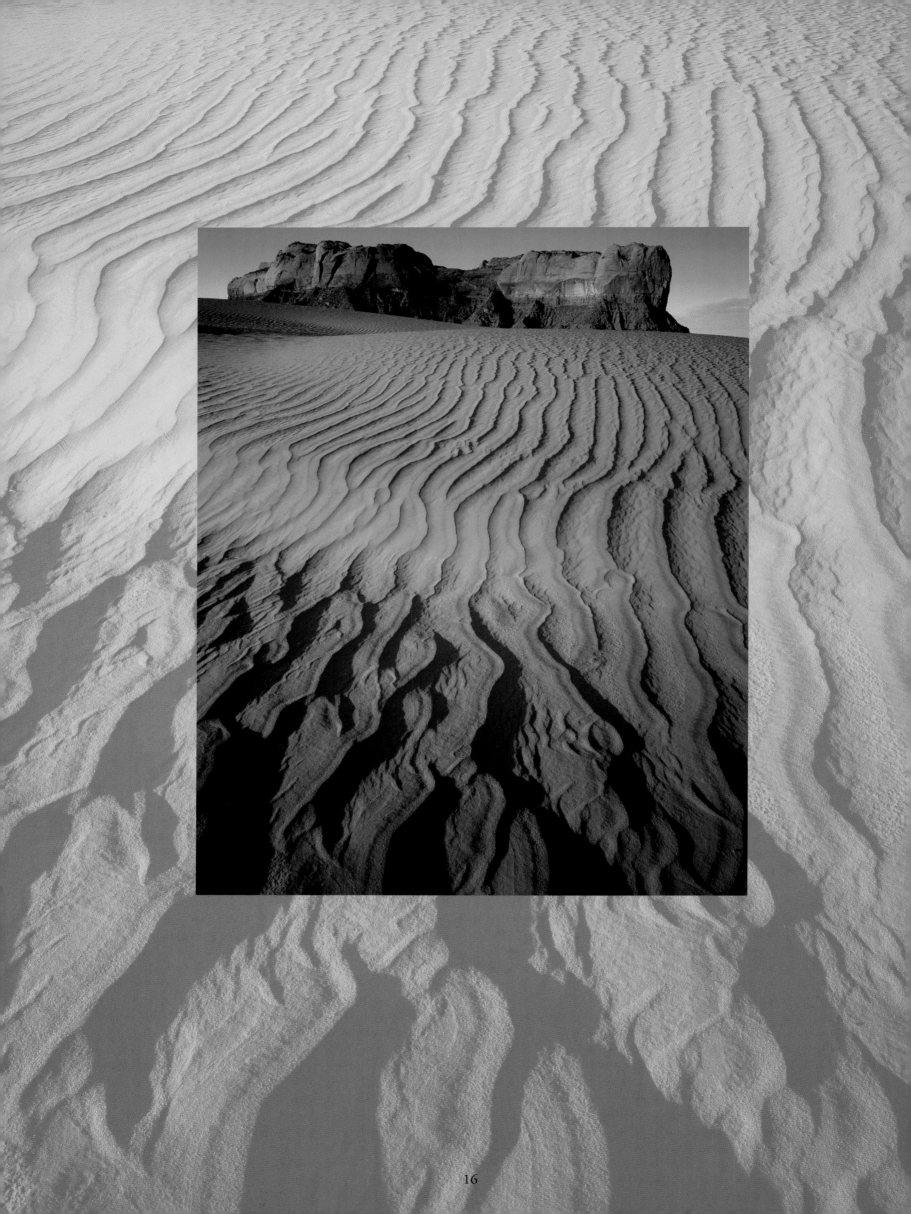

EARTH

In the beginning, say the Bambara of Mali, there was nothing but the emptiness of the void. The universe was born from a single point of sound, the root sound of creation: *Yo. Yo* is the first sound, but it is also the silence at the core of creation. Emanations from this void, through the root sound *Yo,* created the structure of the heavens, of the Earth, and of all living and nonliving things.

Creation stories suffuse the world's religions. Their authors tried to explain what to them was unexplainable: the origin of the world. Some peoples, such as the Bambara, seem to have imagined a creation that nearly mirrors today's scientific explanations. For others, creation was supernatural. To Judeo-Christians and Muslims, the world was created out of nothing by a Supreme Being. To the ancient Greeks, the Earth was created when the god Eros impregnated the goddess Gaea. To many in Asia, the world was born out of a cosmic egg; Earth was then created when mud was lifted by a great beetle from the ocean floor to the surface.

Today, science allows us a more complete—though no less colorful—explanation of our planet's origins. It is through science that we catch a glimpse of a universe unfolding and of life catching hold on a small, inconsequential, blue green planet located in an insignificant region of one galaxy among millions.

Our universe came into being between 10 billion and 20 billion years ago. The most widely accepted theory of its origin is the "Big Bang." Although the exact mechanism of its emergence is unknown, the "Big Bang" holds that the universe began expanding and that expansion continues today. Some scientists hypothesize that in 100 billion years the universe may collapse in on itself to a point where matter and energy are both indistinguishable and unstable, leading to another "Big Bang" and thus possibly starting the whole process all over again.

Our own solar system is thought to have been born 4.6 billion years ago, as was the Earth itself. Although the impetus behind the solar system's formation is unknown, it may have had its catalyst in the shock wave from a supernova. Supernovas occur when a star explodes as it exhausts its nuclear fuel. When a shock wave from such a supernova reached our particular cloud of cosmic dust on the outer rim of the Milky Way galaxy, it caused the cloud to contract. As the dust and gas in the emerging solar system coalesced, the planets and asteroid belts were formed. The sun itself was born out of the center of the gaseous nebula that spawned the planets. For millions of years the solar system was littered with asteroids that impacted the new planets with devastating frequency. Over millennia the number of impacts declined as the meteors were accreted onto the planets.

Our Earth not only orbits around the sun, at a mean distance of 93 million miles (149.5 million kilometers), but it also rotates about its own axis. The Earth takes a year—365 days and 6 hours—to orbit the sun, and a solar day—actually 23 hours, 56 minutes, and 4.1 seconds—to turn one complete revolution on its axis. The Earth is also tilted 23 degrees 26 minutes 28 seconds, and this inclination gives us the seasons and alternately lights or darkens one of the poles.

The Earth's axis is not stable but ranges between 21 degrees 39 minutes and 24 degrees 36 minutes over a cycle of 40,600 years. The shape of the Earth's orbit

The scene is so weird and lonely and so incomprehensible in its novelty that one feels that it could never have been viewed before.

—FREDERICK S. DELLENBAUGH,

The Romance of the Colorado River

around the sun also varies over time, from being nearly circular (as it is now) every 95,000 years to being truly elliptical every 413,000 years. It is the interaction between the changing axis and the changing orbit that may send our planet into an ice age or bring it out of one, depending on whether the change brings the Earth closer to the sun or farther away from it.

As the Earth and the other planets orbit the sun, so too is the sun in motion, orbiting the center of the galaxy. Every 30 million years the sun passes through the densest part of the Milky Way galaxy. Some scientists think that just as the periodicity of the Earth's axis and orbit influence seasonality and ice ages, so too does our progression through the Milky Way.

The newborn Earth of 4.6 billion years ago was a molten planet, a literal melting pot with temperatures above 3,270°F (1,800°C) and an ocean of molten rock 100 miles (160 kilometers) deep. Over the course of a million years, the heavy iron contained in the molten rock sank to the core of the planet. Even today, the core's temperature is an incredible 12,600°F (7,000°C). A crust—the lithosphere—gradually formed at the surface, but turbulence in the molten rock below maintained sufficient stresses and fractures in the crust to form mobile plates. At the edges of these tectonic plates, volcanoes released molten rock and gas into the atmosphere. The proto-atmosphere was one of carbon dioxide, carbon monoxide, water vapor, nitrogen, ammonia, and methane. The Earth was not a hospitable place. Gradually, however, water appeared. It came from the icy cores of comets that struck the planet and from vapor ejected from volcanoes. It was a slow process, but the oceans formed and Earth became a planet more water than land.

The plates on the surface of the Earth cooled quickly, probably well before 4 billion years ago, and gradually the number of meteoric impacts declined. Amazingly, life seems to have appeared soon after conditions were ameliorated. It is likely that the first organisms to appear were "heterotrophs," bacteria that fed on organic molecules in the primordial soup. The earliest known fossils (from Western Australia) have been dated at 3.465 billion years (that's 3,465,000,000 years old). The early evolution of life, from organic compound to proto-cell and finally to a viable and asexually reproducing cell, seems to have been very rapid—in the grand scheme of things—probably beginning 135 to 435 million years after the Earth first became habitable ("habitable" for bacteria being far removed from anything that we would normally consider ripe for life).

For two billion years, single-celled bacteria dominated life on Earth (they still dominate but have now been joined by multicellular creatures). The early single-celled bacteria changed the environments they were inhabiting and thus paved the way for the diversity of life to come. The most dramatic change was the production of oxygen by photosynthesis. Initially this would have been a disaster for most early life forms. Oxygen would have been toxic to the bacteria that evolved in a non-oxygen-rich environment, and most would have become extinct or disappeared into anaerobic environments deep in the mud or rocks.

At first the oxygen released by the early photosynthesizers was used up by the oxidation process—for example, by oxidizing iron to iron oxide. When all of the surface iron had been oxidized, about two billion years ago, free oxygen began to collect in the atmosphere (at a rate of just 0.000000006 percent being added every million years) until the current oxygen level of 21 percent was achieved. If the amount of oxygen in the atmosphere were to continue to rise much above 21 percent, we would find ourselves in a highly combustible environment; if the amount were to decline, we would be starved for breath very quickly. Fortunately, the amount of oxygen produced by plants and cyanobacteria today is offset exactly by the amount of oxygen used up by the weathering of exposed rocks and organic matter.

It can be comforting to look at a world map and imagine that is the way the Earth has always looked: North America connected to South America,

Gigantic walls of rock,
Sheer as the world's end,
seemed to float in air
Over hollows of space,
and change their forms
Like soft blue
wood-smoke, with each
change of light. . . .

—ALFRED NOYES

Antarctica over the South Pole, Europe situated to the north of Africa, Asia stretching over toward the Americas, and the island continent of Australia lying to the south of Asia. The oceans fill in the gaps: the Pacific, Atlantic, Indian, Antarctic, and Arctic Oceans. Sporadically distributed around the world are oceanic islands, such as the Hawaiian Islands, French Polynesia, the Seychelles, the Azores, and the South Shetlands.

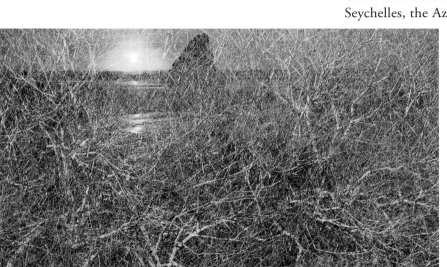

Pacific Willow *(Salix lasiandra),* **Mendocino, California, USA**
Photograph by David Muench
A double exposure, made in camera, combines a chaotic tangle of willow branches and the golden light of a Mendocino sunset along California's northern coast.

But there is something else that shows up on a world map: patterns. Many of the Earth's volcanoes can be linked in the "Ring of Fire" around the Pacific. There are mountain ranges that run along the edges of continents. Then there are the two continents that, like jigsaw pieces, seem to be two halves of a single land: Africa and South America. These features, so obvious to us today, were not so obvious to early geologists, although some credit Francis Bacon, the English philosopher, with first noticing the curious shapes of Africa and South America as far back as 1620. It took centuries longer, however, for the accepted theories of continental permanence to make way for an innovative and unexpected explanation for these patterns: the Earth is a mobile and fluid planet.

The current positions of continents, mountain ranges, and volcanoes, and the location of water-filled oceanic basins, are transitory. The continents are not the static structures we imagine beneath our feet. They are on the move. Inexorably and inevitably the continents move, oceans are born, islands grow, and mountains are pushed upward and erode downward. We cannot perceive these global changes because our presence is so fleeting, but we can learn of the past and imagine the future by looking closely at the rocks at our feet and venturing deep into the oceans.

The Earth's crust, or lithosphere, overlays a highly viscous but still mobile mantle (the lithosphere also incorporates the solid part of the upper mantle). This crust is made up of sixteen major tectonic plates—the North American, Pacific, Juan de Fuca, Cocos, Caribbean, Nazca, South American, Scotia, Eurasian, African, Arabian, Indo-Australian, Philippine, Caroline, Fiji, and Antarctic Plates—as well as numerous smaller plates, or terranes. The tectonic plates that hold the continents are about 75 miles (120 kilometers) thick, while those under the oceans are about half as thick.

It was the German meteorologist Alfred Wegener who made "continental drift" into a viable theory at the beginning of the twentieth century. Wegener noted the similarities between the coastlines of Africa and South America, and he reviewed literature that told of identical fossil forms found on both sides of the Atlantic. The explanation he came up with was revolutionary: at one time the continents had been one and had then been split apart. But how? Convection currents deep below the Earth's surface stir the viscous mantle and literally pull the plates apart or force them together at rates as fast as 2.4 inches (60 millimeters) a year. Admittedly, it doesn't sound like much, but if that rate of movement is maintained for a million years, a plate may move 37 miles (60 kilometers). Time, not speed, provides the explanation for the changing surface of the Earth.

Five hundred million years ago the continents were scattered across the Earth in positions far different from those today. Many were island continents. This was the time of the first fish; there were no land plants, no insects, no reptiles. Over the course of 140 million to 180 million years these continents joined together to form supercontinents that have since been named Gondwana and Laurasia, and life began to take to the land.

Two hundred fifty million years ago, at the end of the Permian Period, the Earth's continents were massed together to form a single supercontinent

known as Pangea, surrounded by a single ocean, Panthalassa. The end of the Permian also saw a mass extinction, the largest ever, when 95 percent of all life vanished. From the survivors of that mass extinction rose the first dinosaurs and ultimately the first mammals. For tens of millions of years small mammals lived in the shadows of the "terrible lizards." Gradually, Pangea began to break apart. North America separated from North Africa 180 million years ago and from Europe 150 million years ago. South America and Africa went their separate ways 110 million years ago. Throughout this time the dinosaurs flourished and the first flowering plants evolved.

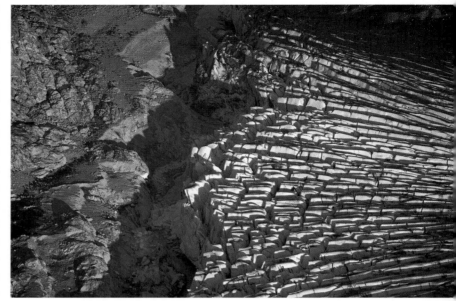

Sixty-five million years ago, the dinosaurs all but vanished. The mass extinction at the end of the Cretaceous Period eliminated just about every land animal weighing more than 55 pounds (25 kilograms). Many have speculated as to the direct cause of this most famous of extinction events. The impact of a 6-mile-wide (10-kilometer-wide) asteroid that left a huge crater along the coast of what is now Mexico's Yucatán Peninsula is still the most likely culprit, since it would have sent millions of tons of debris into the atmosphere, blocking out the sun's light. It is also possible that massive volcanic eruptions in central India—eruptions that formed the 208,000-square-mile (520,000-square-kilometer) Deccan Traps lava beds—were associated with this mass extinction, since they would also have ejected vast amounts of dust and gases into the atmosphere.

Bagley Ice Field, Wrangell–St. Elias National Park and Preserve, Alaska, USA
Photograph by Marc Muench
The largest subpolar ice field in North America, the Bagley Ice Field is more than 150 miles (240 kilometers) long and spawns numerous glaciers, including the Columbus and Bering Glaciers.

Forty-five million years ago, the continents were approaching their present positions, but North America had yet to connect with South America, Africa was still separated from Eurasia by the Tethys Sea, and India was still an island continent heading north toward a union with the rest of Asia. Today, the arrangement of the continents is so familiar as to seem inviolable, but of course, everything is still in motion.

The movements of the Earth's plates have predictable results. When two plates move apart, they are said to be "spreading." As the underlying convection currents force molten rock upward, the plates split apart and new lithosphere is formed as hot rocks are forced through the crust. This is the situation along the 11,978-mile-long (19,320-kilometer) subsea Mid-Atlantic Ridge that separates the North and South American Plates from the Eurasian and African Plates. These plates are spreading at a rate of between 0.8 and 1.6 inches (20 and 40 millimeters) a year in each direction.

The presence of such oceanic "conveyor belts" of new volcanic material means that the ocean floors consist of some of the youngest rocks on Earth. When "spreading" occurs on land, the results can be both explosive and breathtaking. Iceland is positioned right on the Mid-Atlantic Ridge. "Spreading" here means that new land is formed out of the fiery mouths of volcanoes. Iceland was formed 20 million years ago when lava spewing from the spreading ridge reached above the ocean surface. Iceland is still growing—literally being pulled apart—at a rate of about one inch (25 millimeters) a year. The entire island is influenced by volcanic activity. It is rich in geothermal energy, which provides much of the human population with heat. There are hot springs and geysers—all visible surface manifestations of the heat and energy contained just a short distance below the surface. Iceland truly is an amazing union of fire and ice, volcanoes and glaciers. Its citizens live with the knowledge that their home is one of the most unpredictable places on Earth, and one of the youngest.

Since "spreading zones" add new lithosphere to the Earth's crust, there must be corresponding areas where crust is destroyed; otherwise the Earth would be getting ever larger. These areas of destruction are known as "subduction zones."

"Subduction" occurs when oceanic crust is forced under another portion of crust, usually continental. Although thicker than oceanic crust, continental crust is actually less dense, so that a collision between oceanic and continental plates results in the subduction of the former. As the oceanic crust is forced down, it begins to melt when it reaches depths of 40 to 80 miles (64 to 130 kilometers). The melting crust forms magma that, because it is less dense than the surrounding solids, rises to the surface, forming a chain of volcanoes at the margin of the overlying plates. Subduction zones are also shaken by frequent earthquakes as tensions in the crust are released. This is exactly what happened as the Nazca Plate in the southeastern Pacific was subducted under the continental South American Plate, forming both the Andes Mountains and numerous active volcanoes along South America's backbone. The Pacific Plate is also being subducted to the north under Alaska's Aleutian Islands and along the western Pacific coast of Kamchatka and Japan; the resulting volcanoes form part of the violent chain of scorching pearls known as the "Ring of Fire."

The two other plate interactions—"collision" and "transform"—do not produce volcanoes, but do generate substantial earthquakes. The collision of two plates occurs when they are of equal density and neither is subducted. Such is the case in the Himalayas, where the Indo-Australian Plate is moving northward, crashing into the Eurasian Plate at a rate of about 2.4 inches (60 millimeters) a year, and in the Alps, where Africa is pushing into Europe. Since these plates are all continental, neither of the colliding pair is subducted beneath the other; instead they push against each other, forcing the lithosphere to wrinkle and crumple upward, forming mountains of dramatic height. The highest peak in the Alps is Mont Blanc at 15,771 feet (4,807 meters), while Mount Everest is the highest peak in the Himalayas, and the world, at 29,035 feet (8,852 meters). Since the Indo-Australian Plate is still pushing northward, Everest is continuing to grow at a rate of about 0.4 inch (10 millimeters) a year. A climber who summits the mountain today is actually climbing a higher mountain than that first conquered by Sir Edmund Hillary and Tenzing Norgay in 1953—by an impressive 20 inches (50 centimeters), give or take a few inches that might have been lost to the erosive forces of ice and wind.

On the North American continent, the Appalachians of the East and the Rocky Mountains of the West tell a similar story of formation by plate collision. The Appalachians owe their origin to the collision of the ancient continents of Laurasia and Gondwana to form Pangea about 390 million years ago. As these land masses were forced together, the plates crumpled upward, creating a great mountain chain that may once have been comparable to the Himalayas. When Pangea split apart, part of this mountain range traveled a new path with the North American continent, while the rest remained in Europe, forming the Caledonian Mountains that stretch from Ireland and Scotland into Scandinavia. It was the similarity between the Appalachians of eastern North America and the Caledonians of northern Europe that convinced some geologists that Wegener was on the right track with his theory of continental drift.

Today the 1,180-mile-long (1,900-kilometer-long) Appalachians are gentle rather than severe and are one of the oldest mountain chains in the world. The Blue Ridge Mountains of Virginia, the Great Smoky Mountains of North Carolina, and the Green Mountains of Vermont are rolling, heavily eroded peaks, but they are still rich in beauty. The tallest peak in the Appalachians is North Carolina's 6,722-foot (2,037-meter) Mount Mitchell. Among the old mountains of northern Europe, time has also taken its toll and softened the many peaks; Britain's highest mountain, Ben Nevis, stands just 4,431 feet (1,343 meters).

The Rocky Mountains of North America owe their stature to a slightly different process of collision. As North America, freed from its embrace with Gondwana, was pushed ever westward by the spreading along the Mid-Atlantic

Dirty Devil River, Utah, USA

Photograph by David Muench

A skull sits as silent testament to the aridity of this desert pavement landscape. Pavements form where wind and water combine to remove lighter grains and pebbles, leaving behind only the heavier stones and rocks.

Ridge, the continent collided with a number of small plates, or terranes, that pushed up against, and in some cases even overrode, the larger continental plate. Seventy million years ago, the western part of the North American continent was overlain with water and lay thick with sediments. As the plates collided they thrust against each other, and the sediments trapped between the plates were pushed upward. Sediments that had been deposited beneath the waves now reached skyward. Thus, such well-known sites as the Burgess Shale in Canada's Yoho National Park contain fossils of 530-million-year-old marine organisms. While these creatures died at sea level, they now rest at heights of some 4,950 feet (1,500 meters).

The North American continent is still being pushed westward and is moving at a rate of about 0.8 inch (20 millimeters) a year. As the continent shifts, it is converging with the oceanic Juan de Fuca Plate that lies to the west of Vancouver Island. At the convergence zone, the Juan de Fuca Plate is being subducted under the North American Plate. The melting of the oceanic plate as it descends into the mantle has formed the Cascade Volcanic Arc, which includes such fiery (or potentially fiery) mounts as Mount Rainier, Mount St. Helens, and Mount Baker.

To the south of the Cascade Mountains, the situation changes. Instead of one plate being subducted beneath another, two plates are sliding past each other, forming a "transform fault." This is the case in perhaps the best known of the world's transform faults, the San Andreas.

Baja California and coastal California form part of the Pacific Plate, while everything to the east of them is part of the North American Plate. The plate boundary can be traced from the East Pacific Rise (the Pacific equivalent of the Mid-Atlantic Ridge) through the Gulf of California and north into California. At this point, the Pacific Plate and the North American Plate are moving past each other (with the bulk of the movement to the north) at a rate of about 3.2 inches (80 millimeters) a year. If that movement is divided fairly evenly throughout the year, the earthquakes that occur are relatively minor. Over the years such minute movements crack roads and buckle fences, but they do little substantial damage. If, however, one year most of the fault's movements are concentrated into one or two events—each moving the plate, say, 1.6 inches (40 millimeters)—the resulting earthquakes can be severe. Still, not all California earthquakes occur along the San Andreas—in fact, the majority do not. The stresses that occur along the transform fault are released over a wide zone, not solely along this single fracture.

Few natural phenomena are as frightening as an earthquake. Typhoons can be tracked; for all their fierceness, people usually know they are coming. Volcanoes are visible on the horizon. They may erupt unexpectedly, but often they proffer warnings before blowing their tops. Forest fires and grass fires can be watched and combated. Floods can be predicted and even diverted. But faults lie hidden. Discontinuities in rock strata that tell of a surface fault often go unnoticed by all but geologists. Faults lie silent until they rip into the fabric of our world. Most other natural phenomena can be clearly seen as they approach, but the progenitor of the earthquake is largely invisible.

Earthquakes around the world have claimed millions of lives and redesigned entire regions. In China alone, 13 million have died in the last 3,000 years as a result of earth tremors. Cities such as Antioch (Asia Minor), Managua (Nicaragua), Antigua (Guatemala), Tokyo, Yokohama, and Kobe (Japan), Tangshan and Haicheng (China), Lisbon (Portugal), San Francisco, California, and Anchorage, Alaska (United States), have all been laid waste by earthquakes. Even Sodom and Gomorrah likely had their downfall in a shifting of the Earth's tectonic plates. Earthquakes have destroyed entire civilizations. "Civilization exists," said historian Will Durant, "by geological consent, subject to change without notice."

Earthquakes also occur in association with "hot spots," where an intense heating in the Earth's mantle burns through the lithosphere, forming a volcano

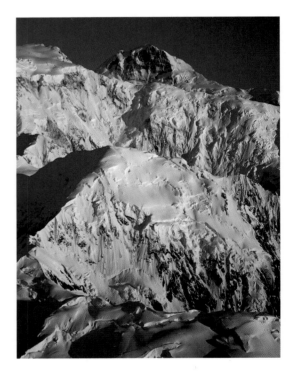

Mount Logan, Kluane National Park, Yukon Territory, Canada
Photograph by Marc Muench
At 19,850 feet (5,951 meters), Canada's highest peak is the focal point of Kluane National Park. The crest of this immense mountain is 10 miles (16 kilometers) across.

far from a plate margin. Such is the case in the Hawaiian Islands, Tahiti, Easter Island, the Azores, and at Yellowstone National Park. Even those rare earthquakes that occur far from a plate margin (and away from any known hot spots), such as in England, Australia, northern Russia, and in southeastern Missouri in the United States, can usually be explained by pent-up pressure resulting from movements at the plate boundary, hidden faults, or other stresses in the lithosphere.

Whatever their cause, the forces unleashed by earthquakes are unparalleled. Shock waves from Alaska's Good Friday earthquake of March 27, 1964, were felt more than 740 miles (1,200 kilometers) from the quake's epicenter in Prince William Sound. The 9.2 magnitude earthquake (upgraded from initial estimates of 8.6 on the Richter scale) was the most powerful ever recorded to hit North America and contained the same amount of energy as 10 million Hiroshima-type atomic bombs, or 200,000 million tons of TNT. This single event was eighty times stronger than the famous San Francisco earthquake of 1906. More than 104,000 square miles (260,000 square kilometers) of land was either uplifted or subsided. Montague Island in Prince William Sound was raised 37 feet (11 meters), while much of Prince William Sound's sea floor was raised 50 feet (15 meters), sufficient to cause a disturbance in the ionosphere 50 miles (80 kilometers) above the Earth's surface. Twenty-six thousand square miles (65,000 square kilometers) of land to the north and west of the fault line was moved seaward; Anchorage shifted by 6 feet (1.8 meters), Valdez by 33 feet (9.9 meters), and Seward by 46 feet (14 meters). For sixty-nine days following the immense earthquake, Southcentral Alaska was shaken by 12,000 aftershocks of 3.5 magnitude or greater.

An earthquake occurs somewhere on our planet every thirty seconds—that's 2,880 every day, more than 86,000 every month, or more than a million a year. Of these million only about 3,000 cause noticeable earth movements, but that still works out to an average of 8 every day. More than 20 earthquakes a year result in serious loss of life. Earthquakes are not the unusual spasms of our planet; they are integral components of a planetary ecosystem 4.6 billion years in the making. They may feel like the wrath of vengeful gods to some, but they are simply the by-products of a planet in motion.

The physical Earth is one of immense beauty, but it is a mutable beauty. Our planet is not a sculpture, crafted and finished in exquisite detail. It is a changeling planet, a work in progress.

What will the Earth look like 100 million years from now? It is fairly certain that no people will exist to witness this new geography for themselves. We can only imagine what creatures evolution will have spawned to take our place.

In 100 million years Africa will have pushed into Europe and wiped out the Mediterranean Sea. Africa itself will have been pulled asunder by the opening of the East African Rift, creating a new ocean. Australia will have moved north to Southeast Asia, running into Borneo and Indonesia, building mountain ranges along the way. California will have long since crashed into Alaska. Another 50 million years and the Earth will look increasingly different from the world we know today. The African Rift Ocean will grow larger, as will the Pacific, while the Atlantic and Indian Oceans will shrink under the converging forces of continents. In 250 million years a new Pangea will emerge. Mountain ranges will mark the locations of former continental boundaries, and the Pacific Ocean will dominate the globe. But things do not draw to a close, and what the tectonic forces bring together, they will ultimately pull apart. Again. And again.

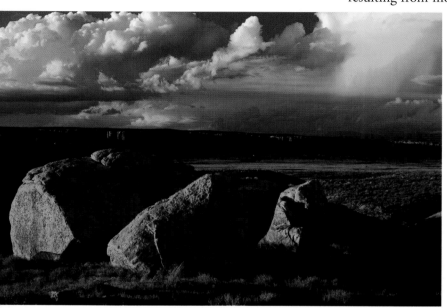

San Juan River, Utah, USA
Photograph by David Muench
Boulders deposited by a meandering San Juan River provide an imposing foreground for this stormy afternoon view of cumulus over the Abajo Mountains. Unnavigable for its entire length, the river has eroded numerous canyons across the Colorado Plateau, some more than 1,000 feet (300 meters) deep.

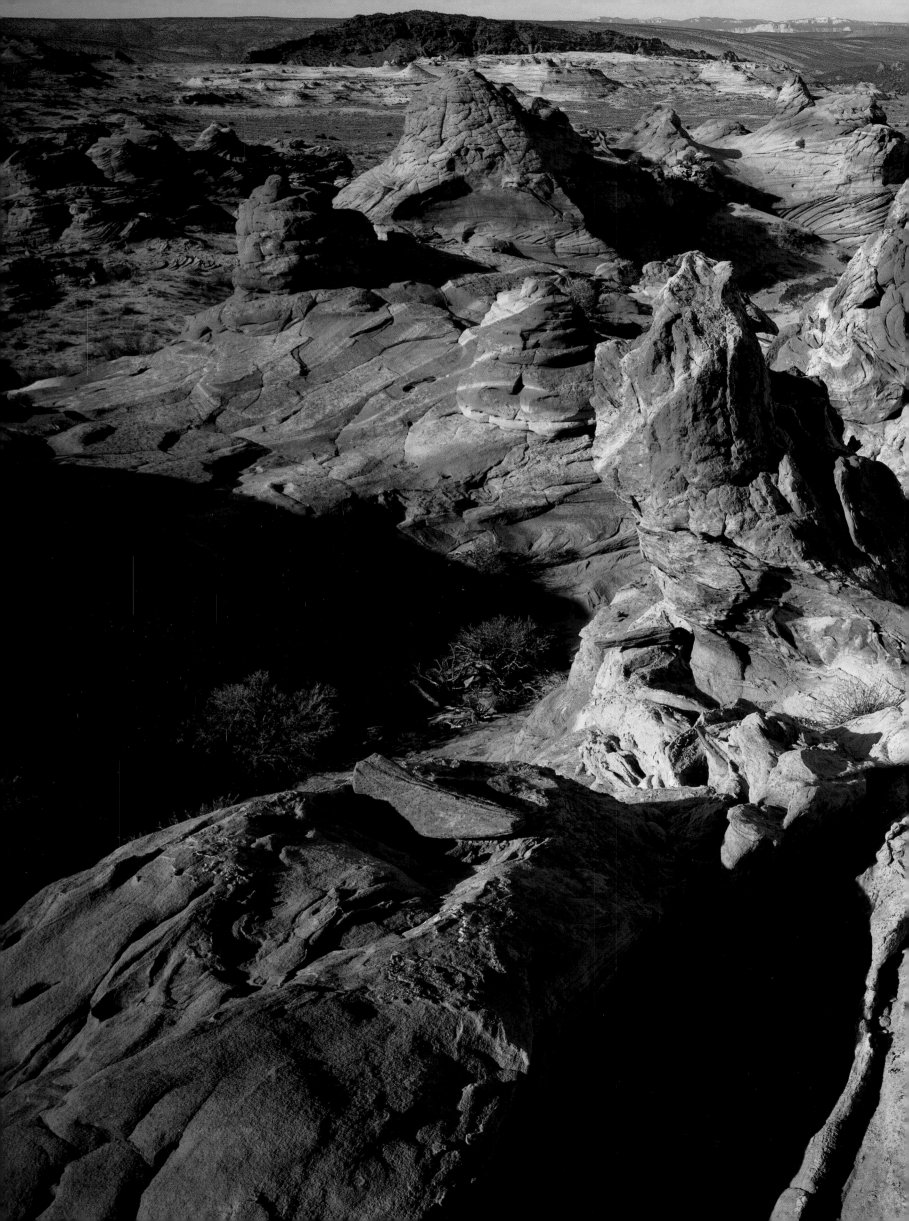

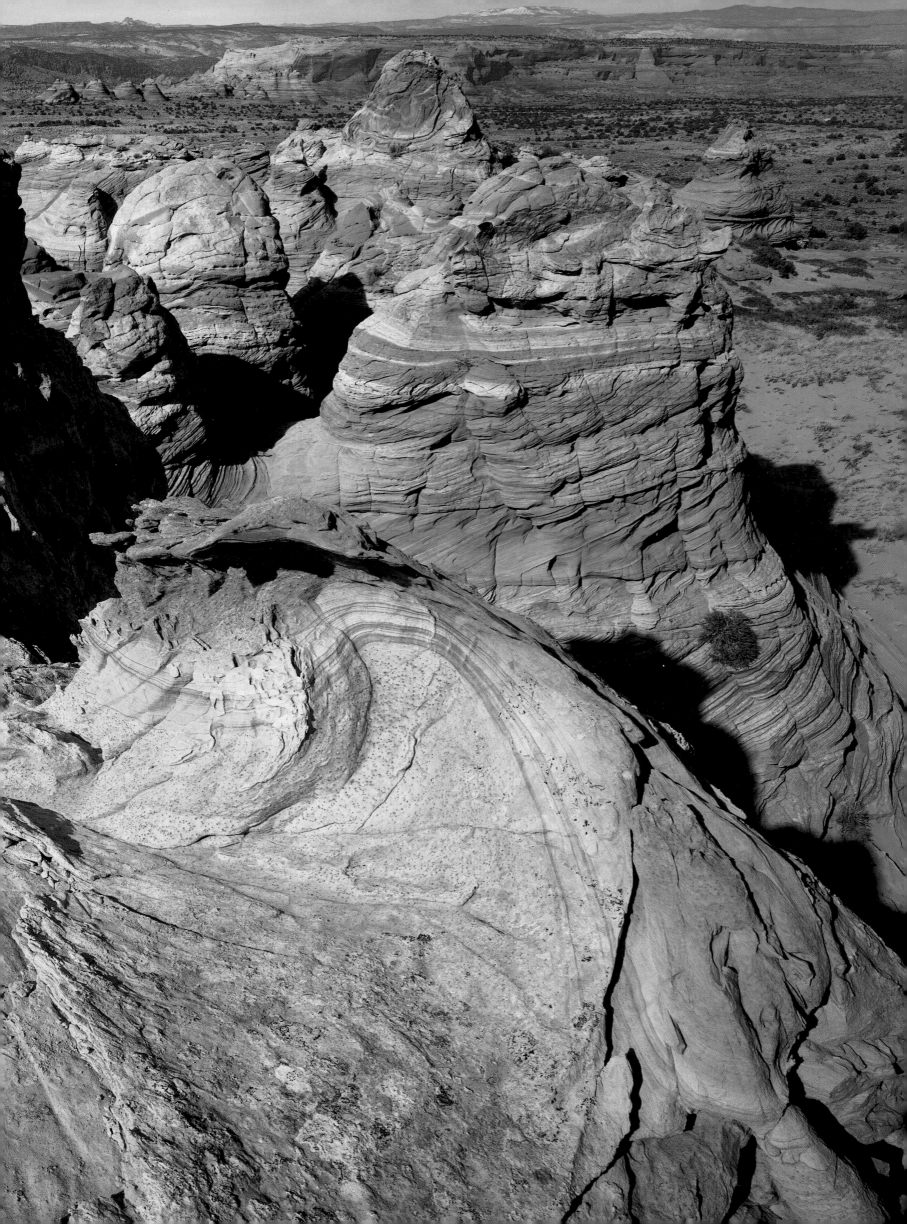

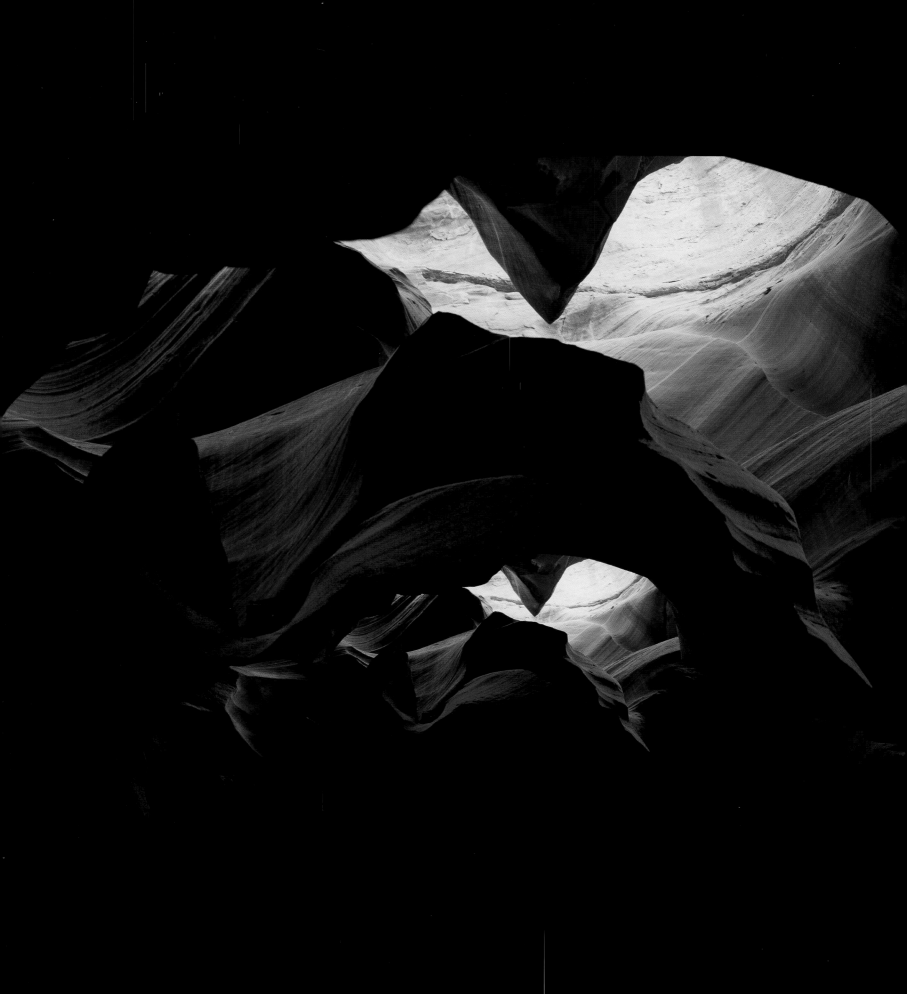

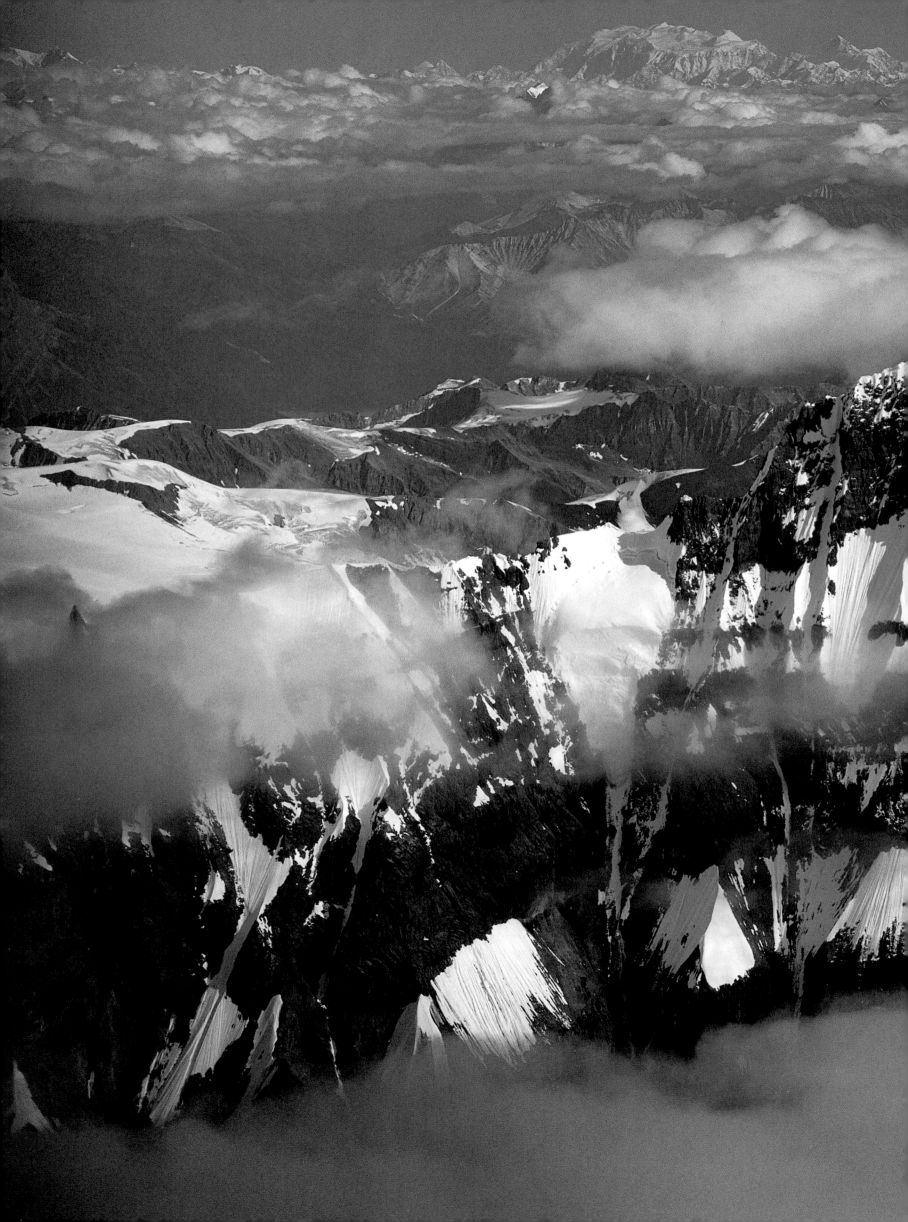

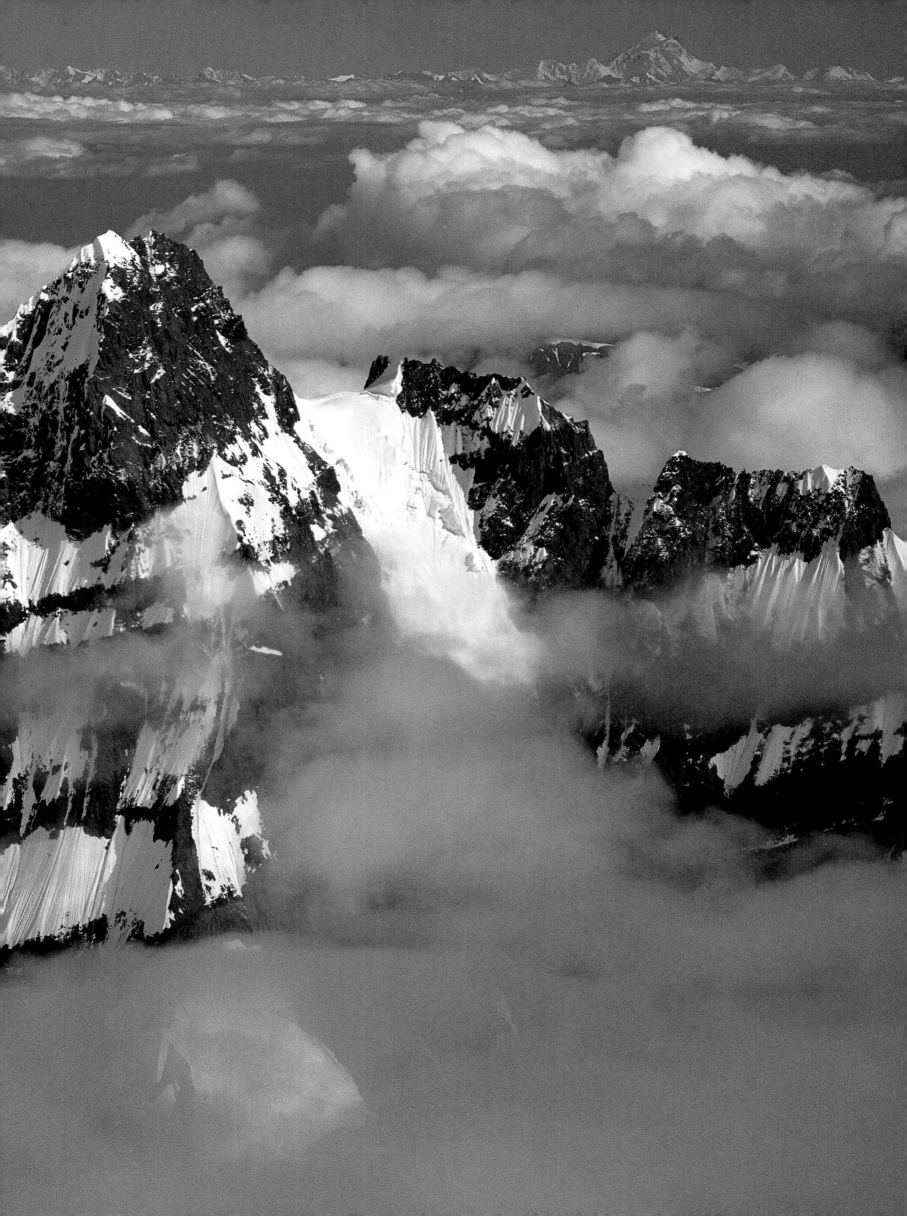

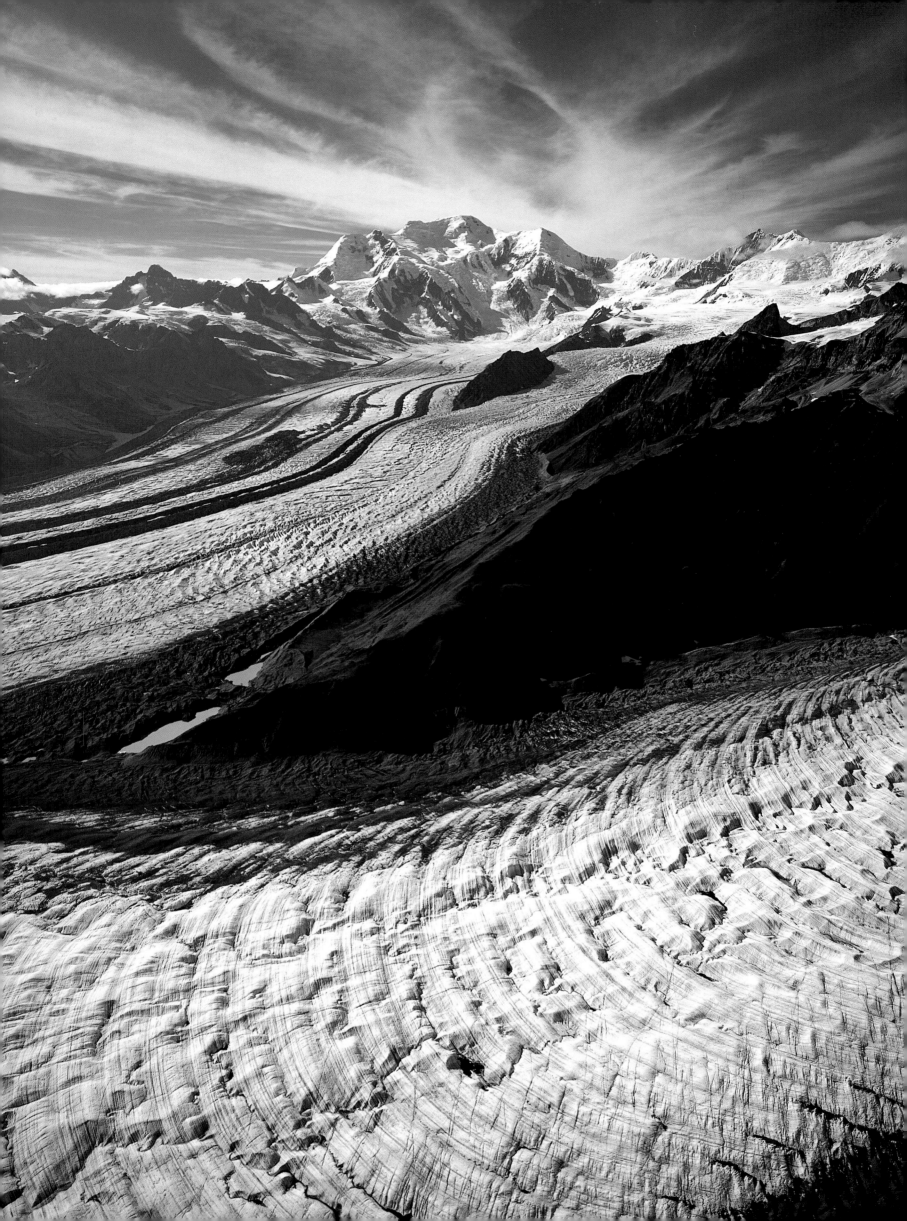

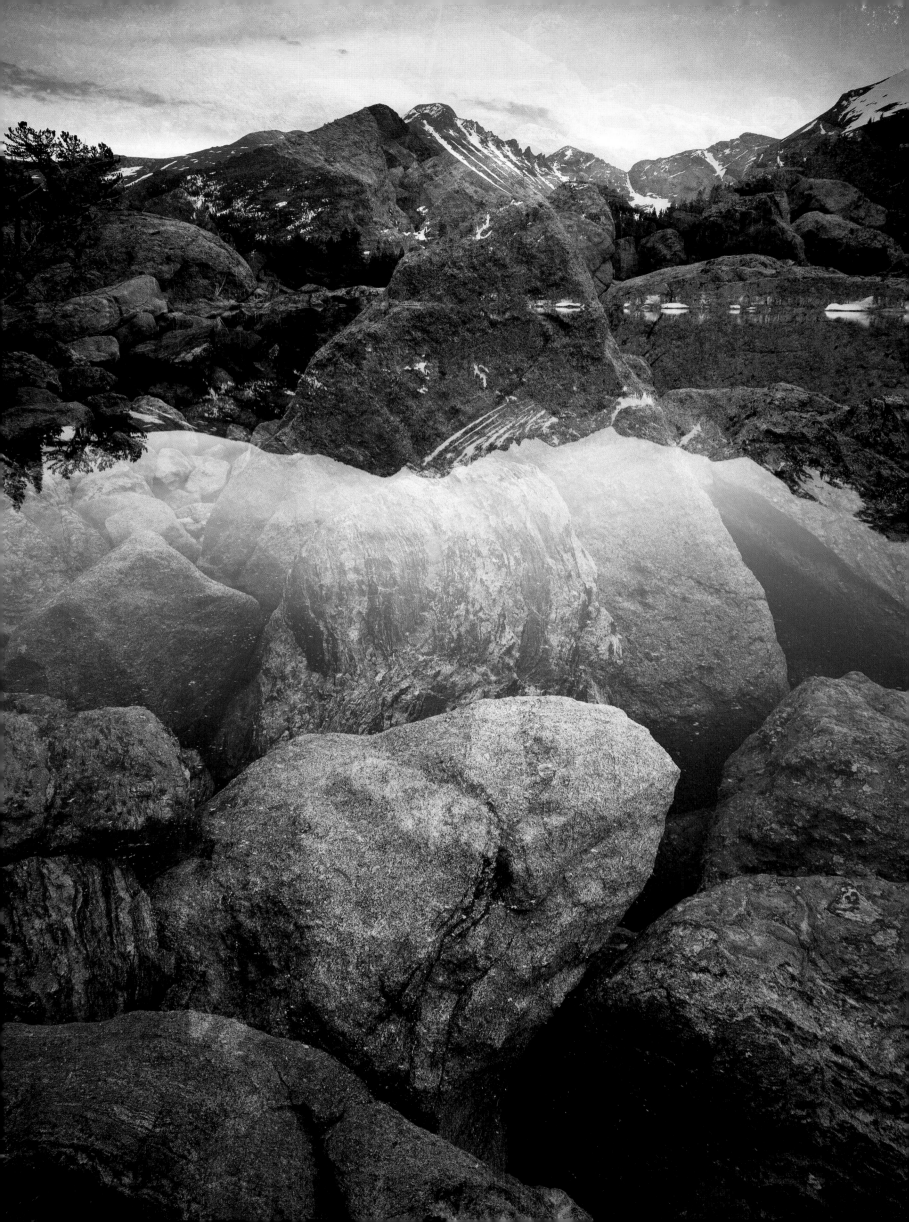

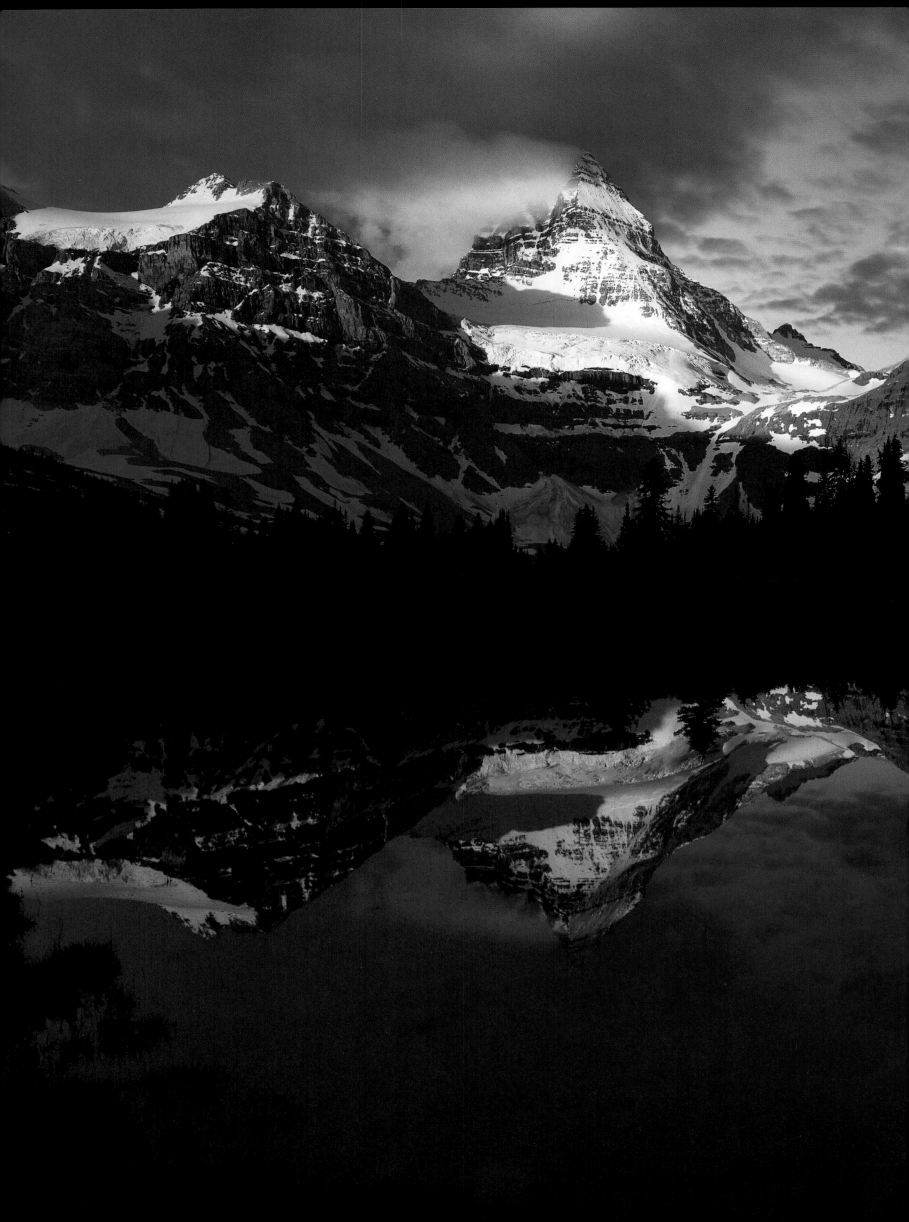

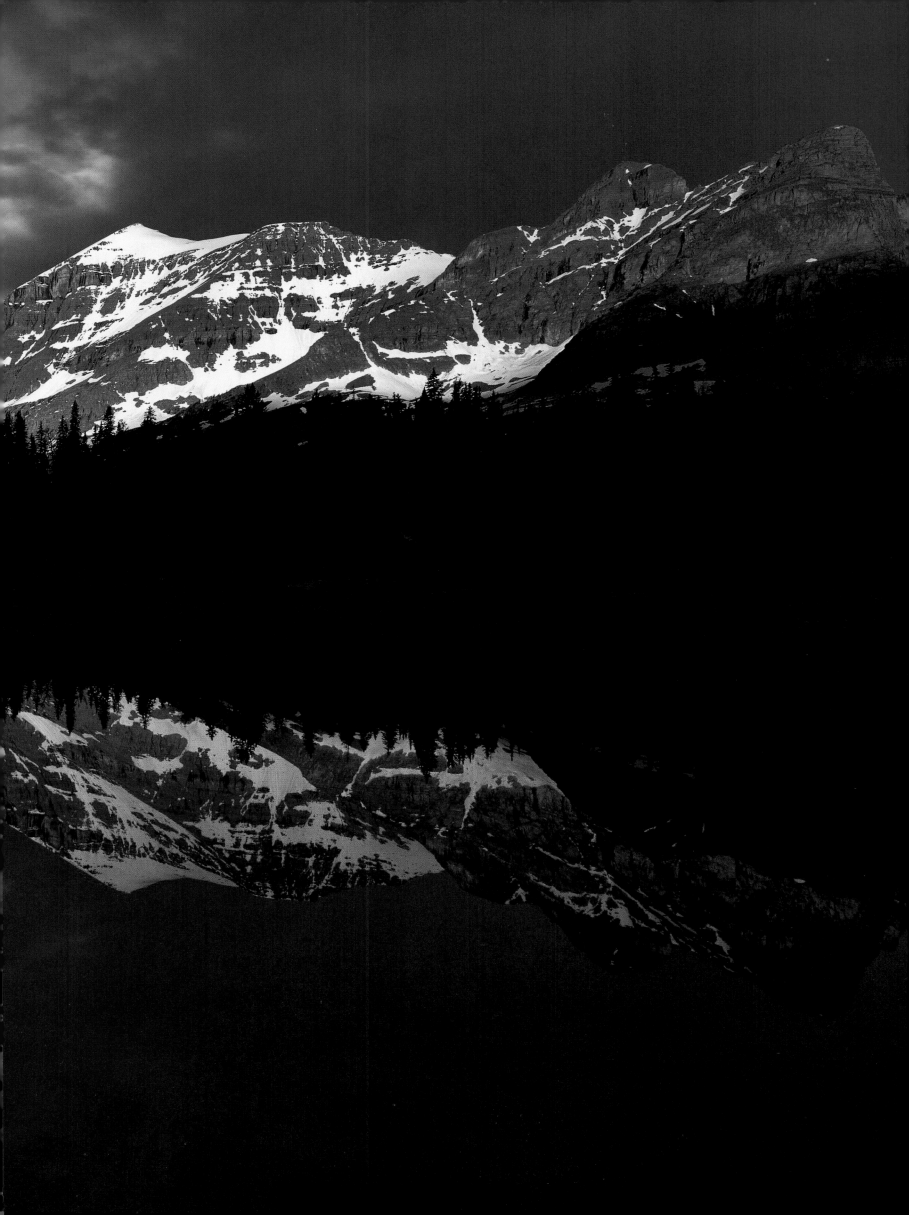

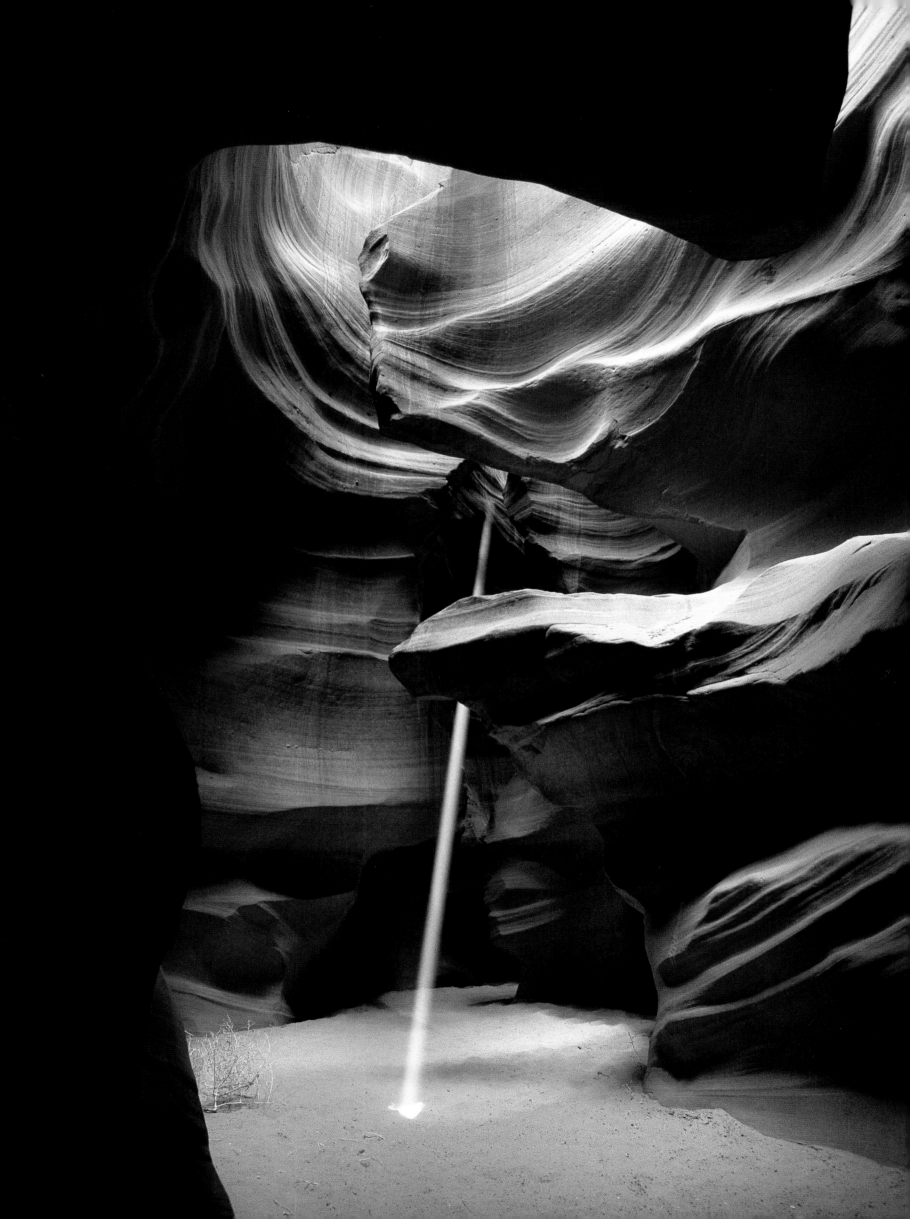

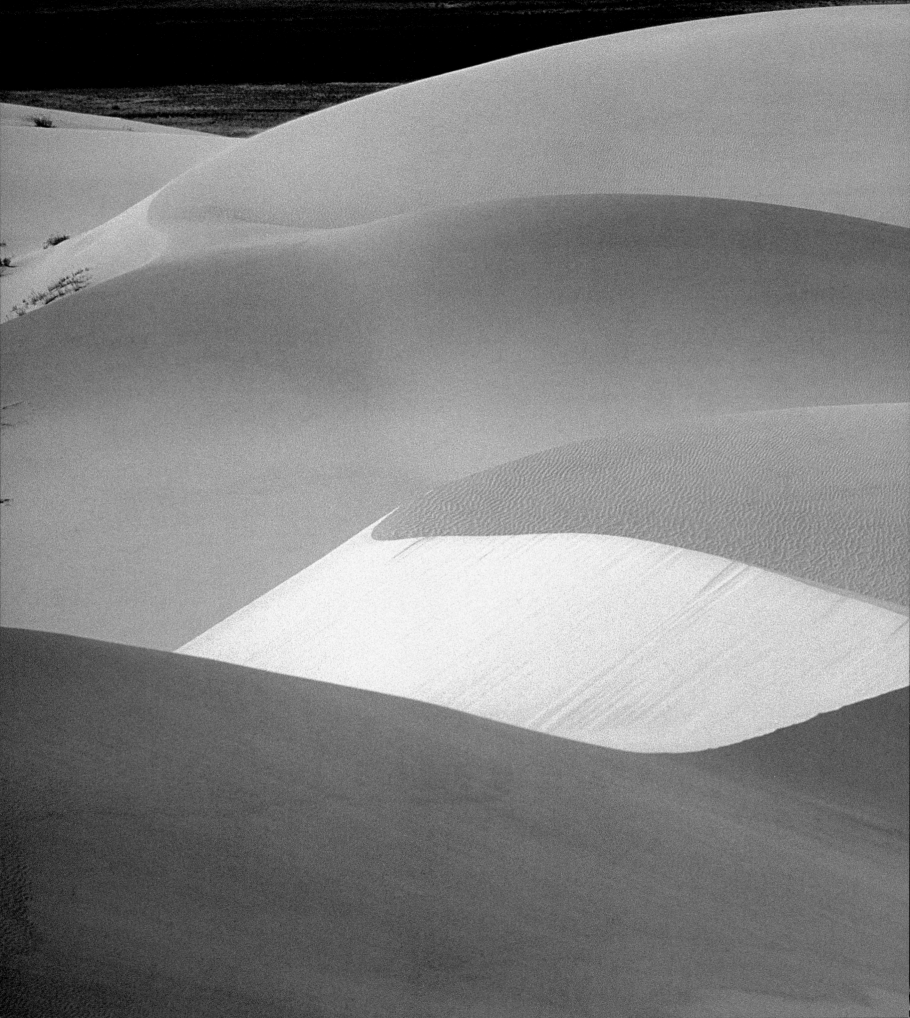

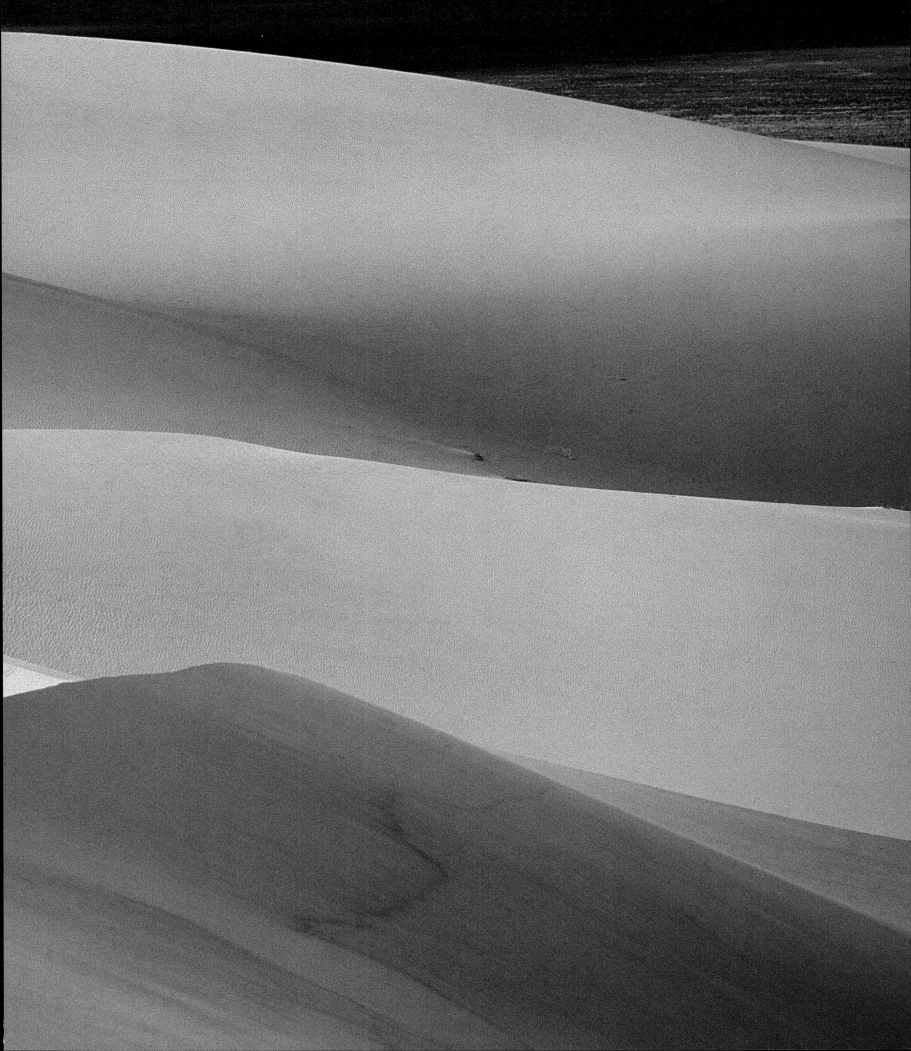

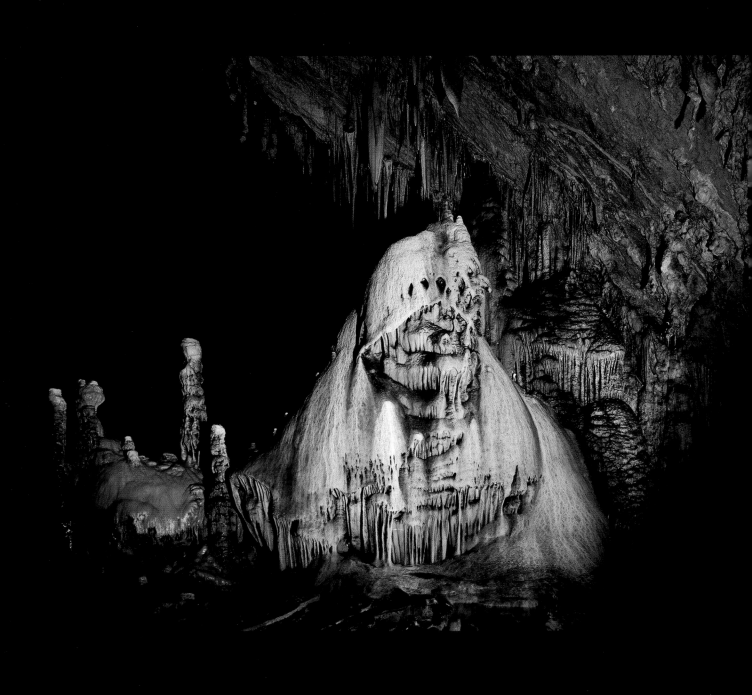

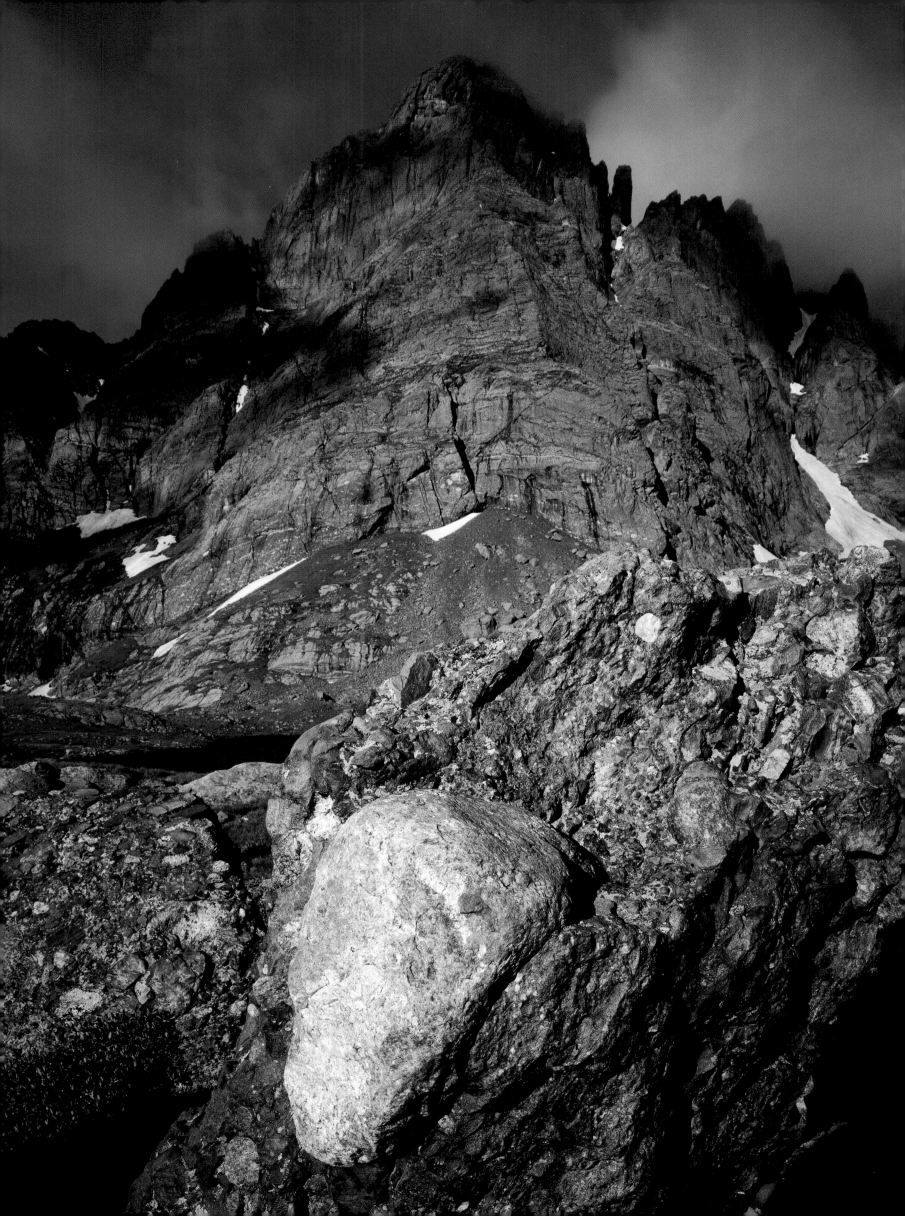

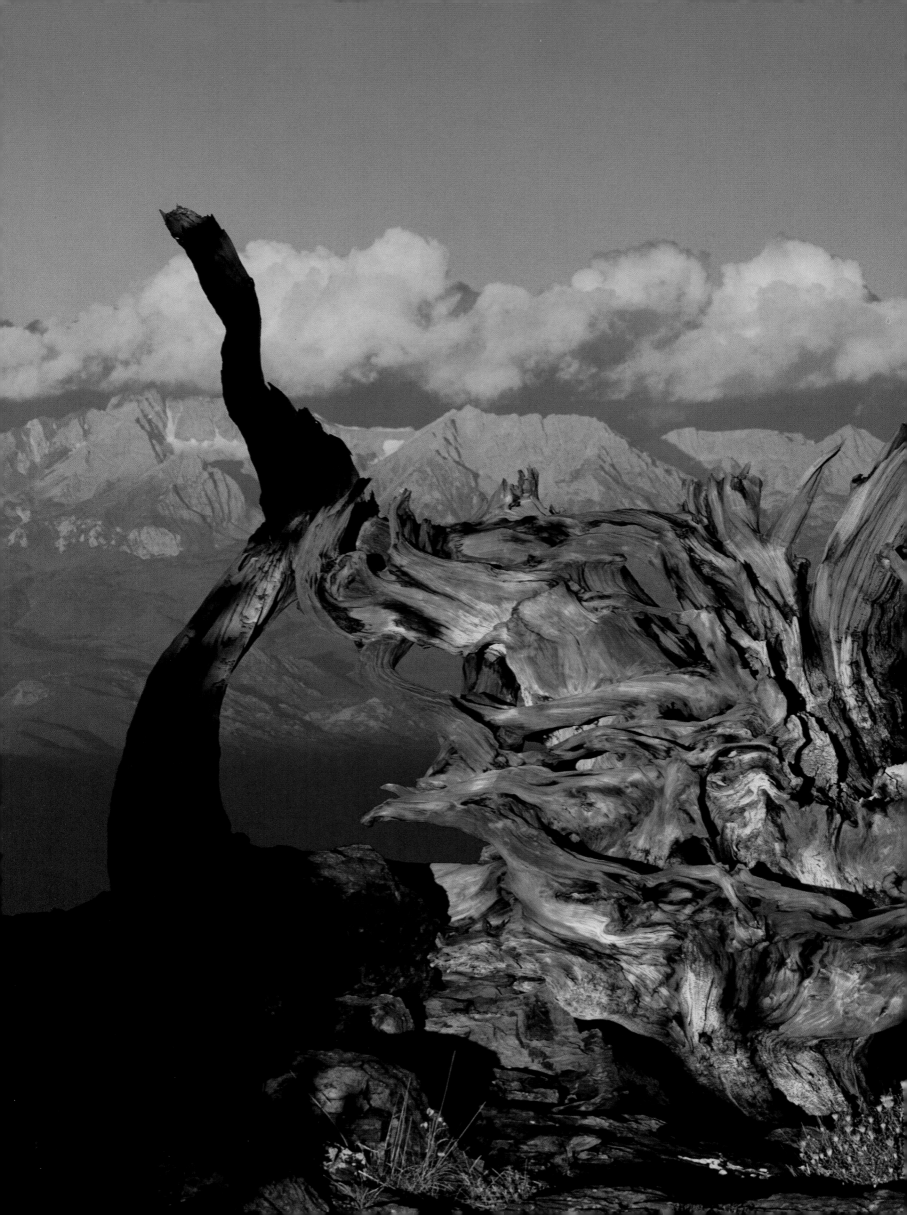

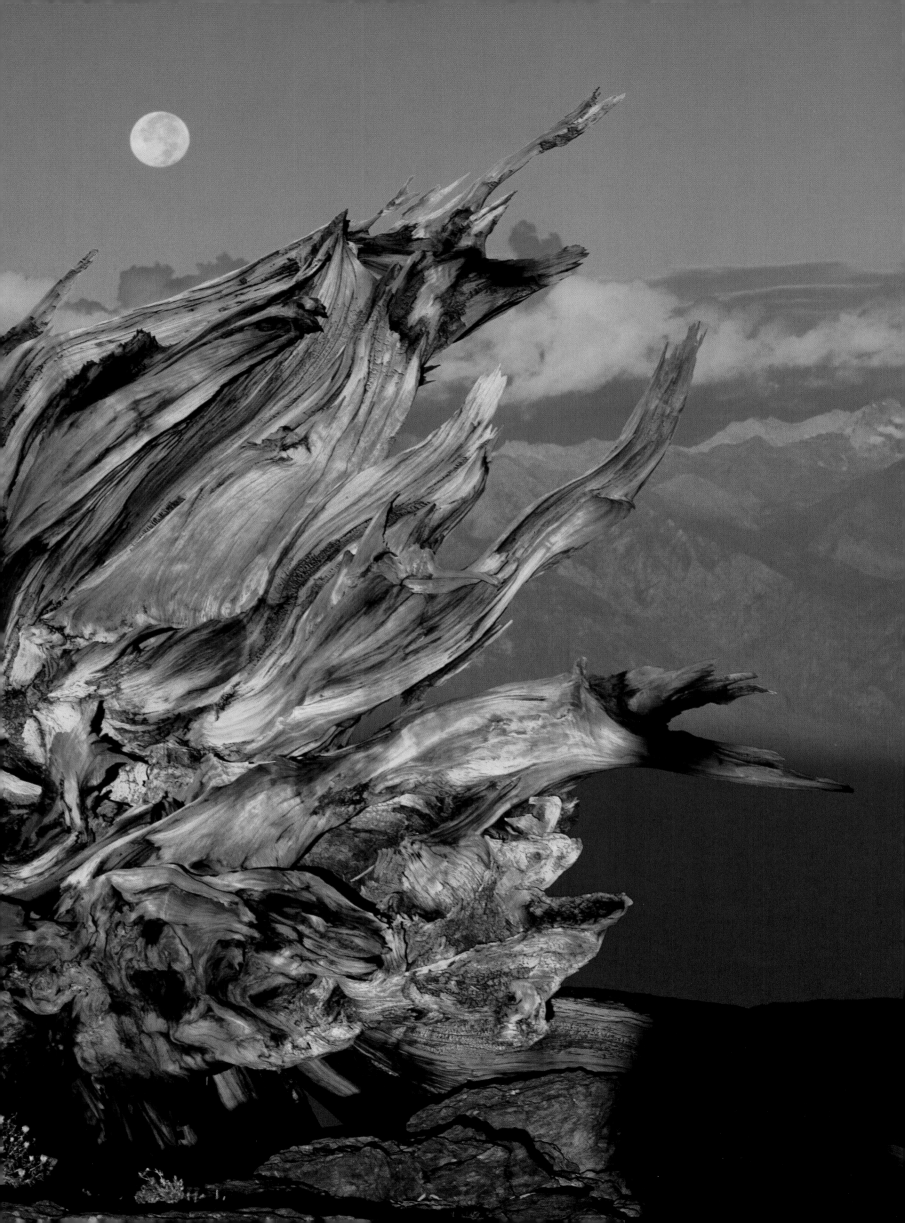

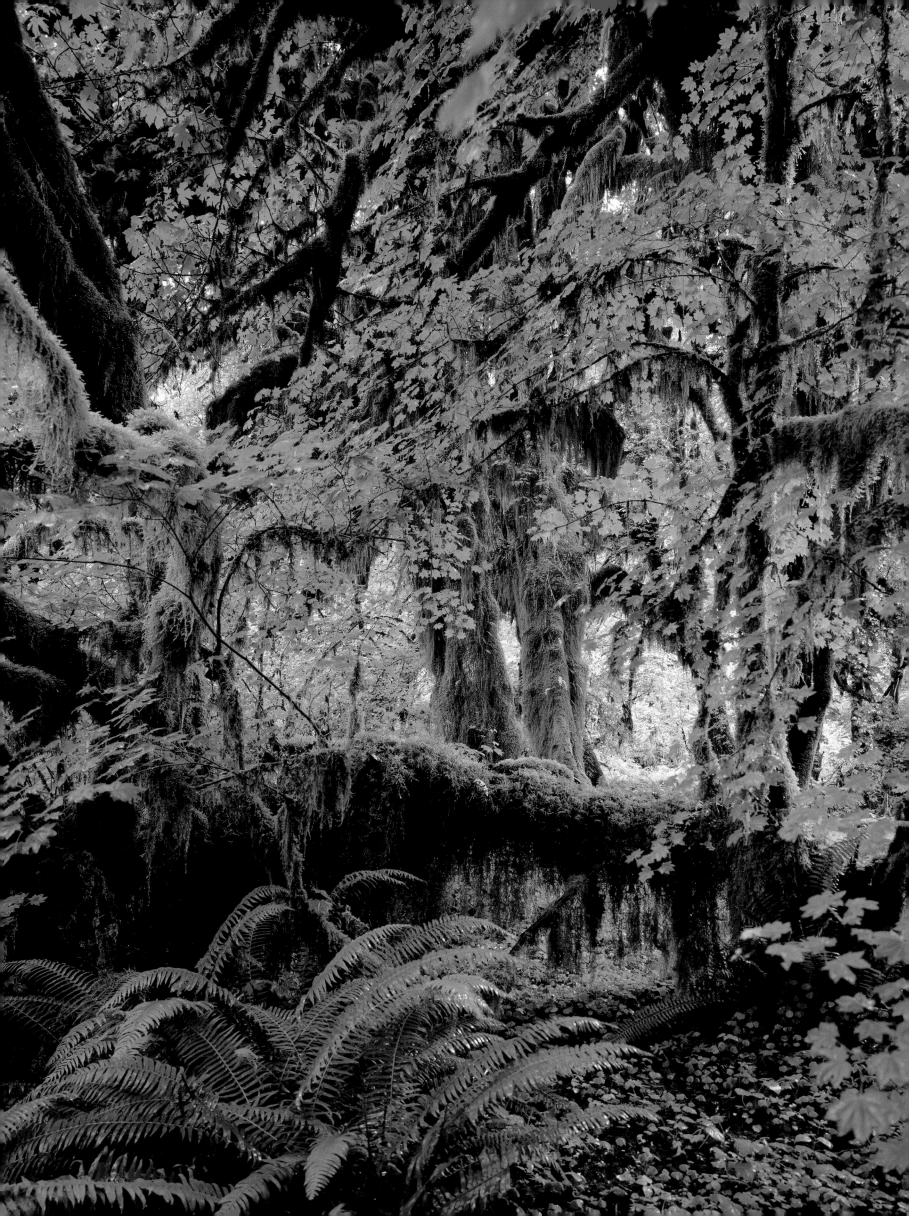

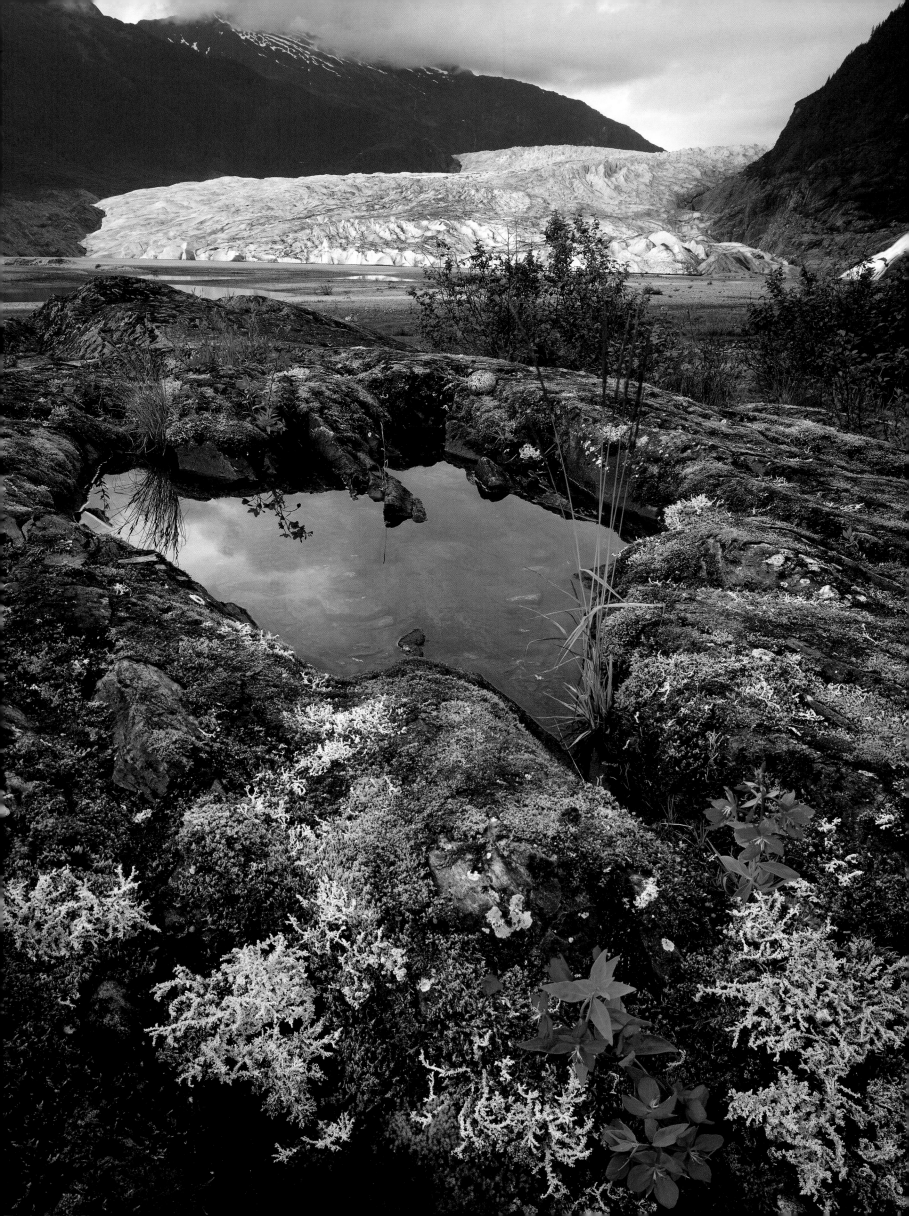

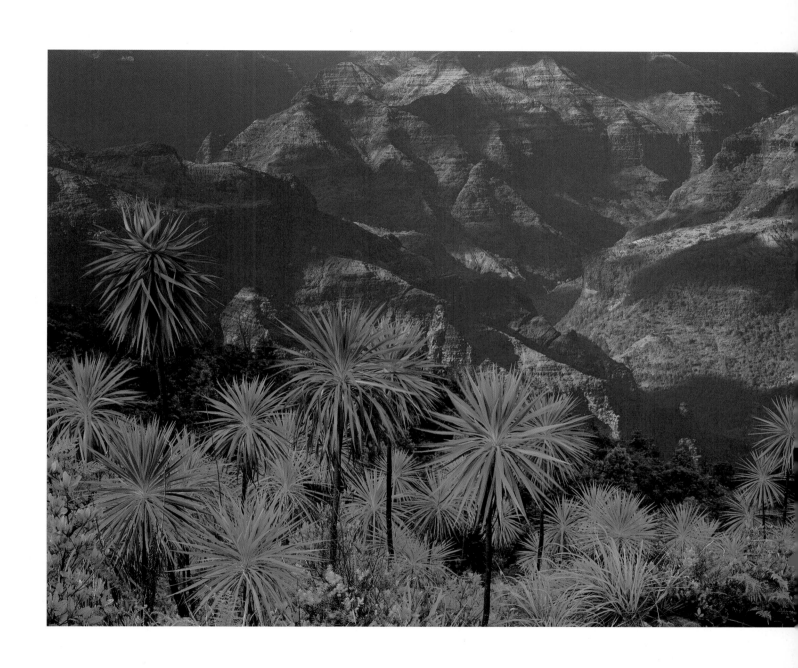

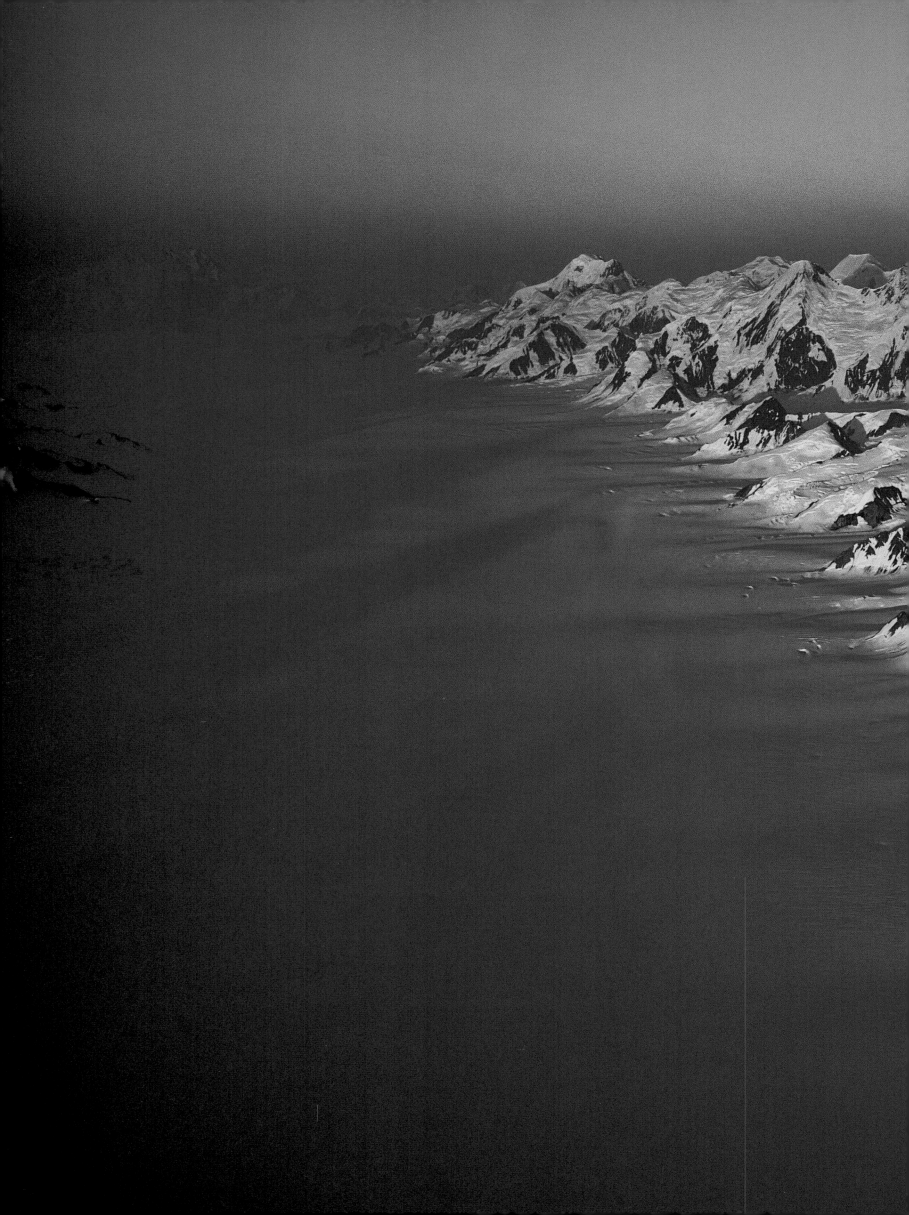

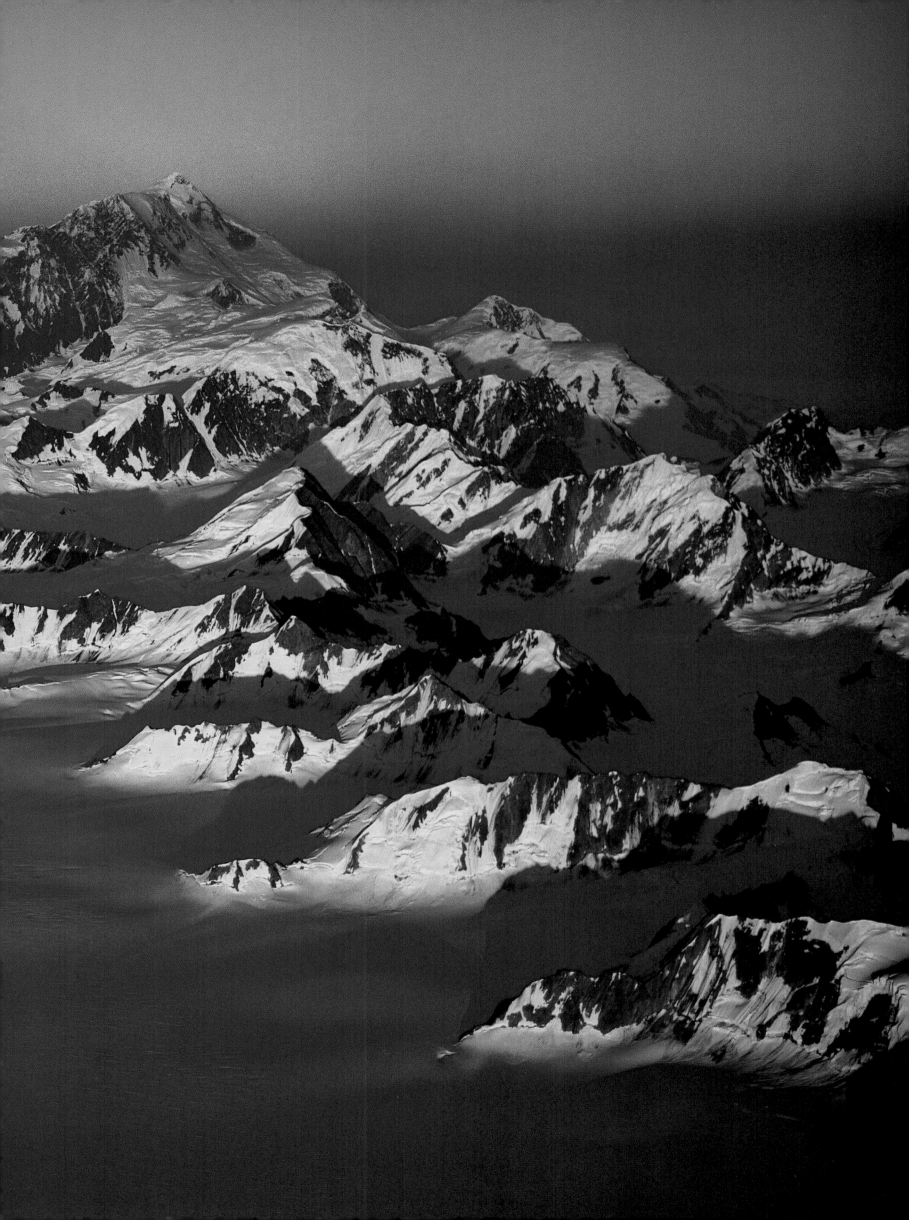

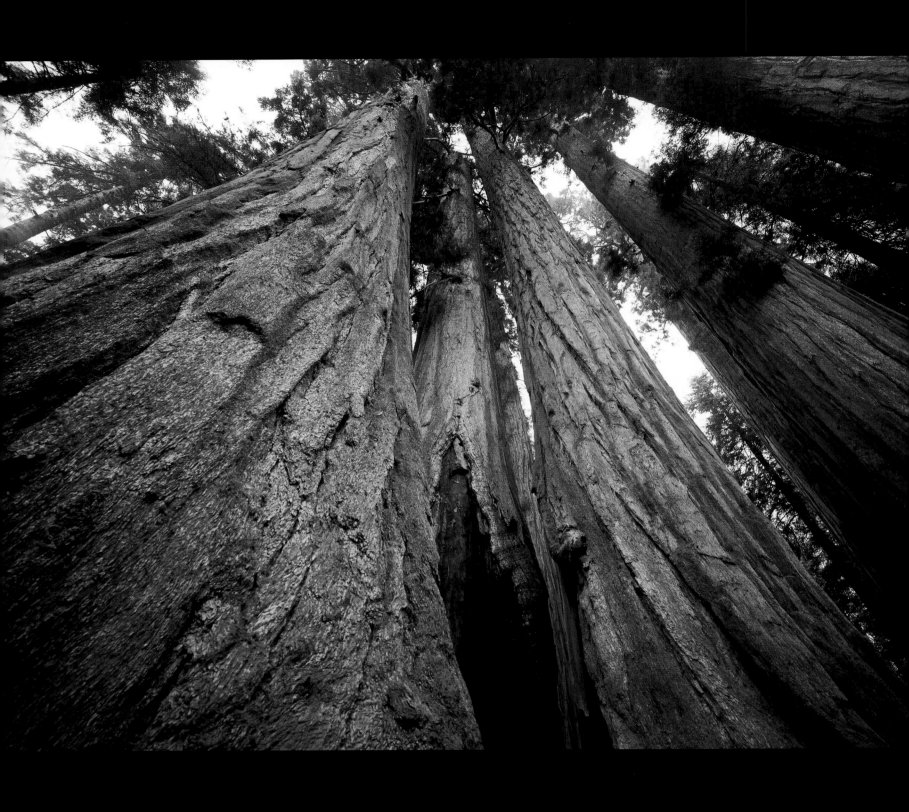

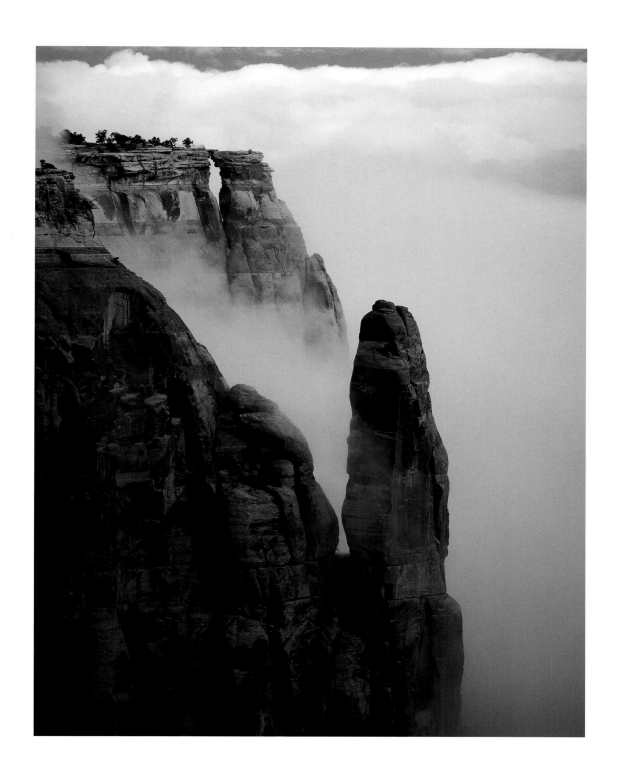

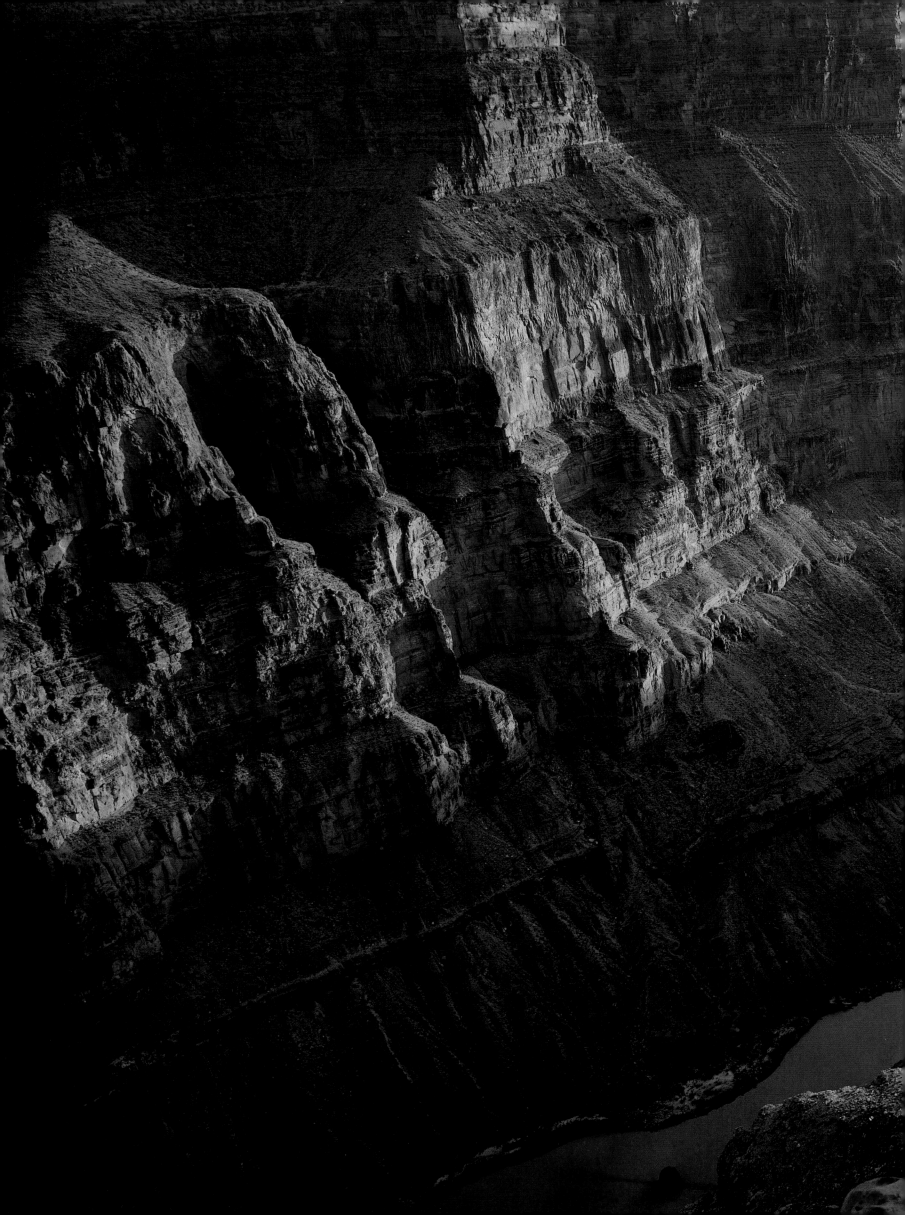

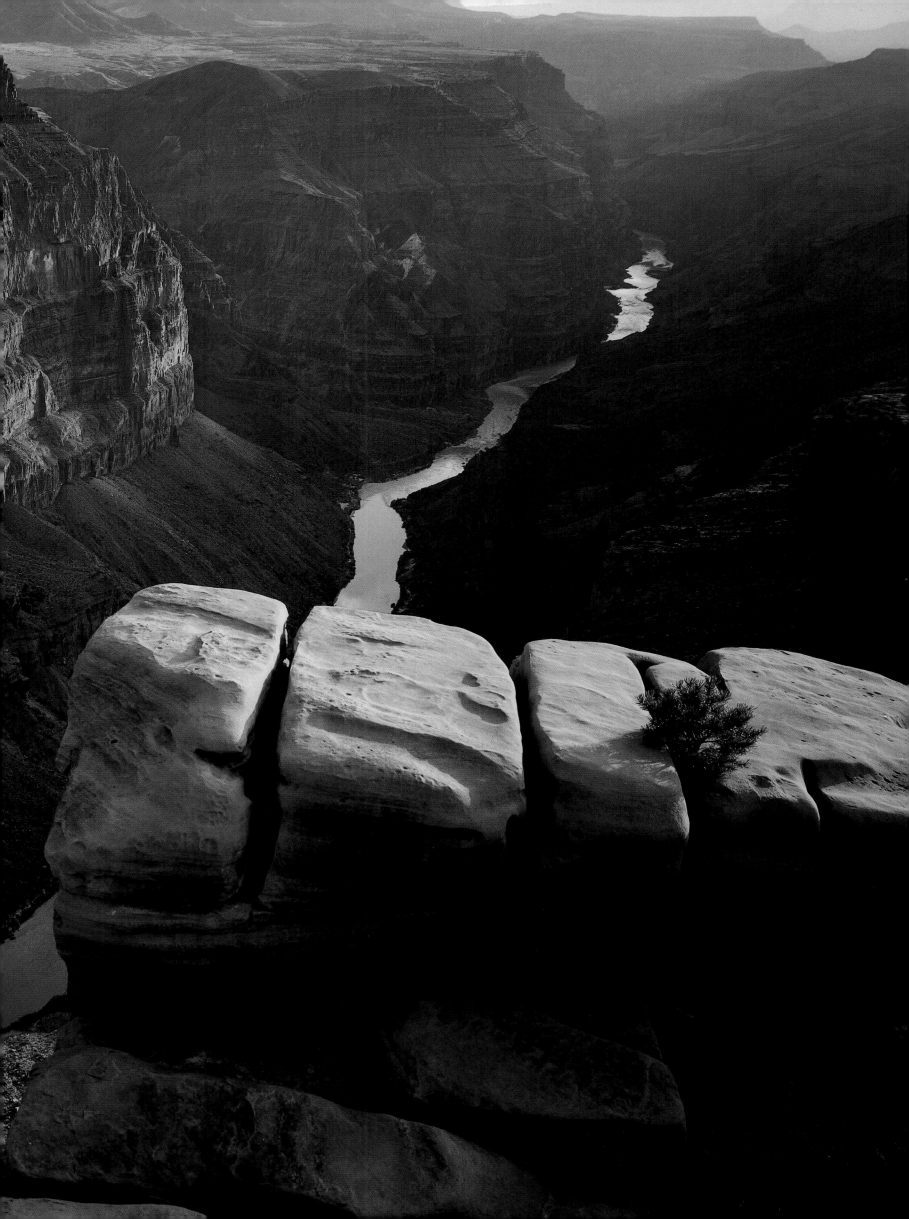

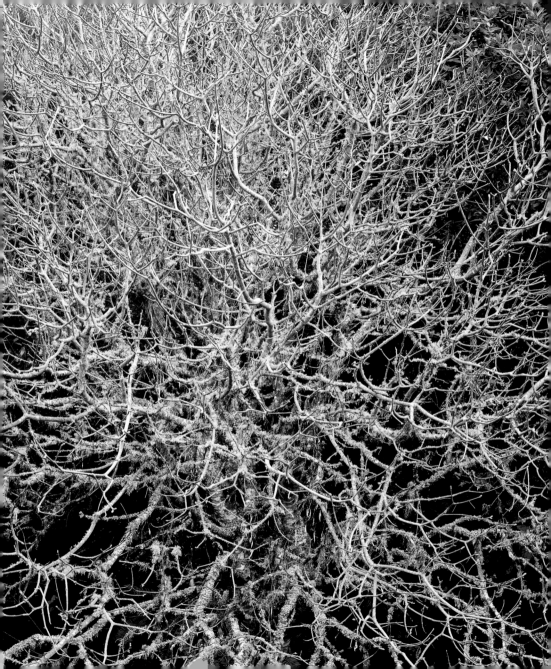

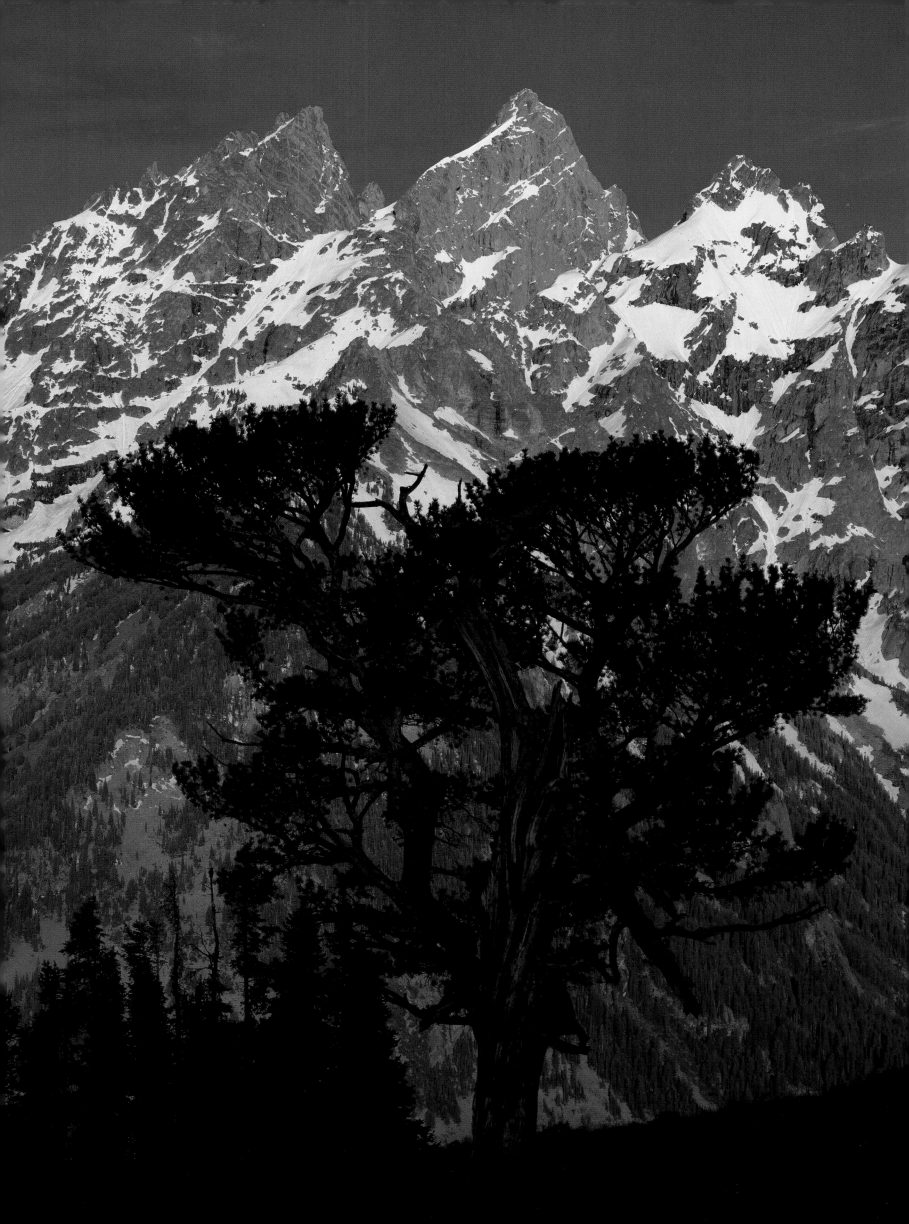

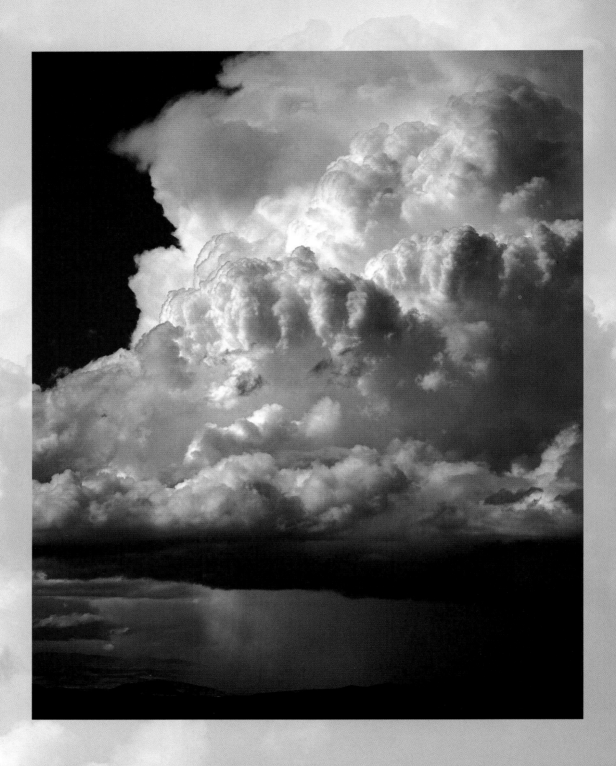

AIR

According to the Maori of New Zealand, Rangi′ and Papa′ were Heaven and Earth. They clung to each other and all was in darkness. Those whom they had created in the darkness wanted to bring light to their world. Tane-mahuta, father of the forests, said, "Let us rend them apart, and let Rangi′ stand far above us and Papa′ lie beneath our feet."

Five of the sons of Rangi′ and Papa′ agreed to tear their parents from each other, but the sixth, Tawhiri-matea, father of the winds and storms, protested. Still, Tane-mahuta, the strongest of the brothers, rent Rangi′ and Papa′ from each other, forcing Rangi′ into the sky and Papa′ to the Earth. Tawhiri-matea vowed revenge on his brothers for this outrage against their parents.

The god of the winds took refuge with his father, Rangi′, in the sky. They planned vengeance on those who had taken the Earth. Rangi′ and Tawhiri-matea begot a fantastic brood and dispatched them to the north, south, east, and west. These became the mighty winds. Tawhiri-matea then sent forth fantastical forms whom he named for their tempers: Fierce Squalls, Whirlwinds, Dark Clouds, Fiery Clouds, Clouds Which Precede Hurricanes, Clouds of Fiery Black, Clouds Reflecting Glowing Red Light, and Clouds of Thunderstorms.

Tawhiri-matea reached the forests of his brother Tane-mahuta, and with a blast of his breath he snapped the trees, leaving them splintered and broken. Next he swept down upon his brother Tangaroa, god of the oceans, sending huge waves and whirlwinds upon the water. Tawhiri-matea then moved to attack two of his brothers who were the gods of food, but they hid deep in the Earth. Finally, Tawhiri-matea came against Tu-matauenga, who was the first Man. Man resisted the winds, and gradually Tawhiri-matea and Rangi′ fell silent. Tawhiri-matea still roams the Earth with a rage equal to that of Man, and he attacks him often, blowing gales and tempests.

Rangi′ and Papa′ were separated forever. Yet they are in love still, say the Maori. Papa′ sends soft, warm sighs from her breast rising up to meet her husband, and these are the mists that rise from Earth to sky. Rangi′ lets fall nightly tears as he mourns the loss of his wife, and in the morning dewdrops cover the Earth.

The winds and movements of the air have personalities, or so it has seemed to many. Joseph Conrad evoked such a sentiment in 1902 when he wrote in *Typhoon:* "An earthquake, a landslip, an avalanche, overtake a man incidentally, as it were—without passion. A furious gale attacks him like a personal enemy, tries to grasp his limbs, fastens upon his mind, seeks to rout his very spirit out of him."

The wind can be gentle, caressing the face, or it can turn violent, tearing down buildings and breaking the masts of ships. Winds are fickle. They blow when not needed and lie silent when demanded. Winds are cursed and blessed. Adored for the life-sustaining rains they carry, and abhorred for their killing cyclones and lashing furies, winds have enthralled storytellers and scientists alike. They are vital and unpredictable in the same breath.

There is the Divine Wind of Japan—the *kamikaze*—that foiled Kublai Khan's invasion attempt in 1281 C.E. (Current Era). There is the *simoon* of

The wind was a torrent of darkness among the gusty trees.

—ALFRED NOYES,

The Highwayman

Arabia, *tebbad* of Turkestan, *sirocco* of the Sahara, *mistral* of France, *Santa Ana* of Southern California, and *chinook* of the North American Rocky Mountains. To the ancient Greeks, the wind was Zephyros, Boreas, Notos, and Eurus. To the ancient Chinese, the god of wind was an old man—Feng Po—who carried the winds with him in a sack slung over his shoulder. To the Dyak of Borneo, the wind spirit carries word of the dead to the underworld, while to the Navajo of the American Southwest, the wind breathes life into people and leaves its mark in the whorls of their fingertips and toes. To the Bushmen of the Kalahari, the wind dwells in a cave, taking the form of a bird.

Writing in 340 B.C.E. (Before Current Era), Aristotle said the winds were a "dry exhalation" that rose from the Earth. He believed the winds were "pushed" by the sun and that even earthquakes were the result of subterranean winds. "It is absurd to suppose that the air that surrounds us becomes wind simply by being in motion," he said, dismissing all who said otherwise.

Earth is encircled by an envelope of air—the atmosphere—that reaches 50 miles (80 kilometers) into the firmament. The lower atmosphere, known as the troposphere, encompasses the first 10 miles (16 kilometers) above the equator and the first 6 miles (10 kilometers) at the poles, and this is where weather is born. Above the troposphere lies the stratosphere (10 to 30 miles [16 to 48 kilometers] above the Earth), home to the ozone layer that filters ultraviolet radiation from sunlight. Next is the mesosphere (at an altitude of 30 to 50 miles [48 to 80 kilometers]), and above that the thermosphere (at 180 to 300 miles [290 to 480 kilometers]) and exosphere (at more than 300 miles), where the *aurora borealis* and *aurora australis* shimmer on clear winter nights in the highest latitudes. Beyond the exosphere lies space, the unearthly void that buoys our world amid a universe of other globes.

The fluid, invisible ocean of air that surrounds our planet shifts and moves with currents and eddies as vital and energetic as any maelstrom at sea. In spite of Aristotle's protestations, wind is most definitely air in motion. Winds are caused by the uneven heating of Earth's surface by solar radiation. The equator receives significantly more energy from the sun—in the form of radiant heat—than do higher latitudes. Since warm, moist air rises, and cold, dry air sinks, a series of atmospheric "cells" is established in each hemisphere: an equatorial cell, a mid-latitude cell, and a polar cell. Because Earth is spinning on its axis, air is deflected to the right in the Northern Hemisphere and to the left in the Southern Hemisphere—the so-called Coriolis force, after French scientist Gaspard Gustave de Coriolis.

At the equator, intense heating by the sun causes air to rise dramatically, and little wind is generated at the surface. This is the "wet tropics," where two out of three days can see rain, and annual rainfall is 70 to 100 inches (1,750 to 2,500 millimeters). With temperatures averaging 77°F (25°C), these are the warm, wet conditions that sustain the world's equatorial rain forests. At sea, mariners call this windless zone the "doldrums," and the region is notorious for stranding sailors for weeks in glass-calm waters. The warm equatorial air rises 10 miles (16 kilometers) until it reaches the boundary layer known as the tropopause that separates the troposphere from the stratosphere. The tropopause acts as a barrier to rising air because the stratosphere is warmer than the underlying air. With the way up barred, air is forced to flow either north or south.

As air in the equatorial cell flows away from the equator at high altitude, it cools and begins to sink. As it sinks the air warms, but this time, warming evaporates any remaining moisture. By the time the air reaches the surface, at about 30 degrees north and south of the equator, it is hot and dry. These areas of high pressure and descending warm air equate to some of the world's greatest deserts: the Sahara, the Arabian Desert, the Mojave of the southwestern United States, the Namib and Karoo of southern Africa, the Great Victoria Desert of Australia, and the Atacama of South America. At sea, the descending warm air creates

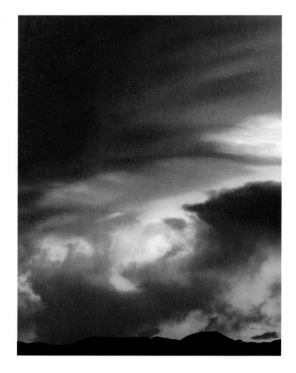

Hachita Valley, Animas Mountains, New Mexico, USA
Photograph by David Muench
Clouds brood, their colors amplified by the setting sun, as a storm builds over one of New Mexico's southernmost mountain ranges.

an area of calm, the "horse latitudes," comparable to the doldrums. The horse latitudes were so named because sailing ships ferrying horses from Europe to the Americas were often becalmed for so long that their cargo died and the carcasses of the unfortunate horses had to be dumped overboard. The flow of air in the equatorial cell is completed as air moves out of the horse latitudes back toward the equator as the easterly trade winds.

On either side of the equatorial cells, at between 40 and 60 degrees, lie the mid-latitude cells. These are home to some of the Earth's most powerful winds, each named for their latitude: the Roaring Forties, the Howling Fifties, and the Screeching Sixties. These winds feed off the differences in temperature and pressure of the polar and tropical air masses that straddle them and, as such, are among the most intense winds in the world. In the Northern Hemisphere the presence of large land masses reduces the average wind speed, but westerlies of 60 miles per hour (mph) (100 kilometers per hour [kph]) are not uncommon. In the Southern Hemisphere the dominance of ocean over land, and thus the unlimited "fetch" over which winds can build, leads to winds of 100 mph (160 kph) or more. While vertical air movements dominate the equatorial cells, lateral air movements take on greater importance in the mid-latitudes, with huge eddies—cyclones that spiral around low-pressure cores and anticyclones that spiral around high-pressure cores—forming among the dominant westerly winds.

Lying above 60 degrees, the polar cells cap both hemispheres. The tilting of the Earth means that one of the poles is cloaked in darkness while the other is bathed in twenty-four-hour sunlight. Even when bathed in summer's light, however, the high albedo of snow and ice reflects most of the sun's heat back into space. The poles are therefore dominated by cold, heavy air that sinks and pushes outward toward the mid-latitudes in the form of easterly winds. When the cold polar easterlies meet the warmer air of the mid-latitudes, they combine to feed storms that can make deadly the waters of the North Sea, North Atlantic, Bering Sea, Gulf of Alaska, and Southern Ocean. On land, cold polar air can meet the warm moist air of the mid-latitudes, spawning thunderstorms and tornadoes.

Atmospheric circulation is felt in the presence or absence of wind. However, it is the clouds that are the visible manifestation of air in concert with water vapor and ice. Clouds make the eddies, currents, and machinations of air masses come alive to the observer. Clouds are the portents of weather to come. They are the vanguards of storms and the harbingers of change.

Clouds exist because of a combination of temperature and moisture. Most of the water vapor in the atmosphere comes from the tropical oceans. Clouds develop when warm, moist air rises and either meets a colder air mass or cools enough that the moisture condenses or freezes. Clouds often form over mountains because mountains are a physical barrier to air movement, forcing the warmer air up into a region of colder air. Mountains in high latitudes are frequently hidden by clouds in summer, but are often cloud-free in winter because winter air is usually cold and dry.

Throughout the summer, tourists flock to Alaska to see a variety of incredible sights, but one in particular is a major draw: Mount McKinley in Denali National Park. "Is the mountain out?" ask residents and tourists alike. Summer tourists are often disappointed; during the brief season, the 20,320-foot (6,096-meter) mountain is rarely "out" for long. In the summer, warm, moist air is forced to rise when it meets the Alaska Range, and the clouds sit stubbornly over the peaks, hiding them from watchful eyes. However, in winter, when few tourists venture to the "Last Frontier," cold, dry polar air blankets the state, and with no moisture

Alaska Range, Denali National Park and Preserve, Alaska, USA
Photograph by David Muench
Summer clouds build over the Alaska Range, as the mountains force moist air upward. Within moments of this image being taken, the entire range vanished from sight.

in the air, the mountain is "out" for all to see, even from Anchorage, 150 miles (240 kilometers) away.

Clouds carry only 0.001 percent of Earth's water, but they are so visible as to be missed when absent for long. They give definition to the sky. They give the sky depth, character, even life. We watch clouds billow over our heads, transforming their shapes into dragons, cotton-wool sheep, faces, and airplanes. Clouds play with our imagination. They are emblems of fantasy and the pliable stuff of daydreams.

Most clouds are born and die in the troposphere. The temperature inversion at the boundary with the stratosphere prevents their reaching heights much above 10 miles (16 kilometers), although there are a few exceptions, including noctilucent clouds, which form 50 miles (80 kilometers) above the Earth and are visible only after dark.

It was Luke Howard, the father of British meteorology—a chemist by trade but a meteorologist by passion—who first named the diversity of cloud formations in the early years of the nineteenth century, bringing a semblance of order to a rather disorderly science. He identified three main cloud types that still form the basis of meteorological nomenclature: cirrus, cumulus, and stratus.

Cirrus clouds are delicate, wispy, insubstantial clouds usually found above 19,800 feet (6,000 meters). *Cirrus* is Latin for "lock of hair." At high altitudes cirrus clouds are made up of ice crystals and are often formed by vertical air movements, especially strong updrafts. Distinctive "mare's tails" are formed when the cloud's ice crystals drop out of the main cloud as air currents move the cloud forward. These clouds often herald unsettled weather because they indicate that the air is moist.

Cumulus clouds are the large, lumpy clouds that look like balls of cotton wool. *Cumulus* is Latin for "heap," and the term seems appropriate for these fluffy, cauliflower-like clouds, which generate when convection currents form over warm ground. Because cumulus clouds are created by sun-induced convection, they often appear in midmorning. If the clouds continue to build through the afternoon, they may grow to reach heights of several thousand feet and spawn thunderstorms. At sundown, with the loss of the sun's heat, the clouds lose their influx of warm air and gradually dissipate.

The last of Howard's cloud formations, *stratus* clouds—from the Latin word for "layered"—are horizontal clouds that fill the sky with a monotonous uniformity. They develop where lighter, warm air slips over a dense, cold air mass and where there is little or no vertical air movement. Stratus clouds that form at ground level, where cold air passes over warm water or where moist air lies over cold ground, have a simpler name: fog.

Not all clouds deliver rain, but without clouds there can be no rain. Howard referred to rain-bearers as *nimbus* clouds, from the Latin word for "rain," and the term can be added to each of the cloud names—for example, cumulonimbus or nimbostratus. To make rain, all clouds—with the exception of those in the tropics—must become cold enough for the water vapor within them to freeze. Raindrops form around condensation nuclei—tiny airborne particles such as dust or salt. Rain begins in the upper reaches of nimbus clouds, where thousands of tiny droplets condense around these small particles. The droplets freeze since the upper reaches of the cloud exist at temperatures well below freezing. The resulting ice crystals continue to grow as more water vapor collects around them. Ultimately the ice crystals become snowflakes, and when heavy enough they begin to fall to the ground. If the air beneath the clouds is cold, the snowflakes may reach the ground intact, but if the air is warm, as it is during the summer, the snowflakes melt as they make their descent and turn to rain.

Moisture in the air, along with dust and ice, is responsible for aerial visions that are far more breathtaking than clouds. Rainbows arc across the sky, colored spectacles of delicate, ephemeral, transparent light. Formed from refracted

I hear the wind among the trees Playing celestial symphonies.

—Henry Wadsworth Longfellow,

A Day of Summer

sunlight passing through water droplets after a rain shower, rainbows are like brief apologies for a storm. The larger the raindrops, the more defined and brilliant the colors of the rainbow.

Ice crystals also scatter sunlight. Phantasmal suns sometimes appear on either side of the sun on a clear, sunny day, the result of refraction caused by ice in the atmosphere. Such "sundogs" indicate that a change in the weather is on the way. Other refraction patterns include complete halos around the sun or moon and even pillars of light amid the clouds. Ice in cirrus clouds may refract sunlight to form a "cloud rainbow."

When clouds build beyond a critical point they may precipitate storms. Storms are some of nature's most dramatic spectacles. Storm clouds hang heavy and dark, brooding purple or black. The air is thick and moist; you can feel it on your skin. The atmosphere is charged, electric. Storms are mobile and unpredictable. They are our planet's safety valve, moving energy from the equator toward the poles. They restore balance, exchanging heat for cold, watering parched land, and cleansing the air of dust and pollutants. Were it not for storms, the average surface temperature of the Earth could rise by 11°F (6°C), with impacts that would be felt from the polar ice sheets to the tropics.

At any one moment 2,000 storms are in progress around the world, the vast majority close to the equator—45,000 rage every day, 16 million in an average year. A typical thunderstorm can release 123 million gallons (475 million liters) of water and produce enough energy to power the United States for twenty minutes. More than 8.5 million lightning flashes are discharged from thunderclouds every day—a few as proverbial "bolts from the blue"—that's an average of 100 flashes per second.

Thunderstorms may be generated in isolation from a single cumulonimbus cloud that grows above sun-baked fields, spawning a storm that lasts for an average of forty minutes, or several cumulonimbus clouds may join to form a squall line that can last for hours. Massive thunderstorms are also born when cold polar air pushes down from the north to mix with warmer air in the mid-latitudes.

Thunderclouds stretch from heights of 4,950 to 34,650 feet (1,500 to 10,500 meters), forming an anvil-like top when they reach the tropopause. Within the anvil of the cloud, condensing water vapor and electrical activity combine to create a low-pressure core. This low-pressure region pulls air upward, feeding the cloud with powerful updrafts that may reach speeds of more than 28 mph (45 kph). As the cloud grows, the condensation nuclei gradually grow in size as water vapor freezes onto them. Eventually the snowflakes and ice crystals reach a critical size whereby they are able to fall despite the updrafts.

Thunderclouds are well known for their highly charged nature. The fact is that there is much about lightning that is not well understood. What is known is that the strong updrafts in the cloud carry light, positively charged particles to the upper part of the cloud, while the downdrafts carry negatively charged droplets to the bottom of the cloud. As the thundercloud moves over the land, the negative ions repel electrons, and a positive "shadow" forms under the cloud. When the difference in electrical charge between the ground and the cloud becomes excessive, a lightning bolt strikes from the cloud to the ground and another strikes from the ground to the cloud. The lightning may travel as little as 1,650 feet (500 meters) or as far as 5 miles (8 kilometers), but the actual stroke is only a few inches across. During the course of a single visible lightning strike there may be as many as fifty strikes occurring back and forth between the ground and the cloud, all in a matter of half a second—with the lightning traveling at 620 to 6,200 miles (1,000 to 10,000 kilometers) per second. It is the return stroke, from Earth to cloud, that is seen by the observer. The lightning strike heats the channel through which it passes to temperatures of 54,000°F (30,000°C)—five times hotter than the surface of the sun. If lightning strikes in

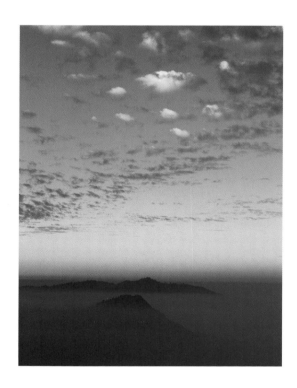

Moro Rock, Sequoia National Park, California, USA
Photograph by David Muench
Dawn light colors the haze over the San Joaquin Valley and adds definition to scarce clouds as a black night sky blends to daylight blue.

the desert it can turn sand into glass. The rapid expansion of air caused by such excessive heating sends thunder rumbling from the center of the storm.

As powerful as thunderstorms are, they pale in comparison to cyclones and tornadoes. Tropical cyclones occur in the Indian Ocean, in the vicinity of Australia, in the Atlantic—where they are known as hurricanes—and in the Pacific, where they are known as typhoons. A hurricane in the United States may be 16,000 times more powerful than an average thunderstorm, and its life is measured in days—even weeks—rather than hours, during which time the storm may journey more than 620 miles (1,000 kilometers). If the average thunderstorm could power the United States for twenty minutes, the average hurricane could do so for seven and a half months.

Tropical cyclones are among the deadliest of natural events. Millions have died from their effects, hundreds of thousands killed by a single storm, and millions succumbing to disease and starvation in their aftermath. Homes are leveled by them, entire ecosystems altered overnight. But without tropical cyclones, humid air that rises from the equatorial oceans would hang and fester, denying rain to nearby land masses. Japan receives a quarter of its annual rainfall from typhoons. If the storms, an average of twenty-two each year, did not move from the tropical Pacific to the coasts and islands of Southeast Asia, these lands would not be nearly as productive—in terms of biodiversity or agriculture. The harshness of cyclones may appear cruel when viewed through our eyes, but nature has no emotion, no intent, and no regret. Our planet seeks only balance between opposing forces: heat and cold, water and land, air and sea.

Tropical cyclones form when humid air rises from the surface of sun-baked tropical seas—the ocean temperature must be at least 80°F (27°C) to spawn them. As this warm, moist air rises, it precipitates into storm systems in the upper part of the troposphere. Where such storms develop around a low-pressure zone, a cyclone may develop. These low-pressure systems average 400 miles (650 kilometers) in diameter but can reach 1,000 miles (1,600 kilometers) across. Each storm cycles around a calm core—the eye—which ranges from 3 to 40 miles (5 to 65 kilometers) wide. The eye wall that separates the eye from the rest of the cyclone contains winds of 100 mph (160 kph), and humid air is sucked up to feed the storm as it passes over water, cooling the ocean surface by as much as 5°F (3°C) for two weeks. Rainfall that results from the rapid cooling of the humid air can exceed 80 inches (2,000 millimeters) a day. Winds in the rest of the cyclone exceed 74 mph (119 kph), while the storm itself moves forward at speeds of 15 to 60 mph (24 to 95 kph). When Hurricane Andrew struck southern Florida on August 24, 1992, destroying more than 80,000 homes, it did so with winds greater than 145 mph (233 kph). When a cyclone hits land or moves too far from its supply of warm, humid air, it runs out of energy and disperses.

No one is quite sure why a cyclone forms; it may be simply a matter of scale, temperature, and abundant fuel in the form of humid air. High rainfall in sub-Saharan Africa may provide the impetus for hurricane formation in the North Atlantic, as may fronts emanating from West Africa. Of the more than 100 atmospheric disturbances that cross the North Atlantic from Africa each year, only 9 or 10 become tropical storms with wind strengths of 40 mph (63 kph) or more, and of those few just 5 or 6 become hurricanes. Most hurricanes in the North Atlantic are born during late summer more than 5 degrees from the equator because closer to the equator the lack of a Coriolis force results in the stagnation of any storms that develop. Cyclones in the Northern Hemisphere spin counterclockwise, while those in the Southern Hemisphere spin clockwise. The doldrums are effective in preventing any cyclone from crossing the equator.

A quarter of all North Atlantic hurricanes bear tornadoes, an average of ten per hurricane, when they make landfall. Tornadoes also form when warm, moist air meets cold, polar air; half of all giant thunderstorms generate these intense vortices

Carrizo Mountains, Arizona, USA
Photograph by Marc Muench
A new moon shows itself over the Carrizo Mountains. The moon produces no light of its own and is visible to us only because it reflects sunlight; it is simply the mirror to the sun's fire.

that drop from the bottom of thunderclouds. Despite their short life—from fewer than ten minutes to two hours—tornadoes generate sustained, destructive winds of 300 to 350 mph (480 to 560 kph) and are capable of traveling tens of miles at speeds of 40 mph (64 kph). Although they occur worldwide, the United States experiences most of the world's tornadoes—700 to 1,150 a year—and one-third of these occur in just three states: Texas, Oklahoma, and Kansas. It is here that warm, moist air from the Gulf of Mexico mixes with cool, dry Canadian air forced eastward by the north-south barrier of the Rocky Mountains. When the sheets of warm air rub up against the sheets of cold air, they roll up horizontally and drop down below the storm clouds as dark rotating fingers of whirling cloud.

Tornadoes can tread curious paths. They will destroy one house, even tearing nails from wooden beams, and leave a neighboring house untouched. Chickens have had feathers pulled from their backs, leaving the birds plucked but alive. Cows and people have been picked up and set down miles distant, sometimes alive but often not. Pianos have been found miles from the homes that housed them; kitchen sinks have landed in far-off fields complete with intact dishes.

The power unleashed by hurricanes and tornadoes is indicative of the impact winds can have on land. These forces of nature uproot trees, move sandbars, destroy islands, and even cause the extinction of entire species. They can, quite literally, redesign the environment. However, even non-storm-force winds can, and do, sculpt the land.

Deserts contain dramatic examples of wind-sculpted formations. Since little soil or vegetation protects the ground, wind can easily sandblast the surface by moving small particles and using them like sandpaper against rock. Wind can erode sandstones and granite alike, creating streamlined structures aligned with the prevailing wind direction—such "yardangs" resemble the upturned keel of a boat and may be a third of a mile (half a kilometer) long. On the Tibesti Massif, which stretches from Libya to Chad, steep-sided grooves a third of a mile wide and covering 36,000 square kilometers (90,000 square kilometers) are aligned with the prevailing northeasterly winds.

Travelers caught in desert sandstorms see the paint stripped from their vehicles and their windscreens abraded to the point of opaqueness. Desert winds are also responsible for a patina called "desert varnish," created when winds polish minerals that have been deposited on rocks by evaporating water. This varnish develops over a period of about 2,000 years, giving desert rocks a characteristic brown- or black-stained appearance. Winds also create "pavements" of large pebbles and stones by carrying off smaller particles; such pavements are found from the Arctic to the Middle East.

Sand dunes are made fluid by wind; they are moved, grain by grain, creating a forever-shifting sea. There are linear dunes, star dunes, and crescent dunes, each sculpted by the prevailing or shifting attitude of the wind. Under the influence of the wind, dunes may move forward more than 12 inches (30 centimeters) a day.

Wind-blown loess—light clays and silts—may be carried for thousands of miles and deposited far from their source. In China, loess deposits cover 312,000 square miles (780,000 square kilometers) to depths of more than 660 feet (200 meters). Arabia's Empty Quarter contains the world's largest "erg"—a huge geological depression filled with wind-blown sand—measuring more than 290,000 square miles (725,000 square kilometers).

Air is the intangible primal force. It is invisible to us except when it combines with another. The atmosphere shields us from the sun's damaging ultraviolet radiation. Winds cool us. Clouds shade us and water us with rain. Atmospheric cells balance heat and cold, wet and dry; they keep our planet in equilibrium. The fleece of air that embraces the Earth is the barrier that protects us from the vacuum of space.

Air is, quite simply, the breath of life.

Stratus Clouds and Mount Floyd, Arizona, USA

Photograph by David Muench
As the sun sets, sunlight passes through the dense lower atmosphere, which prevents most wavelengths in the visible spectrum from penetrating. The exception is red, which, due to its long wavelength, is often the most prominent color in a sunset.

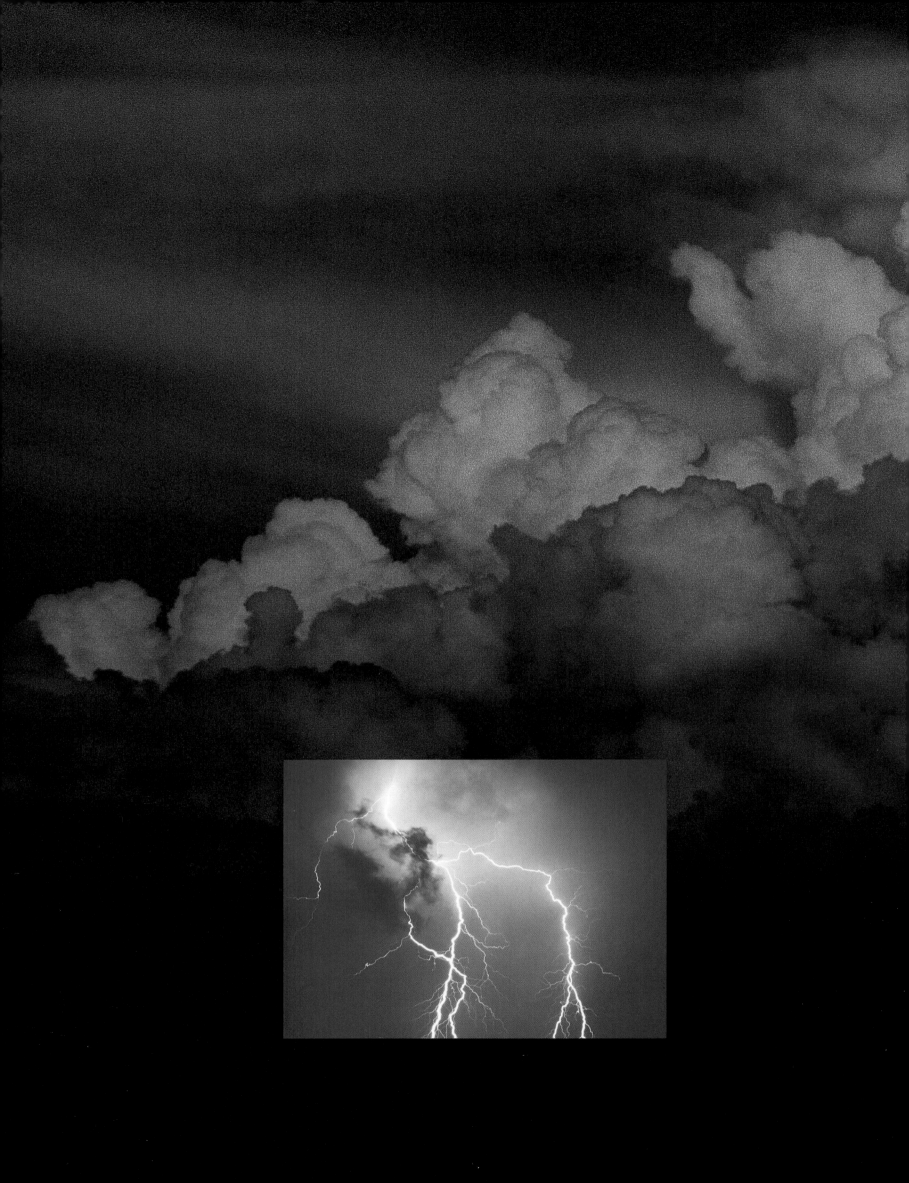

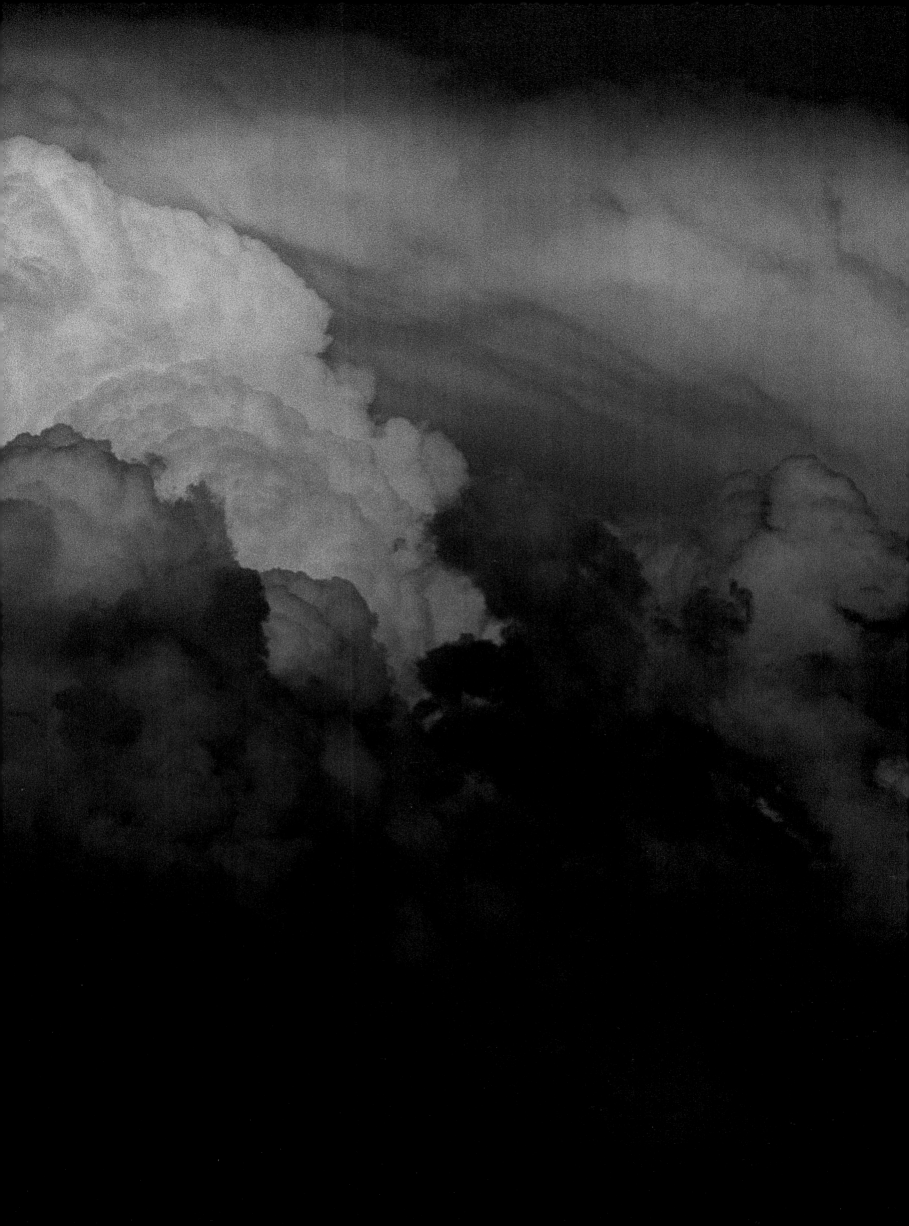

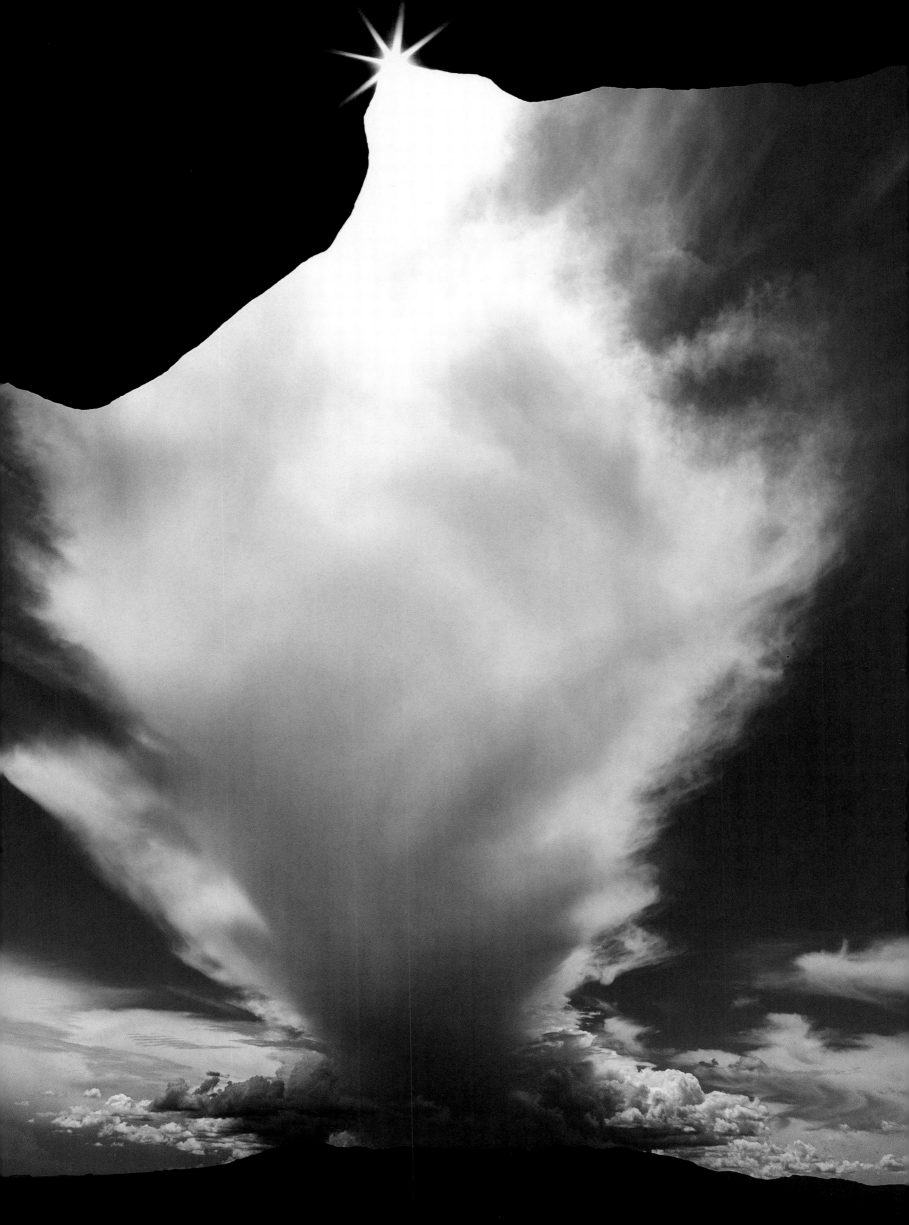

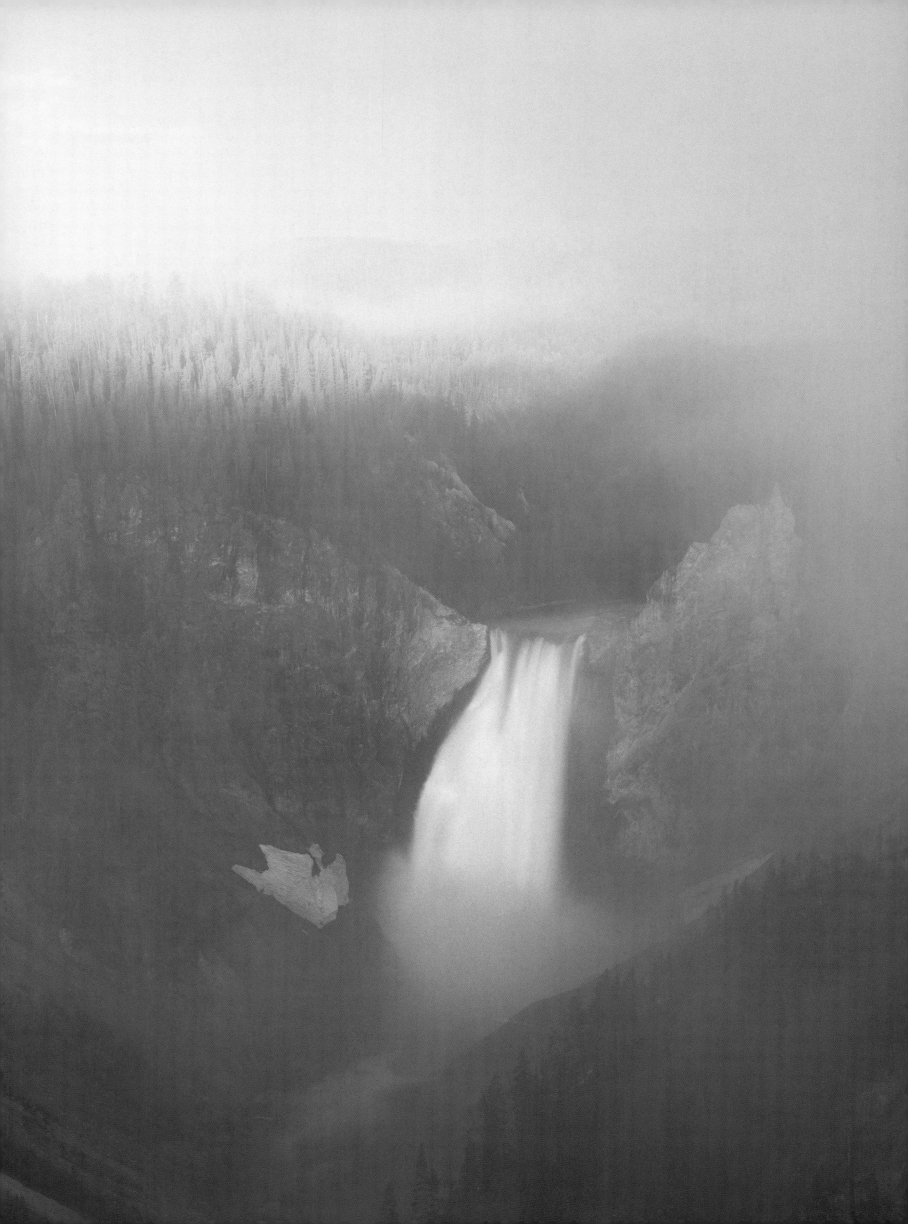

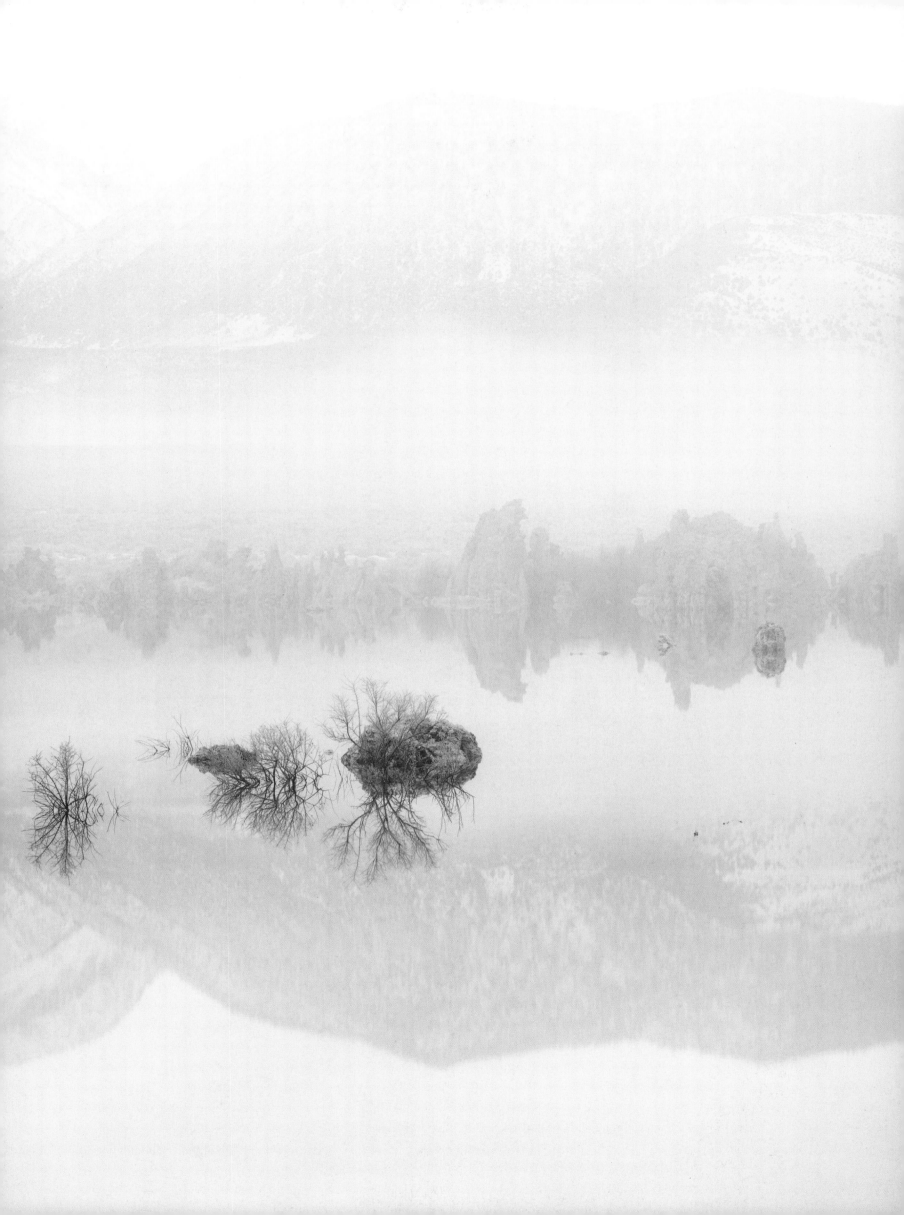

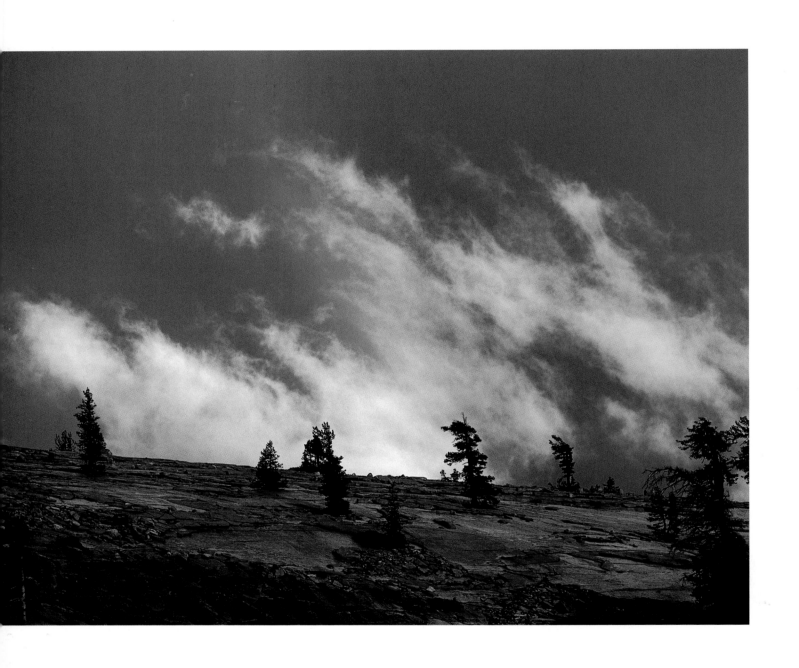

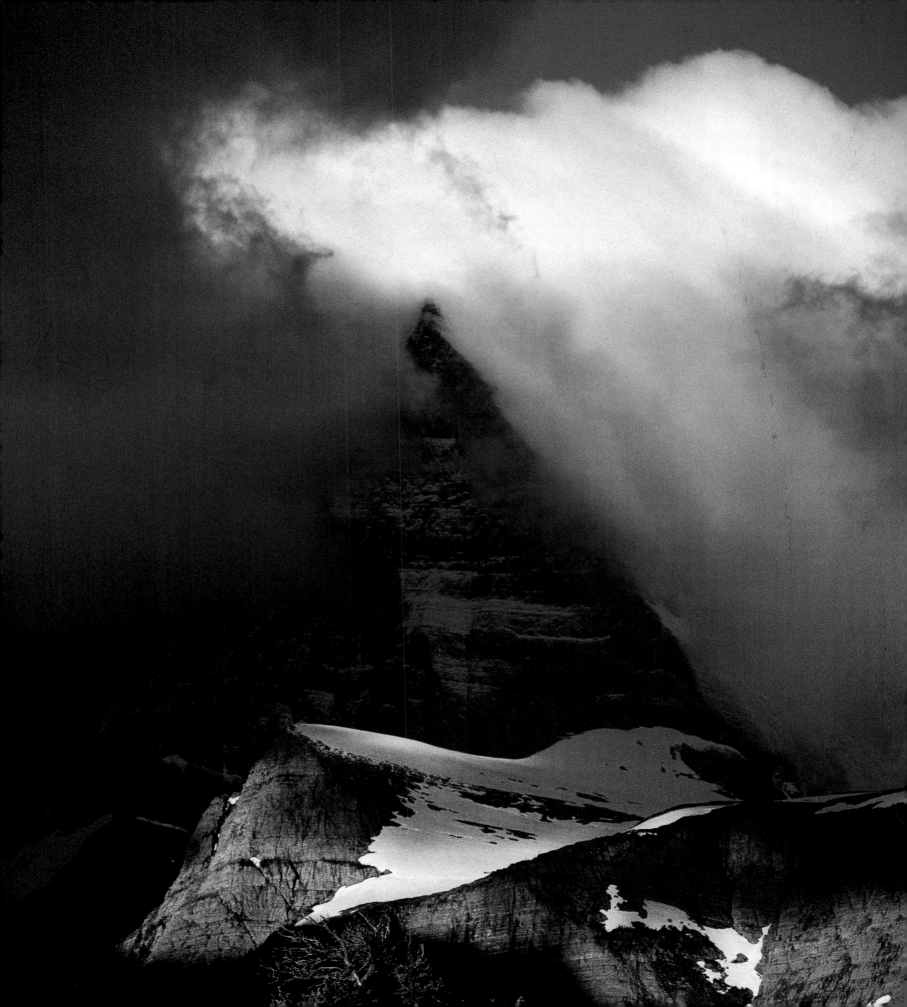

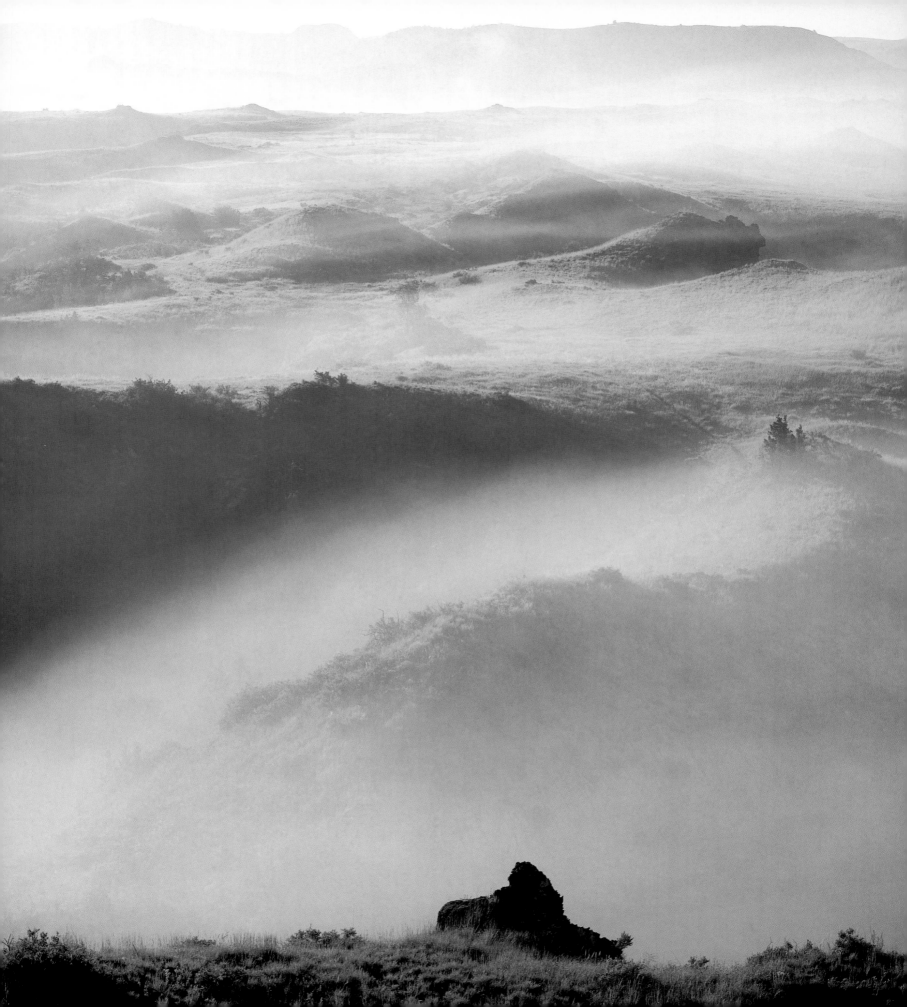

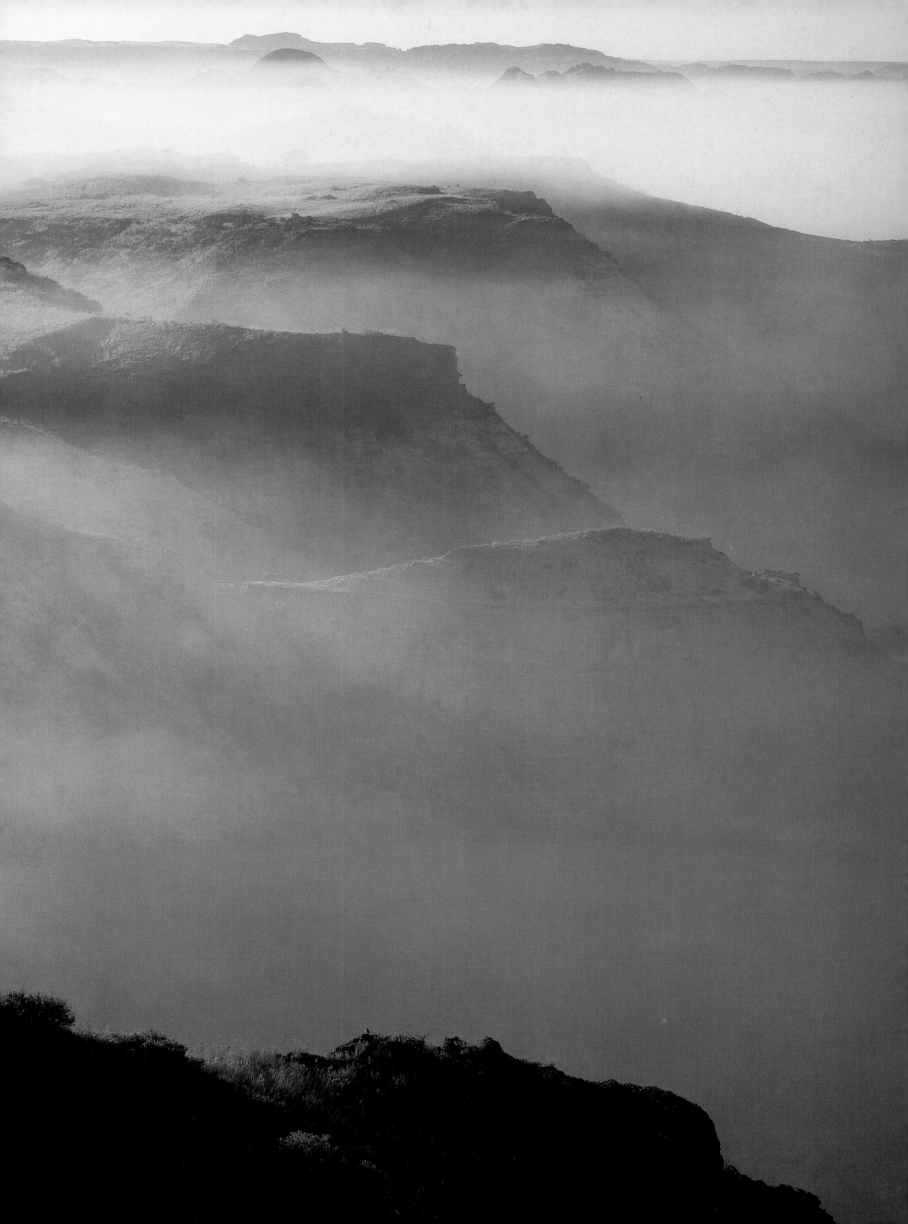

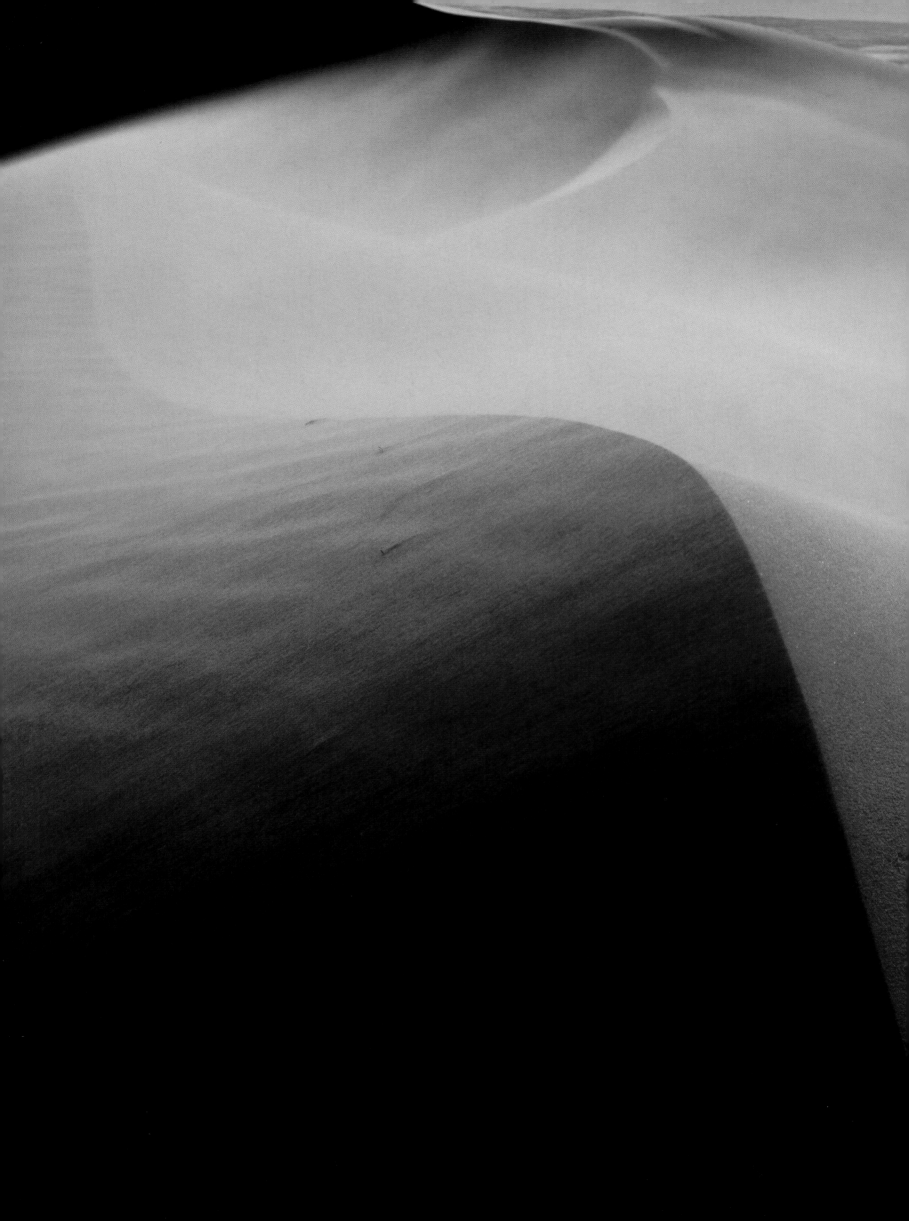

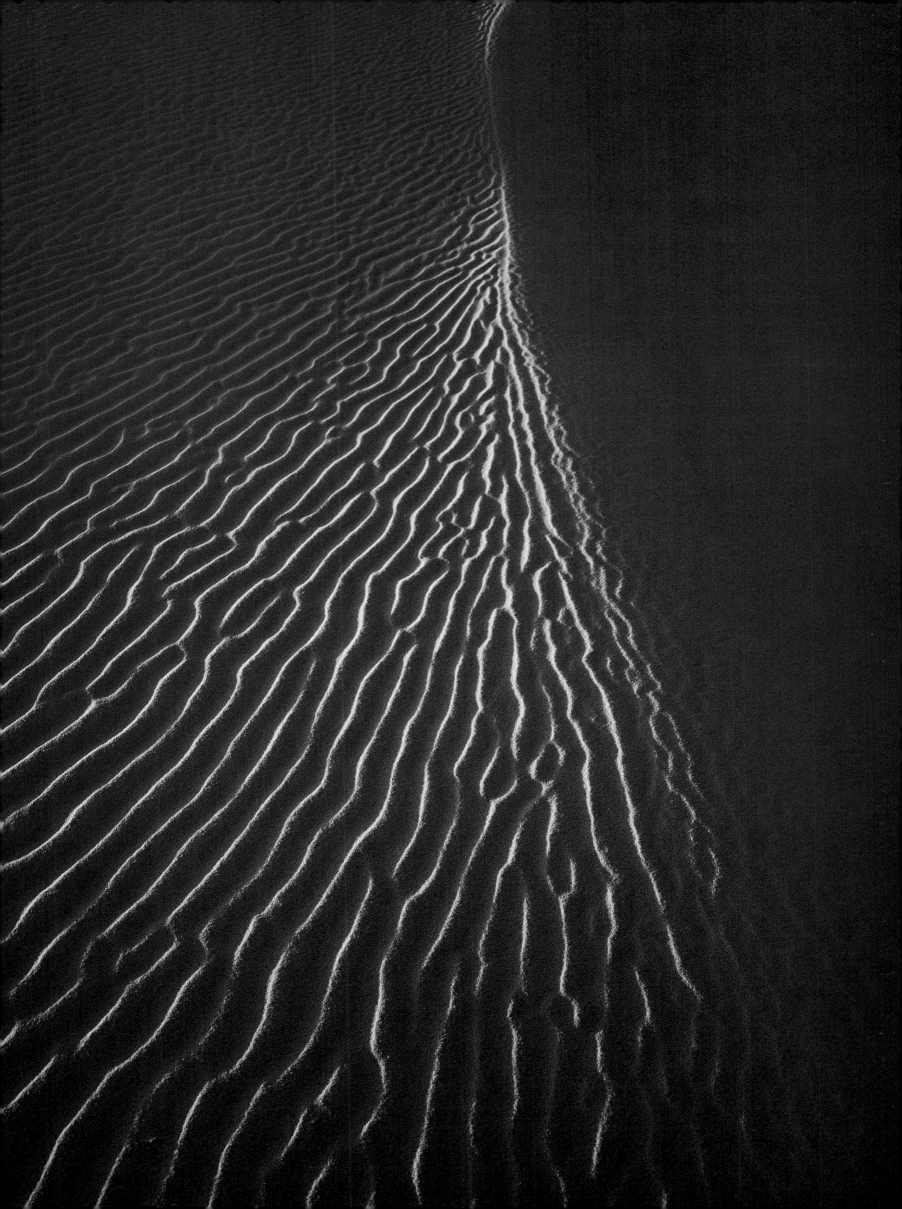

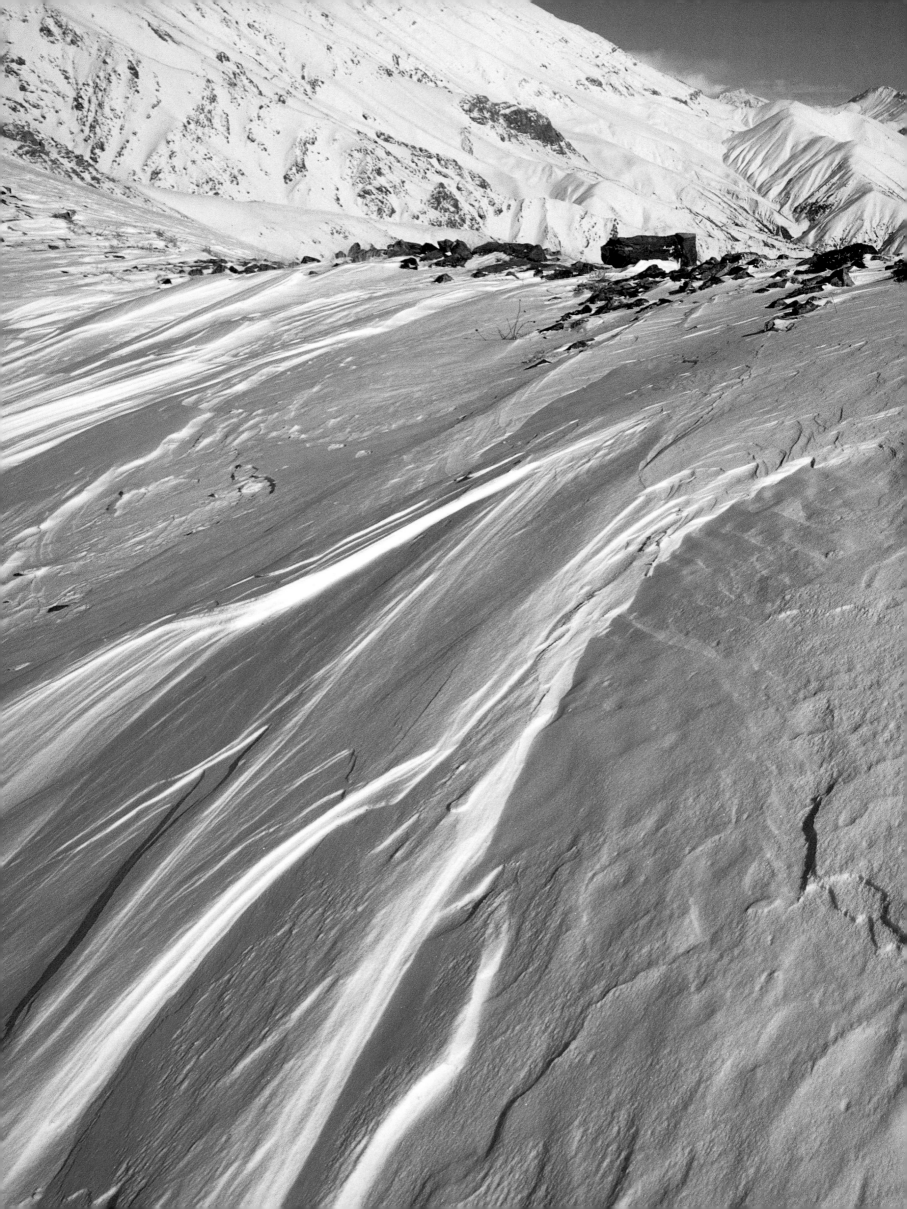

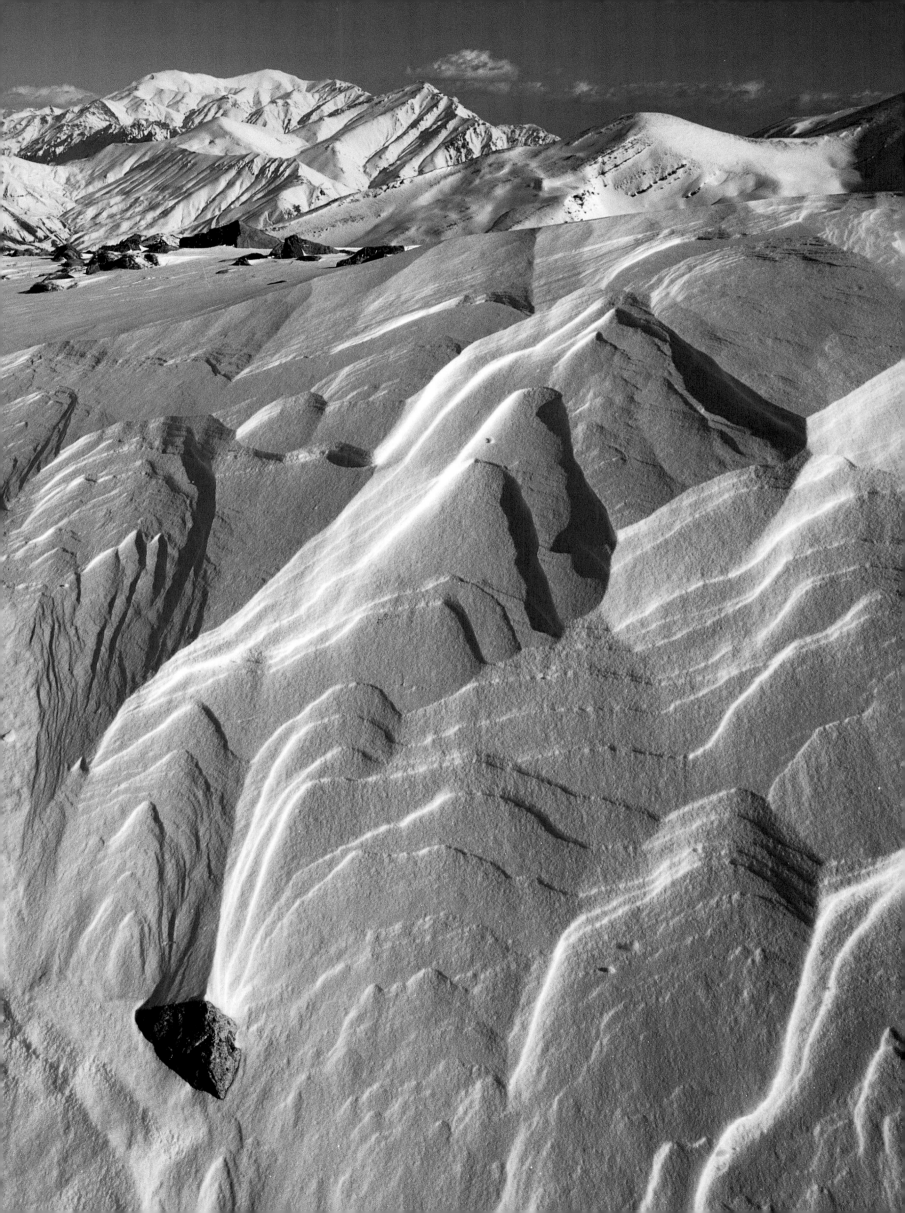

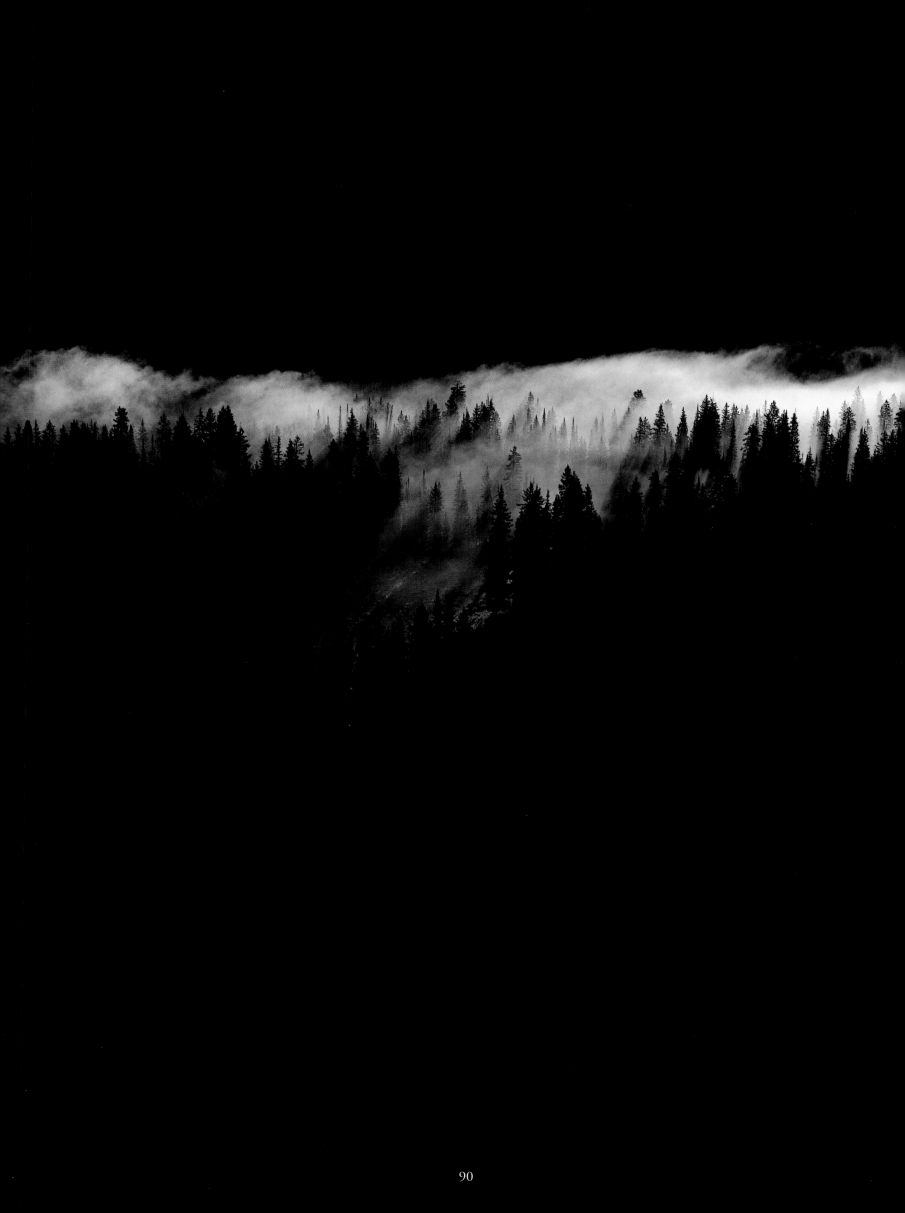

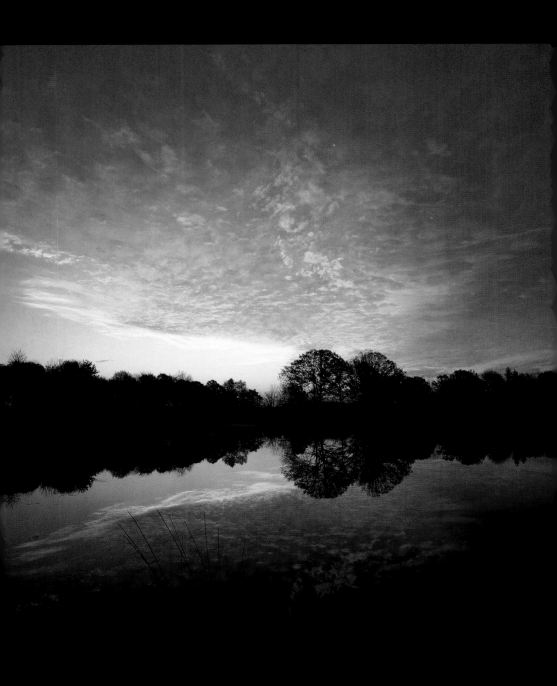

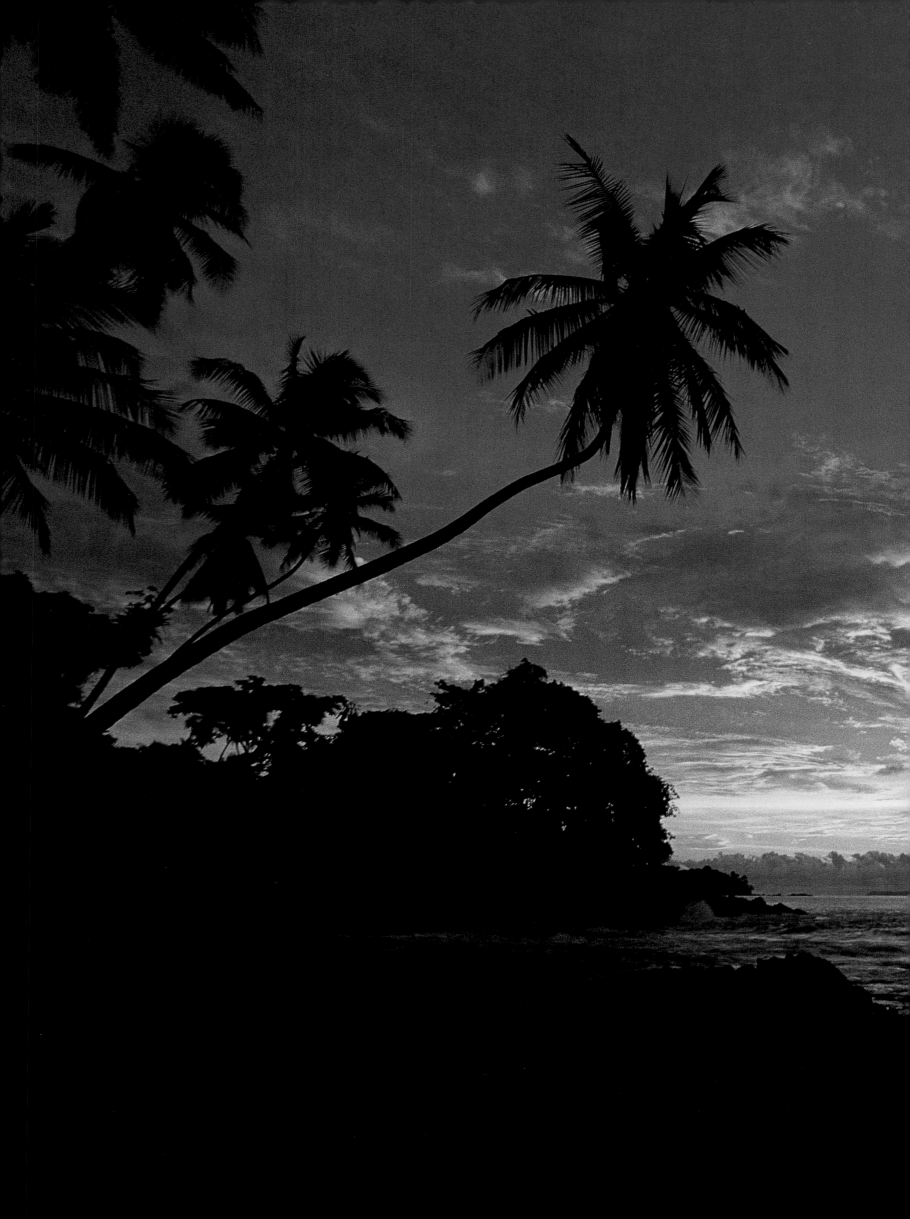

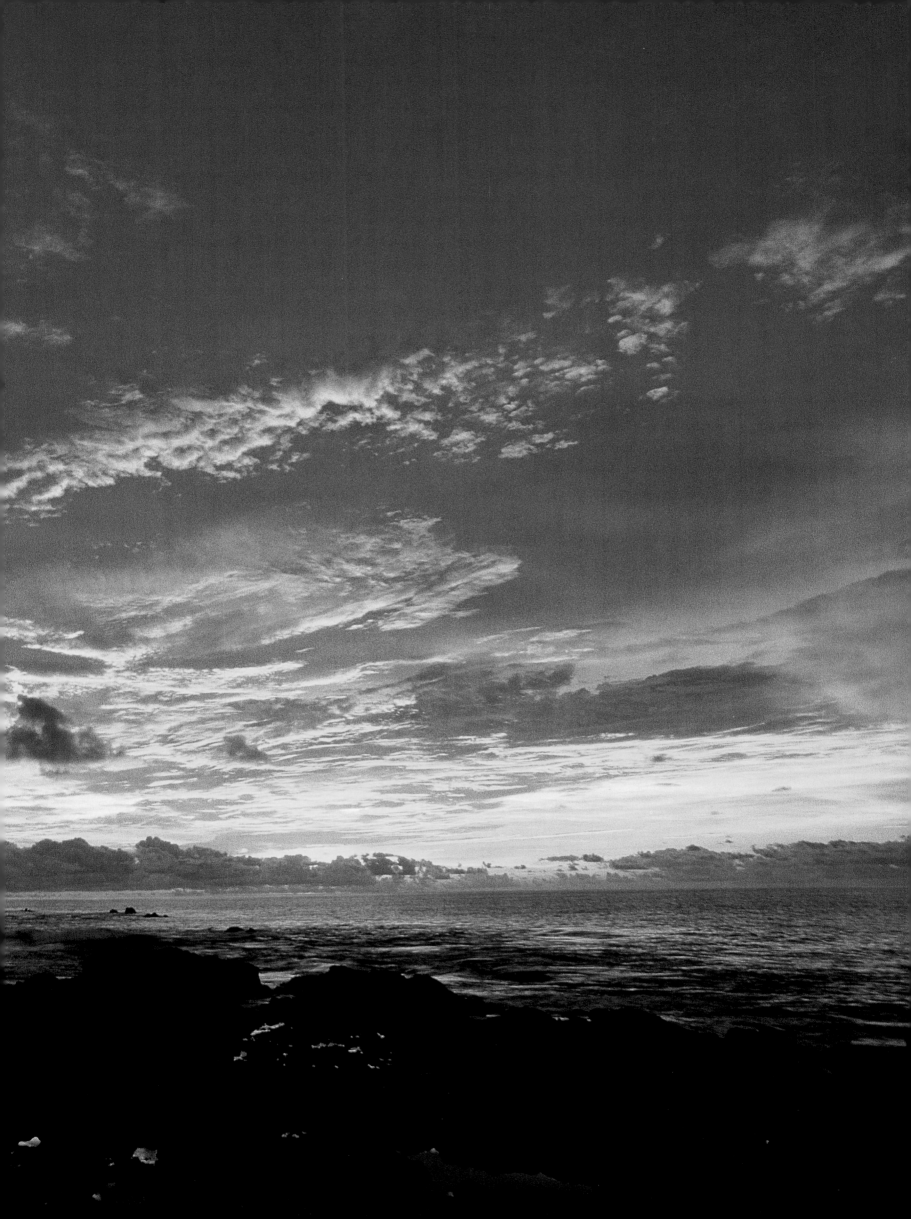

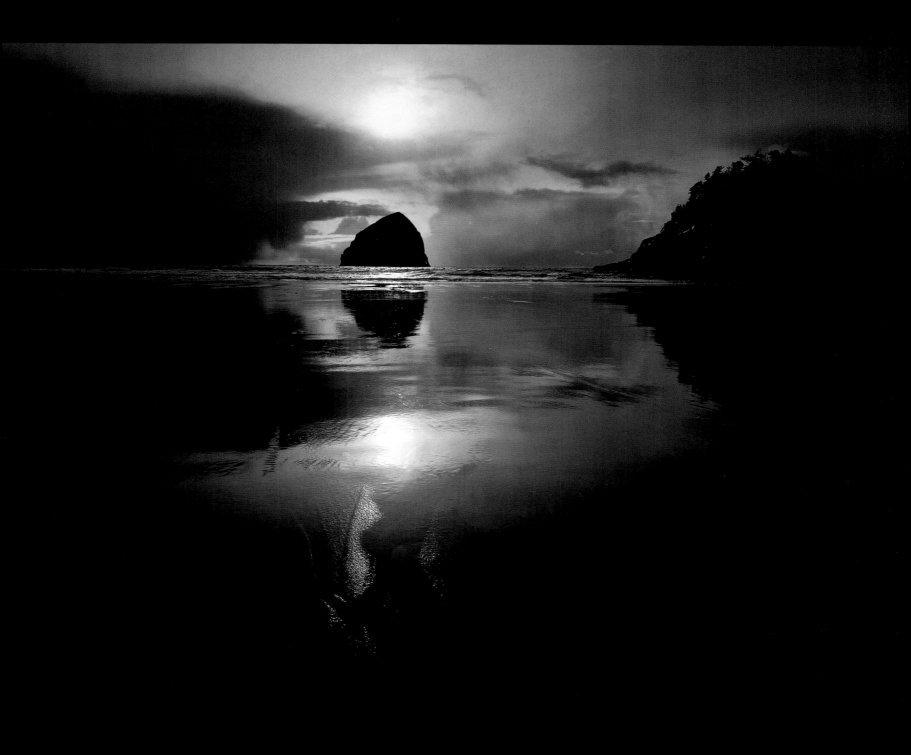

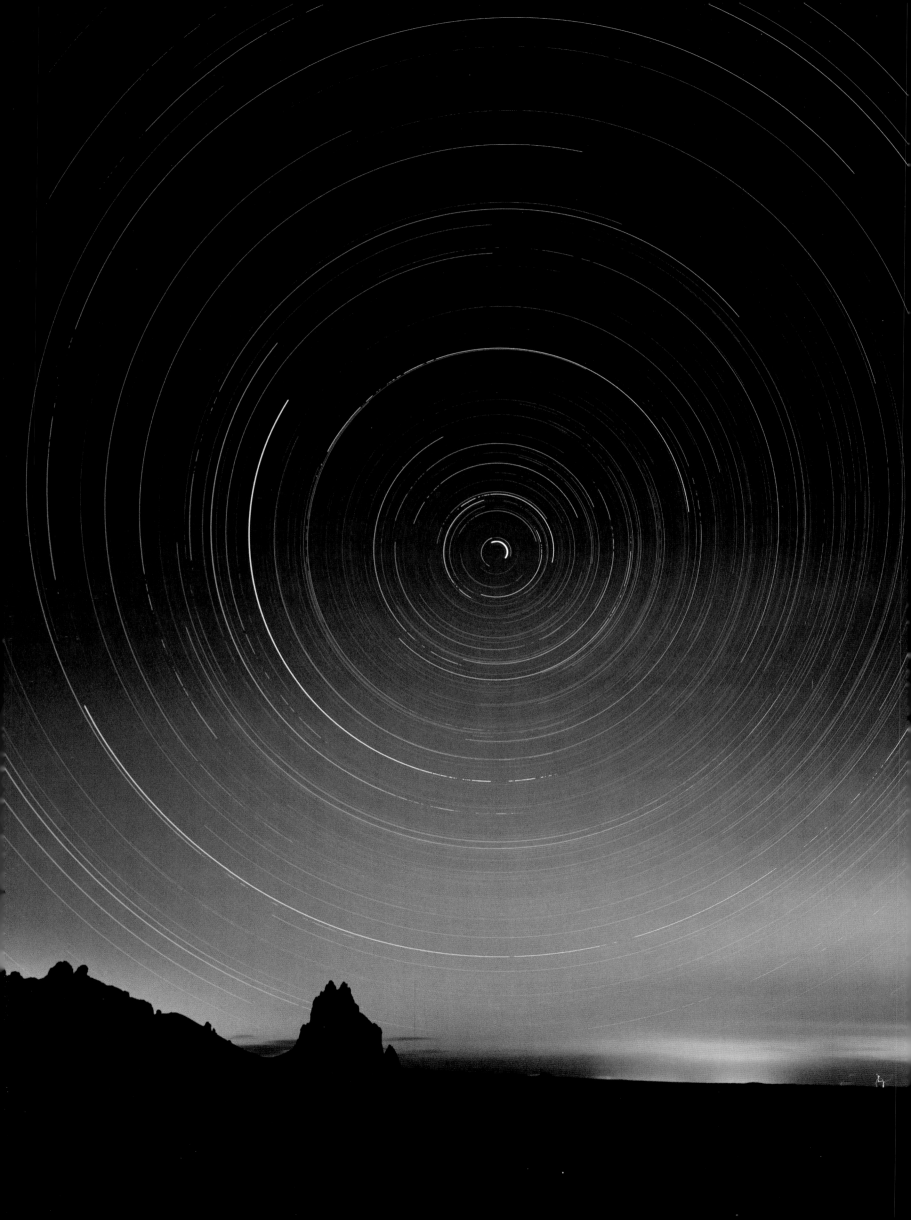

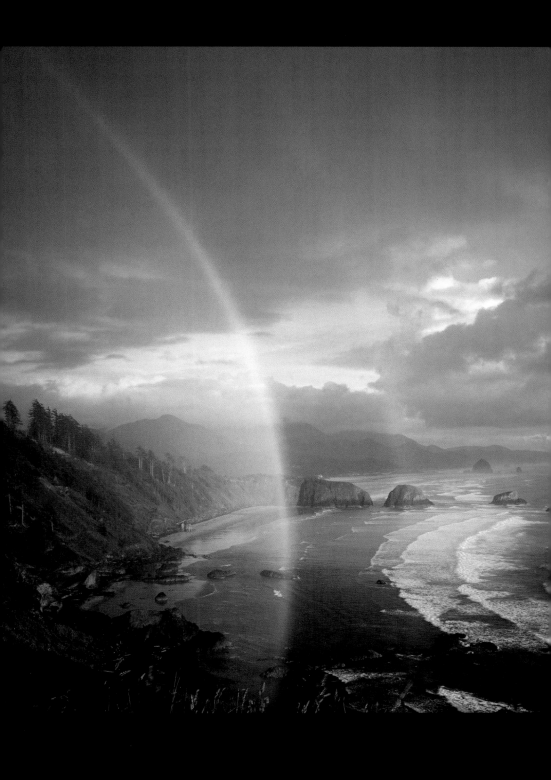

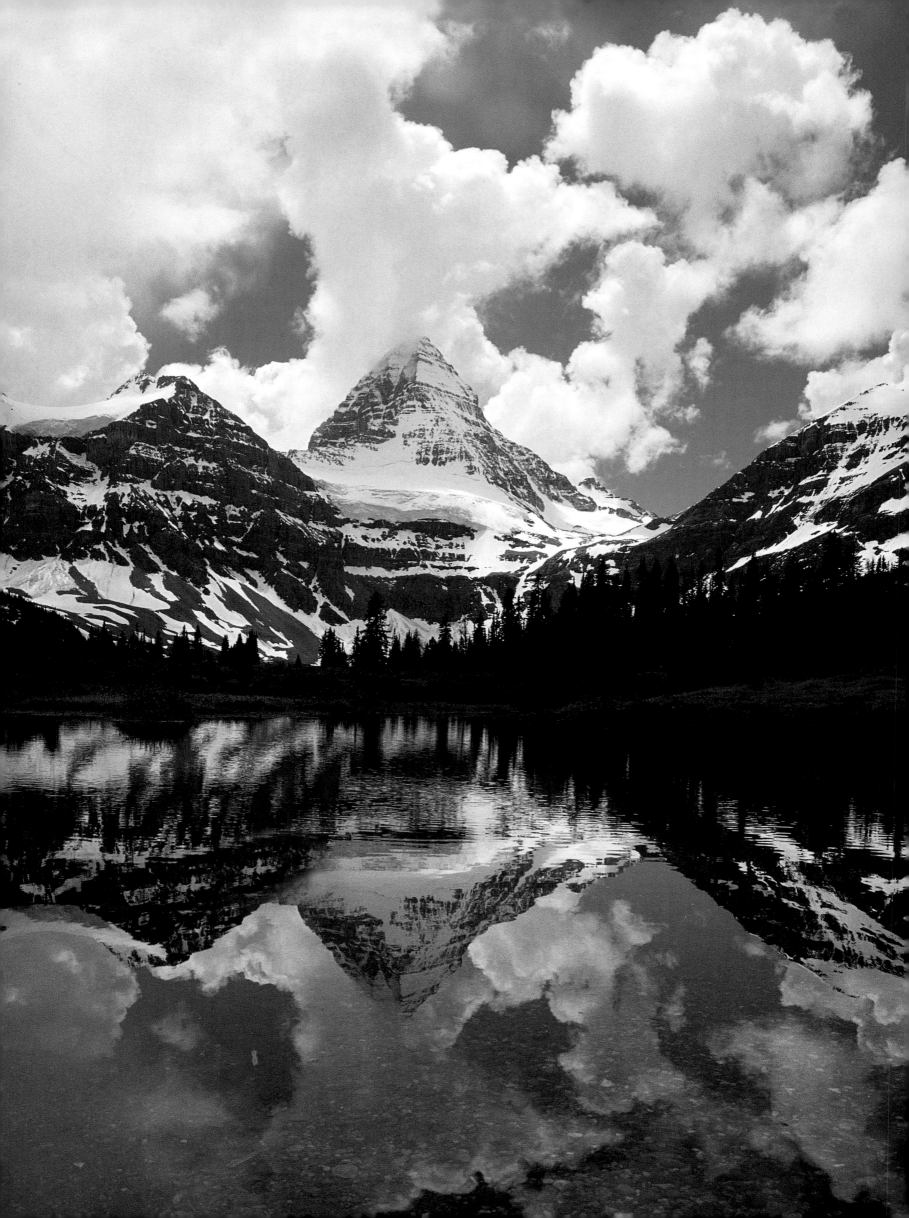

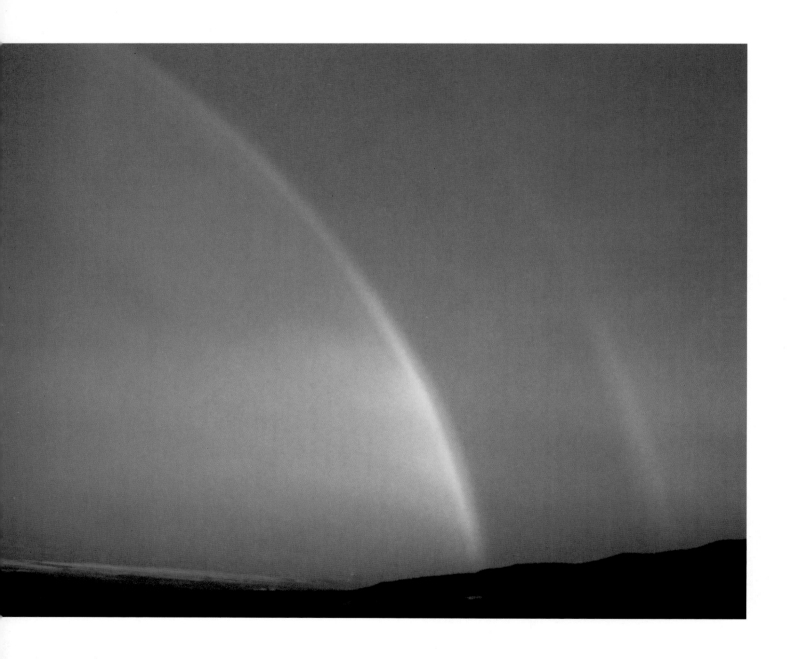

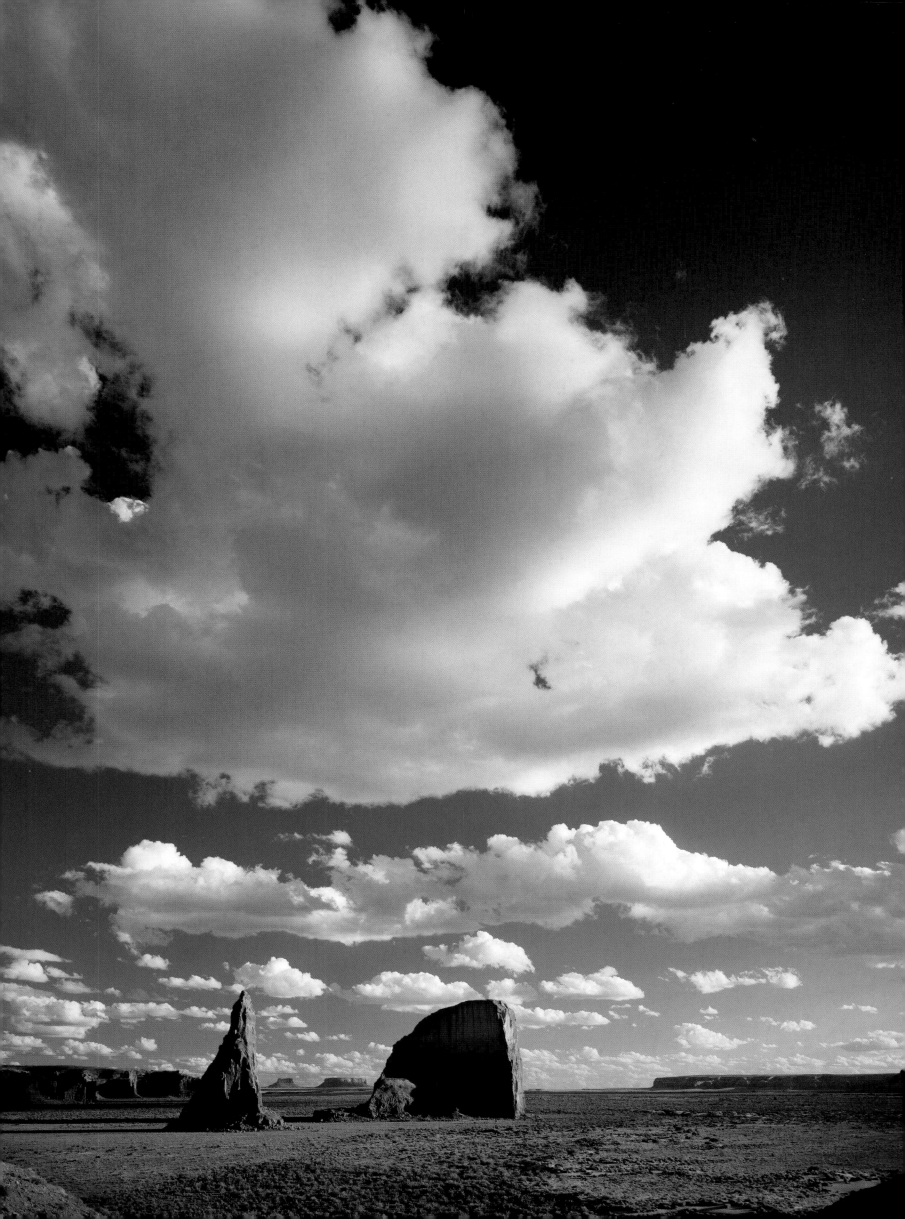

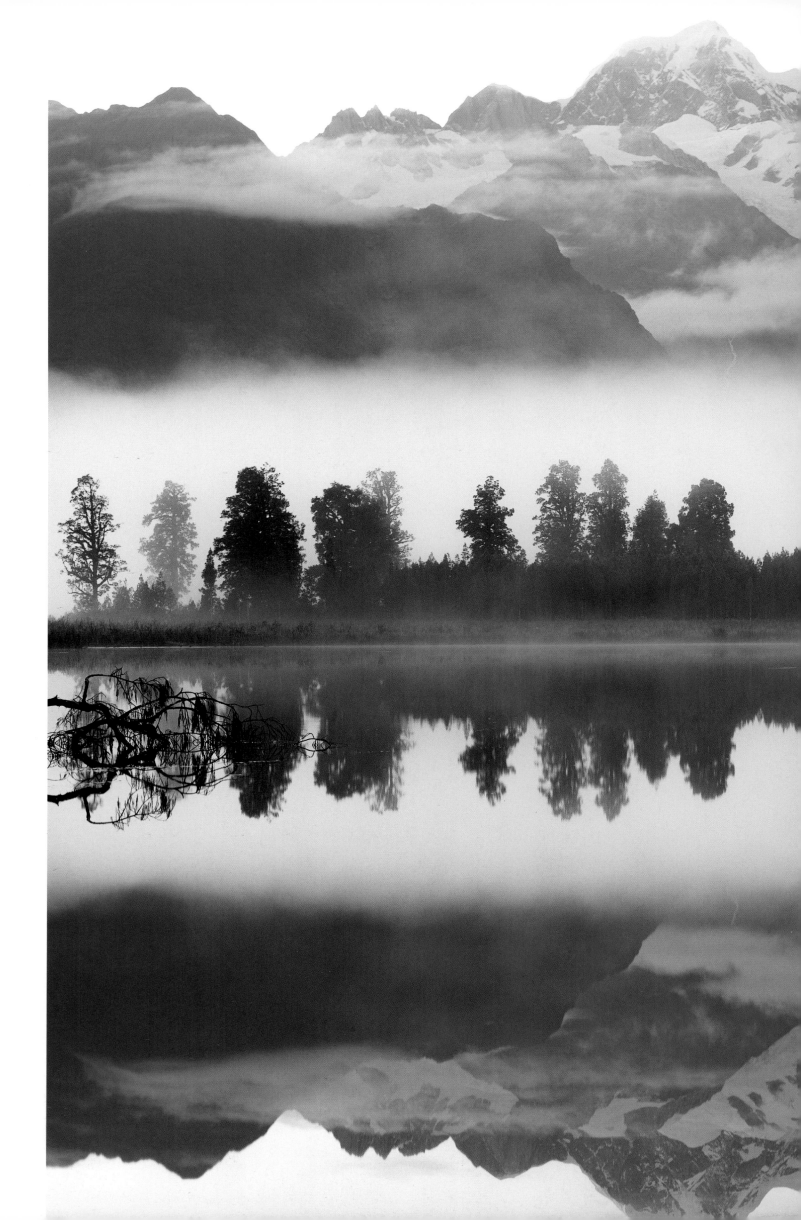

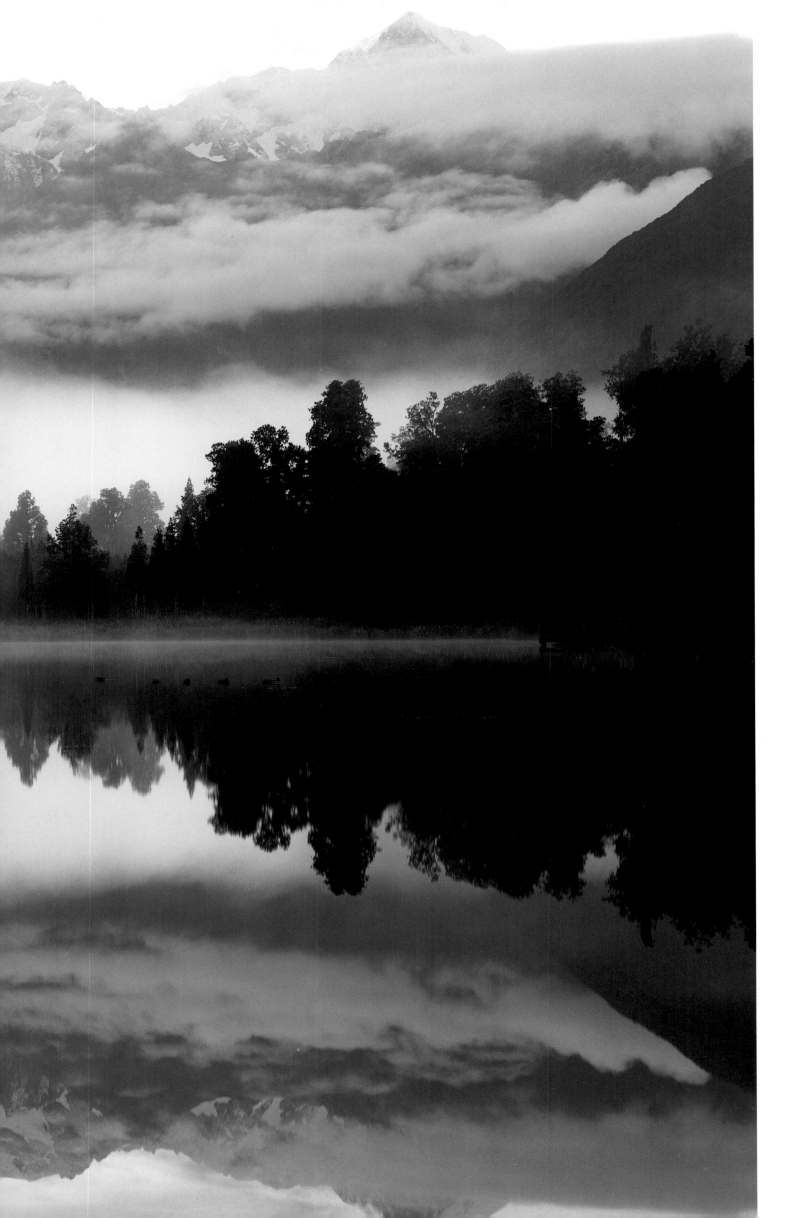

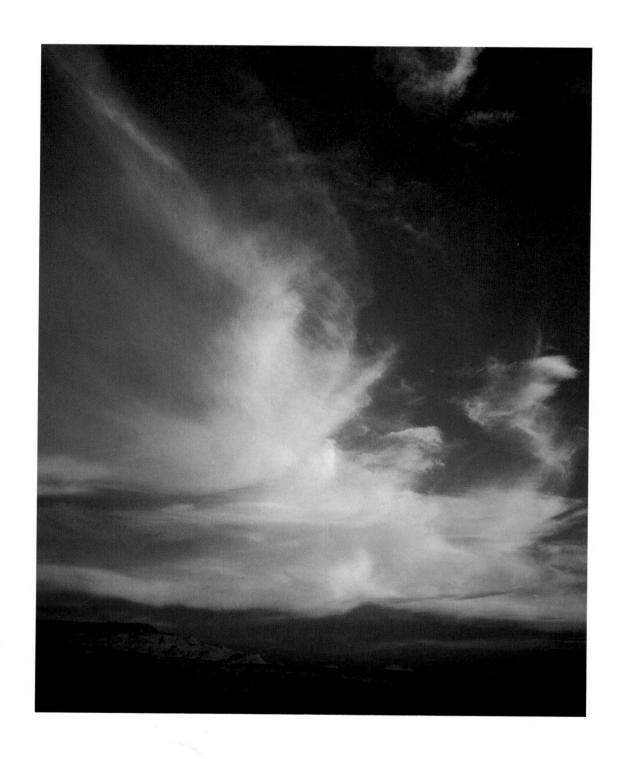

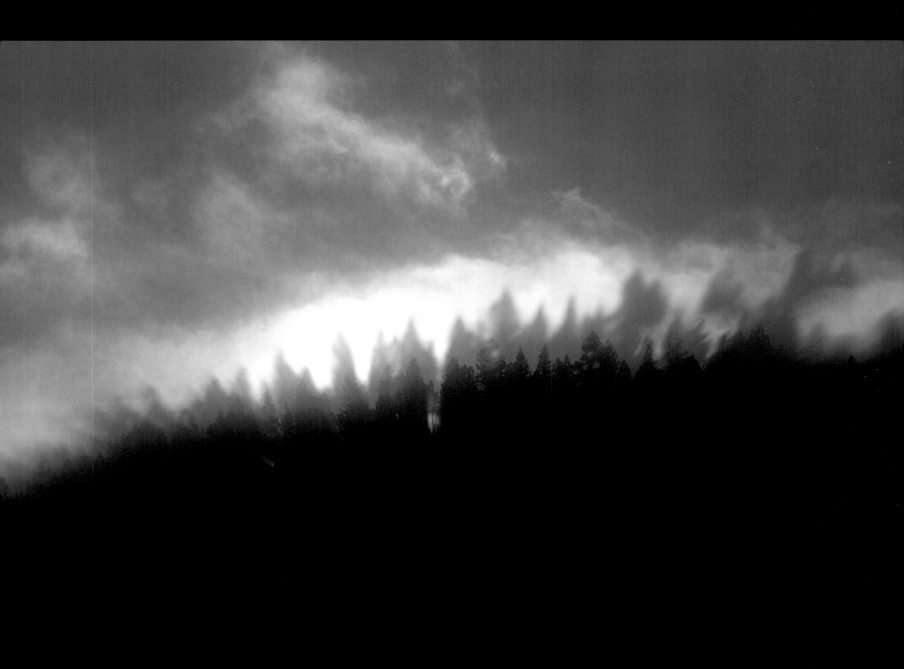

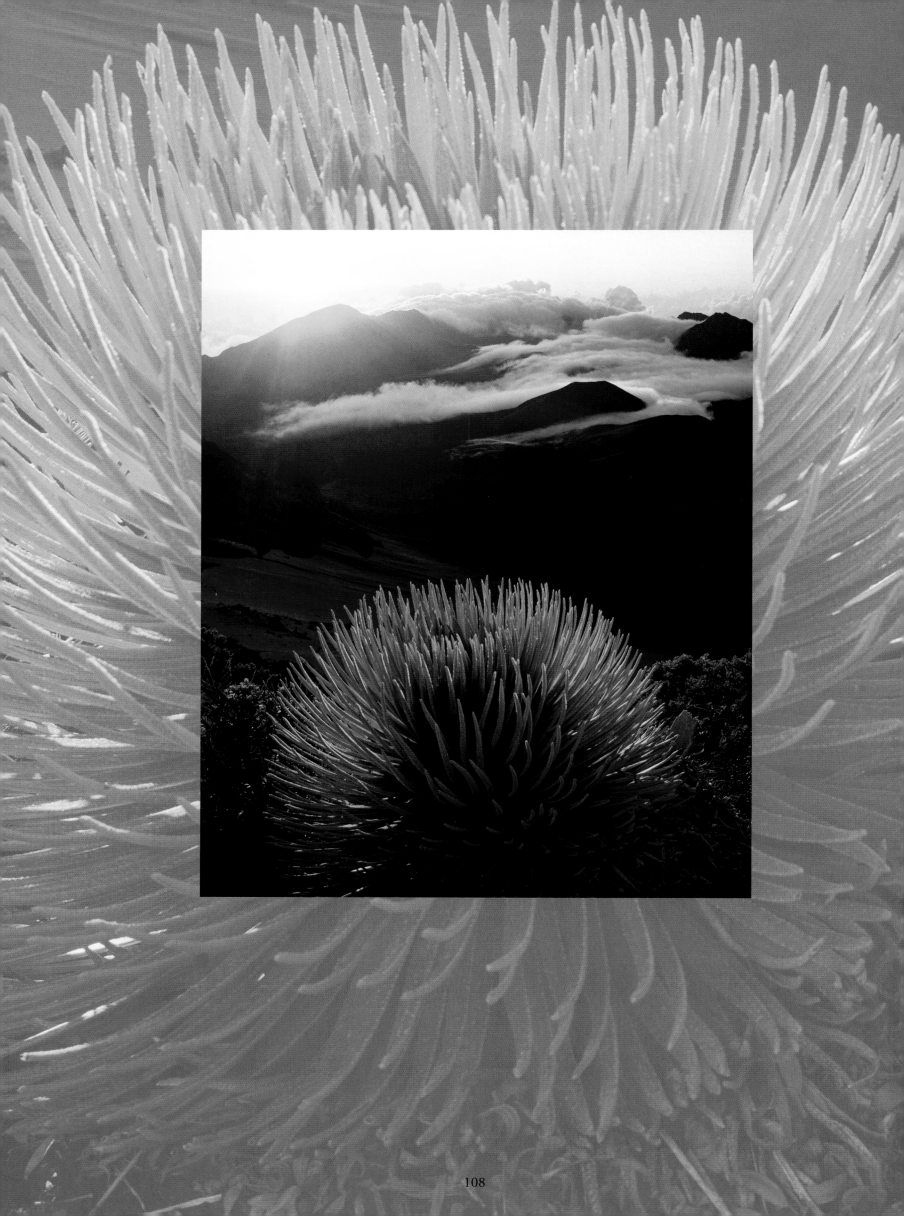

FIRE

Prometheus was a Titan, born of the gods, who, with his brother, Epimetheus, made humans and other animals out of earth and water. It was Epimetheus who gave each of their creations gifts. To some were given wings, to others claws. But, when Epimetheus came to bestow a gift on humans, he had nothing left to give them. He turned to his brother. Prometheus thought long and hard about a suitable gift to give the humans. He wanted to give them something unique, so he journeyed to Heaven, lit his torch from the sun's vast fires, and returned to Earth bringing fire with him. By bestowing fire upon humans, Prometheus planned to set them apart from the rest of Creation.

Zeus, father of the gods, was greatly angered by the presumption of the Titan, and he declared that a terrible punishment would befall humanity. To this end, Zeus sent Pandora to marry Epimetheus. Previously, when Epimetheus had been handing out gifts, there were some that he had withheld. These were the multitude of plagues and pestilences that he had no cause to use. He kept these scourges sealed in a box. One day, seized with an insatiable curiosity, Pandora opened the box and released its contents. All that afflicts humanity to this day was released from Pandora's box as a penalty for humans taking the power of fire from the gods.

The ancient Greeks were not the only ones to see the dichotomy of fire. For many early peoples, fire was at once savior and destroyer. It promised warmth and safety, but it could also elicit terror and fear. Fire was a cleanser, a purifier. It could bring rebirth, punishment, even inner reflection. In ancient Vedic scriptures, fire (in the form of Agni) was the messenger between the gods and humans. To the Zoroastrians of Iran, fire was a fundamental power, an ethereal principle that took center stage in their religion and in their homes. To look into its flames was to look into the fires of hell or the warming embrace of a benevolent deity. Fire was both a gift and a curse. It truly did set humans apart.

Fire is heat, burning embers, and molten rock. It is the sun and the baking desert sand. It is kindling, hearth, and a beacon of hope. It is hellfire, a fireball, and an inferno. Fire is pure unimaginable pain and perfect incandescent beauty.

Volcanoes are the purest manifestation of fire on Earth. They hold the force of creation—and the force of absolute destruction—within their vents. To witness a volcanic eruption is to be privy to a world still in the process of being formed, a world still soft and malleable.

The names of some of our planet's most dramatic volcanoes have gone down in history for the destruction they have rained: Vesuvius, Tambora, Krakatoa, Stromboli, Pelée, and Paricutín—and, more recently, Mount St. Helens, Pinatubo, and Soufrière. Other names have yet to burn themselves into our memories, but they will. A staggering one in ten of the world's population lives near an active volcano.

It is difficult to put a figure on the number of active volcanoes around the world, because there is much disagreement as to what "active" means. To some, an active volcano is one that has erupted in historic times—perhaps during the last 2,000 to 3,000 years—which gives a global figure of about 500. But to many

geologists, who take a somewhat longer view of time, an active volcano is one that has erupted at least once in the last 10,000 years. Such a definition raises the number of potentially active volcanoes to about 1,350. Of those, about 15, or 1 percent, are in the process of erupting at any one time. Just as a definition of "active" can prove problematic, so too is defining "extinct." Once every five years, somewhere in the world, at least one volcano that has been declared extinct erupts.

The world's active volcanoes are concentrated in areas that match the presence of rifts or subduction zones in the Earth's crust. The subduction zone that skirts much of the Pacific Ocean—the "Ring of Fire"—is lined with volcanoes. Indonesia has at least 127 active volcanoes—with 22 on the island of Java alone. Japan has 77, of which 60 have been active in historical times. Chile has 75 volcanoes strung along the Andes Mountains, while the United States has about 165, including those in the Aleutian Island chain that arcs into the northern Pacific. Across the Bering Sea, Kamchatka in the Russian Far East boasts 65 active volcanoes.

Land-based rift volcanoes occur mainly in Iceland, land of fire and ice, which has approximately 200 volcanoes, while the East African Rift Valley supports at least 30. An unknown number are found along the mid-oceanic rifts, although some put the figure as high as 3,000. About 50 "hot spots" around the world have given rise to volcanoes far from plate boundaries, including those that have formed the Hawaiian Islands, the Galápagos, French Polynesia, the Azores, and the great caldera within Yellowstone National Park.

Lava epitomizes volcanoes, but it is rarely their most destructive force. Only about 20 percent of the material ejected by land volcanoes is lava. The elegant, long sprays of fluid lava that leap from the vents of Hawaii's volcanoes are more beautiful than threatening. In 1866, in his book *Hawaii,* Mark Twain described "gorgeous sprays of lava-gouts and gem spangles" from Kilauea on Hawaii's Big Island. He wrote of "a ceaseless bombardment, and one that fascinated the eye with its unapproachable splendor."

The fire fountains of Kilauea have been known to reach heights of more than 1,485 feet (450 meters). This dazzling natural fireworks display occurs partly because Hawaiian lava is low in silica and high in water. Such a combination often results in subdued, even gentle eruptions. Where the magma is high in silica, the lava is viscous and slow-moving, sometimes forming a plug or dome over the crown of the volcano, temporarily blocking the vent and setting the stage for a more explosive eruption in the future. Where high water content combines with high silica, the combination of steam and viscous lava can lead to a substantial buildup of pressure behind the dome, precipitating a cataclysmic eruption as the gas forces its way through the laval cap. Lava viscosity also influences the shape of the volcano. The more fluid the lava, the shallower the slopes of the volcano (as seen in the typical Hawaiian volcano), while the more viscous the lava, the steeper and more cone-shaped the mount (typified by Japan's elegant Mount Fuji).

Lava is the creative extension of the volcano. It redesigns the land and in some cases creates new land, growing an island as it reaches the ocean, filling the air with hissing steam as the red-hot magma touches water. Lava flows at variable rates, the more viscous lava being slower than the more fluid type. Still, rates of 3 feet (one meter) per minute are common, while steep downward slopes can quicken flows to an impressive 14 mph (22 kph). Flows also range between 1 and 16 feet (0.3 to 5 meters) in thickness. As lava reaches vegetation, it sets it aflame, incinerating it at temperatures greater than 1,800°F (1,000°C).

Lava cools as it flows from its source. The surface of the flow cools first, covering the still-fluid lava beneath with a black skin that resembles the ripples of sand on a beach. The outer skin insulates the underlying lava, forming tubes through which the lava continues to flow, sometimes even allowing it to flow underwater. After the flow of lava has been exhausted, vast tubes, often taller than a person, may be left behind, like the arteries of some magical giant.

FIRE

Far more common and destructive than lava is the pyroclastic flow that dominates the eruptions of the vast majority of the world's volcanoes. A "pyroclastic flow" is a hot mass of ash and rock that moves downhill—and even uphill when it has gained enough momentum—as a single unit. Composed of gas, rocks, and ash, pyroclastic flows often form when a rising cloud of ash created at the initial eruption grows too heavy to keep rising and collapses down on itself, sending a cascade of superheated material down the slopes of the volcano. Moving at speeds approaching 185 mph (300 kph), with individual "lava bombs" exploding out of the crater at speeds of 1,240 mph (2,000 kph), the pyroclastic flow is impossible to outrun.

It was the devastating force of pyroclastic flows—not lava—that destroyed both Pompeii and Herculaneum when Mount Vesuvius erupted on August 24, 79 C.E. Herculaneum was buried under volcanic debris 66 feet (20 meters) deep when a river of mud and pumice set loose by the volcano engulfed the town. The volcano had lain dormant for hundreds of years when a series of earthquakes rocked it to life. (Most of the people who lived in its shadow would have had no idea that Vesuvius even was a volcano.) Ash, pumice, and boulders fell from the sky as the people of Pompeii fled the awakening giant. Day was turned to night. Those who had prospered in the shadow of the volcano, growing figs, grapes, almonds, and other crops on the fertile soils, now gasped air that rapidly became unbreathable—filled as it was with noxious gases and suffocating ash. Eventually Pompeii lay under 20 feet (6 meters) of ash. Everything was shrouded in gray: buildings, people, livestock. Today, Naples, home to two million people, lies 10 miles (16 kilometers) from Vesuvius. The volcano has erupted fifty times in the last 2,000 years, twice in the twentieth century. It will erupt again.

Vesuvius ejected 0.75 cubic mile (3.15 cubic kilometers) of material during the course of its 79 C.E. eruption. It was a significant eruption on a local scale, but it pales next to the largest eruption to have occurred in historic times—that of Tambora in 1815. That eruption sent an estimated 36 cubic miles (151 cubic kilometers) of material into the air—almost fifty times larger than Vesuvius's eruption, eight times larger than both the 1883 eruption of Krakatoa and the 1991 eruption of Mount Pinatubo, and seventy times larger than Mount St. Helens' 1980 spectacle.

The Tambora volcano is on the small Indonesian island of Sumbawa, to the south of Borneo and adjacent to Bali and Lombok. When the eruption began, British troops at Batavia (now Jakarta), 740 miles (1,200 kilometers) from Tambora, and at Macassar, Celebes, 200 miles (320 kilometers) distant, were dispatched in vessels in response to what they thought were cannons and artillery being discharged out to sea. The ships returned to port without finding the source of the noise, but the next day ash began to fall on Batavia. For five days the ash rained, followed by a series of massive explosions. It was almost two weeks before relief was on its way to the inhabitants of Sumbawa—at least those who had survived the dramatic upheaval on their island home. Ten thousand people were killed when the volcano erupted; another 82,000 would die from disease and starvation.

Before its eruption, Tambora was 13,200 feet (4,000 meters) high; afterward it was reduced to 9,354 feet (2,851 meters)—one-third of its bulk had literally been blown away. The sea was filled with floating pumice stone and the remnants of trees, and almost three feet of ash covered what remained of the island. In total, ash from the volcano fell on an area that encompassed one million square miles (2.6 million square kilometers). While much of the material ejected by the volcano fell locally, many of the lighter particles were carried high into the atmosphere, and from there they circled the globe.

The year following Tambora's eruption—1816—is often referred to as the "Year Without a Summer." The ejection of so much material into the atmosphere had a dramatic effect on world temperatures. The particles reflected a significant amount of sunlight back into space, and global temperatures fell by an average of nearly 2°F (1.1°C). While the sunsets were spectacular (probably providing the inspiration

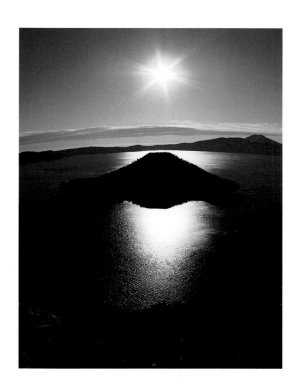

Wizard Island, Crater Lake National Park, Oregon, USA

Photograph by David Muench

Crater Lake was born following the eruption and collapse of Mount Mazama about 7,000 years ago. Wizard Island is a new volcanic cone that has since risen above the waters. No one knows if the volcano is still active.

behind J. M. W. Turner's evocative, almost impressionistic paintings), Western Europe experienced record low temperatures and heavy rains, and New England saw strange summer frosts and snow in June. Crops failed throughout Europe and North America, but no one knew that a small island volcano half a world away was to blame.

In 1883, Southeast Asia was again rocked by a massive volcanic eruption, this time on an island located between Java and Sumatra. The volcano was Krakatoa. The eruption of the 6,000-foot (1,800-meter) volcano on August 21 sent 5 cubic miles (21 cubic kilometers) of debris into the air, and the explosion could be heard 2,200 miles (3,500 kilometers) away in Australia. For two and a half days the region was plunged into darkness, and pumice was so thick on the water that it impeded ship passage. Ash fell over an area of 320,000 square miles (800,000 square kilometers), and for seven years spectacular red sunsets seen around the world were attributed to the volcano. Not only did the eruption strip 3,300 feet (1,000 meters) from Krakatoa's stature, but the resulting tsunamis reached as far as Hawaii and South America. An estimated 36,000 people on Java and Sumatra were killed when the largest of the tsunamis, a 132-foot (40-meter) wave, hit the shore. Forty-five years after the massive eruption virtually destroyed the island, a new volcanic cone growing from the sea floor reached above sea level. It was named Anak Krakatoa, "Child of Krakatoa."

In more recent years, the world witnessed the eruption of Mount St. Helens in the western United States. Native Americans long knew of the deadly potential of this exquisite mountain, and few Native bands approached the peak. When white settlers moved into the area that is now southwestern Washington, they had little regard for the "smoking mountain." Although minor rumblings punctuated the early nineteenth century, few were prepared for the events leading up to the cataclysmic eruption of May 18, 1980.

For seven weeks before the May eruption, the volcano trembled under 10,000 earthquakes, and small amounts of ash smoked from its peak. A bulge then developed on the mountain's north flank, and it grew at a rate of about 3 feet a day as pressure built within the mountain. The day of the eruption, a 5.1 magnitude earthquake collapsed the north face and precipitated an eastward lateral eruption that garnered speeds of more than 620 mph (1,000 kph). Everything that stood within 16 miles (27 kilometers) east of the volcano was either flattened or buried. Even the soil was stripped from the ground. The top 1,680 feet (550 meters) of the volcano were destroyed, and the blast area covered 240 square miles (600 square kilometers); the sun was blotted out over 200 miles (320 kilometers) away, turning midday to night. In total, 60 people lost their lives, as did 5,000 black-tailed mule deer *(Odocoileus hemionus)*, 200 black bears *(Ursus americanus)*, 1,500 elk *(Cervus elaphus)*, and unknown thousands of birds. Ten million trees were blown flat by the blast. Researchers estimated the power of the eruption to be equivalent to 10 million tons of TNT. The once picture-perfect mountain is now a stoic reminder of geological transformation.

The eruption of Mount St. Helens resculpted the land around it, but it did not have a global impact on climate as did Tambora. The scale of St. Helens' eruption was too small, and the ash ejected high into the atmosphere contained little of the sulphur that is usually associated with such impacts. This was not the case when Mount Pinatubo erupted in the Philippines on June 15, 1991.

Mount Pinatubo had been dormant for 500 years before its 1991 eruption, when it ejected more than 15 million tons of sulphurous gas into the stratosphere, depressing global temperatures by 1°F (0.5°C) as the sulphur combined with water to form tiny droplets of sulphuric acid that reflected sunlight. The severe winters felt in eastern Canada and the eastern United States that year were blamed on this cooling. If the total volume of ash and rock ejected from Pinatubo could have been collected in one place, it would have been enough to cover the entire island of Manhattan under 990 feet (300 meters) of debris.

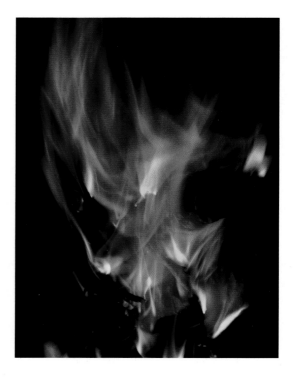

Fire, Colorado, USA
Photograph by Bonnie Muench
Fire plays an essential role in human society and culture, inspiring religions and philosophers alike. It is also an integral part of the natural world, shaping, destroying, and renewing ecosystems.

As powerful as the volcanoes of historical record are, they cannot compare to the "megavolcanoes" that erupted in the distant past. These volcanoes redesigned continents and perhaps changed the course of evolution. The Deccan Traps in northwestern India formed from a million-year-long outpouring of lava 65 million years ago. That scale of volcanic activity probably significantly affected the world's climate. Some have even suggested a link between those eruptions and the extinction of the dinosaurs. Another megavolcano that continues to bubble its way to the surface is found within the world's most famous national park: Yellowstone.

Yellowstone contains thousands of thermal features, including geysers, hot springs, mud pots, and fumeroles. The heart of the national park is a caldera—covering more than 1,400 square miles (3,500 square kilometers)—the collapsed crater of an immense volcano. The activity of the geysers and other thermal features is a testament to the continued "life" of this hot spot, 680 miles (1,100 kilometers) from the nearest plate boundary. Although Yellowstone has been, and continues to be, active, there have been several major eruptions in its past that have yet to be matched in the present.

Approximately two million years ago, an eruption of magma created a depression that ultimately formed the park's caldera. This eruption ejected an estimated 600 cubic miles (2,520 cubic kilometers) of ash and rock—more than sixteen times the volume ejected by Tambora. Approximately 1.6 million years ago, another eruption ejected 67 cubic miles (281 cubic kilometers) of material, while the last major eruption, 600,000 years ago, sent more than 238 cubic miles (1,000 cubic kilometers) of debris into the air. Much of the debris from the latter eruption still covers the park. Since then, other smaller eruptions have punctuated the timeline, leading up to about 70,000 years ago. The region has been relatively quiet since, but the fountain geysers and gurgling mud pots are visible reminders that the past is the best indicator of the future.

What would be the impact of a Yellowstone-size volcanic eruption on our world today? At the very least, such an eruption would coat most of the western United States and Canada in ash. If a large amount of the ejected material were carried up into the atmosphere, global temperatures might be significantly reduced, perhaps enough to induce a new ice age and a new round of mass extinctions.

If volcanoes can destroy hundreds of square miles and cover millions more with suffocating ash, what good can possibly come from such expressions of planetary fury? The farmers on the slopes of Mount Vesuvius knew. Volcanic soils are highly productive, and even though the devastation following an eruption can seem complete, recovery begins almost before the ash has settled.

Within ten days of Mount St. Helens' eruption, animal tracks could be found in the ash, as those who had escaped with their lives traversed the region. Just a month after the eruption, fireweed *(Epilobium angustifolium)* blossomed, regenerating itself from roots that had survived beneath the surface. Lupine *(Lupinus polyphyllus)* pushed through the ash just three months later. But full recovery certainly does not happen overnight. Arizona's Sunset Crater erupted in 1065, and the landscape there is still a surreal mix of crusty black lava and red- and yellow-tinted rocks. Still, in the more than 900 years since the eruption, shrubs and trees have taken hold. Large areas are still all but devoid of life, but it is encroaching.

While the infrequent and absolute devastation wrought by volcanoes is difficult to adapt to, numerous species are, in a sense, pre-adapted to their impacts. Wildfires may not burn with the same intensity as lava or a pyroclastic flow, but the regeneration of the landscape after an eruption owes much to the pioneer plants and hardy seeds that evolved in concert with naturally occurring fires.

McDougal Crater, El Pinocate Biosphere Reserve, Sonora, Mexico
Photograph by David Muench
Ocotillo *(Fouquieria splendens)* blooms along the rim of this volcanic crater in Mexico's Sonoran Desert. Formed during a series of eruptions that began 3 million to 4 million years ago, the volcanism in this region is still little understood.

Fire is as natural to our world as the wind. Fires may have their start in one of the 8.5 million lightning flashes that light up the sky every day—an estimated 10,000 forest fires a year in the United States alone are started by lightning. Fires can also start when rockfalls send sparks into the underbrush, as occurs in the coastal *fynbos* ecosystems of South Africa. Fires may start spontaneously in compacted and rotting vegetation on the forest floor. And, of course, fires can start when set intentionally or accidentally by people.

Fires burn through ecosystems with surprising regularity. In North America, before widespread human settlement, forest fires raged at intervals of between 7 and 80 years, although in some regions—such as the redwood *(Sequoia sempervirens)* forests of California and the cedar-spruce forests of western Washington—such intervals could stretch to 500 years or 2,000 years, respectively. Among ponderosa pine *(Pinus ponderosa)* forests, fires occur at intervals of between 5 and 25 years. In western hemlock *(Tsuga heterophylla)* and Douglas fir *(Pseudotsuga menziesii)* forests, the fire interval is a century or two, while in California chaparral the vegetation is engulfed every 20 to 50 years. The grasslands of Australia were born out of fires set each year by indigenous people, as were the North American plains, while the African savanna also burns annually, often with a helping hand from local people. This association between fire, humans, and grasslands is not a recent occurrence, but has been going on for tens of thousands of years.

When a fire rages through a grassland or shrubland, it burns much of the surface vegetation. The fine leaves and stems of grasses are completely destroyed, but the all-important growing point of the plant lies underground, protected from the flames. Most fires heat only the top few inches of the soil, so anything deeper—including much of the root system and any dormant seeds—is insulated from the intense heat. Fires release the nutrients trapped within the litter layer and thus function as the main agent of nutrient cycling in grassland ecosystems. With a flush of nutrients, a fire-ravaged grassland soon turns green again. Many plants are induced to flower by the passage of a fire, so that the revitalized grassland may be tinged purple, red, orange, or yellow as fireweed, orchids, irises, lilies, Indian paintbrush *(Castilleja miniata),* and a pallet of others lift their blossoms above a scorched land that once seemed at the brink of ruin.

There is no doubt that a forest after a fire is a sorry sight. Trees lie prone, their trunks turned to charcoal. Others remain upright, like sentinels bearing silent witness to the fury of the fire. A burned forest can appear lifeless, a sad reminder of the green, living exuberance that once shaded the forest floor and provided habitat for myriad creatures.

Robert Marshall, founder of The Wilderness Society and author of *Arctic Village,* wrote in 1927: "There were some scenes of desolation that pretty nearly drive an imaginative person crazy. . . . A pessimist would conclude that one summer's fires destroyed more beauty than all the inhabitants of the earth could create in many years, while an optimist would go singing through the blackened, misshapened world rejoicing because the forest will look just as beautiful as before—in two or three centuries."

Marshall eloquently captured the nature of the forest fire. It is a scene of devastation, but that devastation is passing, even though to us humans the time frame involved can seem like an eternity. When a single tree may live for centuries—even half a millennium or longer—a single fire needs to be looked at with some perspective.

Most fires are small both in terms of scale and the amount of destruction they bring to bear on vegetation. The vast majority engulf much less than an acre. Usually when a bolt of lightning hits a tree, only that tree and a small amount of the surrounding area burn. Just as wind-blown trees leave gaps in the canopy of the forest, so do trees destroyed by fire. Since many species of trees, such as lodgepole pine *(Pinus contorta),* are shade-intolerant, they are unable to grow up under their own parents, and to survive they rely on the regular formation of gaps in the forest. With sunlight able to reach the forest floor, seedlings grow skyward,

It surpasses all wonders that a day goes by wherein the whole world is not consumed in flame.

—PLINY,

Natural History

replacing the dead or fallen tree. Thus the forest is renewed, tree by tree, as some die from disease, others are toppled by the wind, and still others suffer the punishment handed out by a passing thunderstorm. Fire can be the ultimate gap creator, at times removing a single tree, at others the entire forest. As long as there is a replacement seed source, either surviving in the soil or blown in from the surrounding area, in time the forest will return.

When Yellowstone National Park burned in the summer of 1988, many feared the loss of a national treasure. The scale and intensity of the fire seemed unprecedented. Fires are not uncommon in the park, but a major fire occurs only once every 300 years. In 1988, eight separate fires—some started by lightning, others by people, all made worse by drought—joined forces to burn 1.4 million acres (560,000 hectares), nearly half the park. The heat of the fire melted steel, exploded boulders, and created tornado-like winds. In places, flames reached 1,580 feet (480 meters) above the ground. Although many areas lost all of their trees, in a third of the burn area only the surface vegetation was destroyed—the trees survived. While more than 10,000 people worked to fight the blazes, it was the rain and snow brought by the end of summer that finally extinguished the flames.

In the years following the Yellowstone fires, researchers have witnessed an incredible resurgence of life. More than a decade later, the impact is still obvious, but so is the regeneration. In some areas, lodgepole pine seeds produced as many as 35,750 young seedlings per acre. Standing dead trees still dominate the skyline, but at their feet are two-foot-tall trees, reaching ever upward.

Many plant species seem to court the destructive power of fire. The plants that make up the desert chaparral include such highly flammable species as chamiso *(Adenostoma fasciculatum),* manzanita *(Arctostaphylos sp.),* desert ceanothus *(Ceanothus greggii),* and the desert shrub oak *(Quercus cornelius-mulleri),* as well as numerous other resinous plants that easily catch and feed the flames. Many chaparral plants require the heat of a fire to break the dormancy of their seeds. Forest and grass fires frequently approach temperatures of 1,800°F (1,000°C), hot enough to kill just about any seed on the soil surface. But such temperatures rarely penetrate deeply, and seeds just a few inches below the surface may be heated sufficiently—often to nearly 200°F (93°C)—to stimulate germination. Without regular fires, the chaparral would vanish.

Conifers also benefit from fire. Lodgepole pine, ponderosa pine, slash pine *(Pinus elliottii),* jack pine *(Pinus banksiana),* the giant sequoia *(Sequoiadendron giganteum),* and others are all "fire trees." Their cones are opened only by heat, spreading seeds that will soon grow to replace the burned-out stands. The ponderosa pine even has flammable needles that may help start the very fire that simultaneously kills the fully grown tree and sets the stage for the next generation it has spawned. Some sequoias survive fires that literally burn out the heartwood of the tree, leaving only the xylem- and phloem-filled outer rings to keep the tree alive. In addition, the Australian eucalyptus *(Eucalyptus sp.)* possesses highly combustible bark and flammable volatile oils that also promote fires. Pieces of its peeling bark may be carried skyward by updrafts rising from a fire and travel more than 20 miles (30 kilometers) to start even more blazes.

Many North American Indian tribes refer to fire as "Grandfather Fire." It is a noble title, one of longevity and venerability. To indigenous cultures around the world, fire was not something to be feared; it was something to be understood and used to advantage. The same has been true throughout the course of evolution. Those species regularly exposed to fire adapted to it—and sometimes even adapted to promote it.

Although fire destroys, it is also linked with renewal. Just as the mythical phoenix rises from the ashes of an immortal fire, so does a seedling rise through the layers of volcanic ash or through the charcoal trunk of its parent. Fire and life are linked on our planet, two sides of the same coin, two vibrant entities that flicker and grow, dazzling all with their brilliance.

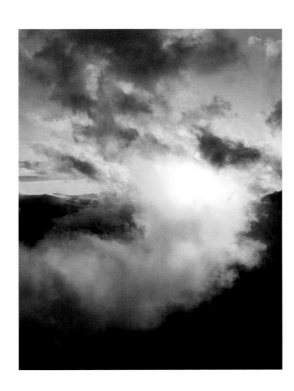

Trail Ridge Road, Rocky Mountain National Park, Colorado, USA
Photograph by Marc Muench
The setting sun breaks through the clouds along Trail Ridge Road. This popular route crosses the Continental Divide at 10,759-foot (3,228-meter) Milner Pass.

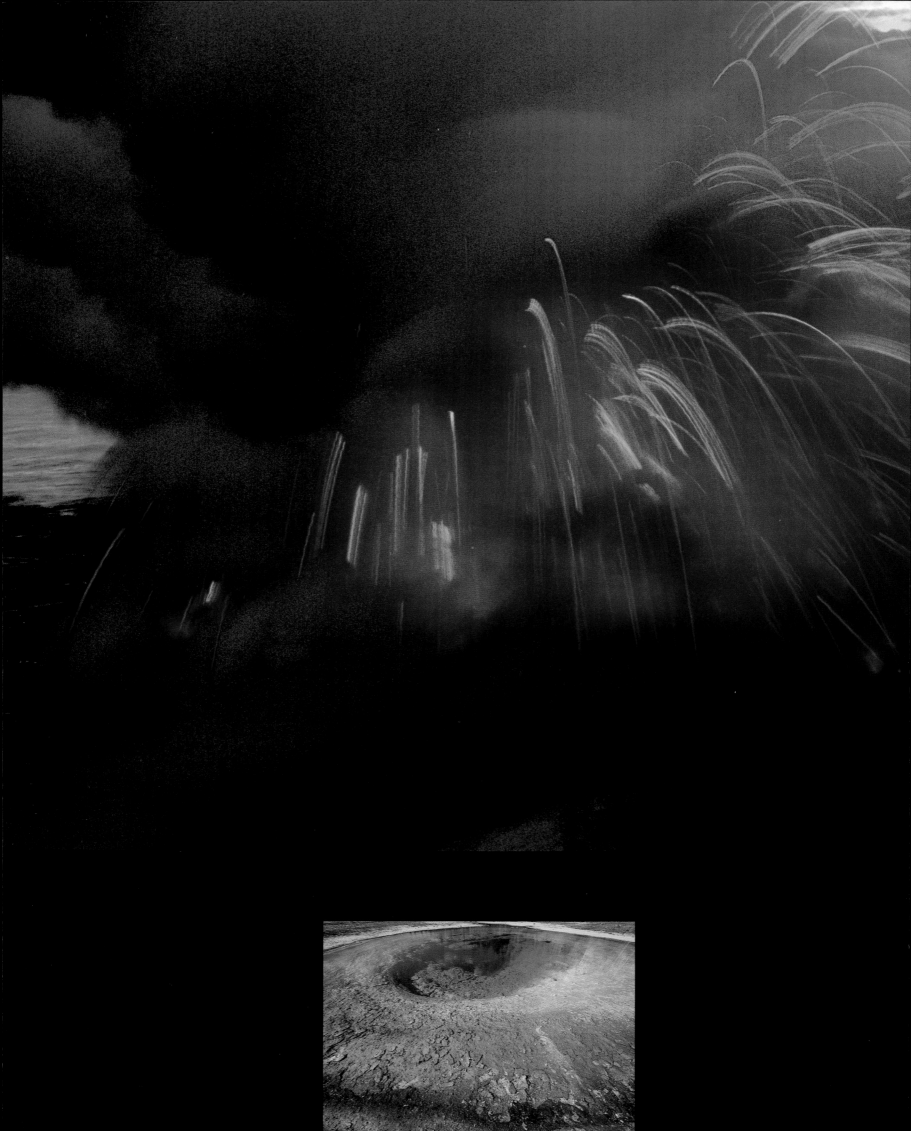

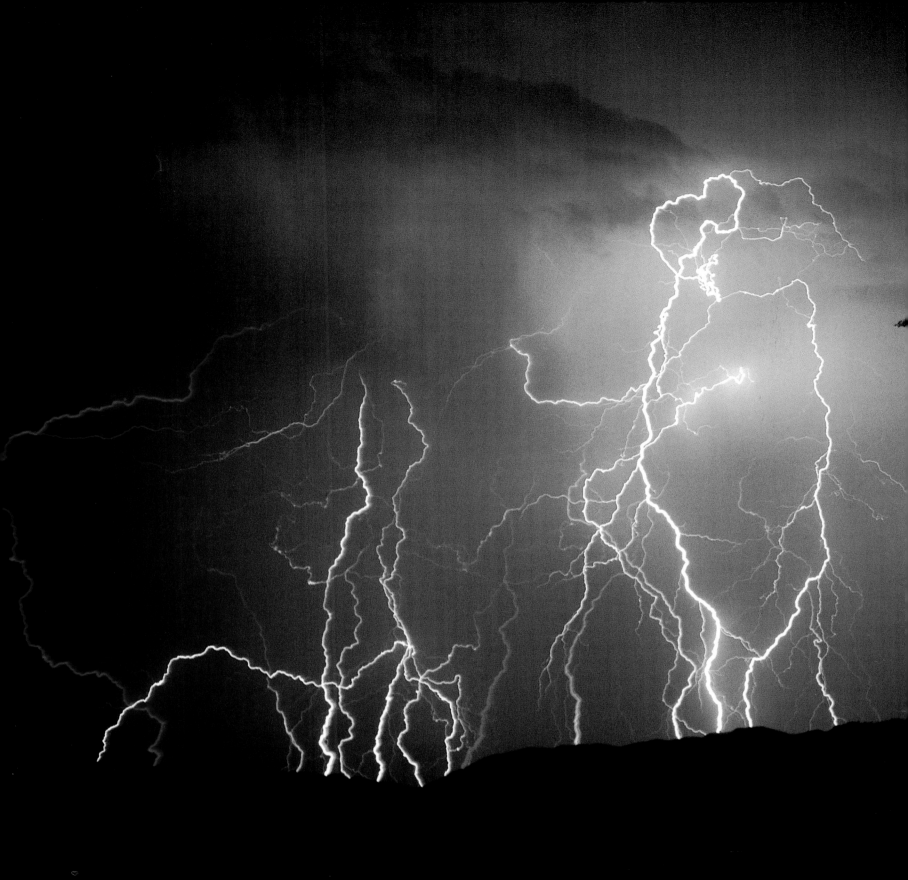

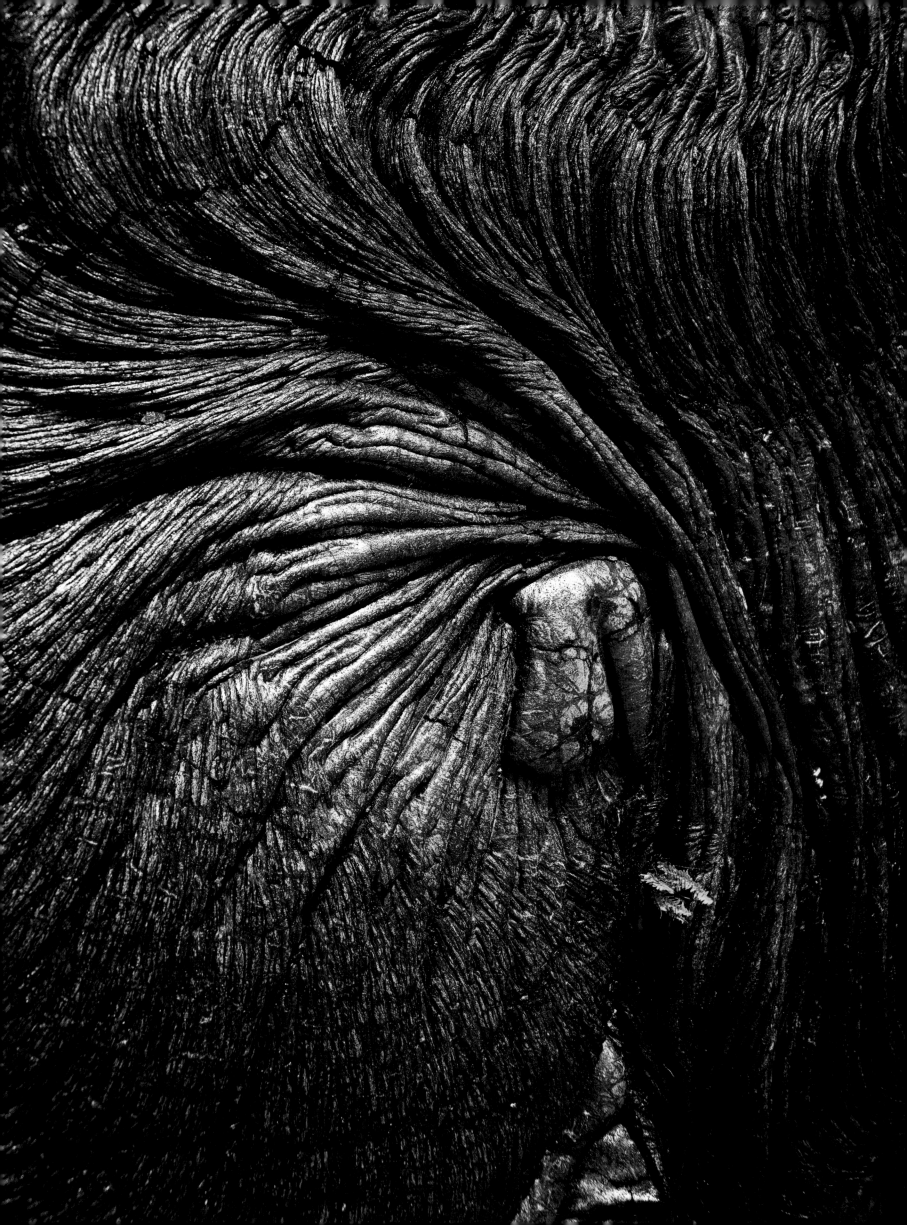

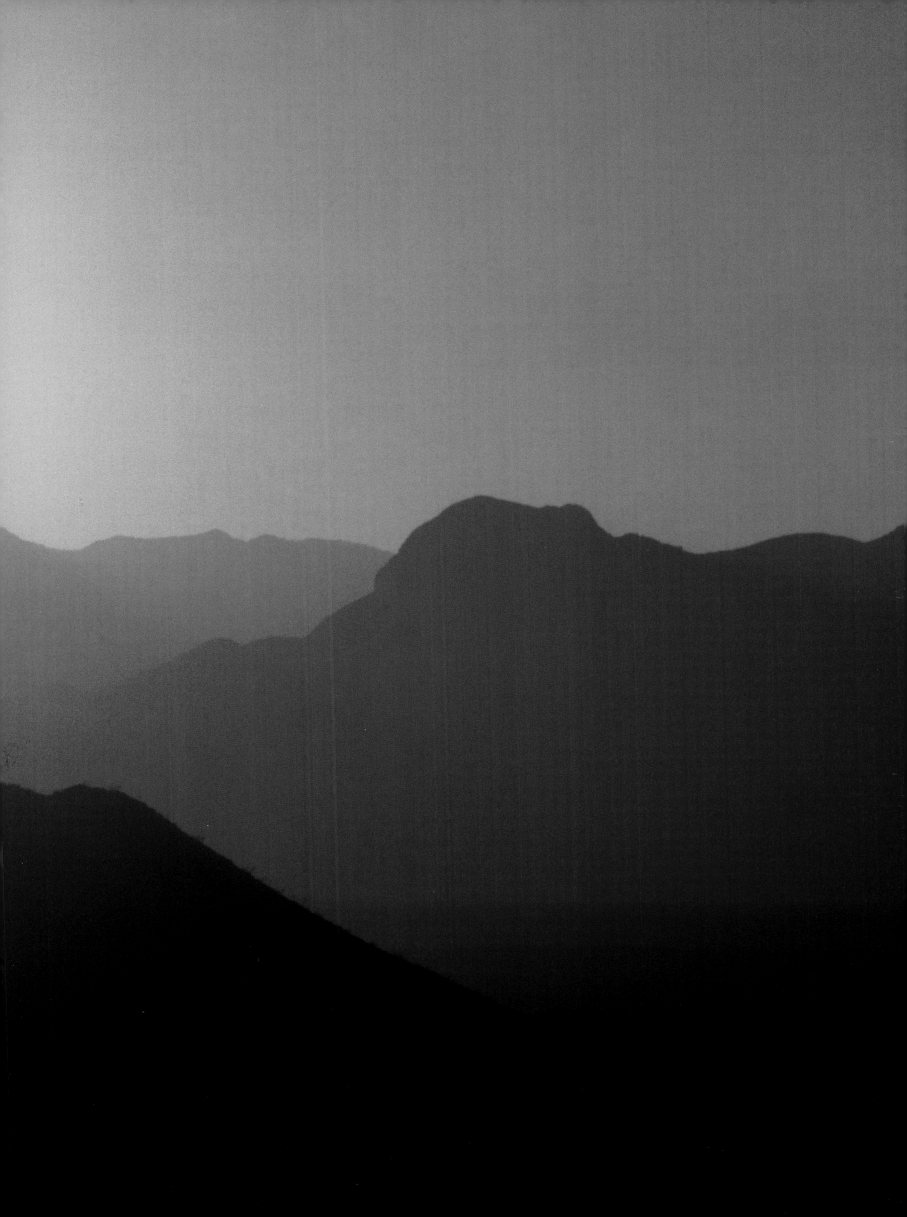

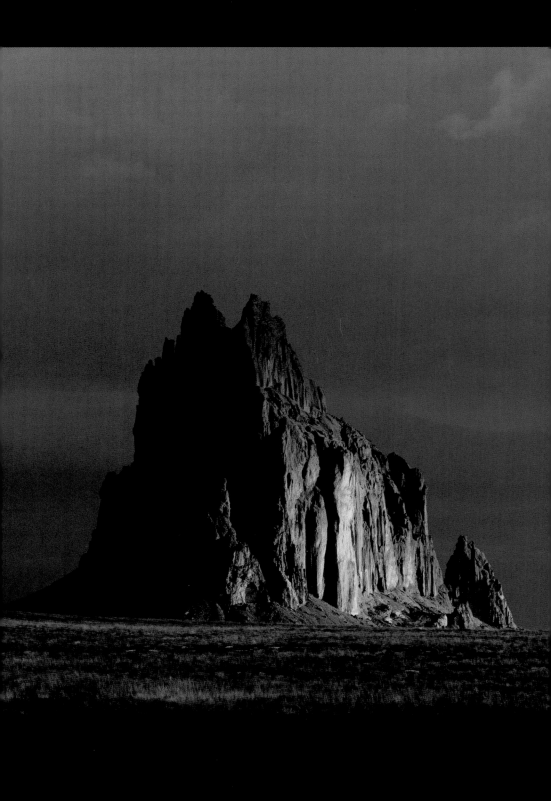

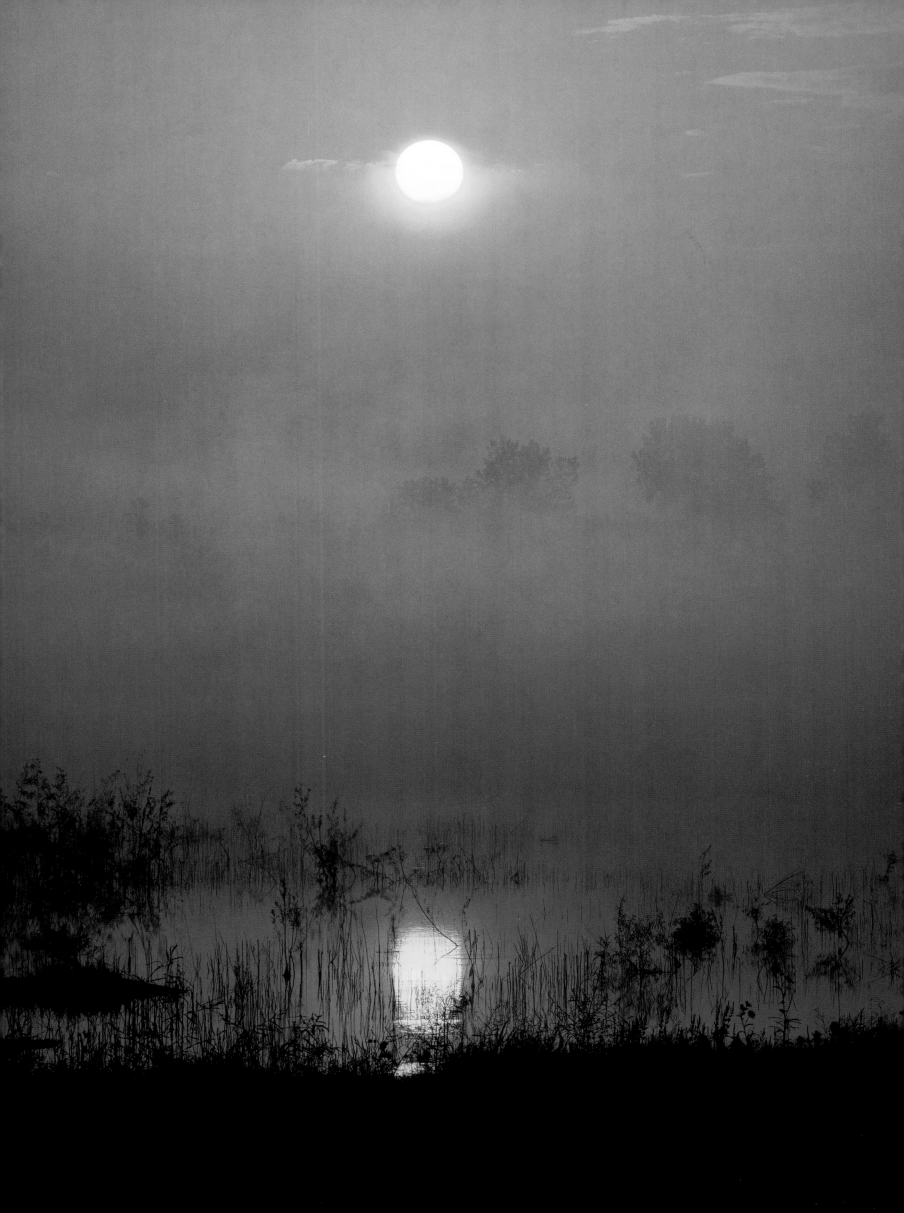

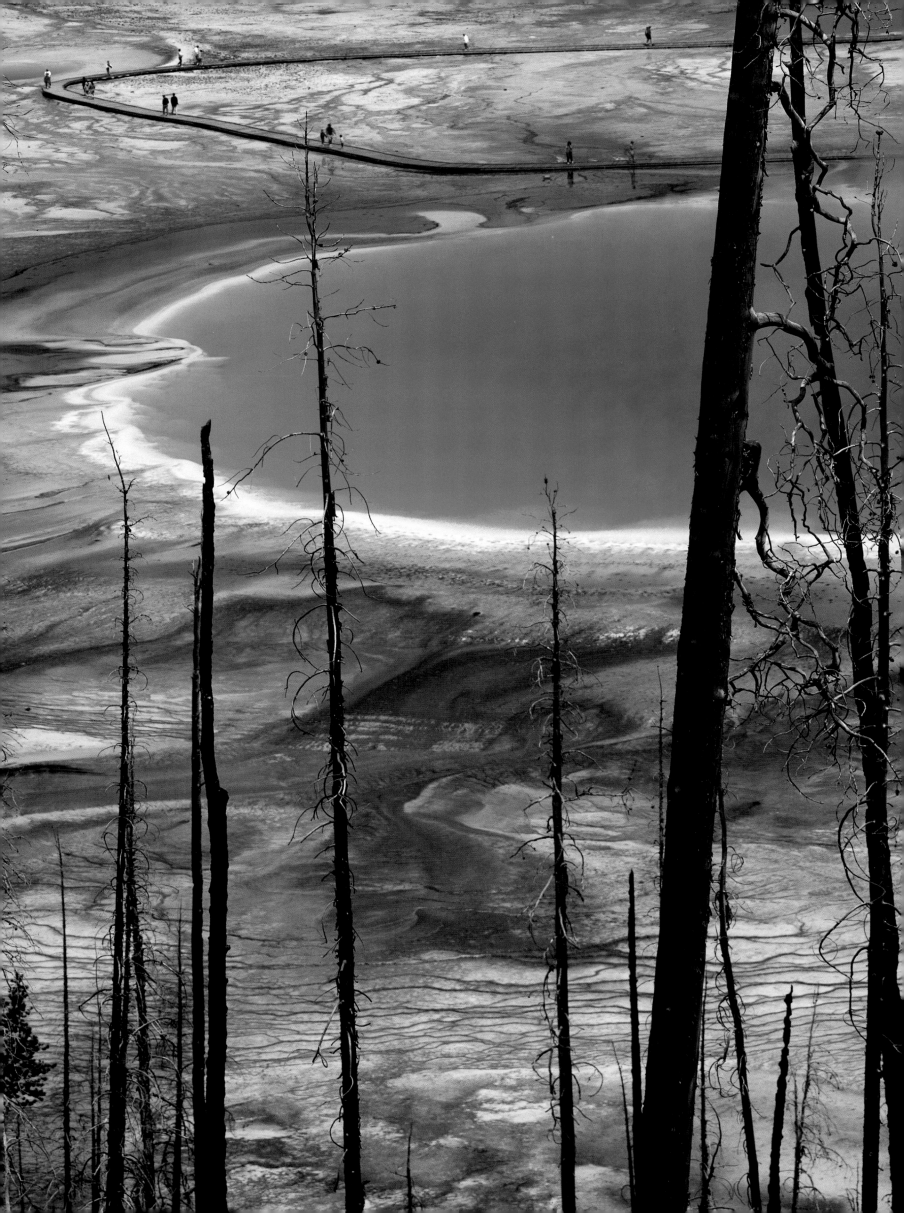

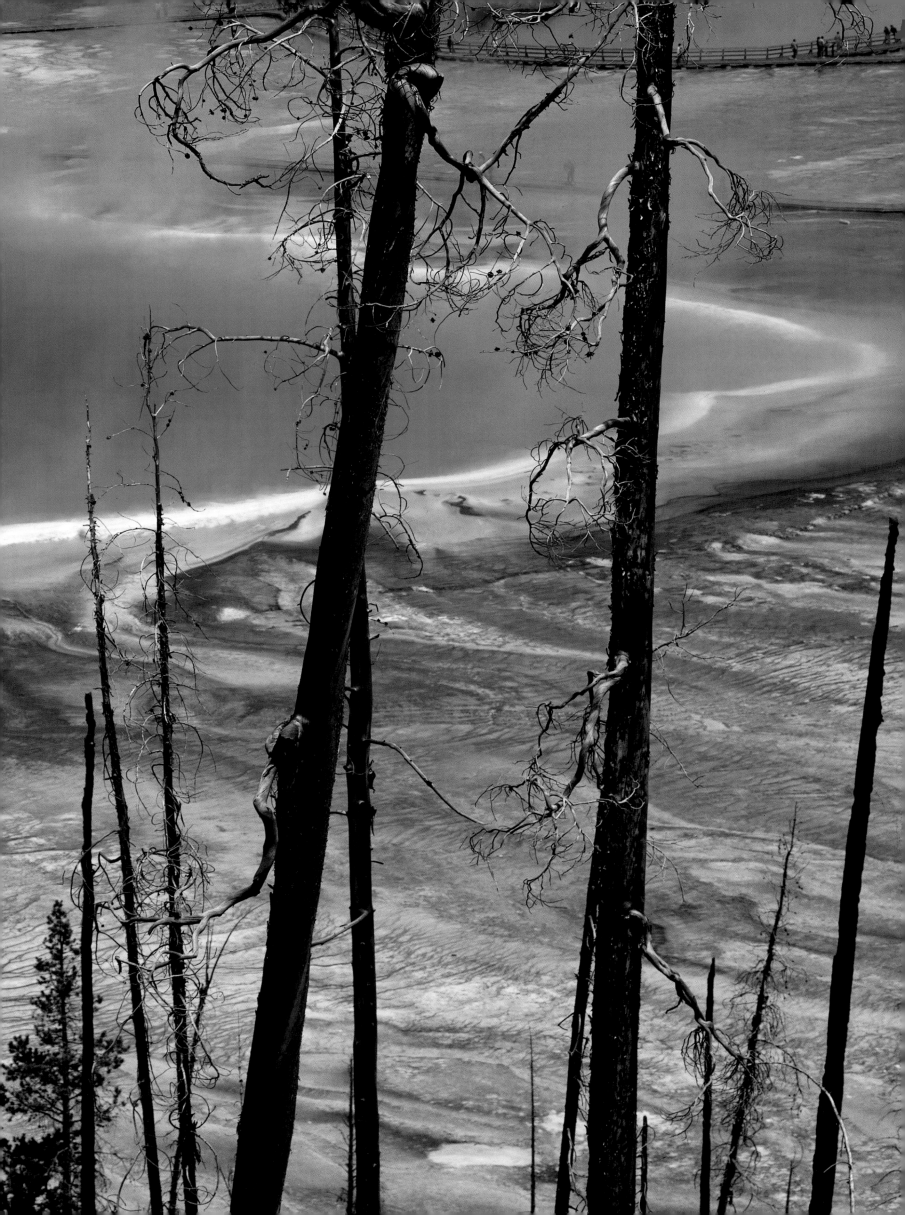

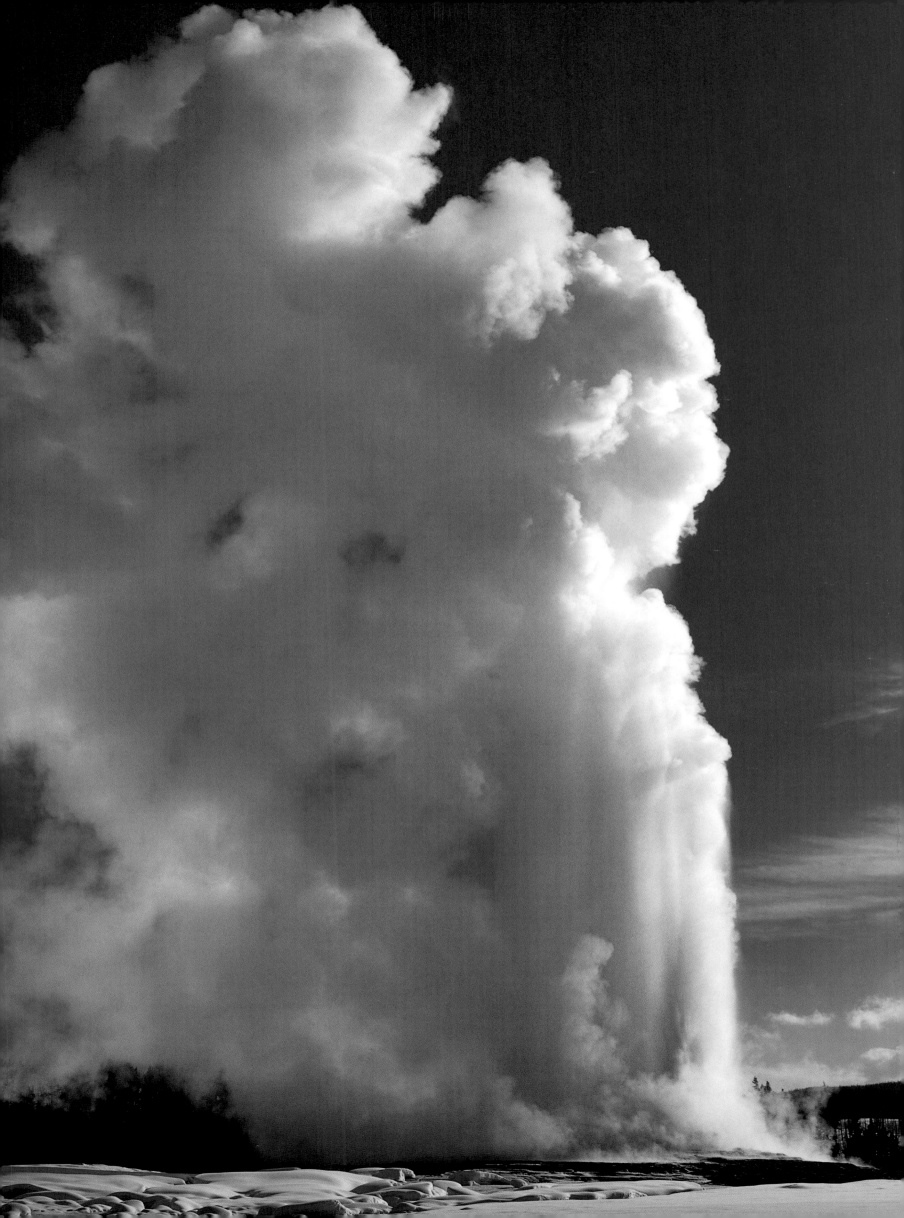

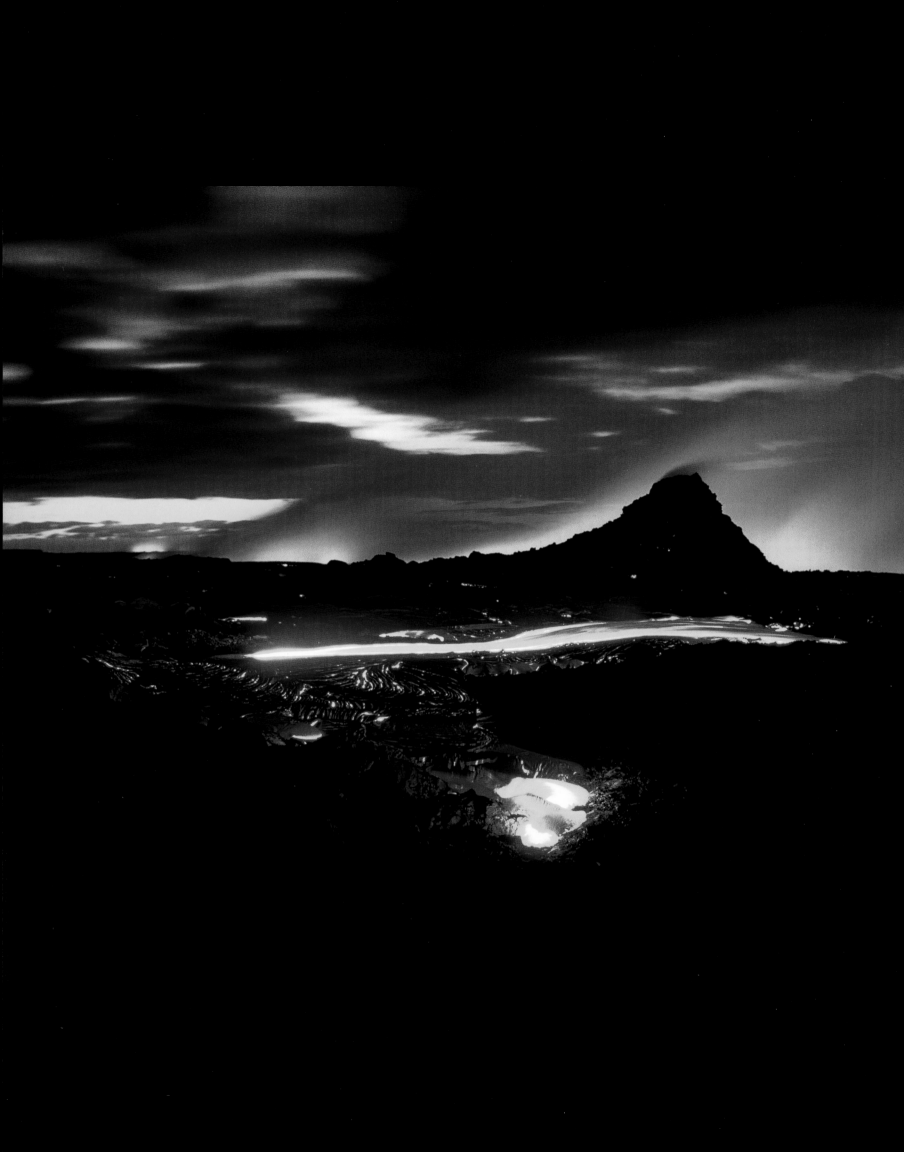

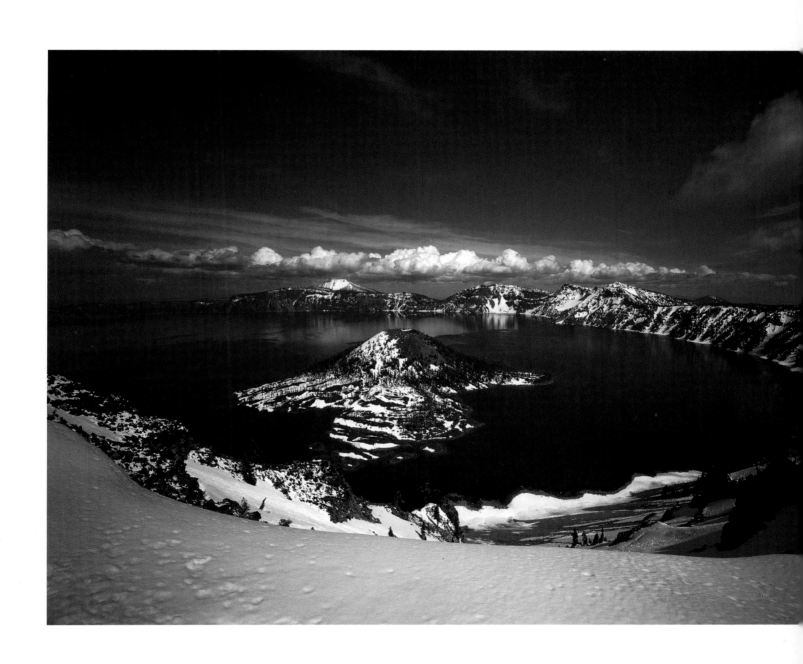

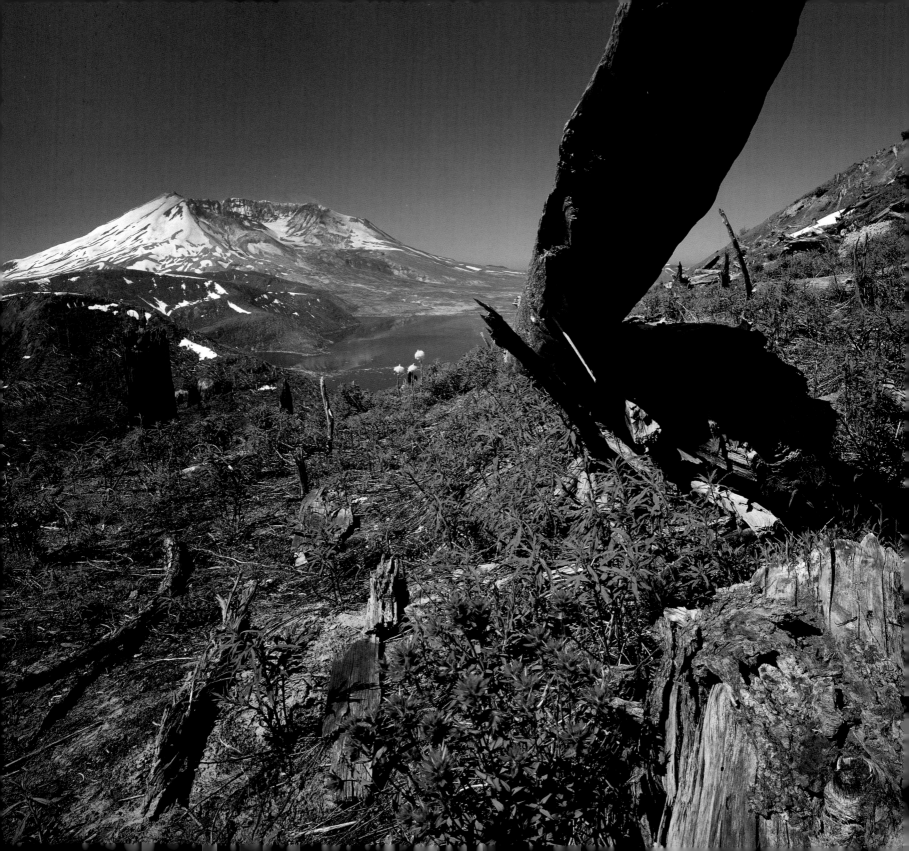

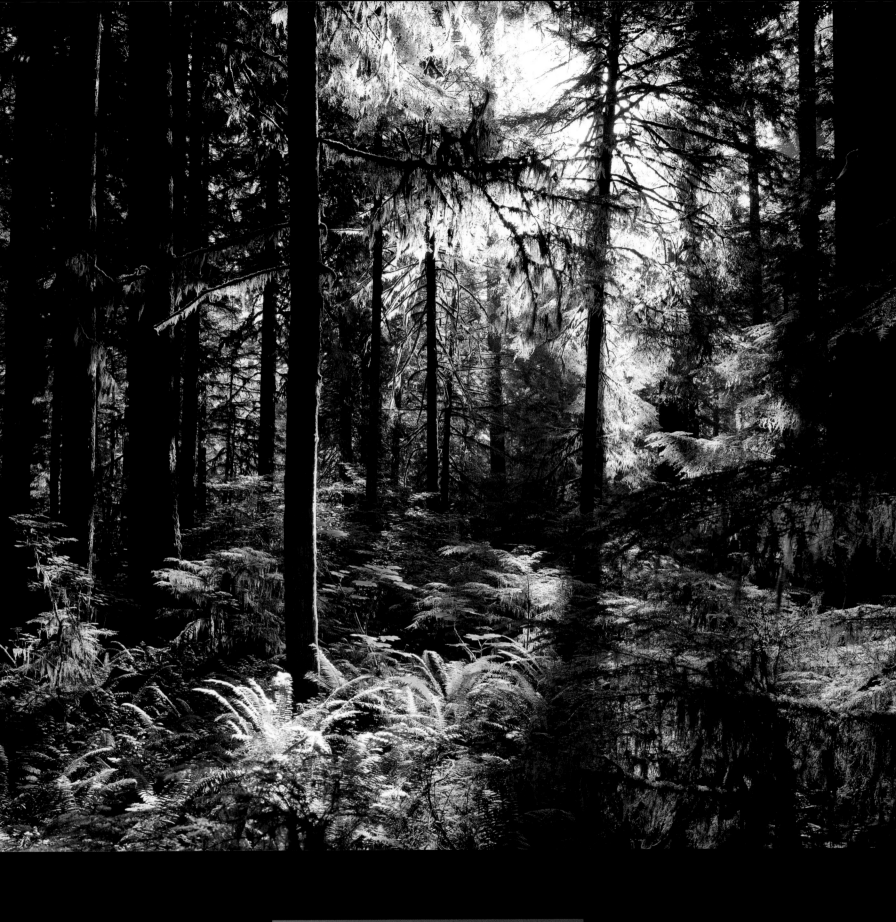

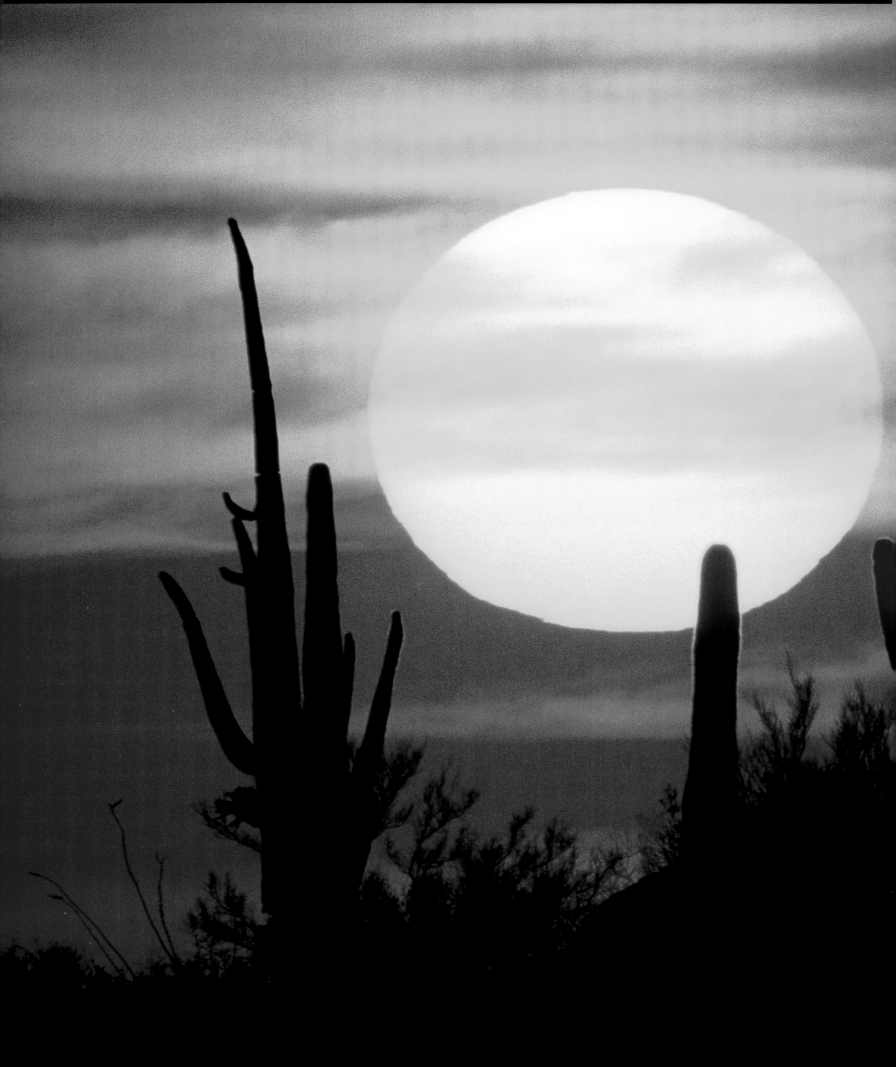

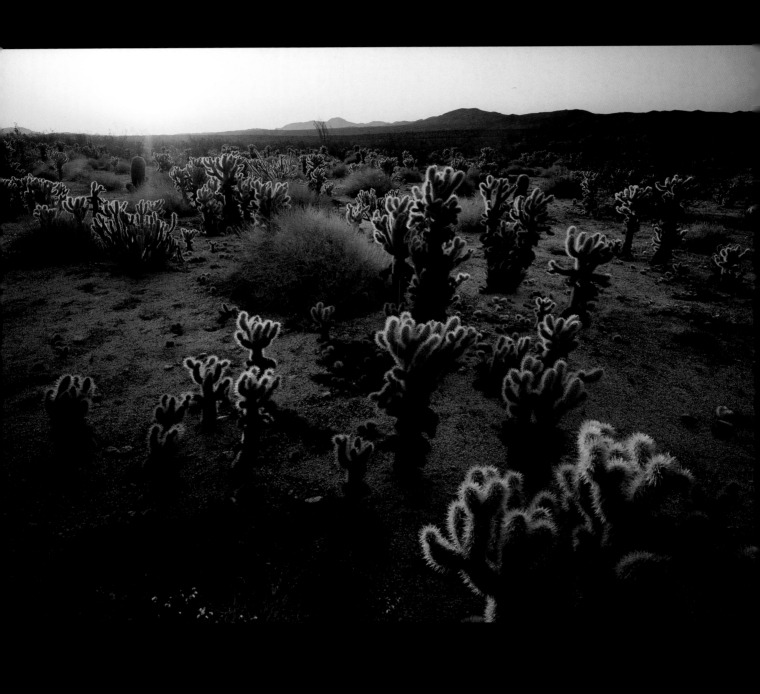

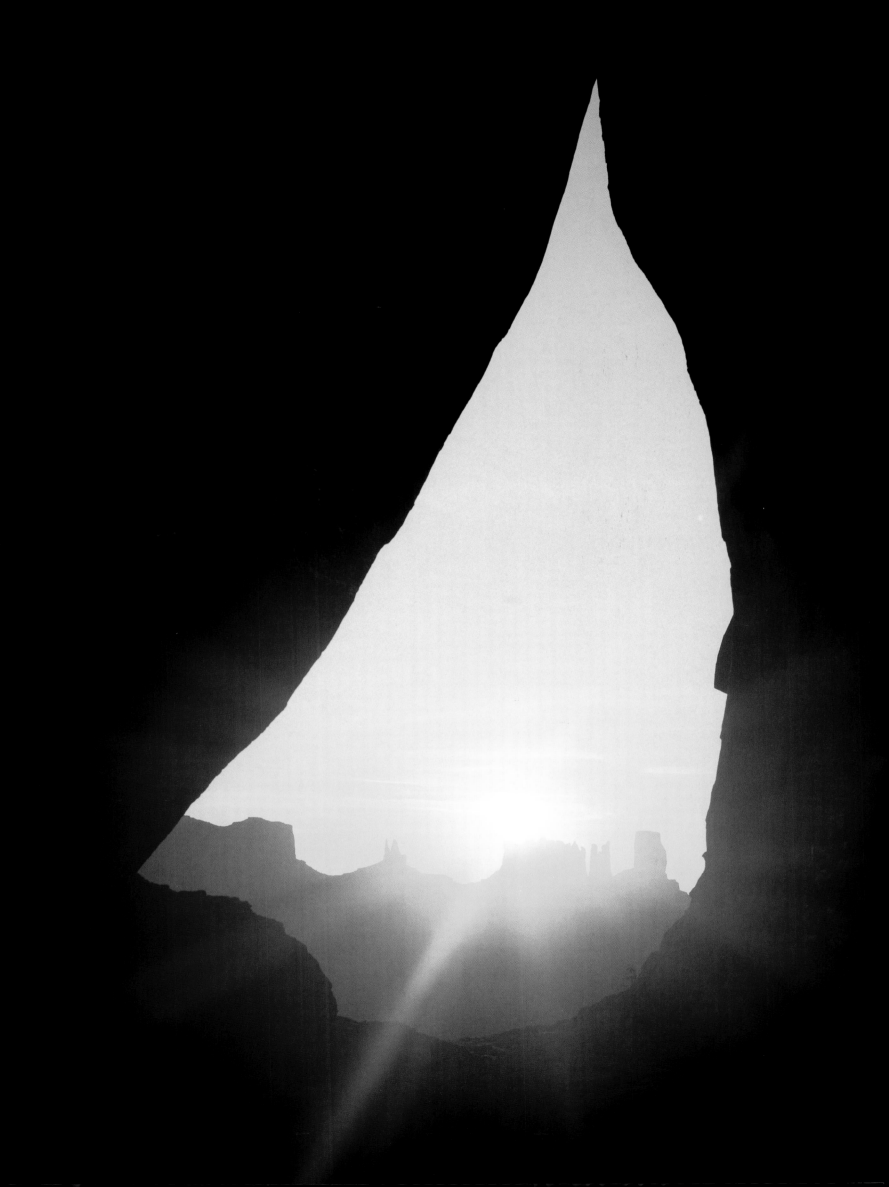

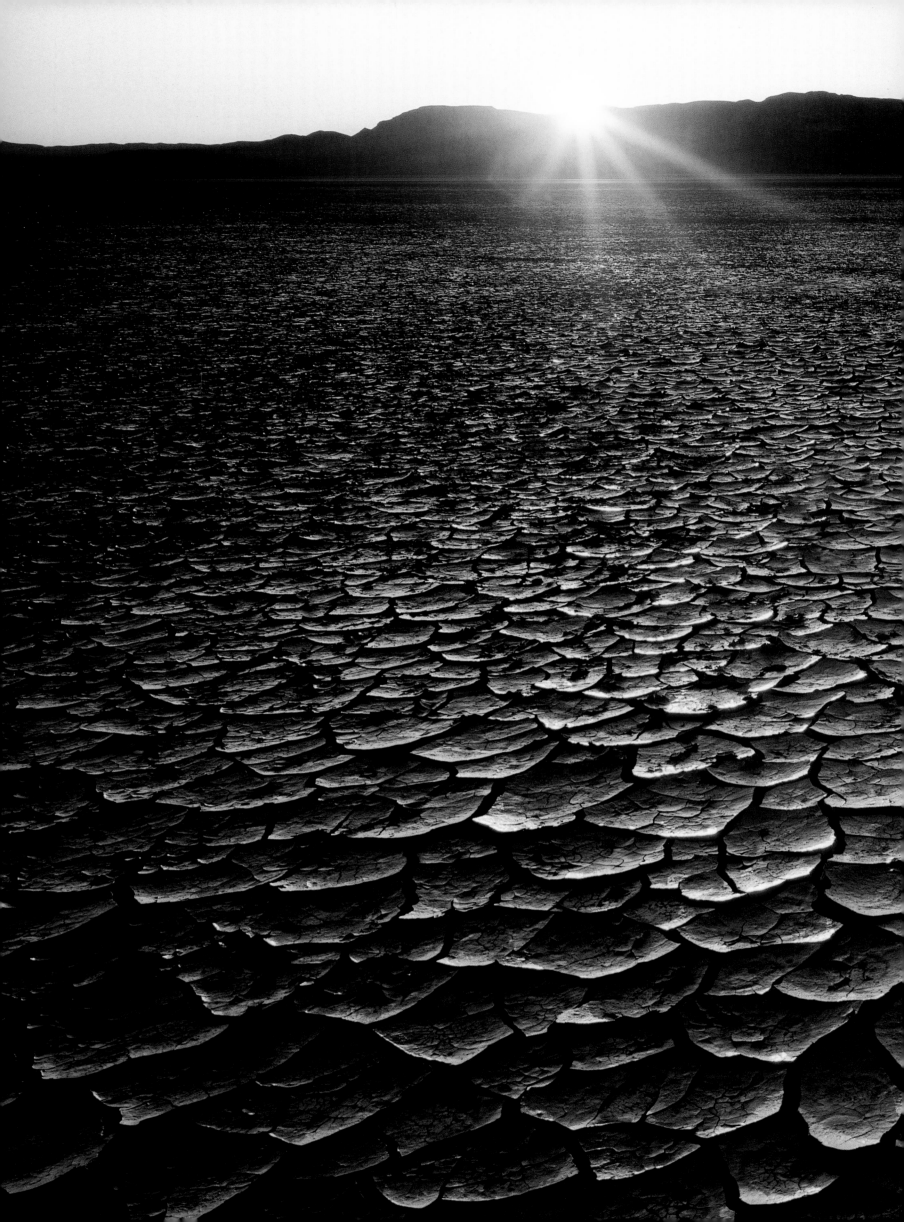

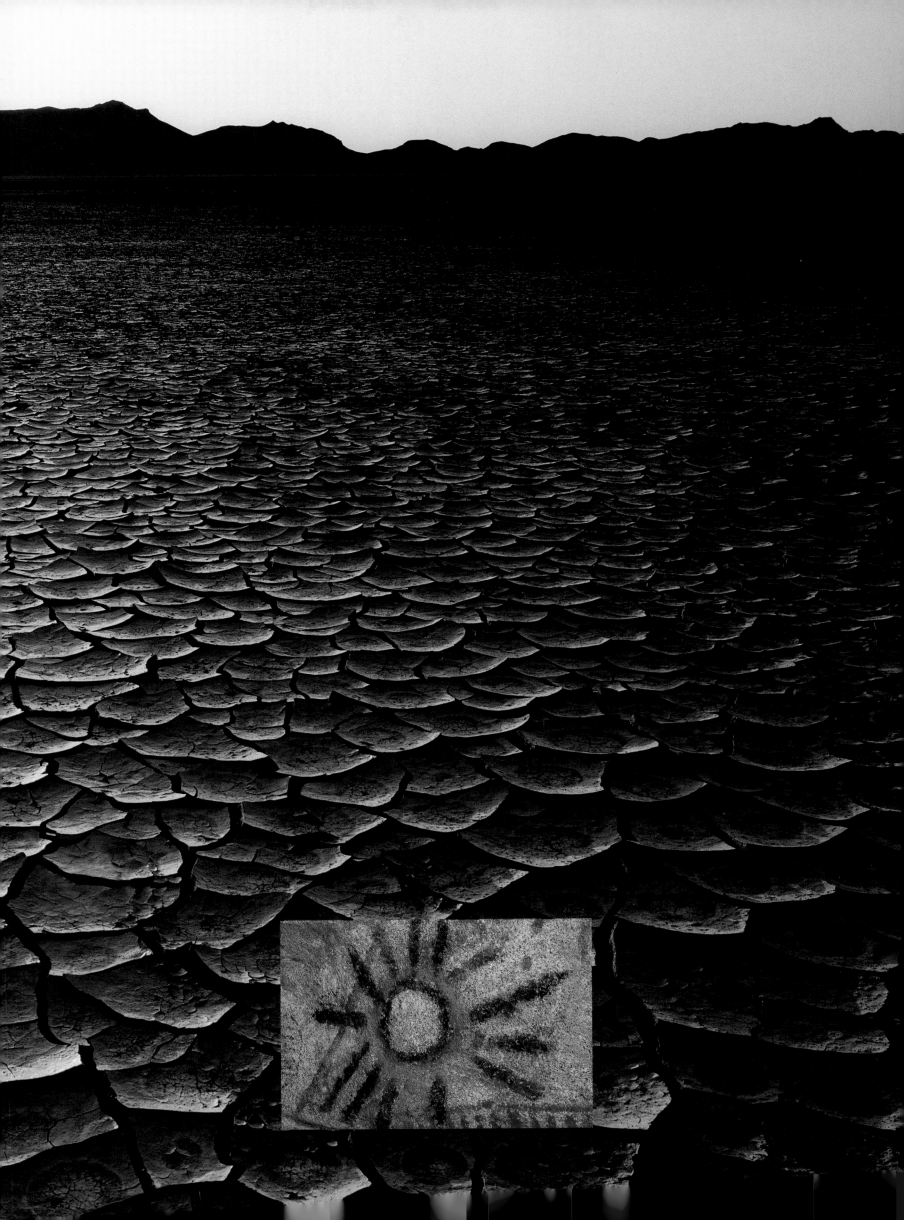

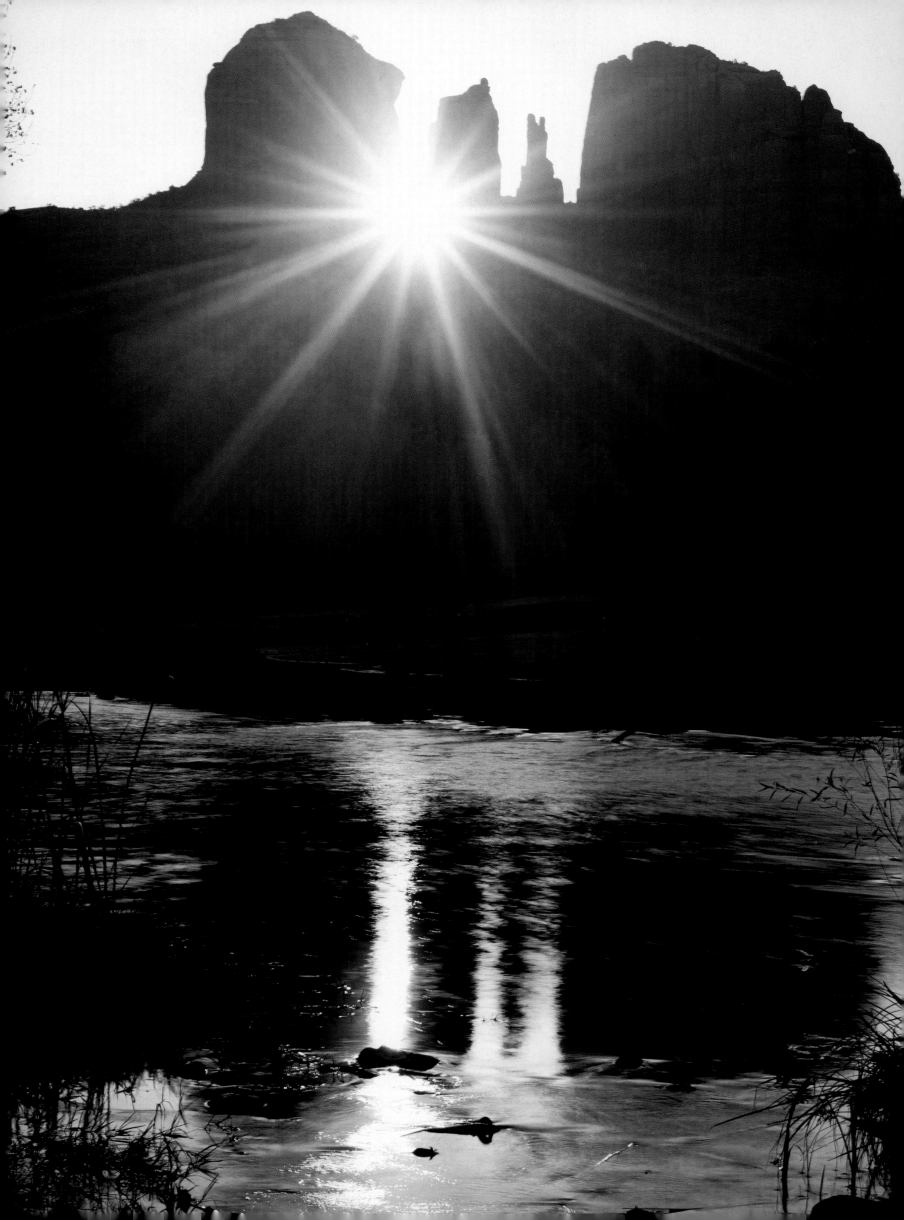

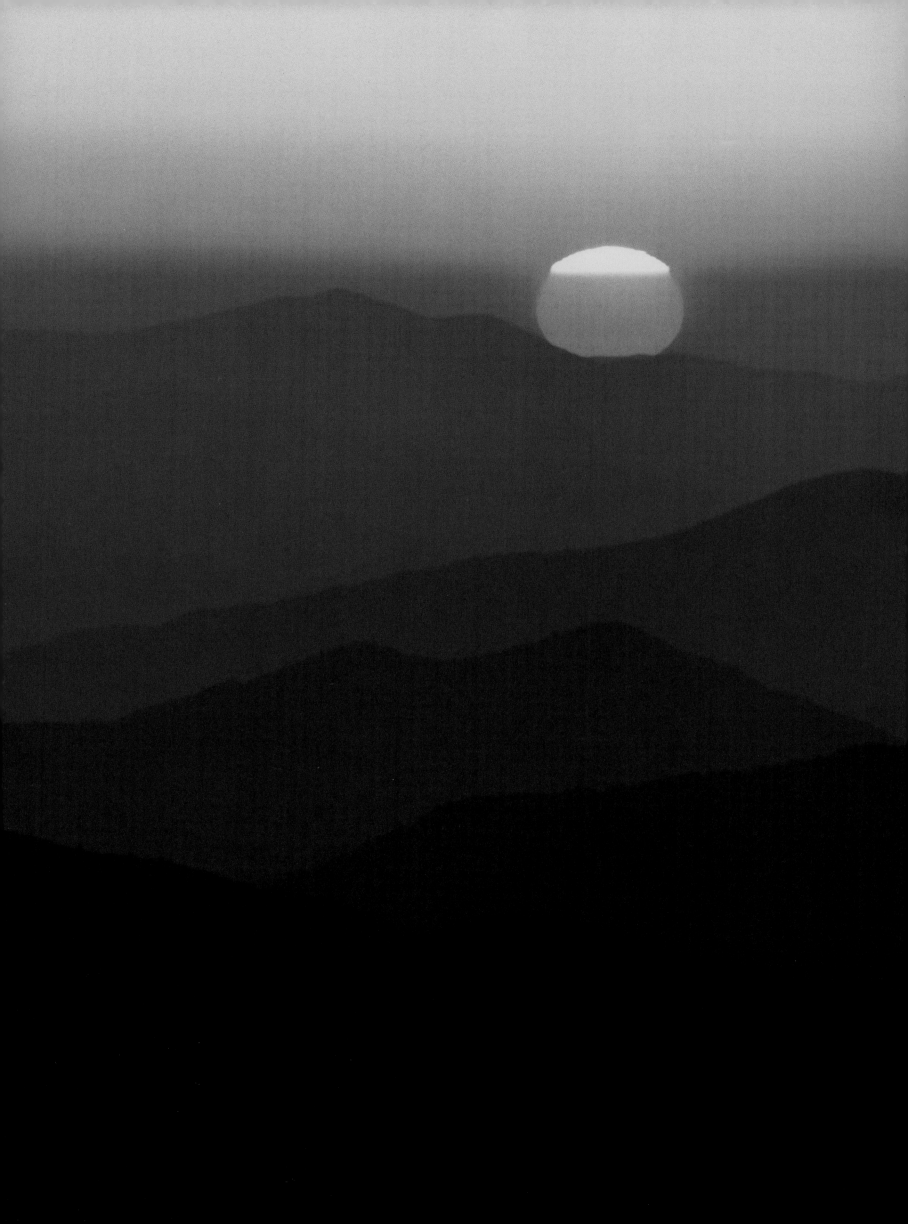

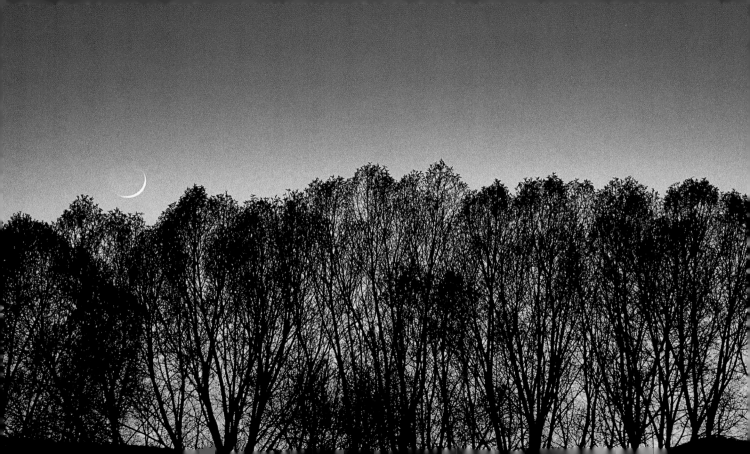

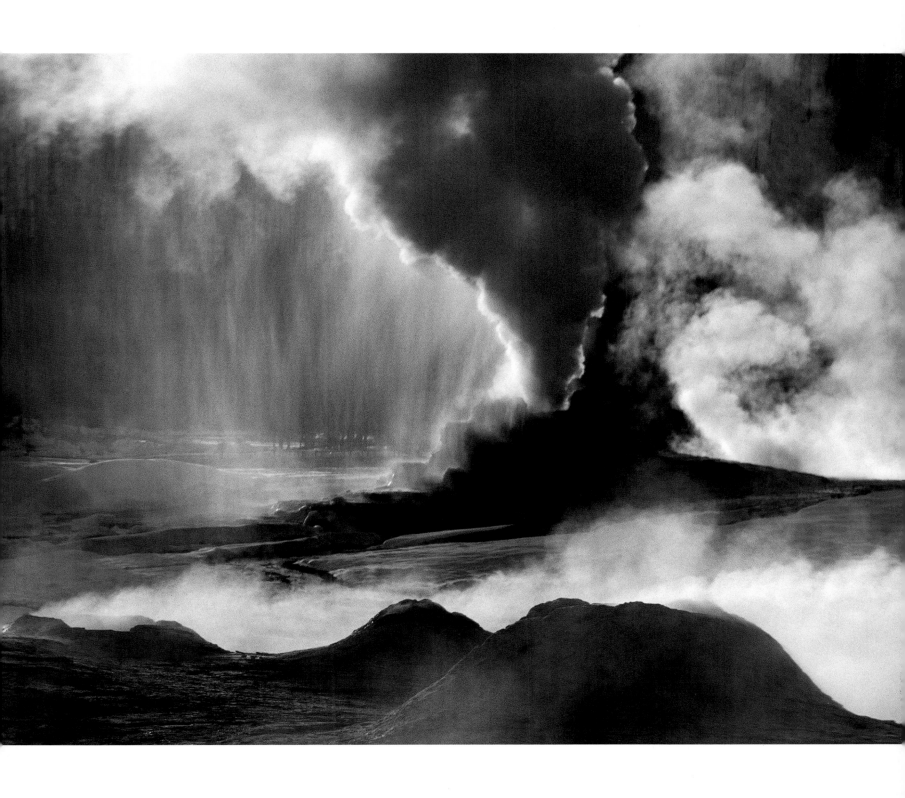

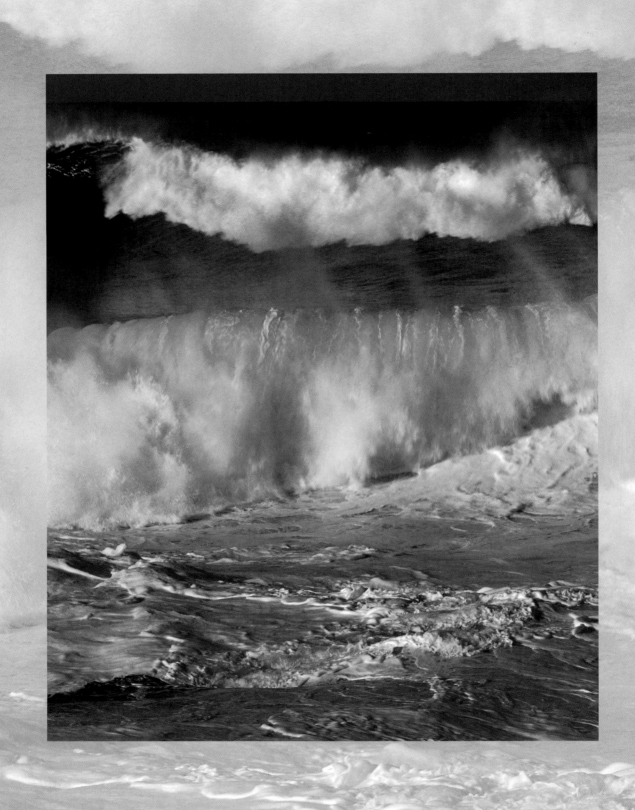

WATER

The year was almost one before memory. The snow fell heavily—more heavily than anyone had ever seen. It snowed and snowed, and just when everyone thought the snow had ended, it snowed some more. Eventually the entire Earth was covered in white flakes. Squirrel led the animal people up toward the sky in search of warmth. At the top of a tree protruding through the blanket of snow they found a leather bag that held each of the elements—rain, snow, fair weather, storms, cold, and warmth.

The animals were thrilled at having discovered the bag, but before they could release the warmth, they had to steal the bag from Bear, who guarded the tree. Some of the animals distracted Bear while others spirited the bag away. The animal people then wandered through the white landscape, carrying the bag with them, planning to release the warmth slowly when they returned home. Their journey was so long that Squirrel wore out his moccasins. He searched for something to patch them with, but the only thing he could find was the leather bag containing the elements. When no one was watching, Squirrel cut a small piece of leather from the bag to mend his shoes. Suddenly, all of the warmth rushed out of the hole. The snow that blanketed the world melted in an instant, and a great flood overtook the Earth.

The animal people were saved only because Old Man came along in his raft and plucked them from the water in pairs. Surrounded by water, the animal people took turns diving off the raft, looking for the Earth beneath them. It was Duck who finally succeeded, and he brought up a piece of mud from the depths; from this the whole Earth was built anew.

The Athabascan people of Alaska and northwestern Canada are not alone in their fascination with a great flood. Myths and legends of a global, catastrophic flood can be found in hundreds of cultures. There is something in the idea of a worldwide flood—destroying all so that all may be reborn—that seems to be immensely appealing to the human imagination. Destruction and salvation are twined in the stories. Why is the account of the great flood so universal? Is there something in our past that links all of the people of the world?

The answer is both yes and no. The amount of water present on Earth is fairly constant. Water is forever cycling through the atmosphere, soil, plants, groundwater, glaciers, icecaps, rivers, lakes, and oceans, but little is being added or lost from the planetary system as a whole. What we have is all we are going to get. Scientific evidence indicates that a global flood that covers all land beneath its churning waters lies solely in the realm of mythology. But, for people with no knowledge of lands beyond their own, floods that are local or regional can take on a seemingly global scale.

This is not to say that massive, ancient floods did not occur, for they surely did. Perhaps the common mythology of peoples as far removed from one another as the Sumerians and the Incas can be traced to events that happened thousands of years ago.

The period between 18,000 and 8,000 years ago was a time of warming temperatures and melting ice. Over the course of 10,000 years, sea levels rose by

300 feet (90 meters)—translating to an average increase of less than half an inch a year, but averages can be deceptive. In some cases, rapid changes in sea level are known to have occurred, and one such flood struck the world between 11,600 and 8,000 years ago, when the 140,000-square-mile (350,000-square-kilometer) Lake Agassiz that lay in front of the immense North American Laurentide Ice Sheet (which was more than a mile thick in places) burst through the ice dam that held its waters in check. The water poured into Hudson Bay and flowed outward, raising global sea levels by between 8 and 16 inches (20 and 40 centimeters). This was the greatest flood the world has likely ever seen, and although a 16-inch rise does not sound like much, it would have been sufficient to flood most coastal areas and leave a lasting impression on coastal peoples who were just beginning to domesticate animals and learning how to cultivate crops.

Of course, the best-known flood is the biblical one. The story of Noah actually has its foundation in tales of even greater antiquity. In Mesopotamian legend, the gods grew displeased with their human creations and decided to destroy the world with a flood. Enki, the god of water, warned a man called Ziusudra of the coming cataclysm. Ziusudra built a huge vessel and rode out the flood until the waters subsided. In the *Epic of Gilgamesh*, the gods also sent a great flood to wipe out their errant children, and this time it was Utnapishtim and his wife who survived. In the Jews' account of the flood, the survivor's name is Noah.

Does the biblical flood—and its precursors—have any foundation in hard science? The answer may well be yes, but as noted earlier, the scale was nowhere near as global as the storytellers imagined. In March 1929, British archeologists working along the Euphrates River in what was Mesopotamia (and is now Iraq) uncovered a layer of alluvial clay 8 feet (2.4 meters) thick. They dated the layer to 3500 B.C.E. and found pre-Sumerian artifacts beneath the layer unrelated to those above it. The clay marked the end—and the beginning—of two completely different civilizations. A great flood—an unprecedented outpouring from the Euphrates caused perhaps by heavy rain on the Turkish Armenian Plateau or in the Taurus Mountains—had destroyed an entire culture and thus engendered one of the greatest and best-known stories in the world.

Water as a mighty force is ingrained in the human psyche. Floods, storm surges, tsunamis, cloudbursts, thunderstorms, flash floods, torrential rains, ice storms, avalanches, white-outs, and blizzards—these are the harsher aspects of the water that cycles through our lives. But water is more than its extremes. It is, quite simply, the most remarkable substance in the universe.

This simplest of substances is a compound of two hydrogen atoms covalently bonded with a single oxygen atom to form H_2O. The three-dimensional water molecules bond to each other (with each hydrogen atom being attracted to an oxygen atom in another water molecule), forming a loose association that gives water its special and unique character. This universal substance can occur—naturally—as a gas, liquid, or solid. At high temperatures (the boiling point of water being 212°F [100°C]) water exists as a gas, and its molecules are highly agitated; there are few bonds between the separate molecules. As the temperature falls, more bonds form, resulting in a lattice-like structure at the heart of the now liquid water. If the temperature drops below 32°F (0°C), the lattice-like bonds become regular and much stronger, forming ice. Since ice is less dense than water, it floats. This seemingly obvious fact is another unique characteristic of water. Most substances are heavier as solids than as liquids, but if that were true of water, lakes and rivers would freeze from the bottom up, and icebergs and floating ice sheets would not exist.

Water is the universal substance (as well as being the near-universal solvent). It perfuses our planet as it does our bodies—and the bodies of all other life forms. We are more water than anything else. It is no wonder that early philosophers, seeking

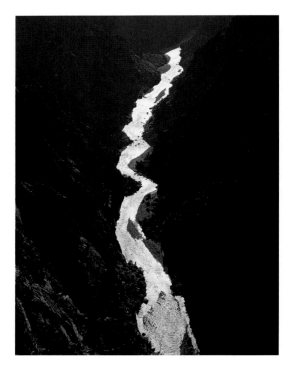

Black Canyon of the Gunnison National Park, Colorado, USA
Photograph by David Muench
In October 1999, the Black Canyon of the Gunnison became the fifty-fifth National Park in the United States. It encompasses 30,000 acres (12,000 hectares), including the 53-mile-long (85-kilometer-long), 2,700-foot-deep (810-meter-deep) Black Canyon gorge carved by the Gunnison River. The spectacular gorge is sometimes called Colorado's Grand Canyon.

the essentials of existence, usually settled on water as the foundation of all things. Thales of Miletus, philosophizing in the sixth century B.C.E., believed water to be the essence of all matter—and hence the essence of the universe. Credited with founding the European philosophical tradition by none other than Aristotle, Thales viewed the universe as a single organism, a superbeing nourished by water.

Water is a transformative substance. It is a transitory cloud and a seemingly permanent glacier. It is an ocean that stretches to the horizon and a clear mountain stream cascading over rounded boulders. It is clear and fresh, a mirror on the world, a reflection of sky and shoreline. It is dark and impenetrable. It is both languid river and wild torrent. Water is synonymous with movement. It is—or should be—far more valuable to us than gold or gems. What value can be placed on that which can bring life to a seed or renewal to parched land?

This misnamed planet Earth owes its beauty to water. From space it is a blue green sphere shadowed by clouds. Water is everywhere. The oceans dominate, covering more than 71 percent of Earth's surface and containing 97.24 percent of the world's water (a staggering 185 million cubic miles [777 million cubic kilometers]). Icecaps and glaciers account for 2.1 percent of the water, although glaciers actually hold 75 percent of the world's freshwater. Rivers and lakes contain 0.014 percent of the world's water (one-fifth of that in a single lake—Russia's Lake Baikal). Groundwater accounts for about 0.57 percent. Another 0.003 percent of Earth's water is runoff from the land. Most of the remainder is present as water vapor in the atmosphere.

The hydrological cycle, by which we trace the movement of water through the biosphere, is driven by heat from the sun. Solar radiation evaporates water from the oceans and begins the cycle. Water and air are joined in the grand cycle that links distant oceans with rainfall in the deciduous forests of southern England, the cornfields of Saskatchewan, the coastal rain forests of Queensland, and the shifting sand dunes of the Namib. Nearly 90 percent of the world's rainfall has its genesis in water evaporated from the oceans. Even life in the center of a vast continent, as far as it is possible to get from the ocean, is reliant on moisture born of the sea.

Just as the air is divided into cells that move warm and cold air in predictable patterns, so too are the world's oceans subject to regular currents and gyres that link all of the oceans into a single system. When solar radiation warms the surface of the ocean, it results in thermal stratification, with warm water overlying colder water. Since some surface water evaporates as it warms, salinity levels increase, and the surface water becomes increasingly dense—and heavy. This heavy, saline water sinks, cooling as it does so, establishing a vertical circulation pattern.

Meanwhile, horizontal circulation patterns are driven and maintained by the wind. The top 330 feet (100 meters) of water is directly influenced by wind. Water is much denser than air, and thus it should be no surprise that water currents do not move as fast as air currents. If the prevailing wind is blowing at 30 miles per hour (50 kilometers per hour), the surface water current is pulled along at just 0.6 mph (one kph), or 2 percent of the wind speed. As with atmospheric circulation cells, surface water currents are strongly influenced by the Coriolis force; they are deflected to the right of the wind direction in the Northern Hemisphere and to the left in the Southern Hemisphere, by 45 degrees. At greater depths the degree of deflection increases, due to increasing friction, until a point is reached where the water is actually flowing in a direction exactly opposite to the wind at the surface—a motion known as the Ekman spiral, after Swedish oceanographer V. Walfrid Ekman.

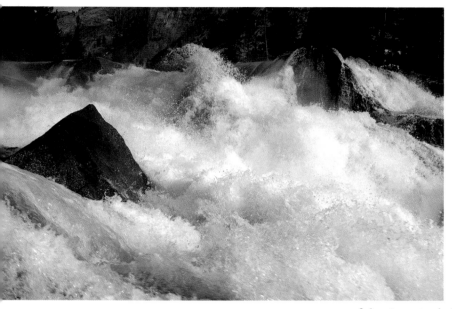

Le Conte Falls, Yosemite National Park, California, USA

Photograph by David Muench

Water rages white at the top of Le Conte Falls. When a dam was proposed that would flood the Hetch Hetchy portion of this valley further downstream, John Muir spoke up in *The Yosemite:* "Dam Hetch Hetchy! As well dam for water-tanks the people's cathedrals and churches, for no holier temple has ever been consecrated by the heart of man." The dam was built in 1923 to provide water for San Francisco.

Waves are also products of the wind. Despite the illusion of movement, the individual water particles that make up waves actually circulate in place, and there is little forward movement until they reach shallow water and crash to shore. With no wind blowing, the sea is quiet, glass-calm. As a slight breeze of 2 to 3 mph (3 to 5 kph) touches the water, scaly ripples appear. As the wind increases to 4 to 7 mph (6 to 11 kph), small wavelets begin to pattern the surface. These are barely waves, perhaps just a few inches high. At wind speeds of 13 to 18 mph (21 to 29 kph), a few waves topple over, cascading into whitecaps. Increase the wind to 25 to 31 mph (40 to 50 kph) and whitecaps are frequent. The wind flicks spray from their crests, and the sea is on the brink of a storm. Winds above 39 mph (62 kph) qualify as a gale. Foam streaks the water's surface, and waves break constantly. At winds of 47 mph (75 kph), the gale becomes even stronger, and sheets of spray lift from the surface. Waves may reach more than 33 feet (10 meters) in height. The greatest (non-tsunami) wave ever recorded was a mammoth 112 feet (34 meters) tall, in the midst of a Pacific typhoon.

Surface currents are mirrored below by currents that move the deeper waters. These currents are vital to the productivity of marine ecosystems, for they are responsible for returning to the surface many of the nutrients that sink to the depths and become "trapped" in the oceans' sediments. Most deep-water circulation has its impetus in the cooling of saline waters in the North Atlantic— especially in the Norwegian Sea. Since cold, saline water is heavy, it gradually sinks toward the bottom. As more water sinks, it pushes the water already at the bottom along the sea floor and away from the northern waters. When these deep currents meet a barrier—such as a continent—they are forced upward, where the cold, saline water mixes with the warmer surface water.

There are also extraterrestrial influences on the world's oceans. Tides are born of the gravitational pull of the sun and the moon, combined with the centrifugal force of the Earth. As the Earth spins in space, the motion causes the oceans and atmosphere (and even the Earth's crust) to bulge upward at the equator. In addition, the moon (even though it is eighty-one times smaller than the Earth) exerts a powerful gravitational pull on the fluid oceans, as does the sun, although its tide-generating force is 2.17 times smaller than that of the moon due to its greater distance from the Earth.

High tides occur when the Earth, sun, and moon are aligned, which happens twice a month, when the moon is full and again when it is new. Even higher tides occur once a month when the moon makes its closest approach to the Earth (its perigee). If the moon's perigee coincides with the alignment of the Earth, sun, and moon, the result is a still higher tide known as a perigean spring tide (such high tides occur about once every six months). The lowest tides occur when the Earth, moon, and sun form a 90-degree angle, resulting in the sun's gravitational pull being canceled out by that of the moon.

Tides are all but invisible on the open ocean, but along the coasts of islands and continents they are not only highly visible, they have shaped the evolution of life in that narrow zone between water and dry land. Were it not for the tides, a whole host of organisms would never have evolved, from barnacles that can survive full immersion to being left high and dry for hours, to crabs that search the exposed rocks and sands for food, to bladderwracks that must survive the pounding breakers, to limpets, mussels, and lichens that cling to exposed rocks.

The shoreline is composed of layer upon layer of life, with the upper-level organisms needing less water than the ones below. These stratified ecosystems are built on the interaction among water, Earth, sun, and moon. The smallest of creatures that we step lightly to avoid as we peer into tidepools owe their lives to the invisible pull of objects tens of millions of miles distant. The sun provides our world with heat, so we value its role in our lives; the moon can appear superfluous. Still, the role of the moon may be far more substantive. We know that the moon's

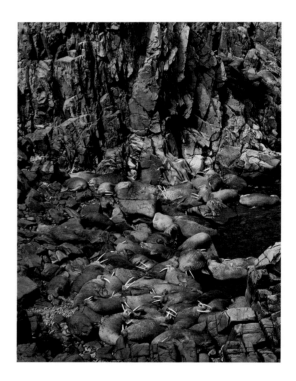

Pacific Walrus (*Odobenus rosmarus divergens*), Walrus Islands State Game Sanctuary, Round Island, Alaska, USA
Photograph by Michelle Gilders
Male walruses crowd a rocky shoreline in northern Bristol Bay. Round Island is one of four major terrestrial haulouts in Alaska; up to 14,000 animals have been counted here in a single day.

We were the first
that ever burst
Into that silent sea.

—SAMUEL TAYLOR COLERIDGE,

The Ancient Mariner

monthly cycle matches the biological cycles of countless species, from human females to spawning corals. The moon is our counterpoint. It gives our planet symmetry and balance. It is the yin to our yang.

The largest oceanic waves—sometimes referred to as tidal waves but more accurately called tsunamis—actually have nothing to do with tides. They are seismic sea waves usually generated by subsea earthquakes—of at least magnitude 6.5 on the Richter scale—that are centered within 30 miles (50 kilometers) of the Earth's surface. They can also be generated by volcanic eruptions or by particularly large landslides. A tsunami is formed because an earthquake or other disturbance sets up a series of oscillating waves. In deep water, these waves may be just one to two feet (0.3 to 0.6 meters) high, and the distance between waves can be as great as 60 to 120 miles (100 to 200 kilometers). The waves themselves may be moving at speeds of more than 430 mph (700 kph). People out at sea may not even notice that they have been passed by a tsunami heading toward shore. As the tsunami approaches land it slows, due to increased friction with the bottom. As the speed of the wave decreases, the wave increases in height. It can attain a height of 98 feet (30 meters) in less than fifteen minutes. A tsunami 120 miles (200 kilometers) across and just less than a foot (0.3 meter) high is capable of delivering 15,000 tons of seawater per foot (0.3 meter) of coastline. The destruction tsunamis wreak on coastlines—on natural ecosystems and human settlements—can be total.

The mobile, forever-shifting oceans are so vast that it takes an estimated 37,000 years for all of their water molecules to move into other parts of the hydrological cycle. The equivalent "residence time" for lakes is usually estimated to be months, for rivers a matter of weeks, and for the atmosphere, just ten days.

When water is evaporated from the surface of the ocean it becomes intimately connected with the atmosphere. Water vapor moves where it is blown. If the air is saturated, rainfall may result. It takes an average of just three minutes for a drop to fall all the way to the ground from the cloud that spawned it.

What happens to the raindrop next depends on where it lands. If the drop hits the soil it may soak in, filling the interstices between granules of organic matter and minerals. It may remain in the soil for some time, providing lubrication within the soil structure and even a mini-ocean for microbes. If the weather is hot, the water may evaporate back into the atmosphere to restart its downward journey. In the United States, 59.2 percent of all annual precipitation evaporates (either directly from the soil or after entering a plant's vascular system), 39.4 percent flows back to the ocean (via streams and rivers), and a little more than 1 percent joins the groundwater.

Groundwater flows downward until it hits an impermeable layer. Its movement halted, the water fills the pores of the rock. As groundwater dissolves minerals in the bedrock, it may transform rock formations into subterranean caves. Limestone is highly soluble and is particularly susceptible to dissolution. If the water flow is seasonal, or if the water table drops, vast caverns formed over millennia are revealed to the intrepid caver. If water continues to drip from the ceiling, stalactites form as calcium carbonate is precipitated, while on the cave floor, stalagmites rise upward, their growth spurred by drops from above. Over the course of thousands of years or more, stalactites and stalagmites meet to form fantastic columns with architectural splendor.

Some cave formations are truly massive. The Mammoth Cave system in Kentucky in the eastern United States, has 330 miles (530 kilometers) of passages that run like underground rivers. The Sarawak Chamber in Malaysian Borneo covers 67.5 acres (27 hectares) making it perhaps the largest single underground chamber in the world. Two of the world's next largest, France's Pierre–St. Martin's Salle de la Verna and the Big Room in New Mexico's Carlsbad Cavern could both fit inside the Sarawak Chamber with room to spare. Each is filled with wonderfully patterned and colored shapes, given such names as the

"Organ," "Temple of the Sun," and the "Bashful Elephant." These mysterious labyrinths are natural sculptures created by the slow combination of water, rock, and time.

Water does not shape the land solely when it filters through soluble rock; it also carves the land as it flows along the surface. Rivers come in all shapes and sizes. They can be straight, meandering, or braided. Their channels may be broken by glorious waterfalls that churn the water white with fury, or by rapids that roll around boulders with turbulent eddies and mini-maelstroms. Water cuts into the ground, carving a V-shaped valley that confines the river to its banks and provides it with sustenance from the surrounding drainage basin. Many of the world's greatest rivers have their start in the mountains that provide them with high rainfall or snow melt. The Amazon rises in the Andes, the Euphrates on the Armenian Plateau, the Nile in Burundi, the Missouri in the Rocky Mountains, and the Danube in the Black Forest Mountains.

Where a river meanders and regularly pours over its banks, it creates a flood plain rich in alluvial sediments. Such regions have long been the center of farming cultures that grew dependent upon—and understood—the seasonal flow and flood of the river. Egyptians owe their civilization to the Nile ("Egypt is the Nile, and the Nile is Egypt," said Herodotus); they refer to their country as the "Black Land" after the river's fertile mud. To farmers, problems did not arise when the river flooded, but rather when the river failed to flood.

In China, the Yellow River (Huang He), named for the color of its sediments, carries an average of 2.2 pounds (one kilogram) of silt per cubic foot, making it the muddiest river in the world. In comparison, the Colorado River averages 0.6 pound (0.28 kilogram) of sediment per cubic foot, while the Nile averages just 0.06 pound (0.03 kilogram per cubic foot). The Yellow River is so rich in silt that, over the centuries, it has built up a thick bed of sediment over which it flows. Along much of its length the river is 13 to 26 feet (4 to 8 meters) higher than the surrounding flood plain; when it floods, there is little that can contain it. At flood stage, the Yellow can carry up to 44 pounds (20 kilograms) of silt per cubic foot, so that sediments account for 70 percent of the total volume of its floodwaters.

The Yellow River has flooded 1,500 times in the last 3,500 years and has altered its course more than any other river in the world; there have been twenty-six significant course changes since 1500 B.C.E. At times these changes have involved shifts of several hundred miles—nearly 620 miles (1,000 kilometers) in one instance. When the river that the Chinese refer to as the "Ungovernable," the "Scourge of the Sons of Han," and "China's Sorrow" finally reaches the coast, it delivers an annual sediment load of more than 1.58 billion tons.

The power of a river is almost unfathomable. It is easy to look at a languid river, slow-moving and seemingly harmless, and forget the power that comes from a mass of water in motion. And yet a 6-inch-deep (15-centimeter) flow of water is capable of knocking a person off his or her feet, and a 24-inch-deep (60-centimeter) flow can wash away vehicles.

The Mississippi River, the largest river in North America, transports an annual sediment load of 346 to 495 million tons, along with an incredible 19 trillion—19,000,000,000,000—cubic feet (0.5 trillion cubic meters) of water. Assuming a highly conservative equation, the Mississippi has the equivalent power of 440 billion tons of TNT, or 19 million atomic bombs. Simply put, the Mississippi River is more powerful than anything humans are capable of building now or in the foreseeable future.

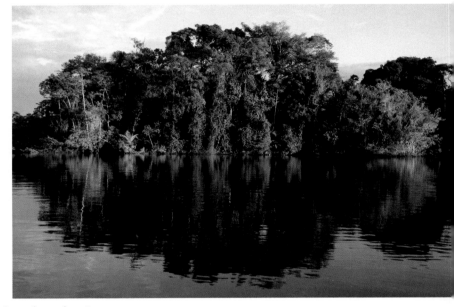

Río Napo, Yasuní National Park, Amazon Basin, Ecuador
Photograph by David Muench
The Amazon Basin encompasses the largest tropical rain forest in the world, covering 2.7 million square miles (7 million square kilometers). It is also one of the richest and most diverse biological systems on Earth; clearing for lumber and agriculture threatens much of the region.

If the power of fluid rivers is almost incomprehensible, then the power of ice is doubly so. Glaciers are much more than frozen rivers—they are plastic, mobile bulldozers that scour the land, making rugged rock smooth and turning V-shaped river valleys into vast U-shaped troughs. Louis Agassiz, the nineteenth-century Swiss geologist, called glaciers "God's great plough." They shape the land through sheer pressure and gradual forward motion. All glaciers move forward (even those that are termed "retreating"). The middle section of the glacier usually moves the fastest; the bottom and sides are slowed by friction. Most move at a rate of about three feet a day; a retreating glacier is simply melting at a faster rate than it is moving forward.

For the last 20 million years an ice age has gripped this planet. The mid-latitude glaciers appeared 2.5 to 3 million years ago, and it is since then that Earth has cycled between glacial and interglacial periods. Cold phases have dominated, lasting 100,000 years at a time, while warmer phases—such as the one we are in now—typically last just 10,000 years. (The current warm phase should be coming to an end within a millennium or two.) When the next cold phase begins, the glaciers and ice sheets will grow, lowering the world's seas by 300 feet (90 meters) or more.

Glaciers have their beginnings in snow that survives the passage of winter, something that generally requires high latitude and/or high altitude. This "firn," or névé, accumulates in mountain hollows and, with the weight of additional snowfall, gradually becomes compacted to form glacier ice. The ice erodes the surrounding rock to form a cirque, and eventually the developing glacier pushes out of its confines and descends into the valley below, carried forward by gravity. Rocky debris streaks the surface of the glacier, forming lateral and medial "moraines." Terminal moraines—huge piles of loose debris—mark the farthest progression of the ice. Rocks transported by glaciers can weigh thousands of tons and measure more than a half a mile in length; when dumped far from their point of origin they are known as "erratics."

The movement of the glacier tears great crevasses and fissures in the ice, giving it a sharp, jagged appearance. Surface pools of intensely blue meltwater collect under the summer sun; this almost unearthly color forms as all other wavelengths of light are absorbed by the ice, reflecting only the blue portion of the spectrum. Pollen and dust blown onto the ice feed iceworms, beetles, and flies that survive in subzero temperatures. Hold them in the palm of your hand and the warmth will kill them.

Even when the glacier melts, victim to rising temperatures and a changing climate, silent witnesses to its former presence remain. Hanging valleys recall the glacier they once joined, and kettlehole lakes owe their origin to remnant pieces of ice that have now melted. Eskers—rivers of gravel deposited under the glacier—trace the course of water that once flowed beneath the ice, while streamlined drumlins mark the points where the glacier dropped some of its rocky load and then rolled forward. Fjords indent the coastline, flooded with water where once there was only ice. Ice is a creative force with a long legacy.

Water—whether gas, liquid, or solid ice—always seeks to return to its lowest point: the ocean that ultimately spawned it. It is drawn by gravity. It follows the course of a river, loiters in a lake, detours to dissolve minerals in a subterranean cavern. It cascades down waterfalls, meanders across flood plains, and transports pebbles from a mountain top to sea level. Finally, it returns to its source—the ocean—where it will buoy plankton and fish, whales and giant kelp, before one day evaporating again to water some distant land and begin the cycle anew.

Planet Earth is immersed in water and suffused with it. It enriches rain forests, marshes, tidepools, grasslands, mountain tops, and even deserts. It is the life force that nurtures all living things, from the smallest bacterium to the tallest tree. "And with water we have made all living things," says the Koran. Without water, nothing can prosper. With water, the world is full of life.

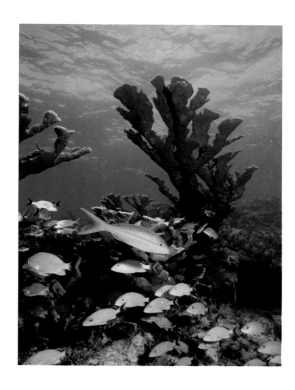

Yellow Goatfish *(Mulloidichthys martinicus),* **Biscayne National Park, Florida, USA**
Photograph by Marc Muench
Located off Florida's southeastern coast, the 173,313-acre (70,137-hectare) park is almost entirely underwater. Fewer people visit Biscayne National Park in an average year than visit Walt Disney World on a single busy day.

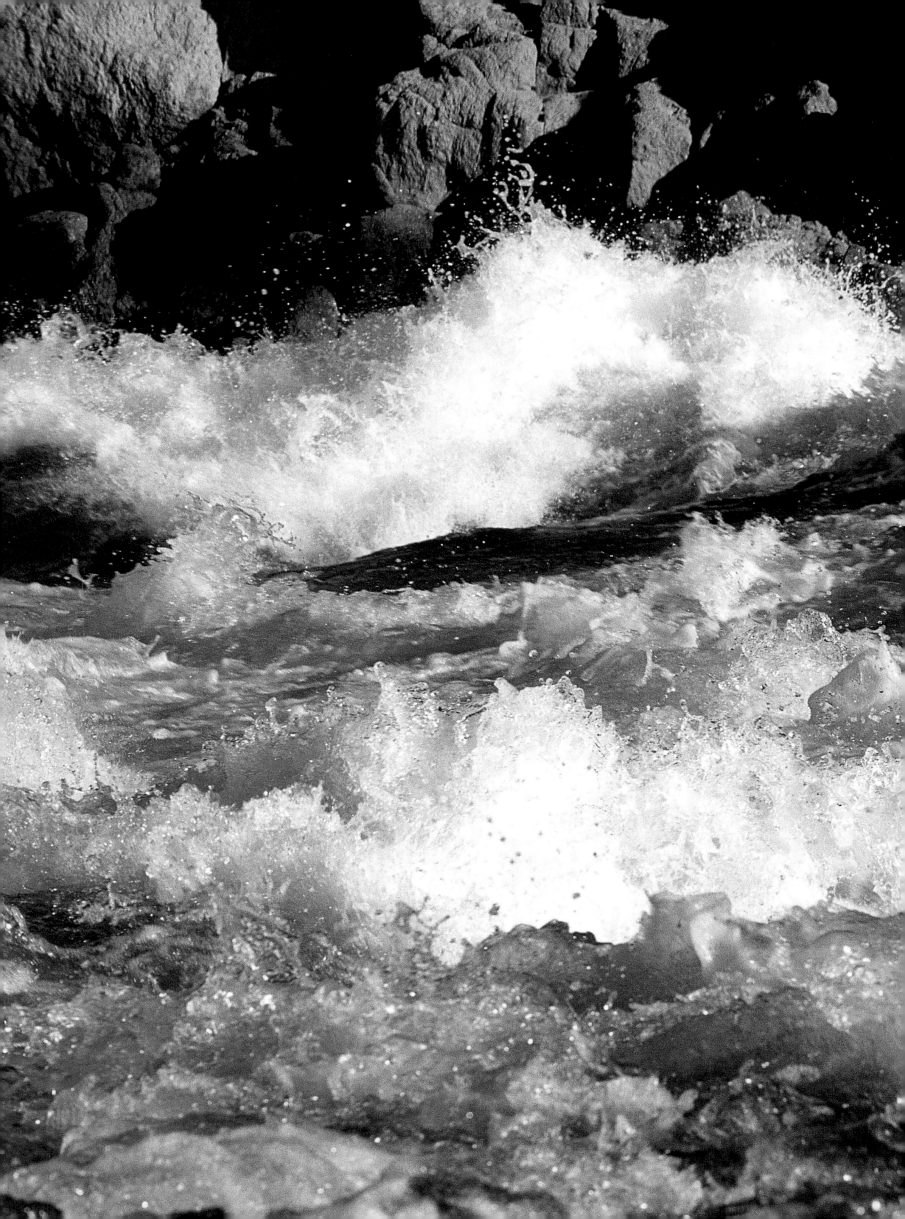

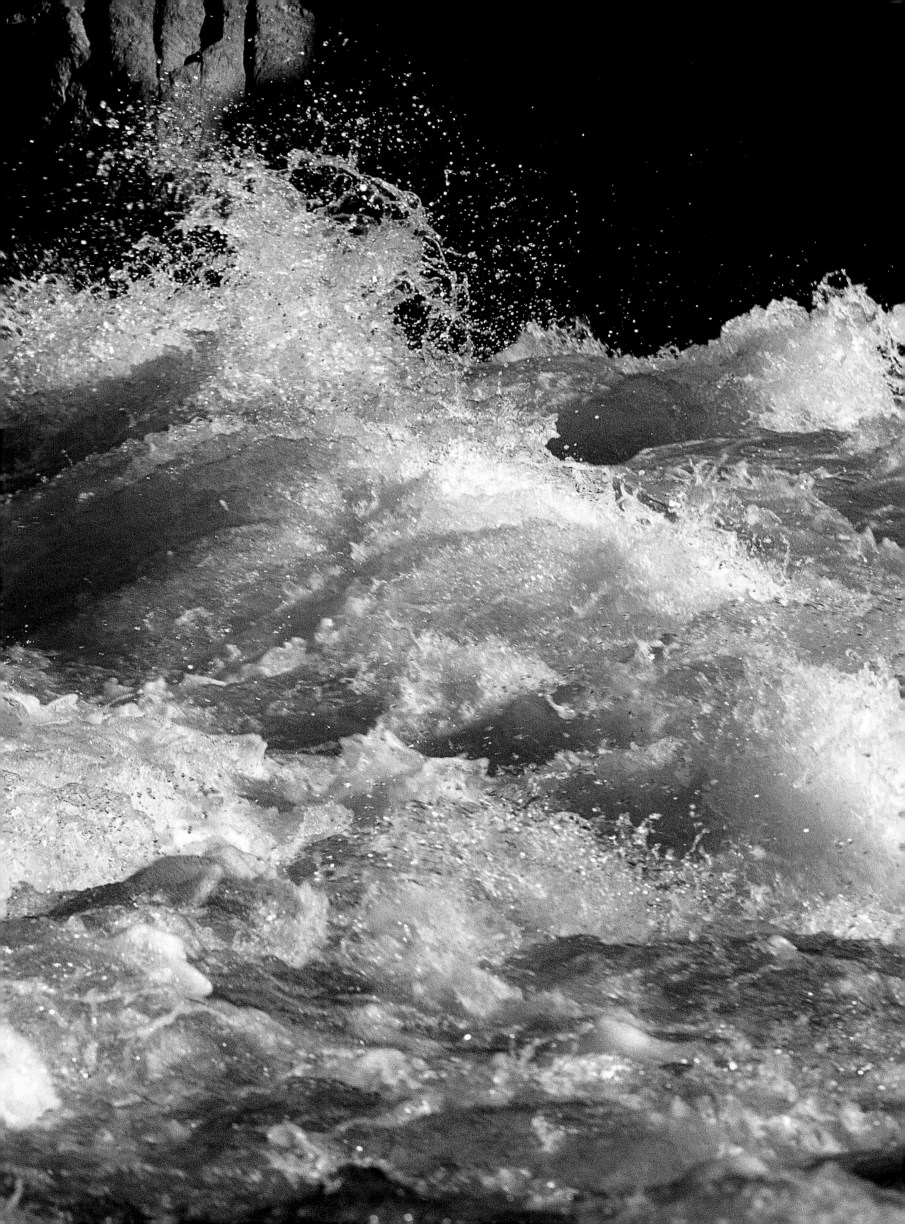

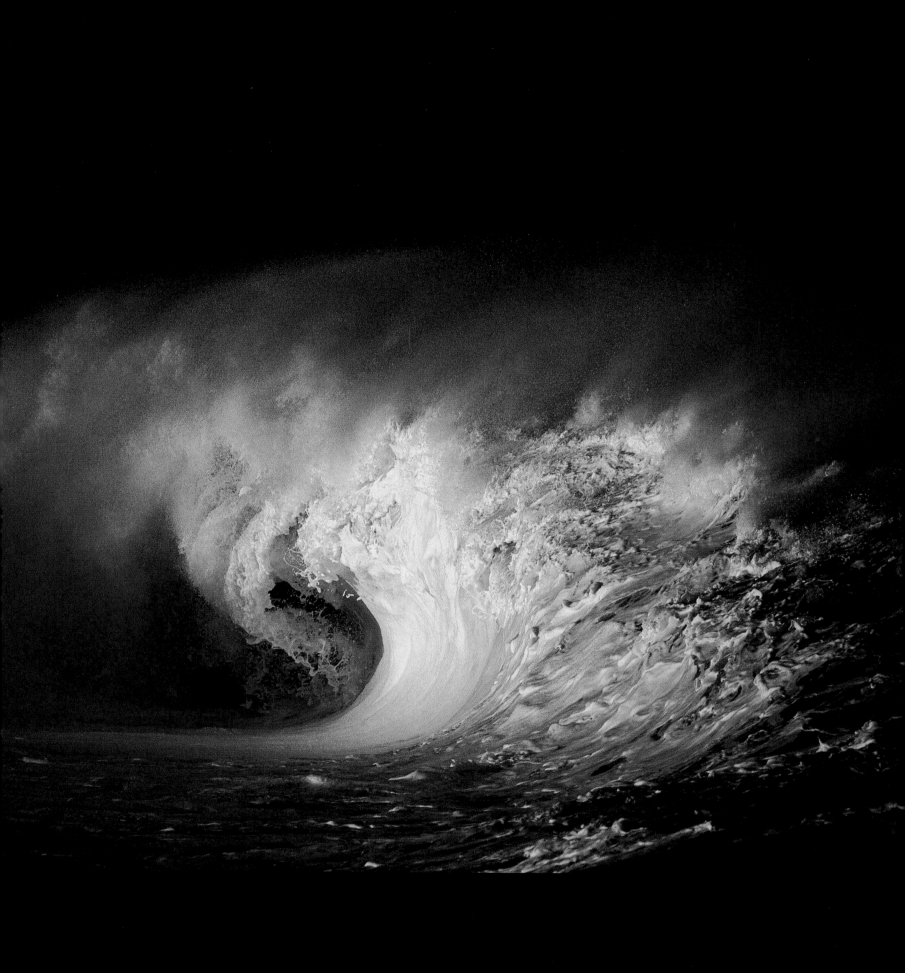

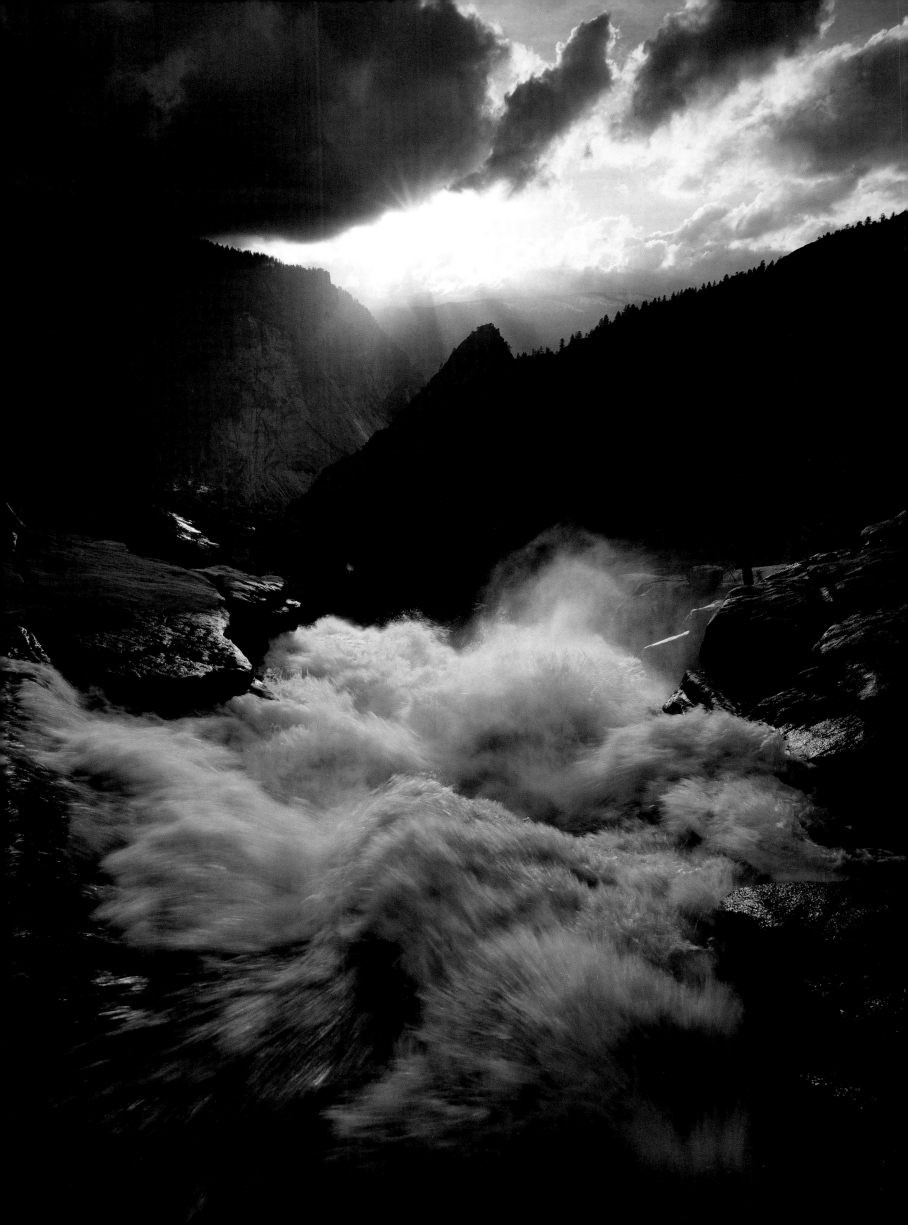

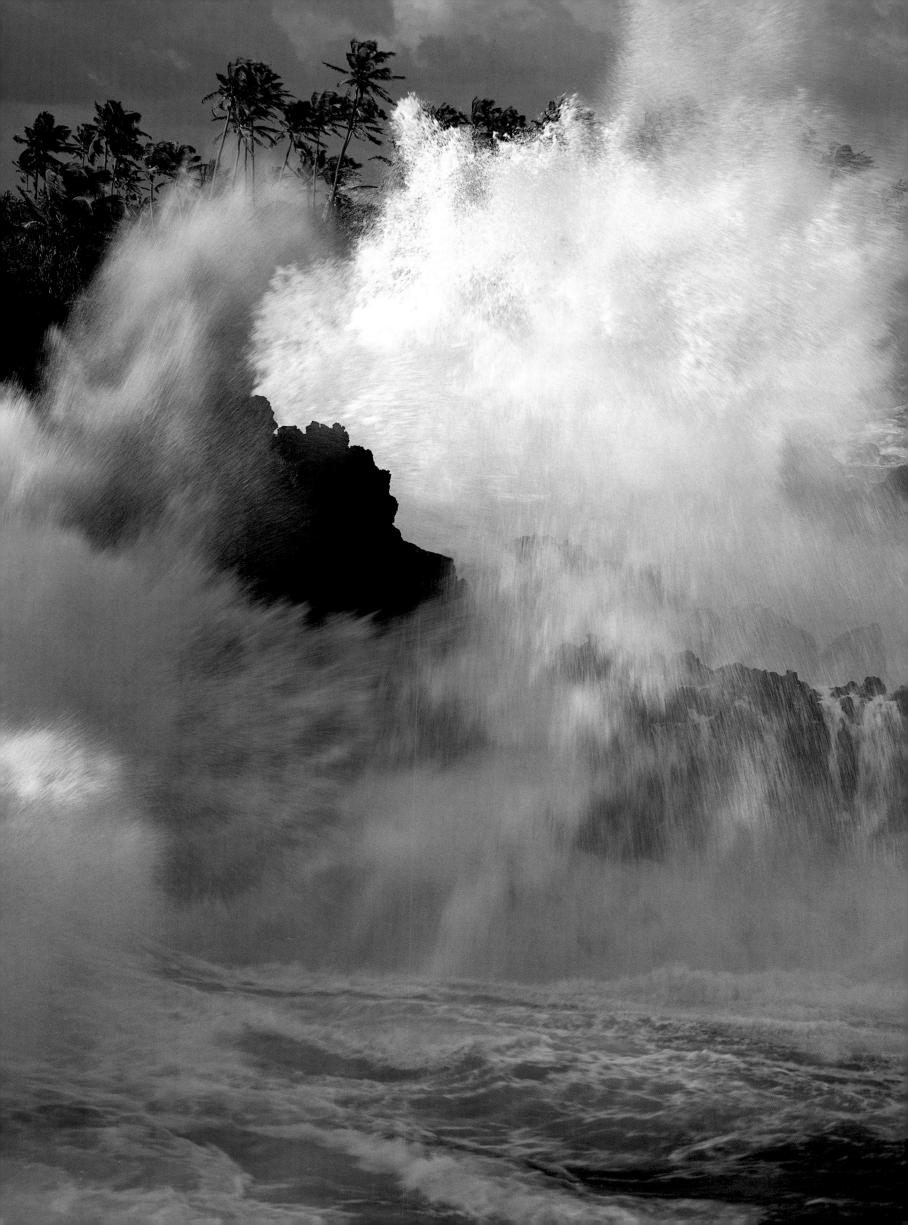

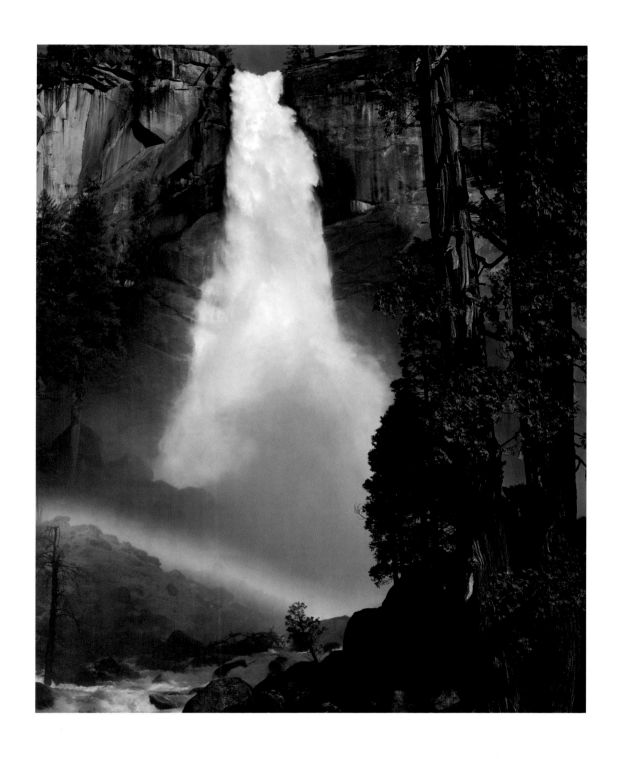

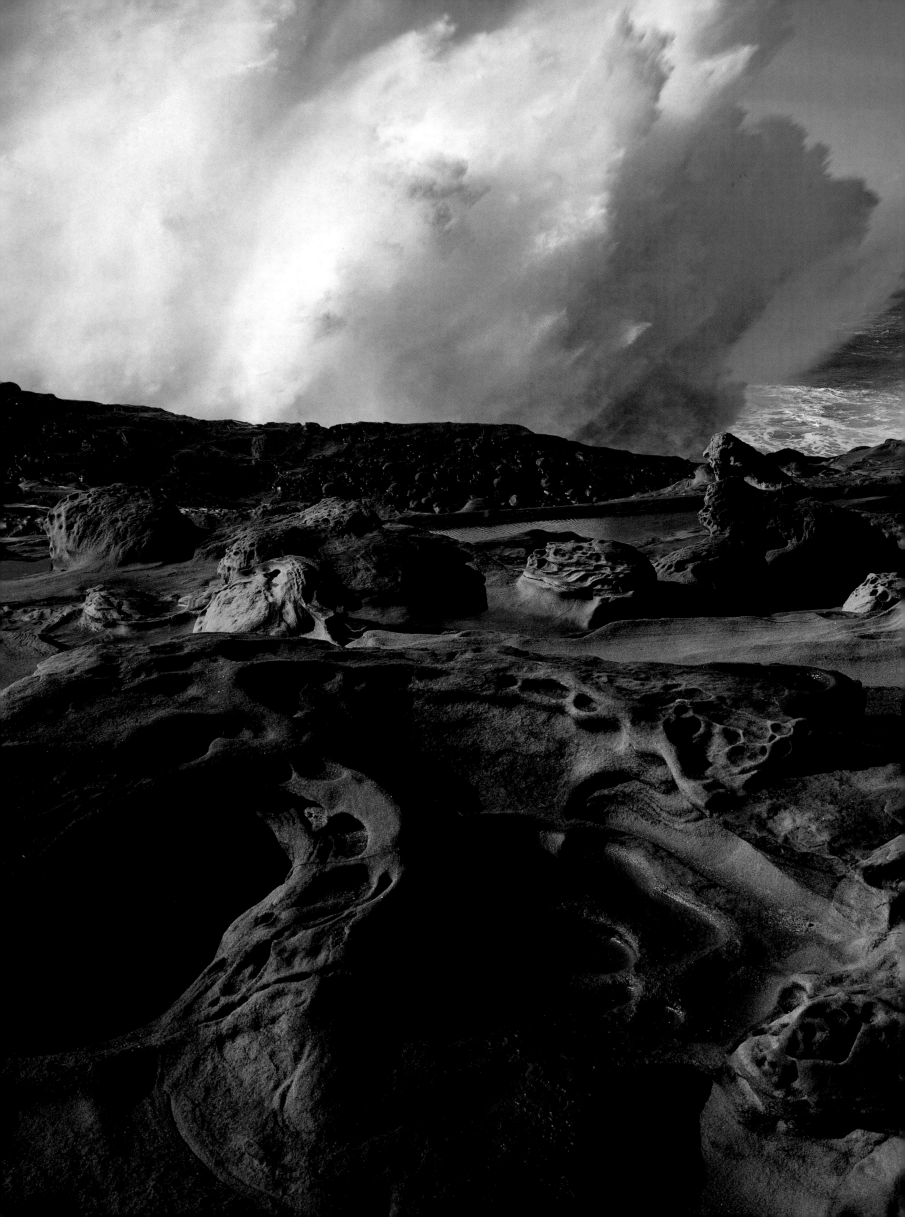

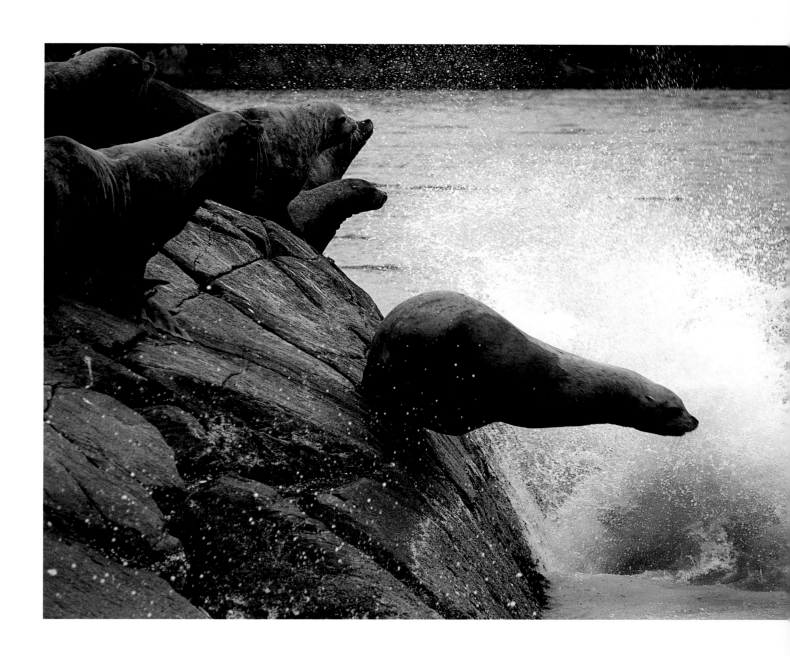

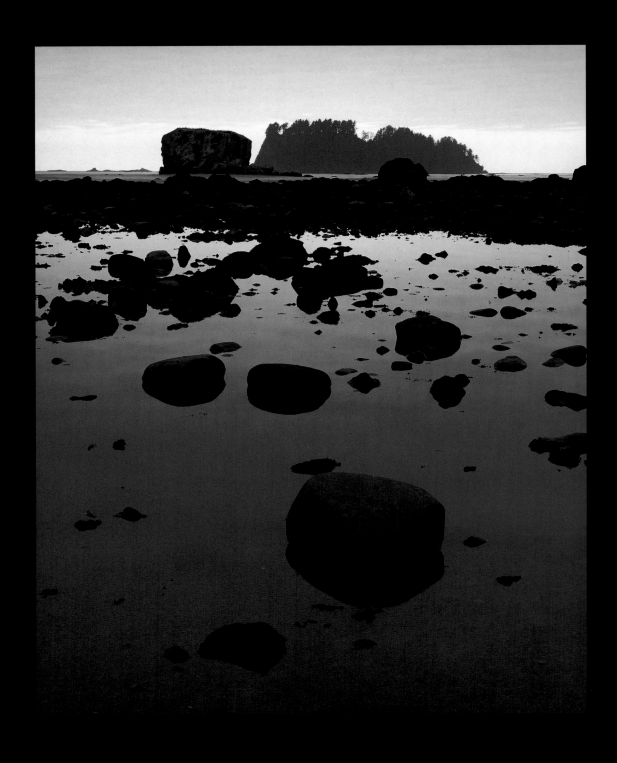

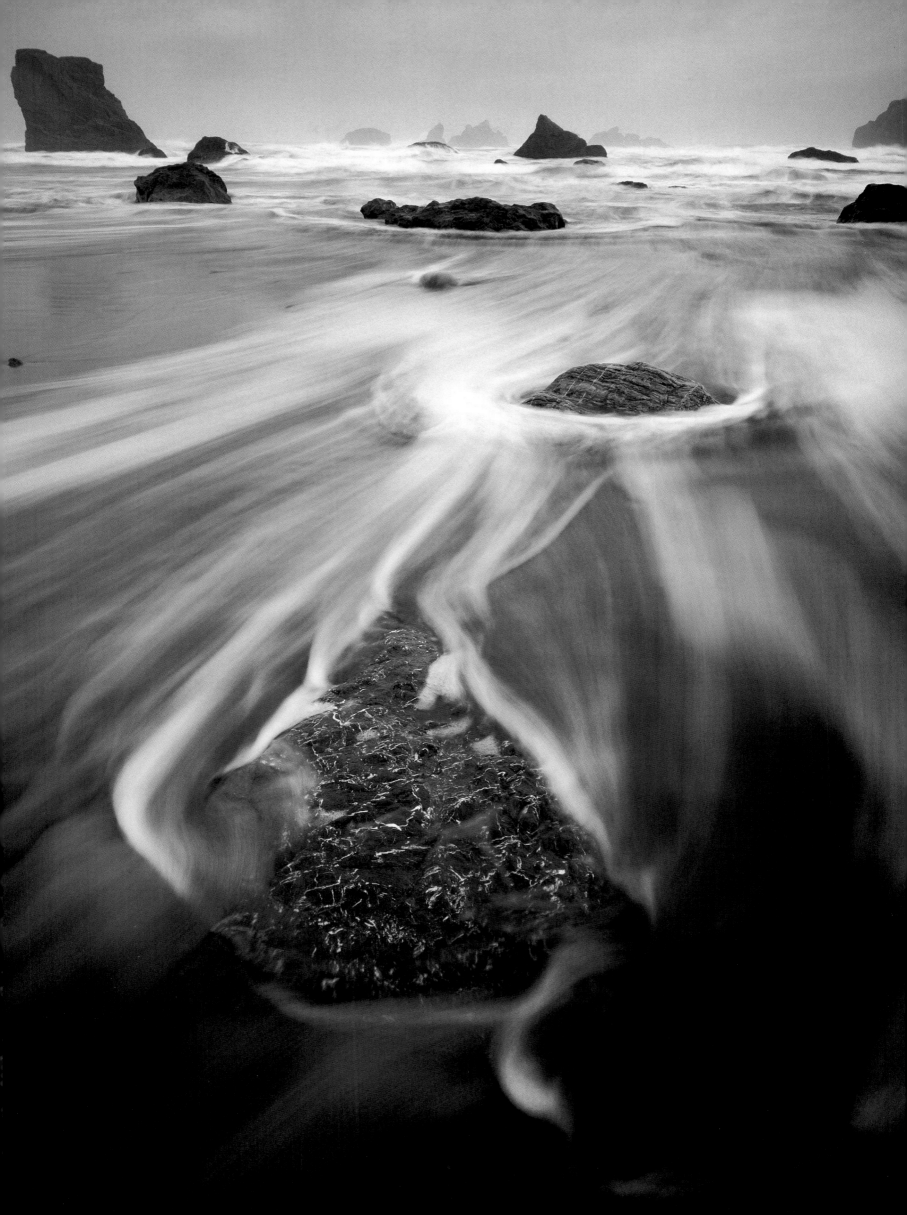

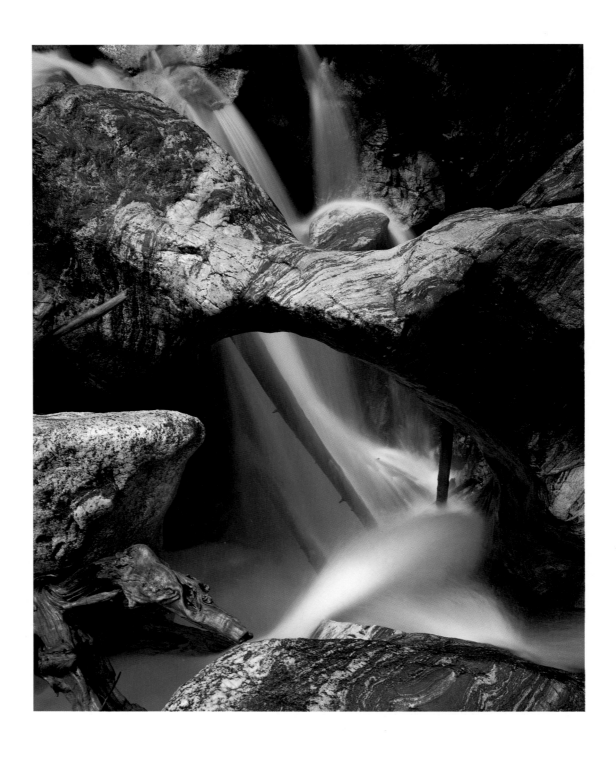

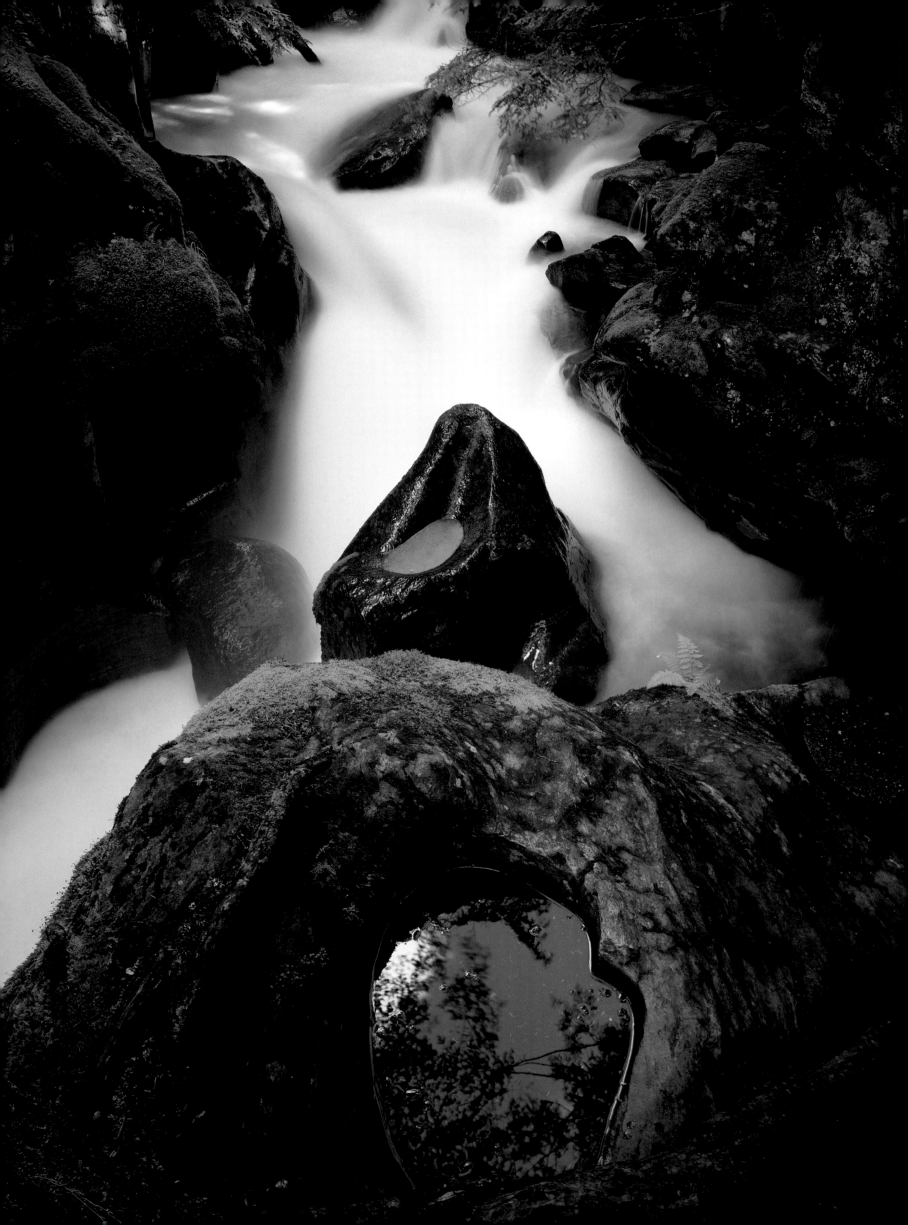

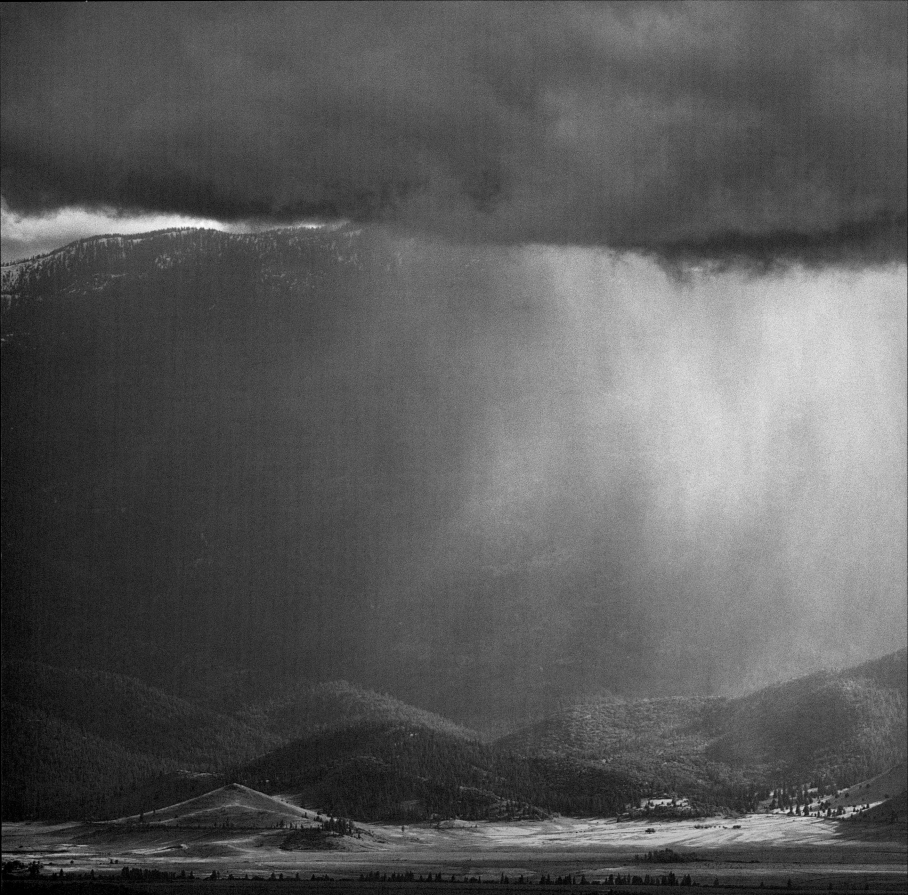

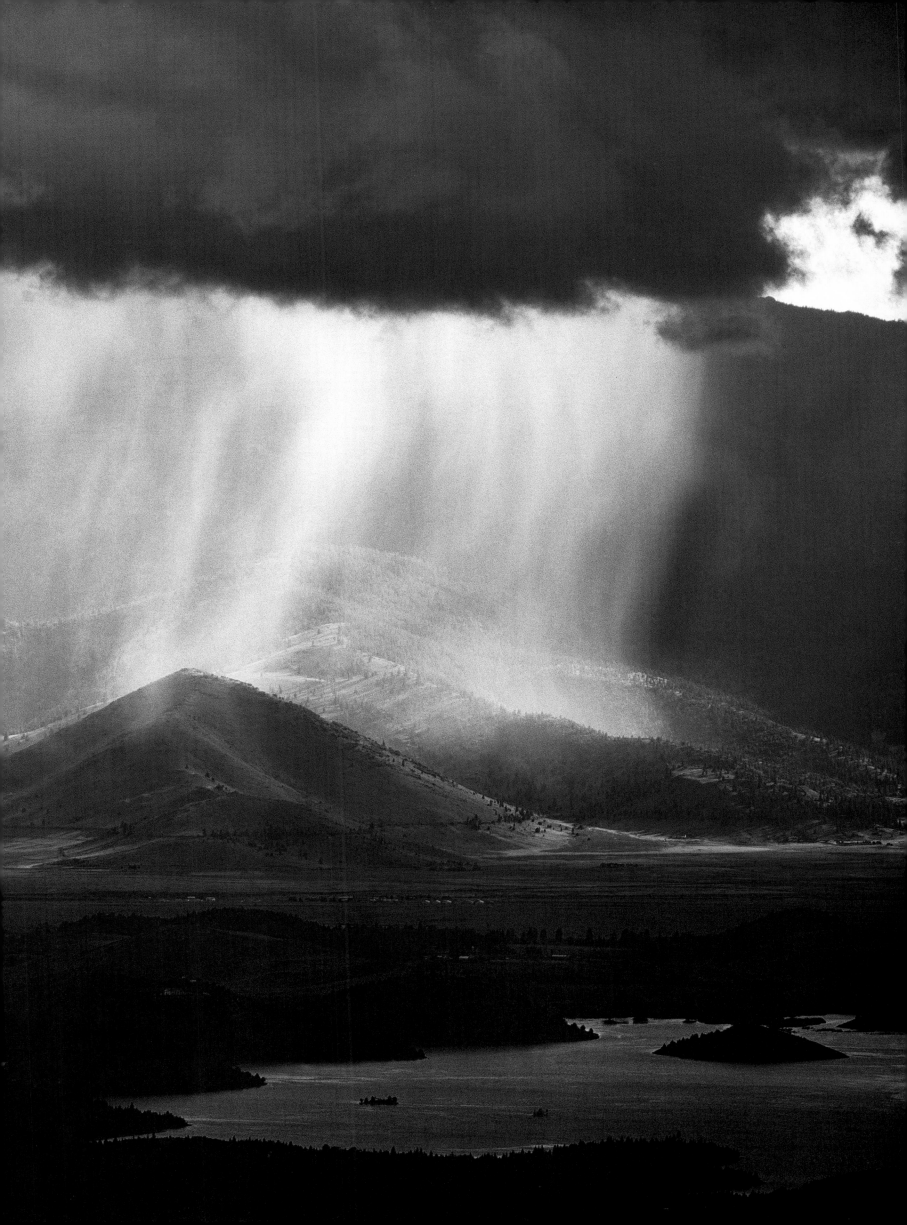

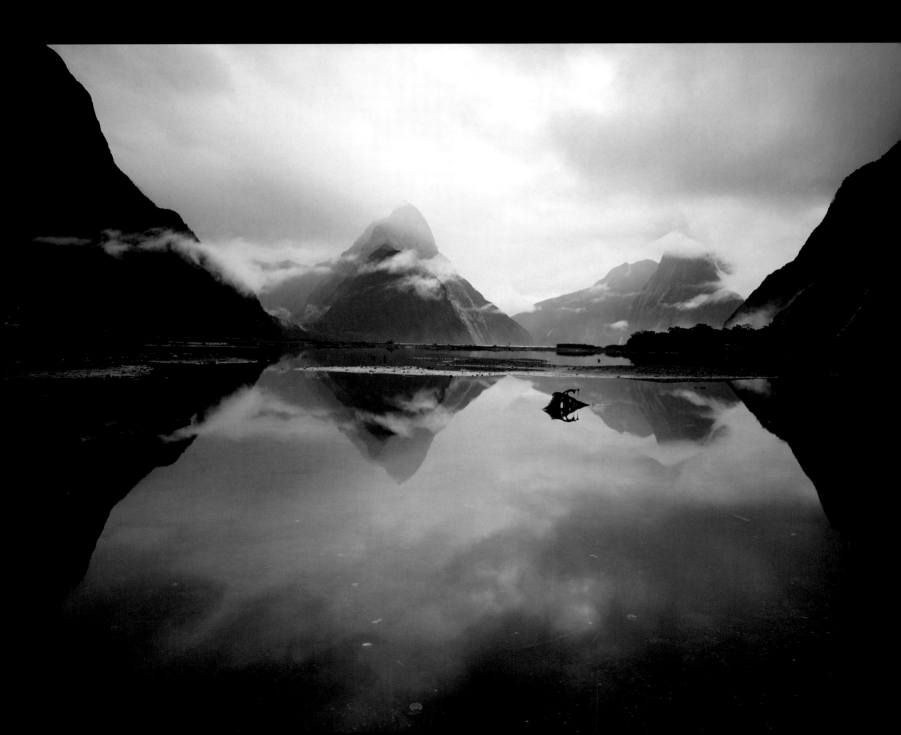

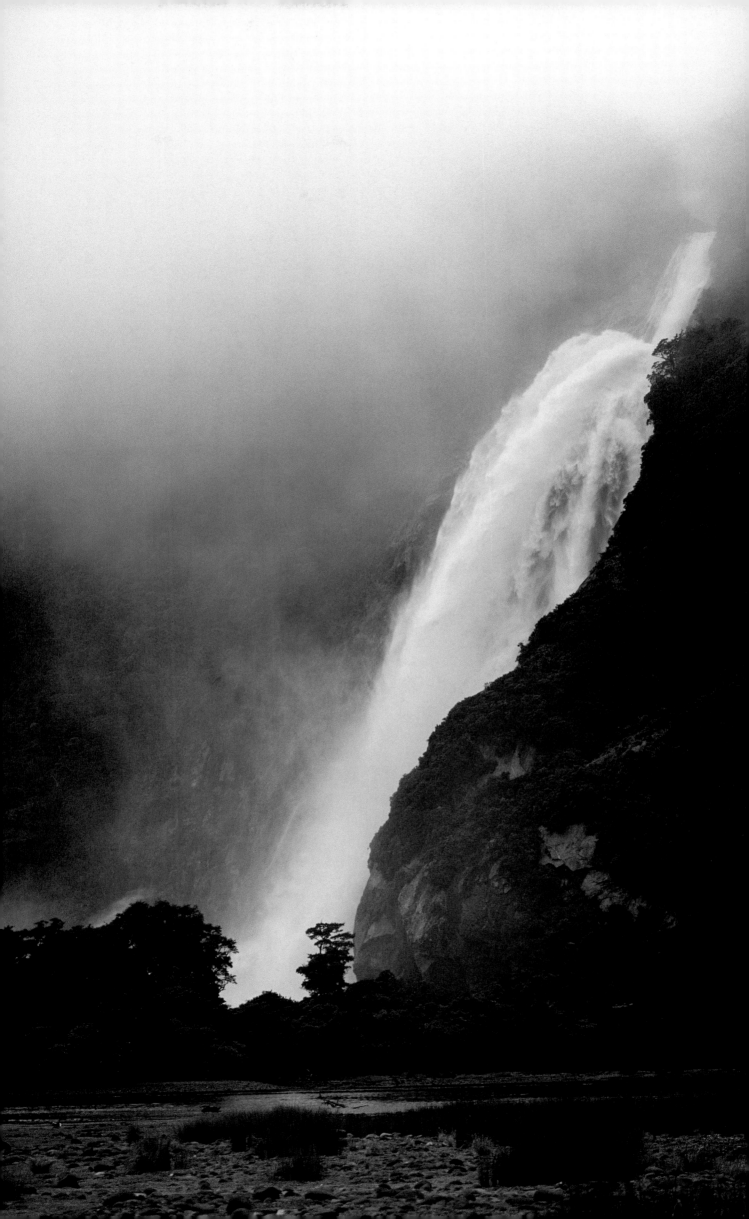

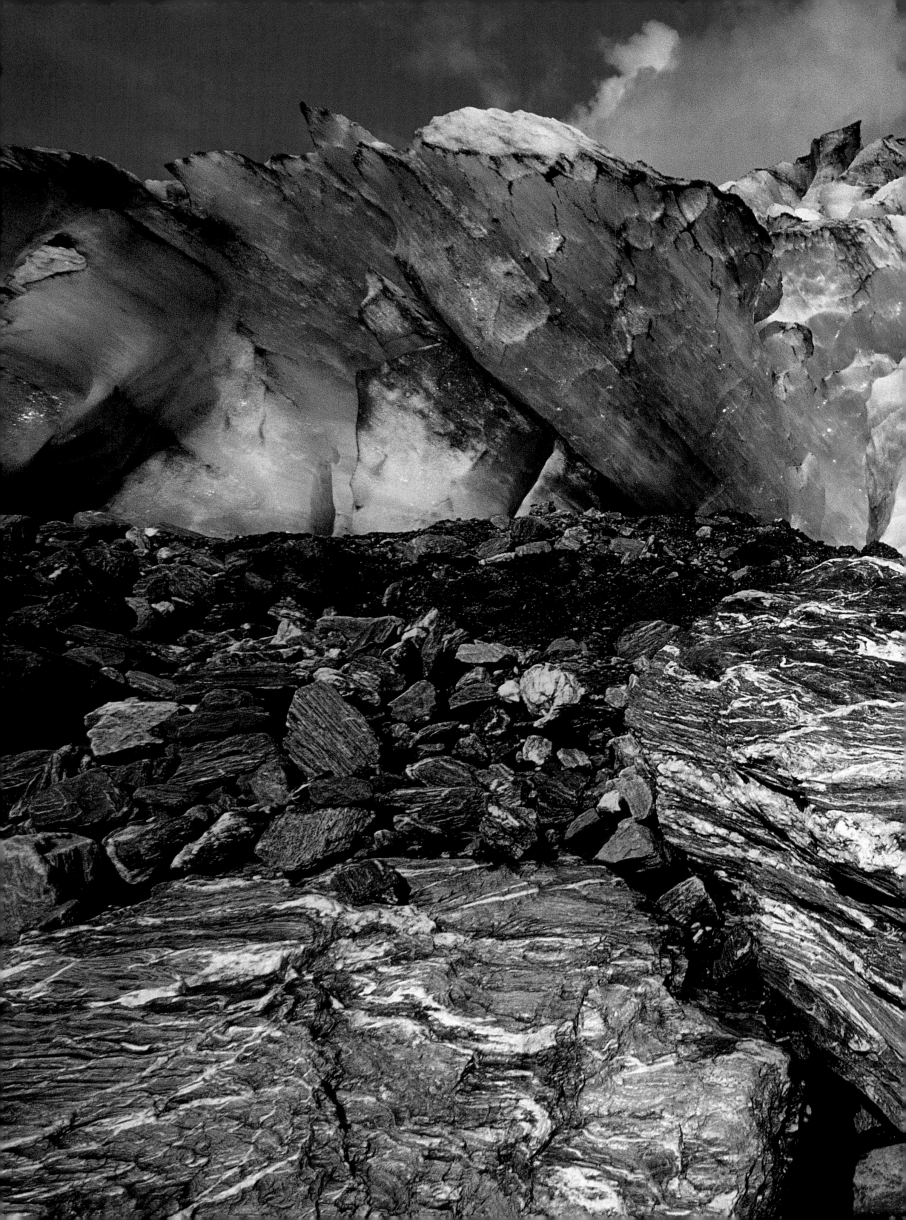

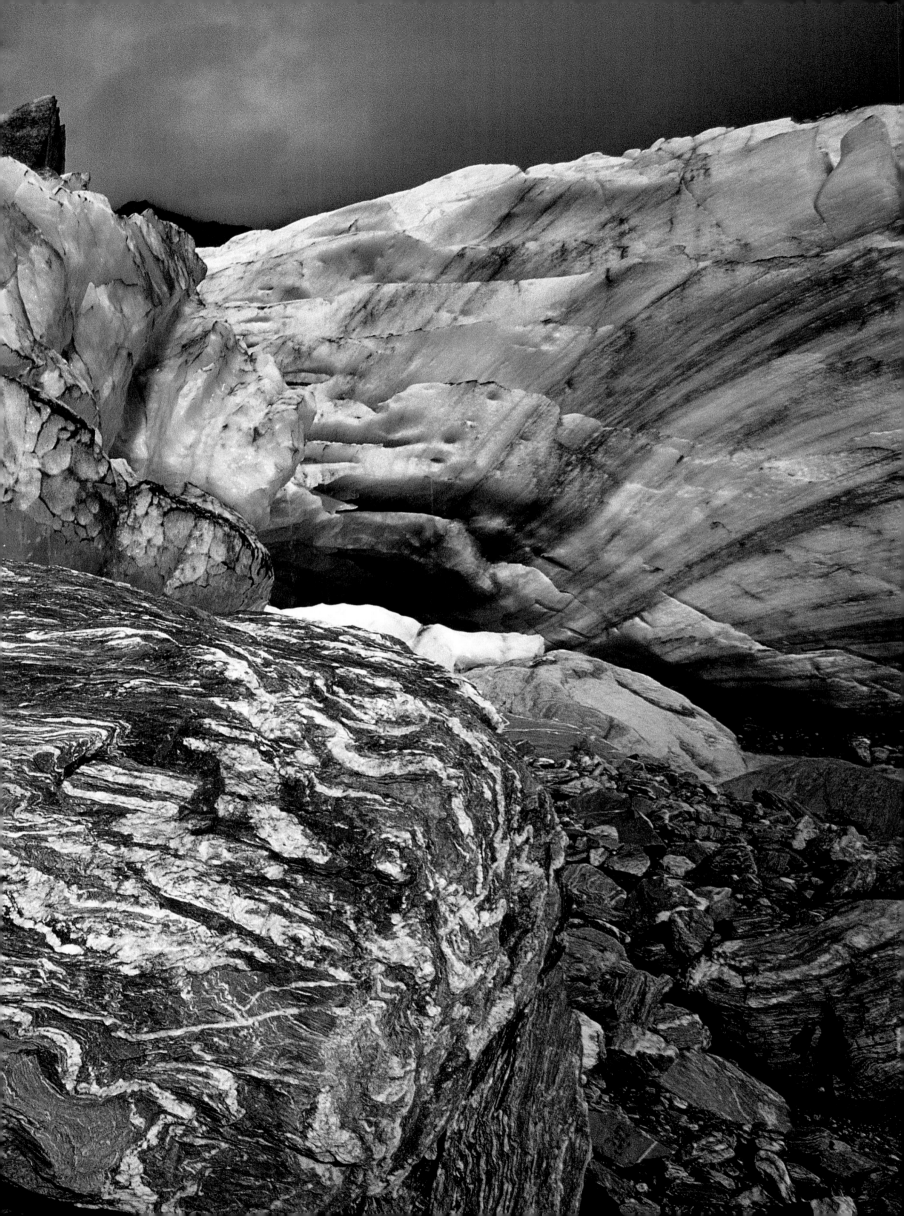

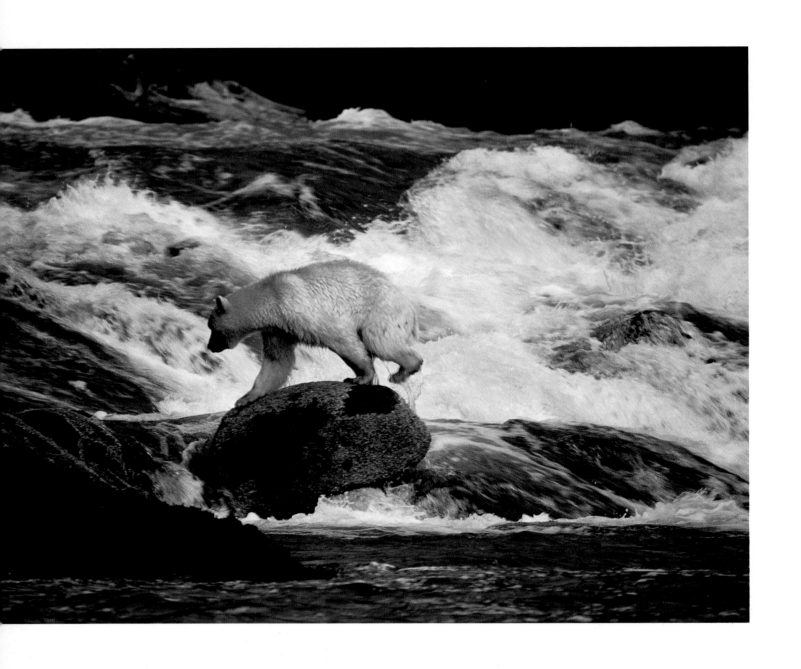

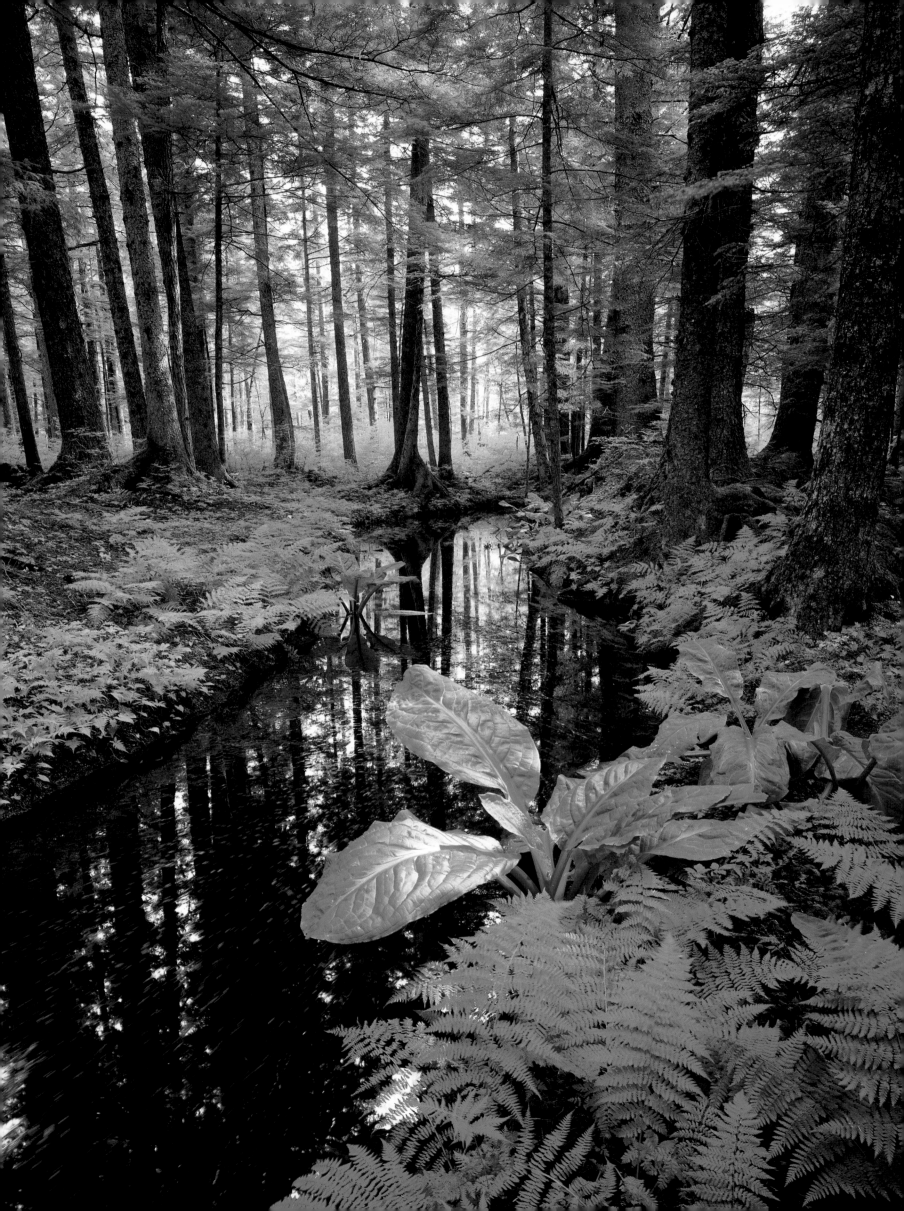

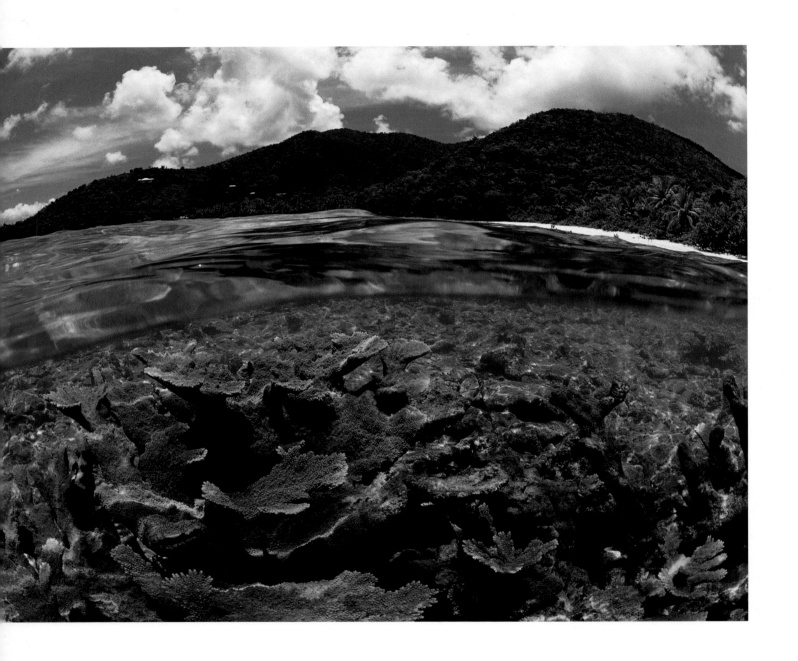

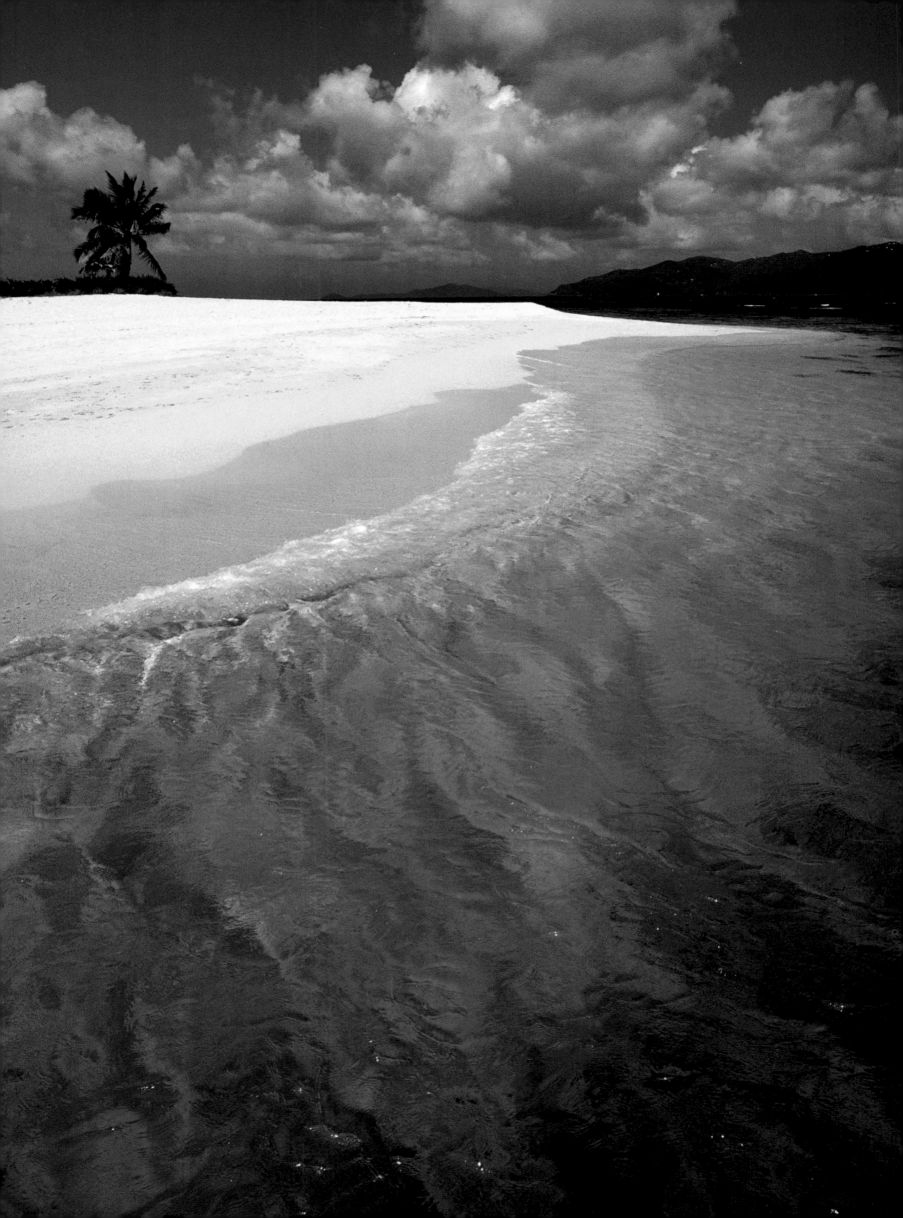

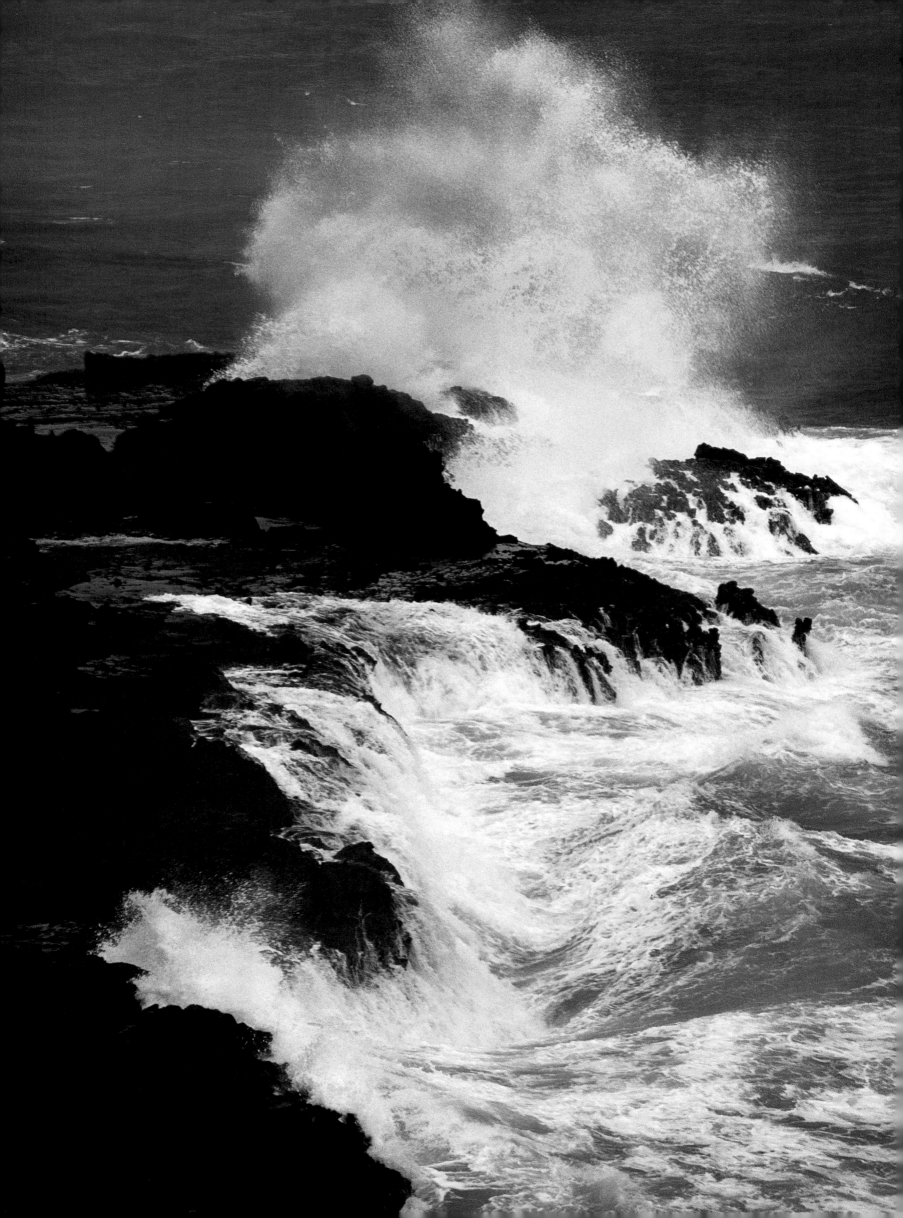

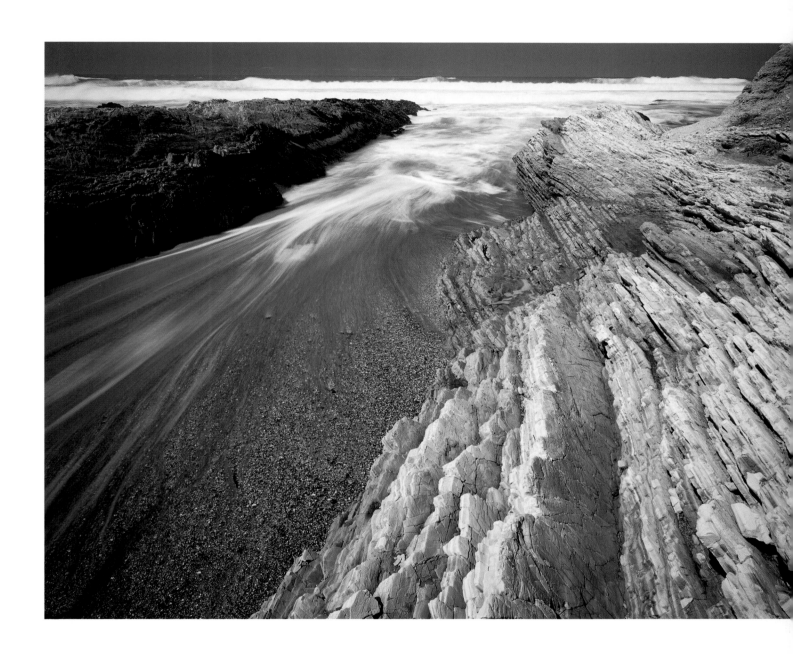

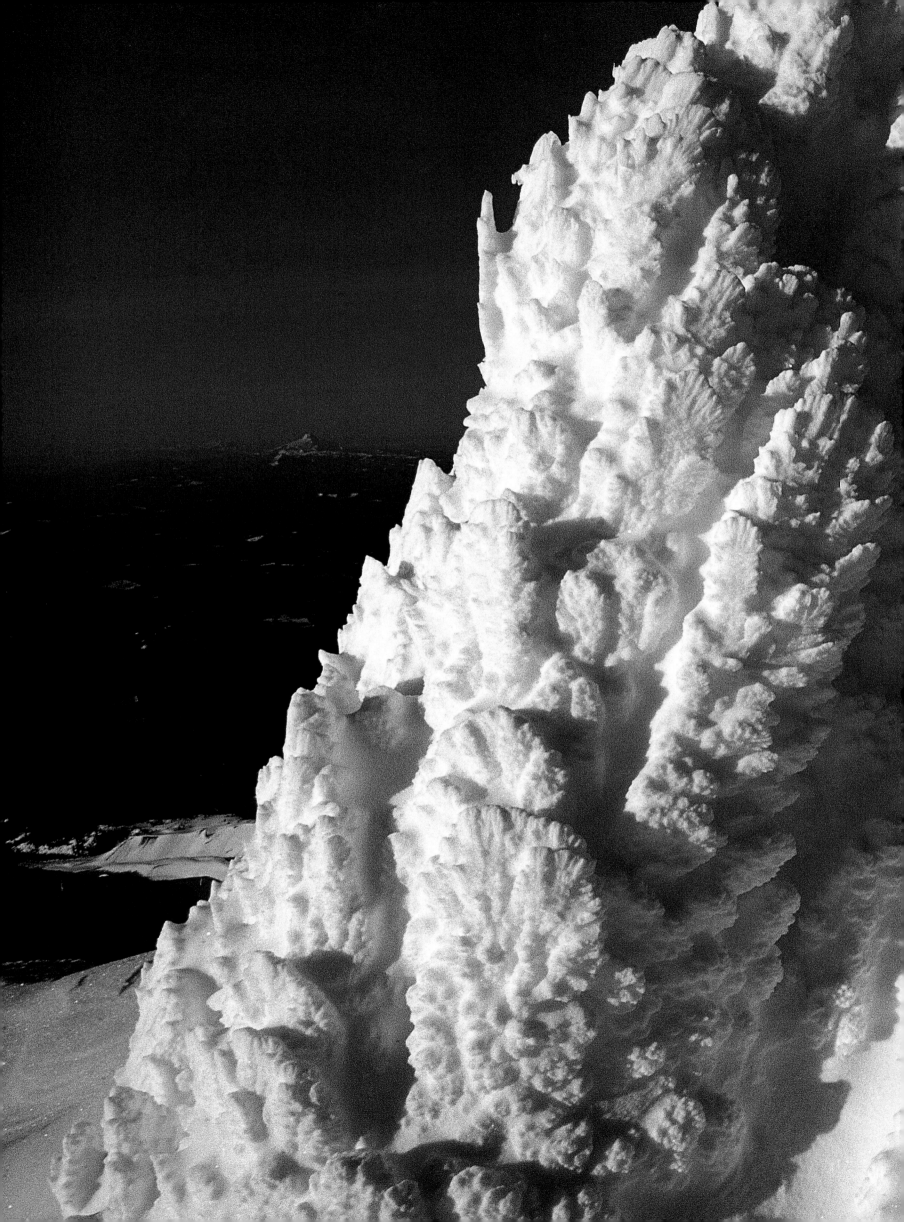

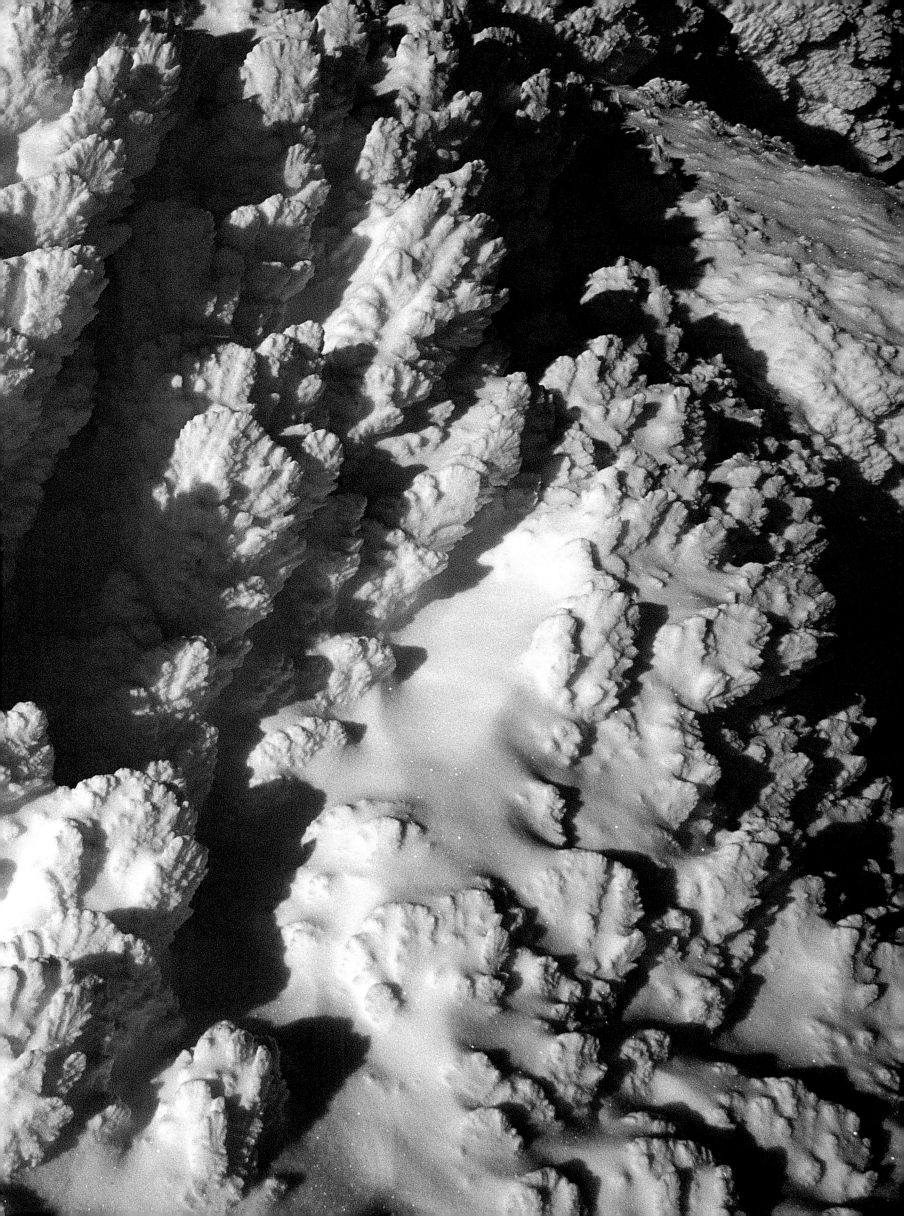

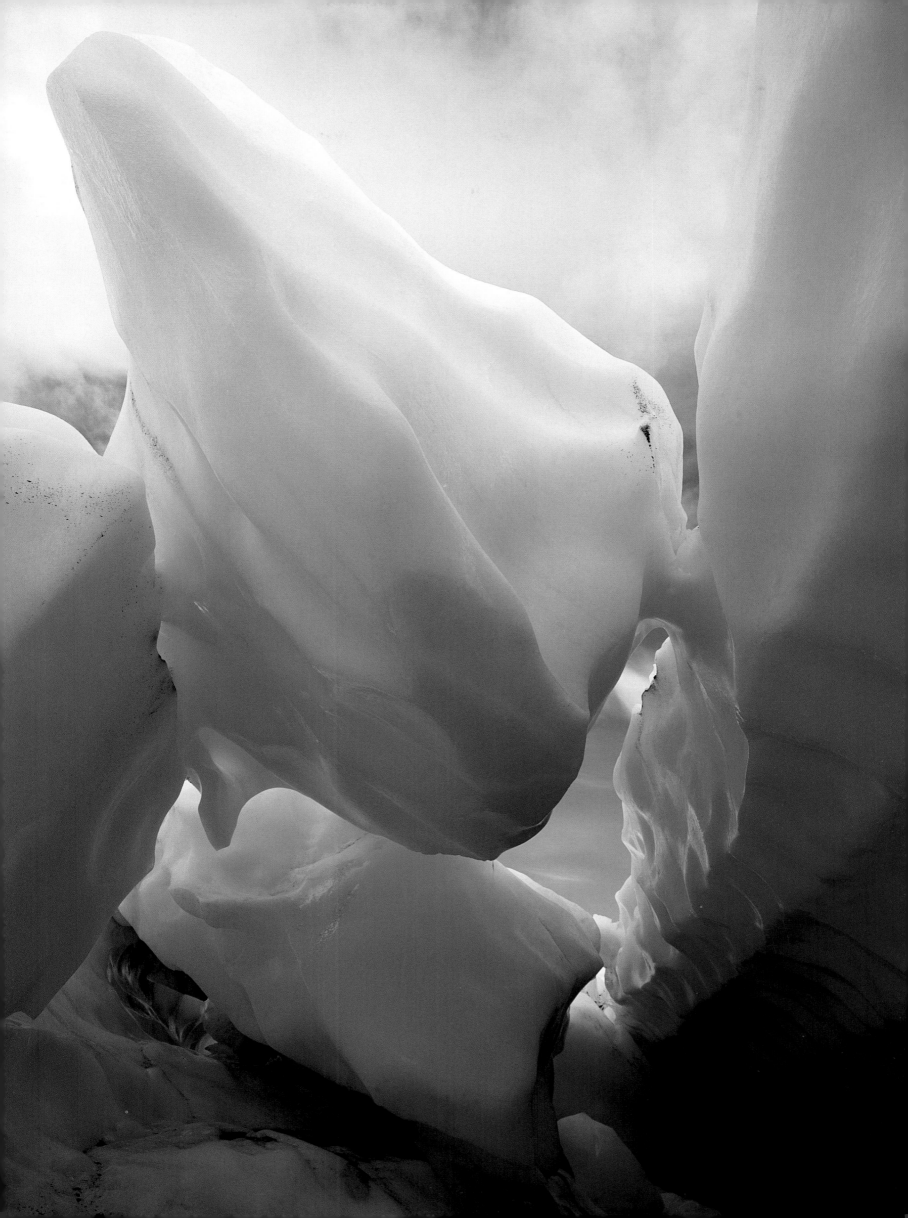

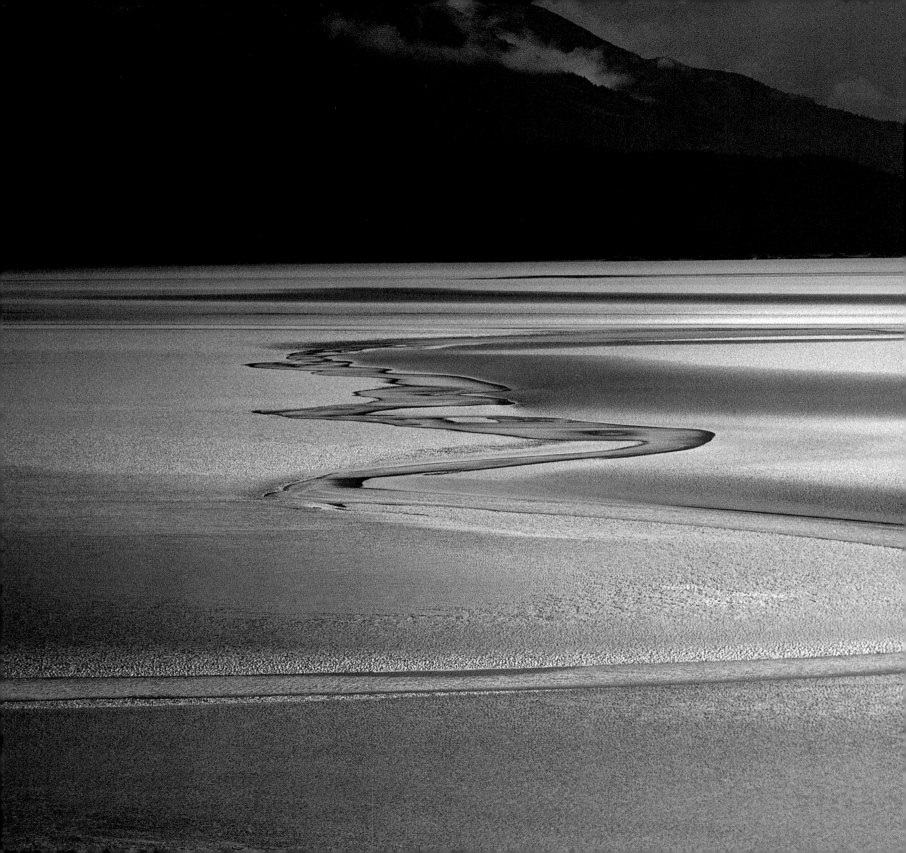

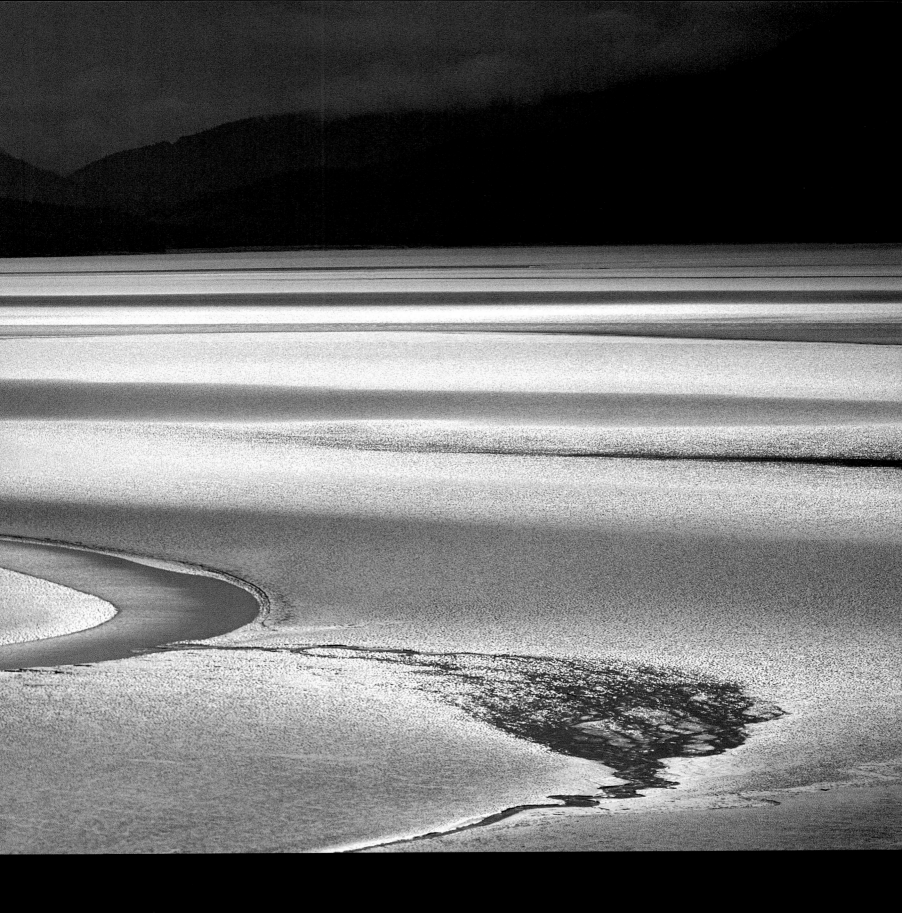

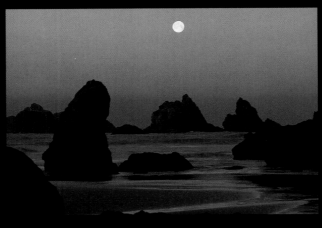

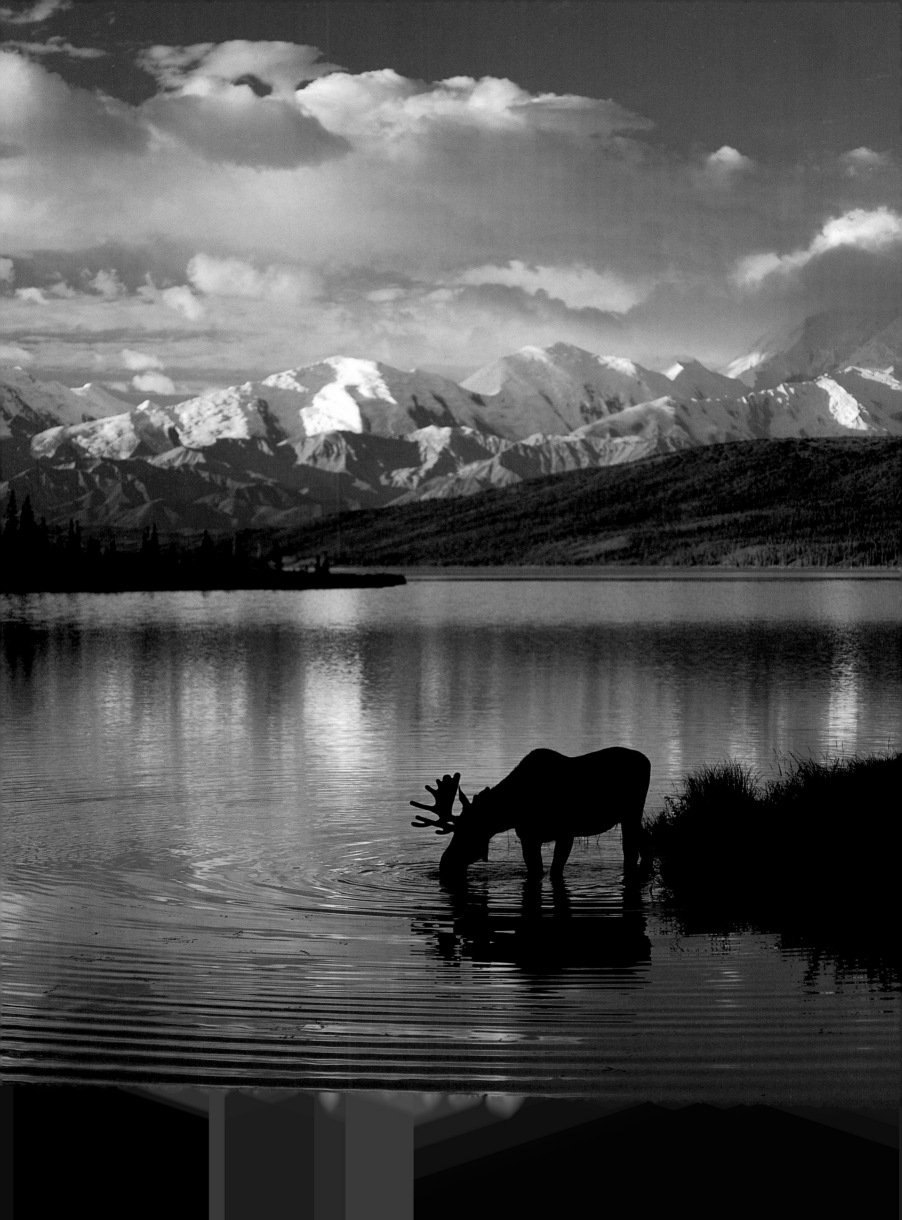

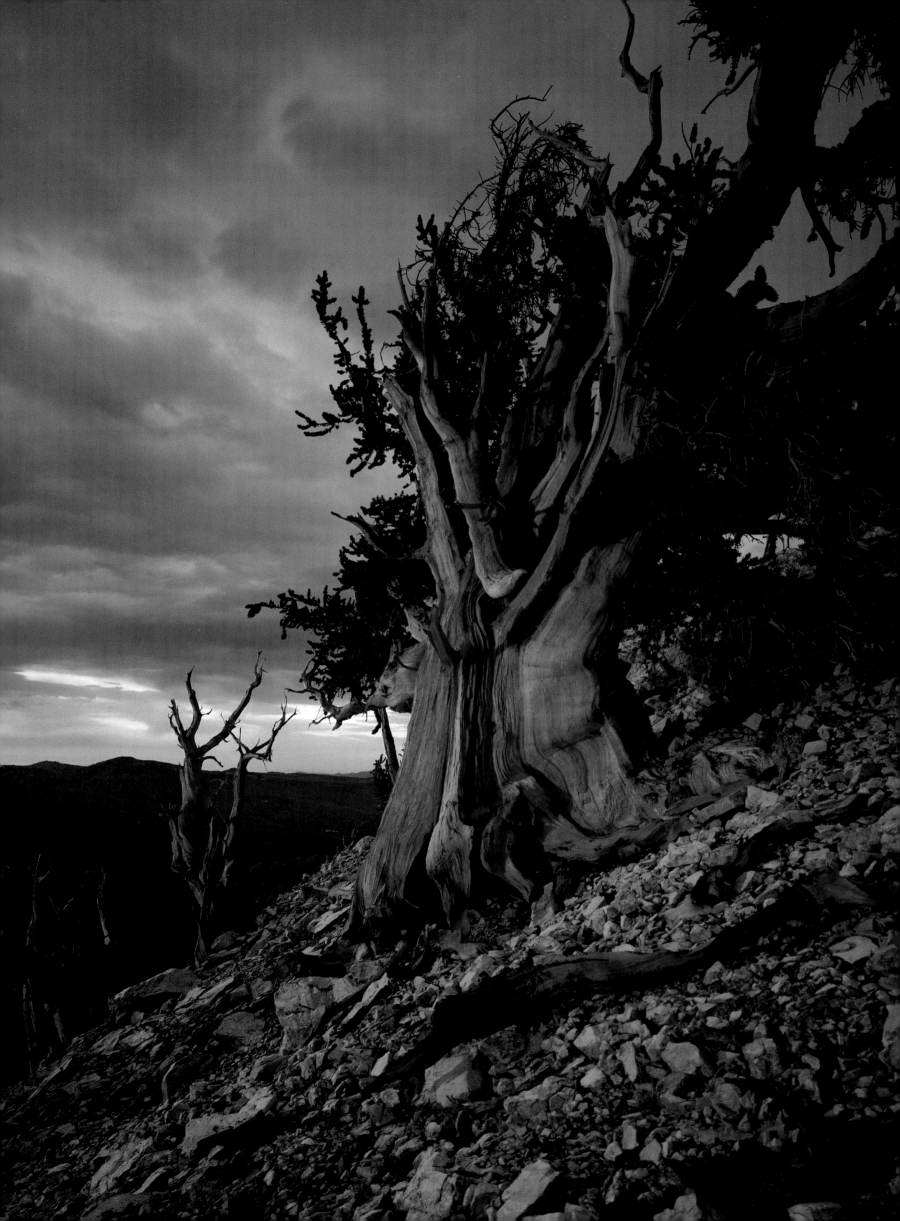

THE LIVING EARTH

When humans first left the confines of this planet, they were afforded a view that previously had been held only in the imagination. First satellites, then astronauts, looked upon the Earth in its entirety.

From a height of several hundred miles, astronauts looked down upon a world that suddenly appeared small and fragile, buoyed by the velvet backdrop of the cosmos. Socrates said that only if we could see the Earth from far above, would we come to understand it. From space, the Earth can be seen as a single entity—the Gaea of Greek mythology.

Gaea was both goddess and mother to the ancient Greeks, who sought order, control, and purpose in all things. She was the giver of dreams who provided sustenance to life. As Mother Earth, all others were born from her body. She was Earth, the foundation, and Earth, the life-giver. In more recent years, the myth of Gaea has been adopted by those for whom science, not fable, is a calling. To these holistic scientists, led by James Lovelock, Gaea is a metaphor for the idea that our planet is more than simply the sum of its parts. Under the Gaea Hypothesis, it is life itself that has made, and continues to make, the Earth habitable.

The Earth is not alive in the traditional sense of the word, nor is it a benevolent entity with altruistic tendencies. The primal forces of earth, air, fire, and water interact through the geosphere—that nonliving portion of the world that encompasses the atmosphere, hydrosphere, and lithosphere—and the living biosphere of bacteria, plant, and animal.

The biosphere is our home. It is the narrow layer where life flourishes. It is where inert and animate merge, where the biotic and the abiotic combine to make something new and wonderful. Life evolved by adapting to the environmental conditions prevalent on the Earth. But as soon as life appeared, it changed the very nature of the Earth. Today, life has become much like a self-fulfilling prophecy. Life builds on life. Life needs life to survive. Life maintains the conditions that life needs to prosper.

While the primal forces cycle water, minerals, and gases through the planetary ecosystem, the force of life hijacks a portion of those materials for its own designs. For a brief moment, using the energy of the sun, life works against the laws of thermodynamics and reverses the universal trend toward entropy. Life organizes against a backdrop of chaos. This quality is the singular characteristic of life, for it fights against the establishment of an equilibrium; it fights against stagnation.

Our remarkable blue green planet is a combination of the physical and the biological. The Earth is a living planet, harboring millions of extraordinary life forms and billions of individuals. It is dramatic mountains and the dark oceanic abyss. It is verdant rain forest and golden desert. The Earth is our forever-changing home, primal, untamed, and unique.

PHOTO CAPTIONS

Page 6: Navajo Sandstone, Coyote Buttes, Paria Canyon–Vermilion Cliffs Wilderness, Utah, USA
Photograph by David Muench
Salmon pink and gray rocks, from 144 to 245 million years old, lie exposed in an area known as "The Wave." The rocks show distinctive striations, or cross-bedding, evidence that this desert landscape was once filled with shifting sand dunes, since "frozen" in place. At the time these dunes were fluid seas of sand, dinosaurs walked here, and occasionally their footprints have been discovered, preserved in the now-rigid sandstone. *October 1996. Linhof 4x5 camera, 75mm wide-angle lens, CCO5R red filter, Fujichrome Velvia film.*

Front Cover: **The Mittens, Monument Valley Navajo Tribal Park, Arizona, with Hawaiian Lava and California Lightning, USA**
Center and left photographs by David Muench
Right photograph by Marc Muench
David combined these images of the Mittens in camera, with the book jacket in mind. Stark silhouettes of rock, without photographic detail, symbolize a continuum of natural forces—ever changing, but ever remaining the same. Both images were taken at dawn and were underexposed by three-quarters of a stop. See pages 116 and 117 for information for the lava and lightning shots. *November 1999. Linhof 4x5 camera, 500mm telephoto lens (dawn exposure), 300mm telephoto lens (sunrise silhouette), Fujichrome Velvia film.*

Page 6 (inset): Star Trails, Monument Valley Navajo Tribal Park, Arizona, USA
Photograph by Marc Muench
A six-hour exposure maps the movement of northern constellations, among them Cygnus, Cassiopeia, Andromeda, Ursa Minor, Taurus, and Draco. The closest star is Proxima Centauri, about 4.3 light-years from our sun. A star may exist for billions of years before exhausting its supply of hydrogen and transforming itself into a red giant and then a white dwarf; particularly large stars end their "lives" by exploding into supernovas that shine a billion times brighter than normal stars. *October 1993. Zone VI 4x5 camera, 210mm medium telephoto lens, Fujichrome Velvia film.*

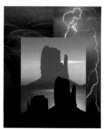

Page 1: **Nevada Falls, Yosemite National Park, California, USA**
Photograph by David Muench
At 594 feet (180 meters) high, Nevada Falls is a powerful, almost cataclysmic waterfall when swelled by spring flow. David captured this image on a return hike from Half Dome. John Muir describes the falls in *The Yosemite:* "[T]he river is first broken into rapids on a moraine boulder-bar that crosses the lower end of the Valley. Thence it pursues its way to the head of the fall. . . . Thus, already chafed and dashed to foam, overfolded and twisted, it plunges over the brink of the precipice as if glad to escape into the open air." *May 1999. Linhof 4x5 camera, 210mm medium telephoto lens, Fujichrome Velvia film.*

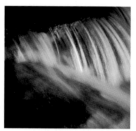

Page 7: Eagle Falls, Lake Tahoe, California, USA
Photograph by Marc Muench
Near Lake Tahoe's beautiful Emerald Bay, Eagle Falls cascades over rounded boulders to deliver its water to the 193-square-mile (500-square-kilometer) lake. Tahoe occupies a fault basin in the northern Sierra Nevada, and is 6,229 feet (1,899 meters) above sea level. The falls are retreating upstream as the powerful force of water gradually undercuts them at their base causing regular rockfalls. Fed by snowmelt, Eagle Falls is at its most forceful during spring "breakup." Here, first morning light illuminates the water. *May 1995. Zone VI 4x5 camera, 210mm medium telephoto lens, Fujichrome Velvia film.*

Page 2: **Engelmann Spruce *(Picea engelmannii)* and Subalpine Fir *(Abies bifolia)*, San Juan Mountains, Colorado, USA**
Photograph by Marc Muench
The San Juan Mountains are the most expansive range in the American Rockies. Birthplace for both the Rio Grande and the San Juan River, the range covers 10,000 square miles (26,000 square kilometers) and is punctuated by such peaks as Eolus (14,083 feet [4,225 meters]), Wilson (14,246 feet [4,274 meters]), and Uncompahgre, the highest, at 14,309 feet (4,293 meters). This double exposure was created on a single piece of film by taking 2 images (turning the camera over between shots) at dusk. *October 1999. Contax 6x4.5 camera, 120mm lens, multiple exposure, Fujichrome Velvia film.*

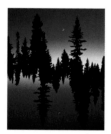

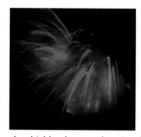

Page 7 (inset): Kalapana Coastline, Hawaii Volcanoes National Park, Hawaii, Hawaiian Islands, USA
Photograph by David Muench
A half-second nighttime exposure reveals a fireworks-like explosion as lava hits water on Hawaii's Big Island. David hand-held the camera on his knees to get this image. The 1,500-mile (2,400-kilometer) Hawaiian Islands chain lies above a "hot spot" in the Earth's crust where hot magma breaks through the Pacific Plate and basaltic lava gradually builds up the shield volcanoes that rise above the water's surface to form islands and islets. *April 1985. Leicaflex camera, 50mm lens, Kodak Ektachrome Daylight film.*

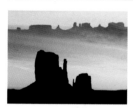

Page 3: **The Mittens, Monument Valley Navajo Tribal Park, Arizona, USA**
Photograph by David Muench
Monument Valley's pillars and towers are formed as wind and rain erode away soft shale, revealing harder sandstone beneath. While much of Arizona is dominated by rocks from 66 to 208 million years old, Monument Valley is formed of much older sandstone, from 245 to 286 million years old. This double exposure, created in camera, combines dawn light with evening glow from the opposite direction. Both images were underexposed by 1 stop. *November 1999. Linhof 4x5 camera, 210mm medium telephoto lens (for westward shot), 300mm telephoto lens (for eastward shot), multiple exposure, Fujichrome Velvia film.*

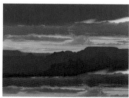

Pages 8–9: **Grand Canyon, Grand Canyon National Park, Arizona, USA**
Photograph by David Muench
A 2-image exposure, created in camera on a single piece of film, produces the impression of floating canyon rims in this sunset image taken from the Grand Canyon's South Rim. The images were made, one above the other, 30 seconds apart. From 9 to 18 miles (14 to 29 kilometers) wide and more than a mile (1.6 kilometers) deep, the canyon is a slice of planetary history. The rocks exposed by the Colorado encompass 2 billion years; it took the river about 2 million years to cut this channel. *August 1999. Linhof 4x5 camera, 300mm telephoto lens (both exposures), multiple exposure, Fujichrome Velvia film.*

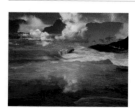

Pages 4–5: **Makapuu Head, Oahu, Hawaiian Islands, USA**
Photograph by David Muench
Morning and afternoon exposures, created in camera, capture Pacific surf pounding Makapuu Head on Oahu's windward shore. The Pacific was named *El Pacífico* by Portuguese explorer Ferdinand Magellan in 1520 because the ocean offered calm respite after a particularly harrowing voyage across the Atlantic. Despite the name, the Pacific, 64 million square miles (166.4 million square kilometers) in area, provides such a huge fetch (the distance a wave can travel without obstruction) that waves of great height are generated. Waves of 30 feet (10 meters) or more are not uncommon in Hawaii, making it a favored destination for surfers. *April 1983. Linhof 4x5 camera, 75mm wide-angle lens, multiple exposure, both images underexposed by 1 stop, polarizer, Kodak Ektachrome Daylight film.*

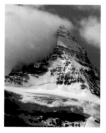

Page 10: **Mount Assiniboine, Mount Assiniboine Provincial Park, British Columbia, Canada**
Photograph by David Muench
Canada's classic horn-shaped Mount Assiniboine, the "Matterhorn of the Rockies," rises 11,939 feet (3,618 meters). The mountain was named, in 1884, after the Assiniboin Indians, members of the Sioux Confederation. Mount Assiniboine is the focal point of the 154-square-mile (386-square-kilometer) Provincial Park of the same name that lies between Alberta's Banff National Park and British Columbia's Kootenay National Park. With no motorized vehicle access, visitors must hike or fly in. Established in 1922, the park was added to the Rocky Mountain Parks World Heritage Site in 1990. *July 1997. Canon EOS-1N camera, 300mm telephoto lens, Fujichrome Provia film.*

PHOTO CAPTIONS

Page 11: **Cape Hatteras National Seashore, North Carolina, USA**
Photograph by David Muench
A multiple exposure, created in camera, melds the Atlantic shore with a forested barrier island at Cape Hatteras. Part of the Outer Banks, Cape Hatteras National Seashore is a delicate union of sand dunes, marshes and wetlands, and maritime forests. Though battered by Atlantic winds and waves, the islands are not a place where ocean and land are in conflict. Here, water and land combine to create the "shore," a locale where species rely on both sea and land to survive. *May 1985. Linhof 4x5 camera, 75mm wide-angle lens (forest interior) and 210mm medium telephoto lens (sunrise and surf), multiple exposure, both images underexposed by 1 stop, Fujichrome Velvia film.*

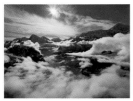

Pages 12–13: **Don Sheldon Amphitheater, Alaska Range, Denali National Park and Preserve, Alaska, USA**
Photograph by Marc Muench
The Don Sheldon Amphitheater is an ice field surrounded by mountains, including 20,320-foot (6,096-meter) Mount McKinley (also called Denali), North America's tallest peak, Mount Silverthrone, Explorers Peak, Mounts Barrille, Dickey, Huntingdon, and Hunter. This is the heart of the Alaska Range, protected within 6 million acres (2.4 million hectares) of national park. In total, the Alaska Range stretches for about 400 miles (600 kilometers) from the Aleutian Range to the border with Canada's Yukon Territory. *August 1999. Contax 6x4.5 camera, 35mm wide-angle lens, Fujichrome Provia film.*

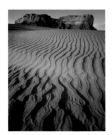

Page 16: **Lukachukai Country, Arizona, USA**
Photograph by David Muench
Rippled by the wind, sand dunes shift beneath the Lukachukai Mountains. Often thought synonymous with desert landscapes, dunes actually cover only about 12 percent of the world's desert regions. Dunes are formed from unconsolidated material that is eroded in one place and deposited by the wind in another. Sand dunes move in two ways: saltation involves the wind blowing individual grains of sand, whereas surface creep involves the wind-blown grains hitting other grains that then move and hit still other grains, creating a "domino" movement effect. *May 1994. Linhof 4x5 camera, 75mm wide-angle lens, Fujichrome Velvia film.*

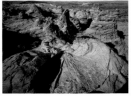

Pages 24–25: **Coyote Buttes, Paria Canyon–Vermilion Cliffs Wilderness, Arizona, USA**
Photograph by David Muench
Navajo sandstone dating from the Triassic and Jurassic Periods (245 to 144 million years ago) reveals that a shifting dune system once dominated this landscape. This is a harsh and unpredictable region. Temperatures may reach 105°F (40°C) in summer, and flash floods can be frequent and deadly. Coyote Buttes is administered by the Bureau of Land Management; in order to protect the fragile and unique landscape, the Bureau allows no more than 20 people to enter the area each day. *April 1993. Linhof 4x5 camera, 75mm wide-angle lens, Fujichrome Velvia film.*

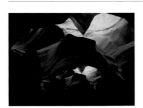

Page 26: **Upper Antelope Canyon, Arizona, USA**
Photograph by David Muench
Antelope Canyon is a slot canyon formed by the erosive force of wind and water. Discovered in 1931, this 600-foot- (180-meter-) long, 150-foot- (45-meter-) deep canyon is a meandering, sculpted masterpiece. Virtually invisible from the surface, the canyon reveals a delicate palette of colors belowground. Though usually dry, the canyon fills with such raging torrents after heavy rains that it may be deepened by up to 4 feet (1.2 meters) a year. In this image, 2 impressions created in camera are melded together to heighten a sense of convolution and illusion. *October 1999. Linhof 4x5 camera, 75mm wide-angle lens and 210mm medium telephoto lens, multiple exposure, Fujichrome Velvia film.*

Page 27: **Neon Canyon, Grand Staircase–Escalante National Monument, Utah, USA**
Photograph by David Muench
Declared a National Monument in 1996, the Grand Staircase–Escalante National Monument covers 1.7 million acres (0.68 million hectares) of southern Utah. This region includes mesas, buttes, pinnacles, plateaus, and canyons—including slot canyons—in hues of pink, gray, white, chocolate, and vermilion. "Grand Staircase" refers to the mesas that rise in "steps" from the Grand Canyon to Bryce Canyon; "Escalante" is for Francisco Silvestre Vélez de Escalante, who explored this region in the 1770s. Water is scarce here, but it is water, along with wind, that carved this landscape. *November 1996. Linhof 4x5 camera, 75mm wide-angle lens, Fujichrome Velvia film.*

Pages 28–29: **Wrangell Mountains, Wrangell–St. Elias National Park and Preserve, Alaska, USA**
Photograph by Marc Muench
An unnamed peak is central in this image of Alaska's Wrangell Mountains. In the distance, Mount St. Elias (right) marks the U.S./Canadian border, while Mount Logan (left), Canada's highest peak at 19,850 feet (5,951 meters), lies in the Yukon's Kluane National Park. At 12.3 million acres (4.9 million hectares), Wrangell–St. Elias is the largest national park in the United States. The park has more glaciers and more mountains over 16,000 feet (4,880 meters) than anywhere else on the North American continent. *August 1999. Contax 6x4.5 camera, 120mm lens, Fujichrome Provia film.*

Page 30: **Sabino Canyon, Santa Catalina Mountains, Arizona, USA**
Photograph by David Muench
Identified by its alternating light and dark minerals, gneiss patterns the metamorphic rock of the Santa Catalina Mountains north of Tucson. Known as a "metamorphic core complex," the gneiss in these mountains was formed when the mountains' granite and sedimentary rock was subjected to immense pressure and high temperatures. Generally resistant to erosion, the rock is penetrated by water only along its joints and fractures. Low temperatures freeze the water, and over time, the rock may be split and pushed apart. The result can be weird, wonderful shapes. *February 1979. Linhof 4x5 camera, 90mm wide-angle lens, Kodak Ektachrome Daylight film.*

Page 31: **Navajo Sandstone, Paria Canyon–Vermilion Cliffs Wilderness, Arizona, USA**
Photograph by David Muench
Patterns swirl in Navajo sandstone like the lines on a contour map—not a map to a present landscape, but a map to the ancient past. The undulating lines suggest movement in the now-static rock, and in fact this rock was once sand, moving with the wind. Over hundreds of millions of years, its movement has been captured and made eternal. The high cirrus-cloud formations on this spring day softened the harsh daylight so that the tones and pastel hues of the sandstone became all the more vivid. *April 1998. Linhof 4x5 camera, 75mm wide-angle lens, CCO5R red filter, Fujichrome Velvia film.*

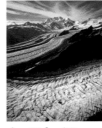

Page 32: **Mount Blackburn, Kennicott Glacier, and Root Glacier, Wrangell–St. Elias National Park and Preserve, Alaska, USA**
Photograph by Marc Muench
Medial and lateral moraines stripe the surface of two glaciers in the Wrangell Mountains. Moraines form when debris is carried along on the surface of the ice. Lateral moraines occur on each side of the glacier; medial moraines mark the midline. Although many glaciers are retreating, all glaciers are actually moving forward, often by 3 feet (1 meter) or more each day; in the Wrangells, some are moving more than 30 feet (10 meters) a day. Retreating glaciers are simply melting back faster than they are advancing. *August 1999. Contax 6x4.5 camera, 35mm wide-angle lens, Fujichrome Provia film.*

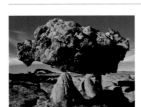

Page 33: **Sunset Arch and Balanced Rock, Grand Staircase–Escalante National Monument, Utah, USA**
Photograph by David Muench
A low angle emphasizes the precarious perch of a boulder. In the background, Sunset Arch bends across the horizon. Although water seems unlikely to shape desert environments, it, combined with wind, is the primal force behind these strange shapes. Rare in the desert, rainfall is typically less than 10 inches (250 millimeters) each year. When it does rain, the ground is hard; little soaks in to replenish underground aquifers. Resulting flash floods move boulders, erode gullies, and clear river beds. *November 1999. Canon EOS-3 camera, 17-35mm zoom lens, Fujichrome Provia film.*

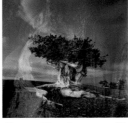

Page 34: **Bristlecone Pine *(Pinus aristata)*, Great Basin National Park, Nevada, USA**
Photograph by David Muench
The bristlecone pine has the longest lifespan of any living conifer. Below Wheeler Peak in Great Basin National Park, several pines are more than 3,000 years old; one is believed to have been 4,950 years old. If that is accurate, the tree would have sprouted when civilization was still in its infancy. This image, a double exposure created in camera on a single piece of film, combines the texture of living bark with the gnarled-trunk and foliage-topped countenance of a living tree. *July 1989. Linhof 4x5 camera, 75mm wide-angle lens, 210mm medium telephoto lens (close-up), CC10M filter, multiple exposure, both images underexposed by 1 stop, Fujichrome Velvia film.*

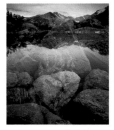

Page 35: Bear Lake and Longs Peak, Rocky Mountain National Park, Colorado, USA
Photograph by David Muench
Established in 1915, Rocky Mountain National Park encompasses 262,191 acres (106,109 hectares) of the Front Range. Several peaks exceed 10,000 feet (3,000 meters), including Longs Peak at 14,256 feet (4,278 meters). First "officially" climbed in 1868 by John Wesley Powell, Longs Peak was likely first conquered by Arapaho Indians. In this image, boulders are melded with dawn reflections on Bear Lake. *July 1987. Linhof 4x5 camera, 75mm wide-angle lens (reflection) and 300mm telephoto lens (boulders), multiple exposure, both images underexposed by 1 stop, Kodak Ektachrome Daylight film.*

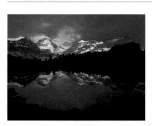

Pages 36–37: Mount Assiniboine, Mount Assiniboine Provincial Park, British Columbia, Canada
Photograph by David Muench
Dawn light bathes the skyline of Mount Assiniboine as it and the neighboring peaks of Magog (10,151 feet [3,095 meters]), Strom (9,915 feet [3,022 meters]), and Wedgwood (9,643 feet [2,939 meters]) are reflected in the tranquil waters of an alpine pond. This image reflects a story of rising mountains, eroding ice, and seemingly infinite time. Over eons that are daunting to contemplate, these mountains rose, and over eons that are even more immeasurable, they will slowly crumble. *July 1997. Linhof 4x5 camera, 75mm wide-angle lens, polarizer, Fujichrome Velvia film.*

Page 38: Lichen, Kolob Canyons, Zion National Park, Utah, USA
Photograph by David Muench
A union of algae and fungi takes hold on sandstone in Utah's Kolob Canyons. Lichen evolved through a symbiotic relationship in which algae provide nutrients to their fungal partners, while fungi absorb vapor and provide shade for the algae. The result is an organism that can survive in environments that neither algae nor fungi alone could colonize. Lichens also aid in a rock's decomposition. As rock decomposes, a simple soil forms, and other plants soon establish themselves. *September 1998. Linhof 4x5 camera, 210mm medium telephoto lens, CC05R red filter, Fujichrome Velvia film.*

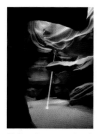

Page 39: Upper Antelope Canyon, Arizona, USA
Photograph by Marc Muench
Throughout the year, the colors of this slot canyon are at their richest during the hours closest to noon. It is then that the light makes the undulating, sensuous, sandstone walls glow in shades of red, orange, and yellow. It's as if the sun unleashes a pallette of colors trapped within the walls. During early summer, another transformation takes place here. For a few brief seconds, the midday sun sends a narrow sliver of light penetrating to the canyon floor. It is a surreal moment when light, shape, and color unite to create something ephemeral that lasts forever in the mind's eye. *May 1997. Canon EOS-1N camera, 20-35mm zoom lens, Fujichrome Velvia film.*

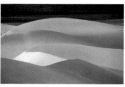

Pages 40–41: Eureka Dunes, Death Valley National Park, California, USA
Photograph by Marc Muench
White sand dunes lie like a body's contours across the landscape. Measuring some 140 miles (225 kilometers) in length and up to 15 miles (24 kilometers) across, Death Valley is the hottest and driest location in North America. At 282 feet (82 meters) below sea level, it is also the lowest point in the Western Hemisphere. Temperatures may rise to more than 120°F (49°C); ground temperatures, as high as 190°F (88°C). In this image, fast-moving clouds have created shadow to separate the dunes from one another, enhancing both contrast and definition. *April 1997. Canon EOS-1N camera, 70-200mm zoom lens, 1.4x extender, Fujichrome Velvia film.*

Page 42: The Clansman, New Cave, Carlsbad Caverns National Park, New Mexico, USA
Photograph by David Muench
Protecting more than 80 caves, Carlsbad Caverns National Park is a subterranean wonderland. The main cavern is 20.8 miles (33.5 kilometers) long; the deepest section, 1,027 feet (313 meters) below ground level. The caves were created over millennia, as groundwater dissolved the limestone rocks deposited 286 to 245 million years ago on a Permian Period coral reef. As groundwater drips from the ceiling, it deposits calcium carbonate, and slowly, stalactites and stalagmites (the former hanging downward and the latter growing upward) decorate the caves with spires, sheets, columns, and more. This is natural art at its most spectacular. *March 1992. Linhof 4x5 camera, 75mm wide-angle lens, Ektachrome Daylight film.*

Page 43: Crestone Peak, Sangre de Cristo Mountains, Colorado, USA
Photograph by David Muench
Crestone Peak rises 14,294 feet (4,288 meters) in the Sangre de Cristo Mountains, one of more than 50 ranges that form the Rockies. Arcing down from southern Colorado into northern New Mexico, this range represents the southern end of the Rockies—the point where the mountains rise from the plains to become something immense, grand, and far greater than a single range. From here the Rockies build northward for more than 2,000 miles, ending in northern British Columbia. *August 1989. Linhof 4x5 camera, 75mm wide-angle lens, Kodak Ektachrome Daylight film.*

Pages 44–45: Bristlecone Pine *(Pinus aristata)* and Sierra Nevada, California, USA
Photograph by David Muench
Toppled by intense winds, an ancient tree lies lifeless but still abstractly beautiful. In the contorted, gnarled shape of its roots can be glimpsed the tenacity with which this tree clung to life—for what may have been several thousand years. As the first light of day illuminates the distant Sierra Nevada, a full moon fades into nothingness. This is an image of cycles, of night into day, and of the continuity of life, even as life comes to an end. *September 1999. Linhof 4x5 camera, 500mm telephoto lens, CC05R red filter, Fujichrome Velvia film.*

Page 46 (left inset): Three-Spot Mariposa Lily *(Calochortus apiculatus)*, Theodore Roosevelt National Park, North Dakota, USA
Photograph by Marc Muench
Morning dew coats a delicate, white flower. There are about 40 species of *Calochortus,* all of which are native to western North America. Also known as tulip or butterfly lilies—*mariposa* is Spanish for "butterfly"—mariposa lilies have 3 large petals up to 2 inches (5 centimeters) long and 3 sepals. The bulbs of mariposa lilies were traditionally harvested by Native peoples and also proved to be a valuable food source for settlers heading west, particularly the Mormon pioneers, who harvested tons of sego lily (*C. nuttalli*) bulbs. *May 1999. Contax 6x4.5 camera, 120mm macro lens, Fujichrome Velvia film.*

Page 46 (right inset): California Poppy *(Eschscholzia californica)*, Montaña de Oro State Park, California, USA
Photograph by Marc Muench
Native to the west coast of North America, the California poppy (California's state flower) is an annual species that ranges in color from orange to yellow to cream. The flowers are open only in sunlight and are familiar meadow blooms in many areas; they are also popular garden flowers. In mild climates California poppies flower year-round; in northern areas, only in summer. Montaña de Oro State Park, near San Luis Obispo, is named for these golden wildflowers; its name means "Mountain of Gold." *April 1999. Canon EOS-1N camera, 50mm macro lens, Fujichrome Velvia film.*

Page 47: Hall of Mosses, Hoh Rain Forest, Olympic National Park, Washington, USA
Photograph by David Muench
Four tree species dominate the Olympic Peninsula's verdant rain forest ecosystem: Sitka spruce (*Picea sitchensis*), western hemlock (*Tsuga heterophylla*), Douglas fir (*Pseudotsuga menziesii*), and western red cedar (*Thuja plicata*). Both Douglas fir and western red cedar may live for a thousand years, reaching heights of 300 feet (90 meters) and 200 feet (60 meters), respectively. The rain forest is a cacophony of other life as well, with trees covered in mosses, ferns, and other epiphytes. *July 1989. Linhof 4x5 camera, 75mm wide-angle lens, CC10G green filter, Kodak Ektachrome Daylight film.*

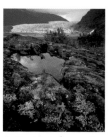

Page 48: Mendenhall Glacier, Alaska, USA
Photograph by David Muench
The Mendenhall Glacier—12 miles (19 kilometers) long and 1.5 miles (2.4 kilometers) wide—flows out of Southeast Alaska's Juneau Ice Field. Covering 1,500 square miles (3,900 square kilometers) to a thickness of up to 2,000 feet (600 meters), the ice field gives rise to about 140 glaciers. The glacier formed about 3,000 years ago and reached its maximum extent during the "Little Ice Age" in the mid-1700s; since 1767, it has retreated about 2.5 miles (4 kilometers). As it retreats, barren, ice-polished rock is exposed. Eventually, lichen, moss, and other pioneering plants may gain foothold, beginning a process that may one day establish a forest here. *August 1991. Linhof 4x5 camera, 75mm wide-angle lens, CC10M magenta filter, Fujichrome Velvia film.*

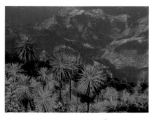

Page 49: **Iliau** *(Wilkesia gymnoxiphium)*, **Waimea Canyon, Kauai, Hawaiian Islands, USA**
Photograph by David Muench
Ten miles (16 kilometers) long and about 3,600 feet (1,080 meters) deep, Waimea Canyon has been called the "Grand Canyon of the Pacific." Located on Hawaii's "Garden Island," Waimea is close to what is probably the wettest place on Earth—the flanks of Mount Waialeale (its name means "overflowing water"). The area can receive as much as 624 inches (15,850 millimeters) of rainfall annually. *May 1997. Linhof 4x5 camera, 300mm telephoto lens, Fujichrome Velvia film.*

Page 50: **Autumn Leaves, Adirondack Mountains Park, New York, USA**
Photograph by David Muench
Strong winds stripped these leaves from their boughs to pattern a north-woods forest floor. Autumn is a time when forests are daubed in colors, as the passage of seasons leads to biochemical changes in the leaves. As daylight hours decline and temperatures drop, trees stop making carbohydrates through photosynthesis, and their chlorophyll begins to degrade, causing the leaves' typical green color to disappear. Then other normally masked pigments begin to show through. *October 1987. Linhof 4x5 camera, 210mm medium telephoto lens, CC05R red filter, Kodak Ektachrome Daylight film.*

Page 51: **Specimen Ridge, Yellowstone National Park, Wyoming, USA**
Photograph by David Muench
Yellowstone National Park is famous for its fossils. Specimen Ridge, near Tower Junction, is particularly rich in plant fossils. Some leaves are so well preserved that organic tissue is still present; more than 200 different species have been identified in these "fossil forests." David came across this rock slab while hiking up the ridge. The leaves were probably preserved after being inundated with mud and ash that cascaded down the river valleys during one of Yellowstone's many volcanic eruptions. *July 1969. Linhof 4x5 camera, 210mm medium telephoto lens, Kodak Ektachrome Daylight film.*

Page 51 (inset): **Fossilized Palm Frond, Fossil Butte National Monument, Wyoming, USA**
Photograph by David Muench
Established in 1972, the 8,198-acre (3,279-hectare) Fossil Butte National Monument protects the unique fossils discovered in the limestone, mudstone, and volcanic ash of a 50-million-year-old lake bed. Fossils of plants, fish, insects, birds, and reptiles detail the life that flourished here over a 2-million-year period. Subtropical palms, figs, and other plants thrived around the lake, while willows, maples, and spruce grew on the cooler slopes. Fossils of large crocodiles, turtles, stingrays, early primates, and bats have all been found here. *July 1991. Linhof 4x5 camera, 300mm telephoto lens, 81A filter, Fujichrome Velvia film.*

Pages 52–53: **Bagley Ice Field and Mount St. Elias, Wrangell–St. Elias National Park and Preserve, Alaska, USA**
Photograph by Marc Muench
An aerial view of the Bagley Ice Field captures creeping shadows rising up the slopes of Mount St. Elias. The 18,008-foot (5,489-meter) mountain was "officially" discovered in 1741, when Vitus Bering sighted the peak from his ship; the mountain would not be climbed until 1897. The St. Elias Range, which itself is part of the Pacific Coast mountains, extends for about 250 miles (400 kilometers) from the Wrangell Mountains to Cross Sound near the Canadian border. *August 1999. Contax 6x4.5 camera, 80mm lens, Fujichrome Provia film.*

Page 54: **Giant Sequoia** *(Sequoiadendron giganteum)*, **Parker Grove, Sequoia National Park, California, USA**
Photograph by David Muench
Distinct from the coastal redwoods *(Sequoia sempervirens)*, the giant sequoia is found only in isolated groves in California's Sierra Nevada, at elevations of between 3,000 and 8,500 feet (900 to 2,600 meters). One of the oldest and largest of living things, the "big trees" can reach heights of more than 270 feet (81 meters) with a circumference greater than 100 feet (30 meters) and a weight in excess of 6,000 tons (5,400 tonnes). The largest sequoia, the General Sherman tree, is found in Sequoia National Park, which was set aside in 1890 to protect these magnificent trees. *June 1998. Linhof 4x5 camera, 65mm ultra-wide-angle lens, CC10R red filter, Fujichrome Velvia film.*

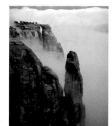

Page 55: **Colorado National Monument, Colorado, USA**
Photograph by Marc Muench
Established in 1911, the Colorado National Monument covers 32 square miles (83 square kilometers) of the Uncompahgre Plateau in western Colorado. The heavily eroded canyons and pinnacles are painted in the familiar colors of this part of the world: reds, oranges, and yellows. Bighorn sheep *(Ovis canadensis)*, mule deer *(Odocoileus hemionus)*, and mountain lions *(Felis concolor)* can all be found in this high-plateau country—even the canyon floors are 4,700 feet above sea level. With rocks dating from Precambrian to Cretaceous, the region is also rich in fossils. *February 1992. Pentax 6x7 camera, 300mm telephoto lens, Fujichrome Velvia film.*

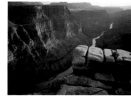

Pages 56–57: **Colorado River, Grand Canyon National Park, Arizona, USA**
Photograph by David Muench
From its birth in the Rocky Mountains, the Colorado flows for 1,450 miles (2,330 kilometers), draining an area of 246,000 square miles (637,000 square kilometers) and carving the 277-mile- (443-kilometer-) long Grand Canyon; its channel ranges from 3,500 to 6,000 feet (1,050 to 1,800 meters) deep. Over 2 million years, it removed an estimated 1,000 cubic miles (4,200 cubic kilometers) of material. This image, depicting the power of erosion, was taken from Toroweap Overlook, 2,500 feet (750 meters) above Lava Rapids. *February 1998. Linhof 4x5 camera, 75mm wide-angle lens, Fujichrome Velvia film.*

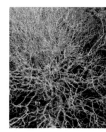

Page 58: **California Buckeye** *(Aesculus californica)*, **Inverness, Point Reyes National Seashore, California, USA**
Photograph by David Muench
Buckeye branches present a dense, abstract pattern along California's coast. The only member of the horse chestnut family *(Hippocastanaceae)* native to the Golden State, buckeye is a small, shrub-like plant. In spring, it bears long clusters of white flowers; in fall, large seed pods replace the blooms. The "buckeyes" in each seed pod are an important food source for wildlife and were also harvested by Native peoples, who leached the seeds before consuming them; if not treated, the seeds are toxic to humans. *February 1991. Linhof 4x5 camera, 300mm medium telephoto lens, Fujichrome Velvia film.*

Page 59: **Redwood** *(Sequoia sempervirens)*, **Prairie Creek Redwoods State Park/Redwood National Park, California, USA**
Photograph by David Muench
Redwoods are the tallest living trees, often exceeding 300 feet (90 meters) in height; the tallest has been measured at 367 feet, 6 inches (112 meters). Restricted to southwestern Oregon and north-central California, coastal redwoods may take five centuries to reach maturity and may live more than 1,500 years. Redwood National Park was established in 1968 to protect the trees. This image, created in camera, merges 2 images taken at 90-degree angles. *January 1992. Linhof 4x5 camera, 75mm wide-angle lens, multiple exposure, both images underexposed by one-half stop, Fujichrome Velvia film.*

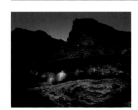

Pages 60–61: **Anasazi Petroglyphs, San Juan River Drainage, Utah, USA**
Photograph by David Muench
The Anasazi Native people lived in this area between 700 and 1220 C.E. (Current Era). Anasazi means "Ancient Ones" in Navajo. Anasazi culture reached its zenith in 1000 C.E., but by 1600 C.E. the region had been abandoned. In this image, a 60-second exposure highlights a rock art panel of mountain goats, handprints, antelope, snakes, and a 3-foot (1-meter) birdhead shepherd. Each petroglyph was illuminated by a penlight to create a sense of transition, between day and night, and between past and present. *November 1999. Linhof 4x5 camera, 75mm wide-angle lens, CC10M magenta filter, Fujichrome Velvia film.*

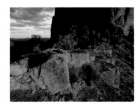

Page 62: **Oak Creek Canyon, Arizona, USA**
Photograph by Marc Muench
Located near Sedona, Oak Creek Canyon is more than 2,000 feet (600 meters) deep in places. The diverse geology of this area is testament to its complex history. The red sandstone buttes were laid down as a beach or sand bar on the shores of some long-vanished sea, 300 to 270 million years ago. The white Coconino sandstone was formed from wind-blown dunes that existed here partway through the Permian, while the Kaibab sandstone that overlays the white sandstone was deposited when the sea returned. A fault line runs through the canyon, and lava flows have frequently clogged the canyon; in places, highly fractured basalt has tumbled to the canyon floor. *October 1995. Pentax 6x7 camera, 45mm wide-angle lens, Fujichrome Velvia film.*

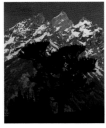

Page 63: Limber Pine *(Pinus flexilis)* and Grand Teton, Grand Teton National Park, Wyoming, USA
Photograph by David Muench
Located south of Yellowstone, Grand Teton National Park encompasses 310,521 acres (125,663 hectares) of snow-covered mountains, glaciers, canyons, lakes, and meadows. At 13,747 feet (4,190 meters), Grand Teton is the tallest peak in this range. An estimated 9 million years ago, sedimentary rocks were forced upward for 40 miles (64 kilometers) along the Teton Fault. Over time, the granite bedrock has been sculpted by the elements to form pinnacles and spires. *June 1999. Linhof 4x5 camera, 500mm telephoto lens, CC10M magenta filter, Fujichrome Velvia film.*

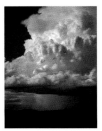

Page 64: Cumulus Cloud, Cascade Range, California, USA
Photograph by Marc Muench
High over the Cascade Range, a cumulus cloud builds to storm force. Visible accumulations of ice and water, clouds come in many shapes and forms. Many clouds look white—because water droplets and ice crystals scatter all portions of the light spectrum equally. Thin clouds allow a significant portion of light to go through them, so we see them as brilliantly white, but as clouds thicken, less light is able to penetrate, dulling that brilliance. The bottoms of clouds often appear darker than the tops, and although they also scatter all portions of the light spectrum, we perceive them as gray. *May 1997. Pentax 6x4.5 camera, 80-160mm zoom lens, Fujichrome Velvia film.*

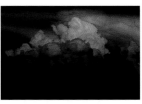

Pages 72–73: Cumulonimbus Clouds, Sonoran Desert, Arizona, USA
Photograph by David Muench
Building to heights of several thousand feet (tens of thousands of feet in some cases), cumulonimbus clouds billow above the desert floor. As the sun heats the ground, the air above it warms and rises. If the air contains moisture, the result can be midafternoon desert thunderstorms. Often thunderstorms are brief with little rain, but if cumulus clouds join up to form a squall line, the resulting storms can be violent and long-lived. Although ample rain may fall, little soaks into the hard desert ground. *September 1999. Canon EOS-3 camera, 100-400mm zoom lens, Fujichrome Provia film.*

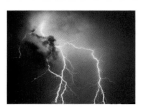

Page 72 (inset): Lightning, Virgin Islands National Park, St. John, Virgin Islands, USA
Photograph by Marc Muench
With a visible upstroke lasting 70 microseconds (70 millionths of a second), catching lightning on film is no easy task. A typical lightning bolt is only inches across, but can travel up to 5 miles (8 kilometers). Although lightning most often occurs in association with cumulonimbus clouds, it can also accompany nimbostratus clouds, snowstorms, dust storms, and volcanic eruptions. This image was taken during a thunderstorm that lasted 30 minutes. The multiple lightning strikes were obtained using a 5-minute exposure. *August 1998. Nikon F4 camera, 20mm wide-angle lens, Fujichrome Velvia film.*

Page 74: Sacaton *(Sporobolus wrightii),* Animas Valley, New Mexico, USA
Photograph by David Muench
Tall grasses, up to 6 feet high, blow in the wind, making waves across the landscape and turning solid land into something more fluid; the Animas Mountains fill the distant horizon. The sense of motion is heightened by this 4-second exposure taken at dawn. Sacaton is most often found at high elevations, above 2,000 feet (600 meters), on alkali soils and bottomlands that experience some flooding. Grasslands also may benefit from burning every three or four years. *February 1993. Linhof 4x5 camera, 75mm wide-angle lens, Fujichrome Velvia film.*

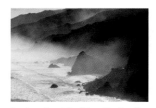

Page 75: Paparoa National Park, South Island, New Zealand
Photograph by David Muench
Mist and water intertwine along the west coast of New Zealand's South Island. Here, air and water merge, spray rises from the waves, and mist condenses over cold currents that flow up from the Antarctic Ocean. The ample precipitation that hits New Zealand's western shore is borne from the sea, and carried by the wind. Two primal forces—sea and air—combine to drench this place, making it one of the wettest locations on Earth. This is also one of the world's most active coastal environments. Pounding waves erode the limestone shoreline creating wonderful shapes, including countless caves and noisy blowholes. *April 1999. Linhof 4x5 camera, 500mm telephoto lens, Fujichrome Velvia film.*

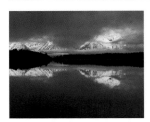

Pages 76–77: Mount Moran, Grand Teton National Park, Wyoming, USA
Photograph by David Muench
Named for landscape artist Thomas Moran, Mount Moran rises 12,605 feet (3,781 meters), making it one of the highest peaks in the Tetons. Unlike other mountains here, Moran is capped by Cambrian sandstone. This sandstone layer has vanished from most of the remainder of the range, victim of constant erosion during the last 9 million years. The uplift that created this range—and that still lifts it—is evidenced by a matching layer of sandstone that lies 24,000 feet (7,200 meters) belowground. *June 1998. Linhof 4x5 camera, 300mm telephoto lens, Fujichrome Velvia film.*

Page 78: Sonoran Desert, Arizona, USA
Photograph by David Muench
A storm dissipates at sunset. Less than 10 inches (250 millimeters) of rain falls in the Sonoran Desert each year; what does fall, usually runs off into wadis and streambeds; little water soaks into the ground. The desert spreads across 120,000 square miles (310,000 square kilometers) of the southwestern United States and northern Mexico. Native to this desert, the saguaro cactus *(Cereus giganteus)* may grow to 50 feet (15 meters) tall. It takes 10 years to grow less than an inch (2 centimeters) and at least 50 years to reach maturity and bloom. *September 1999. Linhof 4x5 camera, 500mm telephoto lens, Fujichrome Velvia film.*

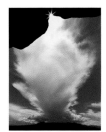

Page 79: Cumulonimbus Cloud, Carrizo Mountains, Arizona, USA
Photograph by Marc Muench
Rising to heights of 34,650 feet (10,500 meters), a cumulonimbus cloud rises until it meets the tropopause—the boundary between the troposphere and the stratosphere. Air temperature declines with height—reaching as low as −80°F (−62°C). This temperature drop is suddenly reversed at the tropopause due to high levels of ultraviolet radiation; the temperature may actually rise to +65°F (18°C). Prevented from rising higher by this warm air, the storm cloud flattens out, forming a distinctive anvil head. *July 1999. Contax 6x4.5 camera, 35mm wide-angle lens, Fujichrome Velvia film.*

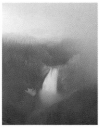

Page 80: Yellowstone Falls, Yellowstone National Park, Wyoming, USA
Photograph by David Muench
Tumbling 308 feet (92 meters) to the floor of the Grand Canyon of the Yellowstone, Yellowstone Falls channels an estimated 64,000 gallons (243,200 liters) of water a minute when swollen by winter snowmelt. The Yellowstone River has carved a canyon 1,200 feet (360 meters) deep at its deepest, and up to 4,000 feet (1200 meters) across. In this image, early morning fog shrouds the falls, one moment they are invisible, then they emerge, a primal force springing forth out of the void. *June 1999. Linhof 4x5 camera, 500mm telephoto lens, Fujichrome Velvia film.*

Page 81: Mono Lake, Mono Lake Tufa State Reserve, California, USA
Photograph by David Muench
One of the oldest continually existing lakes in North America, Mono Lake is more than 730,000 years old. During the Pleistocene, the lake was 900 feet (300 meters) deep. Between 1941 and 1988, up to 60 percent of the water flowing into the lake was diverted to supply Los Angeles, and the lake's water level dropped by 40 feet (13 meters). Since 1988 careful management has helped restore the lake. Tufa formations are created as limestone precipitates around freshwater springs on the lake bed. *November 1999. Linhof 4x5 camera, 210mm medium telephoto lens, Fujichrome Velvia film.*

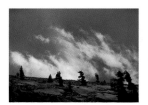

Page 82: Olmsted Point, Yosemite National Park, California, USA
Photograph by Marc Muench
A storm clears over Olmsted Point, adding a sense of uncertainty to this fall day. Clouds are made up of ice crystals, and just as drops of water in the air can refract sunlight to form a rainbow, so can ice crystals. Each crystal functions as a prism, separating white sunlight into its constituent colors. Storms are common in these mountains; they build over the peaks as warm, moist air is forced to rise over the ranges. A combination of wind, rain, and ice sculpts these mountains, breaking apart rock as hard as granite, as water penetrates into deep cracks and forces the rock apart from the inside out. *September 1997. Pentax 6x4.5 camera, 80-160mm zoom lens, Fujichrome Velvia film.*

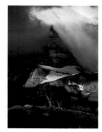

Page 83: Mount Gould, Glacier National Park, Montana, USA
Photograph by David Muench
Glacier National Park encompasses more than one million acres (400,000 hectares) of America's northern Rockies. Unlike rocks in most mountain ranges in the Rockies, those in Glacier National Park have moved so much that sedimentary Proterozoic rock deposited between 1,600 and 800 million years ago lies on top of younger Cretaceous rocks, thus providing geologists with unparalleled access to ancient rocks. Stromatolite fossils and sedimentation features such as ripples, mud cracks, and even raindrop impressions enable researchers to uncover information about a billion-year-old environment. *June 1999. Canon EOS-3 camera, 100-400mm zoom lens, Fujichrome Provia film.*

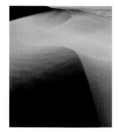

Pages 84–85: Theodore Roosevelt National Park, North Dakota, USA
Photograph by Marc Muench
Named after the "conservation president," this grassland park covers 70,448 acres (28,180 hectares) of Dakota badlands. The rolling hills, valleys, and tablelands formed as streams slowly eroded sediments that were themselves eroded from the Rocky Mountains to the west. Low rainfall, fire, and drought prevent trees from establishing in much of the state, and the park protects the vegetation that dominated the land prior to human settlement. More than 180 species of birds are found here, along with a variety of large mammals. *May 1999. Zone VI 4x5 camera, 210mm medium telephoto lens, Fujichrome Velvia film.*

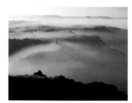

Page 86: Kelso Dunes, Mojave National Preserve, California, USA
Photograph by David Muench
Created in 1994, Mojave National Preserve protects 1.6 million acres (640,000 hectares) of desert biodiversity. Kelso Dunes, in the southwestern portion of the preserve, tower more than 600 feet (180 meters) above the surrounding desert. On occasion, they "boom" or "sing." When sand grains cascade down a dune face they may resonate in audible frequencies. To generate such noises, the grains must be spherical, polished, and extremely dry. The dunes must also be largely devoid of vegetation. *June 1968. Linhof 4x5 camera, 210mm medium telephoto lens, Kodak Ektachrome Daylight film.*

Page 87: White Sands National Monument, New Mexico, USA
Photograph by David Muench
Just as waves leave ripples on a beach, the wind creates a mobile, abstract sculpture out of near-fluid sand. The White Sands lie in the Tularosa Basin in south-central New Mexico. This is the world's largest gypsum dune field at 275 square miles (715 square kilometers). Dunes 10 to 45 feet (3 to 13.5 meters) high shift and flow, blown by relentless southwesterly winds. At times, the winds blow true gales, moving the dunes by dozens of feet. The few plants that eke out a life here are frequently covered, and only the hardiest endure. *July 1978. Linhof 4x5 camera, 360mm telephoto lens, Kodak Ektachrome Daylight film.*

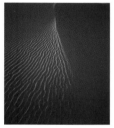

Pages 88–89: Central Elburz Mountains, Iran
Photograph by Marc Muench
Rarely visited by westerners in recent years, the Elburz Mountains dominate Iran's north. Called Reshteh-ye Kuhha-ye Alborz in Persian, the range is 560 miles (900 kilometers) long. The highest point in the range is a dormant volcano called Damavand at 18,602 feet (5,670 meters). The mountains form a distinct climatic and ecological barrier. The north side of the range, covered in lush forests, receives ample snow and rainfall; the southern slopes receive just 11 to 20 inches (280 to 500 millimeters) of precipitation as they merge with the desert of the Iranian Plateau. *March 1997. Pentax 6x4.5 camera, 35mm wide-angle lens, Fujichrome Provia film.*

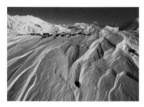

Page 90: Grand Mesa National Forest, Colorado, USA
Photograph by Marc Muench
Colorado's Grand Mesa is an 11,000-foot- (3,300-meter-) high plateau—actually the largest flat-top mountain in the world—that formed during lava flows an estimated 10 million years ago. These lava flows emanated from fissures rather than a volcanic cone, and more than 25 separate flows have been identified. The lava that caps the Grand Mesa is between 200 and 600 feet (60 to 180 meters) thick. Because lava is harder than the surrounding rocks, erosion gradually lowered the area surrounding the Grand Mesa, leaving the plateau a mile above the valleys. In this image, morning fog—the remnants of the previous day's thunderstorms—lingers among the high forest. *July 1999. Pentax 6x4.5 camera, 80-160mm zoom lens, Fujichrome Velvia film.*

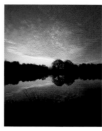

Page 91: Cuyahoga Valley National Recreation Area, Ohio, USA
Photograph by David Muench
Moisture, dust, and other small particles all refract and scatter sunlight. As the sun rises, its rays must pass through denser atmosphere, and that allows particles to scatter the light even more; since the shorter (blue and green) wavelengths are scattered the most, the sunrise (like the sunset) appears orange and red. The unusual name *Cuyahoga* comes from a Native American word—*ka-ih-ohg-ha*—meaning "crooked." The meandering river is only 100 miles (160 kilometers) long, but the twists and turns it takes are deserving of the name. *October 1998. Linhof 4x5 camera, 75mm wide-angle lens, Fujichrome Velvia film.*

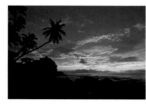

Pages 92–93: Drake Bay, Osa Peninsula, Costa Rica
Photograph by Marc Muench
Sunsets around the world are often enhanced by volcanic eruptions. When volcanoes erupt, they send thousands of tons of material into the atmosphere; small particles remain aloft for months—even years. Prior to Marc's trip to Costa Rica, several local volcanoes had erupted, including Arenal on May 5, 1998, and Rincón de la Vieja on February 16, 1998. Because the jet stream carries volcanic debris around the globe, volcanoes can influence sunsets thousands of miles away. This sunset, photographed on Costa Rica's Pacific coast, whether enhanced by volcanoes or not, is stunning. *June 1998. Canon EOS-1N camera, 17-35mm zoom lens, Fujichrome Velvia film.*

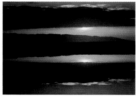

Page 94: Point Reyes National Seashore, California, USA
Photograph by David Muench
A Pacific sunset creates an artist's pallette along the California coast. Part of the Golden Gate Biosphere Reserve, Point Reyes is a small park—100 square miles (260 square kilometers)—but it encompasses panoramic ocean vistas and huge breakers, as well as grassland, shrubland, and forest habitats. Almost one-fifth of California's flowering plants and nearly half of the bird species sighted in North America have been found here. The world's best-known fault—the San Andreas—passes through the park. The shoreline is shaped by the ocean and by the movement of the Pacific and North American Plates. *May 1991. Canon EOS-3 camera, 135mm lens, Fujichrome Provia film.*

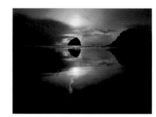

Page 95: Haystack Rock, Cape Kiwanda State Park, Oregon, USA
Photograph by David Muench
Storm clouds part, allowing the sun to illuminate tidal sands at Cape Kiwanda. In the distance, Haystack Rock sits in silhouette. This shoreline is frequently buffeted by high winds and crashing waves. The coastline's sandstone has been heavily eroded, forming caves and pinnacles. Haystack Rock, however, is made of basalt, a volcanic rock that is extremely hard and erosion resistant. Haystack Rock protects Cape Kiwanda by intercepting the largest waves and absorbing much of their energy before they hit shore. *January 1998. Linhof 4x5 camera, 75mm wide-angle lens, Fujichrome Velvia film.*

Page 96: Ship Rock, New Mexico, USA
Photograph by David Muench
The night sky revolves around Ship Rock, a remnant volcanic plug, in this 6-hour exposure. Known as the "Winged Rock" *(Tse' Bit' a' i')* by the Navajo, Ship Rock rises 1,500 feet (457 meters). White settlers thought it resembled a windjammer under sail; Native legends about the rock also have a marine theme. To the Navajo, the rock was once a ship that carried their people from the Far North, saving them from their enemies. In this image, dusk afterglow is still visible on the left, while dawn glow begins to the right; an evening lightning storm in Colorado illuminates the horizon. *September 1999. Linhof 4x5 camera, 75mm wide-angle lens, Fujichrome Velvia film.*

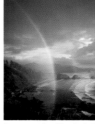

Page 97: Ecola State Park, Oregon, USA
Photograph by David Muench
Drenched by a passing squall, David had almost given up looking for photographic opportunities when the clouds cleared enough for the sun to venture forth with a rainbow. This beautiful arc of color, with each of its constituents clearly visible—violet, indigo, blue, green, yellow, orange, and red—gives a dramatic, evanescent quality to Cannon Beach below. Although we only see a bow-shaped rainbow, rainbows are actually spherical—we can't see the entire rainbow because the Earth is in the way. Incidentally, the lower the sun is to the horizon, the more of the circular rainbow we can see; so at sunset, a rainbow becomes a full semicircle. *April 1991. Linhof 4x5 camera, 90mm wide-angle lens, polarizer, Fujichrome Velvia film.*

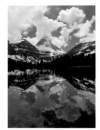

Page 98: Lake Magog, Mount Assiniboine Provincial Park, British Columbia, Canada
Photograph by David Muench
Cumulus clouds build and dissipate over Lake Magog, the largest lake in the park. Snowfall in British Columbia's Rocky Mountains averages 67 to 81 inches (171 to 206 centimeters) each winter, and snow remains on the highest peaks, including Mount Assiniboine, throughout the year. Spring comes late to the mountains; although some flowers may bloom as early as April in the lower valleys, June can still be considered a spring month. Mountain weather is fickle, however, and snow may fall at any time. *July 1998. Linhof 4x5 camera, 75mm wide-angle lens, Fujichrome Velvia film.*

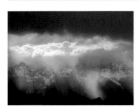

Page 99: Teton Range, Grand Teton National Park, Wyoming, USA
Photograph by David Muench
An early summer storm lights the sky above Jackson Hole and the Teton Range. June typically sees more rain than the other summer months in the Tetons, but thunderstorms are fairly regular occurrences from May to September. Temperatures range from the occasional 80°F (26.7°C) in the summer to well below 0°F (–17.8°C) on winter nights; frosts are possible throughout the year, as is snow, although most falls between October and April. The average snowfall recorded at Moose is 191 inches (485 centimeters), or nearly 16 feet. *June 1998. Canon EOS-3 camera, 100-400mm zoom lens, Fujichrome Provia film.*

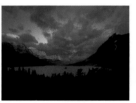

Pages 100–101: St. Mary's Lake, Glacier National Park, Montana, USA
Photograph by David Muench
Glacier National Park is a superb example of a glacially carved landscape, with U-shaped valleys, hanging valleys, crystal blue and emerald green lakes, bowl-shaped cirques, and glacial horns (mountain peaks eroded on three or four sides). Ten thousand years ago, ice dominated the landscape. As the climate warmed, the ice retreated, and by 5,000 years ago, most of the glaciers had vanished or retreated to the highest elevations. Today, about 50 small alpine glaciers remain in the park. *June 1999. Linhof 4x5 camera, 75mm wide-angle lens, CC10M magenta filter, Fujichrome Velvia film.*

Page 102: Double Rainbow, Verde Valley, Arizona, USA
Photograph by David Muench
A double rainbow fills the sky above Verde Valley as a huge lightning storm leaves Mingus Mountain. Primary rainbows are caused by light refracted as it passes through raindrops; the larger the raindrops the more vivid the colors. Occasionally, a secondary rainbow is visible, caused by a second internal reflection inside the raindrops. Light rays leave a primary rainbow at an angle of 42 degrees, while they leave the secondary bow at an angle of 53 degrees. The colors in the secondary bow are also reversed compared to the primary, and the colors are less intense. *September 1999. Canon EOS-3 camera, 100-400mm zoom lens, Fujichrome Provia film.*

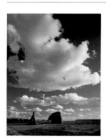

Page 103: Lukachukai Country, Arizona, USA
Photograph by David Muench
Sandstone formations sculpted by wind and rain stand beneath billowing cumulus clouds. The clouds form during the day as the sun heats the ground, which in turn heats the air. As the warm air rises, it cools, and the water vapor condenses and freezes to form clouds. If the clouds build, they may darken, and rain may fall. In all regions but the tropics, rain begins as ice crystals. As the ice crystals grow, they eventually become too heavy to remain aloft, and they begin to fall— as snowflakes. If the air beneath the cloud is warm, the snowflakes melt, and it rains. *October 1999. Linhof 4x5 camera, 75mm wide-angle lens, polarizer, Fujichrome Velvia film.*

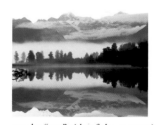

Pages 104–5: Lake Matheson, Westland National Park, South Island, New Zealand
Photograph by David Muench
The Maori revered Mounts Tasman and Cook as children of Rangi´, the sky father, and it is moments like this, captured on film, that seem to blur the line between land and air. Westland National Park is part of Te Wahipounamu, the Southwest New Zealand World Heritage Area. Located on the "wet" side of the mountains, it receives ample rainfall. The park includes some of the highest peaks of the Southern Alps, more than 60 glaciers, vast snow fields, hot springs, waterfalls, alpine grasslands, and lowland forests, lakes, and rivers. *April 1999. Linhof 4x5 camera, 500mm telephoto lens, CC10M magenta filter, Fujichrome Velvia film.*

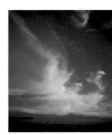

Page 106: Storm Clouds, Arizona, USA
Photograph by Marc Muench
Luke Howard, father of modern meteorology, wrote: "The sky too belongs to the landscape. The ocean of air in which we live and move, in which the bolt of heaven is forged, and the fructifying rain condensed, can never be to the zealous Naturalist a subject of tame and unfeeling contemplation." Despite holding just 0.001 percent of Earth's water, clouds give the air substance and depth. It is no wonder that poets and writers have waxed lyrical about their shifting, flowing countenances. In this image, a dissipating thunderhead is bathed in warm, evening light. *October 1990. Pentax 6x7 camera, 45mm wide-angle lens, Fujichrome Velvia film.*

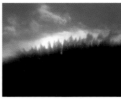

Page 107: Sawtooth Mountains, Sawtooth National Recreation Area, Idaho, USA
Photograph by Marc Muench
Part of the Rocky Mountain system, the Sawtooth Mountains are one of four ranges (others are the Boulder, White Clouds, and Smoky Mountains) included in the Sawtooth National Recreation Area. More than 40 peaks in the region exceed 10,000 feet (3,000 meters). In this glacier-carved landscape, more than 300 lakes dot the wilderness, and the Salmon, Payette, Boise, and Bigwood Rivers have their headwaters here. This backlit image was darkened in Adobe Photoshop™ to enhance the contrast and bring out the trees' delicate shadows. *August 1996. Zone VI 4x5 camera, 450mm telephoto lens, Fujichrome Velvia film.*

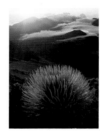

Page 108: Silversword (Argyroxiphium sandwicense), Haleakala National Park, Maui, Hawaiian Islands, USA
Photograph by David Muench
Growing on the slopes of Haleakala, the world's largest dormant volcanic crater, are rare silverswords—named for their silver, sword-shaped leaves. Each plant blooms only once during its 5-to-15-year lifespan. Haleakala, the only place where silverswords can be found, hasn't been active since 1790, but a large eruption could wipe out the remaining endangered plants. An early-morning trip to see the sun rise—from inside the crater—is a magical experience. *April 1995. Linhof 4x5 camera, 210mm telephoto lens, Fujichrome Velvia film.*

Page 116: Kalapana Coastline, Hawaii Volcanoes National Park, Hawaii, Hawaiian Islands, USA
Photograph by David Muench
Hawaii is the youngest of the major Hawaiian Islands; its principal lava flows are just 700,000 years old. The island is made up of 5 shield volcanoes: Mauna Loa, Kilauea, Kohala, Haulalai, and Mauna Kea. Mauna Loa and Kilauea are both active; Kohala and Mauna Kea, inactive. Haulalai last erupted in 1801. Here, lava from Kilauea explodes into the Pacific surf. David hand-held the camera to give himself greater mobility. He used a half-second exposure to capture this image. *April 1985. Leicaflex camera, 50mm lens, Kodak Ektachrome Daylight film.*

Page 116 (inset): Morning Glory Pool, Yellowstone National Park, Wyoming, USA
Photograph by David Muench
The Morning Glory Pool is probably Yellowstone's best-known feature, next to Old Faithful. Located inside the caldera, this deep-blue pool is tinged in yellows and oranges, colors that result from thermophilic bacteria that thrive in these waters; unfortunately, vandals have dulled the colors by throwing objects into the pool. Photosynthetic bacteria survive water temperatures of 194°F (90°C); Archaea bacteria, known as hyperthermophiles, survive at even greater temperatures—230° to 239°F (110° to 115°C). *June 1998. Canon EOS-3 camera, 14mm ultra-wide-angle lens, Fujichrome Provia film.*

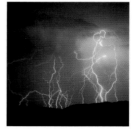

Page 117: Lightning, Los Padres National Forest, California, USA
Photograph by Marc Muench
Jagged bolts fill the sky in a pattern that resembles blood vessels in a human organ. This image was obtained by opening the shutter for 15 minutes and switching back and forth between red and blue colored filters. People have long sought to understand lightning. The Romans, Mayans, Incas, and Syrians all credited their gods. Aristotle was among the first to search for a more rational explanation. He believed lightning was caused by wind ejected from the clouds. *September 1991. Zone VI 4x5 Camera, 210mm medium telephoto lens, red and blue filters, Kodak Ektachrome 64 Daylight film.*

Page 118: Hawaii Volcanoes National Park, Hawaii, Hawaiian Islands, USA
Photograph by G. Brad Lewis
A lava bubble more than 30 feet (9 meters) in diameter bursts as water floods a lava tube. As the lava shoots upward, fractured sheets of hot glass are visible. Hawaiian lava is fluid, flowing like molten rivers down the flanks of volcanoes or spewing forth from lateral vents. Liquid lava that has just erupted may be 2,200°F (1,200°C). As it cools, its minerals solidify. However, if it cools rapidly, compounds in the lava cannot form minerals, and the result is glass. If it cools slowly, the minerals crystallize into distinctive, angular shapes. *December 1995. Nikon N90S camera, 80-200mm zoom lens, Fujichrome Velvia film.*

Page 119: Pahoehoe Lava, Hawaii Volcanoes National Park, Hawaii, Hawaiian Islands, USA
Photograph by David Muench
Pahoehoe lava (pronounced *pa hóy hóy*) forms when fluid lava congeals into a wrinkled, ropy surface. The island of Hawaii is the result of thousands of individual lava flows, each raising the surface a few feet higher. Often the surface cools and solidifies while liquid lava still flows underneath, forming a lava tube. When the flow stops, the tube is left empty. One lava tube on Kilauea is 20 feet (6 meters) high and 22 feet (6.6 meters) wide. Within a few months of an eruption, the surface may be colonized by scattered plants. *April 1989. Linhof 4x5 camera, 210mm medium telephoto lens, Fujichrome Velvia film.*

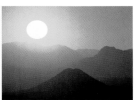

Pages 120–121: Patagonia, Santa Rita Mountains, Arizona, USA
Photograph by David Muench
The sun casts its golden light across southeastern Arizona. The orb may be an average of 93 million miles (149.5 million kilometers) away, but it is the life force of our planet—the source of the energy that drives our oceans and our atmosphere, and that sustains the vast majority of biological systems. The sun lights our days and even colors our nights, reflecting off the moon and giving rise to polar auroras. *May 1983. Linhof Kardigan 4x5 camera, 1000mm telephoto lens, Wratten G-orange filter, Kodak Ektachrome Daylight film.*

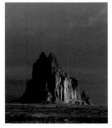

Page 122: Ship Rock, New Mexico, USA
Photograph by David Muench
Composite and shield volcanoes, calderas, major ash flows, pahoehoe and aa lava, maar craters, fissure eruptions, and cinder cones are all found in New Mexico. Ship Rock is considered a perfect example of a volcanic "plug." The rock tower was the core of a volcano 27 to 32 million years ago. All that is left of the volcano is the "plug" of material that solidified within the vents. Located in the Chuska volcanic field, Ship Rock formed following a maar-type eruption—a maar is a crater formed by shallow eruptions. Over time, surrounding softer rock eroded, revealing the tower. *September 1999. Linhof 4x5 camera, 210mm medium telephoto lens, Fujichrome Velvia film.*

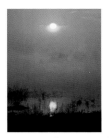

Page 123: Tupelo National Battlefield, Mississippi, USA
Photograph by David Muench
From space, the sun appears white, but from Earth, it is yellow due to the scattering properties of our atmosphere—key to life's existence here. Without the natural "greenhouse effect" caused by traces of carbon dioxide, our planet would be frigid like Mars. Atmospheric layers also protect us from harmful levels of solar radiation. In the stratosphere, ultraviolet radiation causes molecular oxygen (O_2) to dissociate, forming atomic oxygen (O), which combines with the remaining molecular oxygen to form ozone (O_3); ozone is a barrier to UV radiation, protecting life on earth from mutagenic rays. *October 1984. Linhof 4x5 camera, 300mm telephoto lens, Ektachrome Daylight film.*

Pages 124–25: Grand Prismatic Spring, Yellowstone National Park, Wyoming, USA
Photograph by David Muench
Charred lodgepole pines (*Pinus contorta*), victims of the 1988 fire, stand silently near Yellowstone's—and North America's—largest hot spring. Part of the Midway Geyser Basin, this spring still pumps out more than 4,000 gallons (15,200 liters) of boiling water a minute. Excelsior Geyser once erupted here, but it is believed that its last eruption, in 1888, removed the pressure that fires a geyser skyward. The brilliant colors are from bacterial and algal mats that thrive in boiling water. Many worried that the 1988 fires might destroy the springs. Fortunately they were wrong. *June 1999. Linhof 4x5 camera, 210mm medium telephoto lens, Fujichrome Velvia film.*

Page 126: Elk *(Cervus elaphus)*, Firehole River, Yellowstone National Park, Wyoming, USA
Photograph by Marc Muench
A bull elk settles down in the snow near Yellowstone's Firehole River. An average snowfall of twelve and a half feet (3.75 meters) blankets Yellowstone each winter. Many animals leave the park, migrating south to warmer climes; others hibernate in protected dens. The larger mammals tend to endure rather than flee. Elk and bison *(Bison bison)* are often seen standing in hot pools, their coats frosted by steam. Many will not make it to spring, but the strongest will see the winter through with stoic fortitude. *March 1997. Canon EOS-1N camera, 70-200mm zoom lens, 1.4 converter, Fujichrome Provia film.*

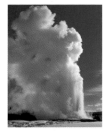

Page 127: Old Faithful Geyser, Yellowstone National Park, Wyoming, USA
Photograph by Marc Muench
Old Faithful is the icon geyser of Yellowstone. Located in the Upper Geyser Basin, Old Faithful is not Yellowstone's largest geyser, nor even the most regular, but its name has become synonymous with the park. It has erupted 20 to 23 times each day for the last 120 years. Each eruption lasts between 2 and 5 minutes and sends 3,700 to 8,400 gallons (14,000 to 32,000 liters) of water 130 feet (39 meters) skyward. Old Faithful's temperature can reach 204°F (95.5°C) during an eruption. *March 1997. Pentax 6x4.5 camera, 80–160mm lens, Fujichrome Provia film.*

Page 128: Littoral Cone, Kamoamoa, Hawaii Volcanoes National Park, Hawaii, Hawaiian Islands, USA
Photograph by G. Brad Lewis
For 3 hours explosions rocked this coast as lava shot 200 feet (60 meters) into the air. The display was caused by ocean water entering the lava-tube system and meeting hot lava. The sound was like a jet taking off. As lava poured forth, it built up a littoral cone in the surf. Within hours the cone was 30 feet (9 meters) high—as seen in this picture, taken at dawn, using a 30-second exposure. Within a year, the cone was gone, the site covered by additional lava flows. The new land extended the island by more than half a mile. *November 1992. Nikon N90S camera, 24mm wide-angle lens, Fujichrome Velvia film.*

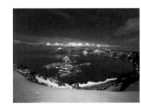

Page 129: Wizard Island, Crater Lake National Park, Oregon, USA
Photograph by David Muench
The caldera of Crater Lake is all that remains of 12,000-foot (3,600-meter) Mount Mazama. Mazama began to grow during the Pleistocene, 75,000 years ago. The most destructive eruptions took place approximately 6,845 years ago. Twenty-five cubic miles (105 cubic kilometers) of material were sent into the air—more than 40 times that ejected by the 1980 eruption of Mount St. Helens. The caldera then collapsed in on itself. A thousand years ago, a new cinder cone began to grow in the crater, and it now forms Wizard Island. *June 1991. Linhof 4x5 camera, 75mm wide-angle lens, Fujichrome Velvia film.*

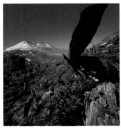

Page 130: Mount St. Helens, Mount St. Helens National Volcanic Monument, Washington, USA
Photograph by David Muench
On May 18, 1980, one of the largest volcanic eruptions to occur in North America in historic times tore apart Mount St. Helens. In the weeks before the cataclysm, 10,000 earthquakes rocked the area. A landslide finally precipitated the eruption. In seconds, the elegant volcano was transformed into a desolate, lunar-like landscape. In 1999, David was amazed at the regeneration taking place: life really does find a way to prosper under even the most arduous of circumstances. *July 1999. Linhof 4x5 camera, 75mm wide-angle lens, 81EF warming filter, Fujichrome Velvia film.*

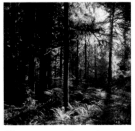

Page 131: Gifford Pinchot National Forest, Cascade Range, Washington, USA
Photograph by David Muench
Gifford Pinchot National Forest was set aside in 1897 as part of Mount Rainier Forest Reserve. It covers 1.3 million acres (520,000 hectares), including 110,000-acre (44,000-hectare) Mount St. Helens National Volcanic Monument. The area includes the longest lava tube in the contiguous United States. Known as the Ape Cave, it is 12,810 feet (3,843 meters) long. The temperate forests here are filled with old-growth western red cedar (*Thuja plicata*), western hemlock (*Tsuga heterophylla*), and Douglas fir (*Pseudotsuga menziesii*). *June 1999. Linhof 4x5 camera, 75mm wide-angle lens, 81EF warming filter, Fujichrome Velvia film.*

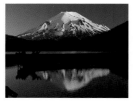

Page 131 (inset): **Mount St. Helens and Spirit Lake, Mount St. Helens National Volcanic Monument, Washington, USA**
Photograph by David Muench
Before its 1980 eruption, Mount St. Helens was a picture-perfect volcano. That changed one Sunday, when 10 million trees were flattened by the eruption, and lakes and streams were clogged and dammed with ash, mud, and silt. The 9,680-foot (2,950-meter) peak was replaced by a horseshoe-shaped crater about 8,000 feet (2,400 meters) high. The eruption did not destroy the volcano, however; since 1980, a new cone has built up inside the crater. One day, Mount St. Helens will likely roar to life again. *June 1968. Linhof 4x5 camera, 210mm medium telephoto lens, CC10R red filter, Kodak Ektachrome Daylight film.*

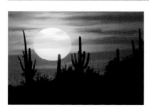

Pages 132–33: **Saguaro Cactus *(Cereus giganteus),* Sonoran Desert, Santa Catalina Mountains, Arizona, USA**
Photograph by David Muench
Saguaro cacti are well adapted to the dry desert. They have very shallow, wide-ranging roots that allow them to gather water from some distance away. When water is available, their ribbed trunks store the water in their tissues. A lack of leaves reduces the water lost by evaporation; the spines protect the plants from animals and reduce air movement close to their trunks, further reducing evaporation. With no leaves for photosynthesis, their green trunks take over that role. Despite the harsh environment, saguaro may live for 200 years. *August 1998. Canon EOS-1N camera, 500mm telephoto lens, Fujichrome Provia film.*

Page 134: **Teddy Bear Cholla *(Opuntia bigelovii),* Anza-Borrego Desert State Park, California, USA**
Photograph by David Muench
The desert offers some wonderful contradictions: beauty wrapped in thorns is one of them. Cholla are well known to desert hikers. Their hooked spines evolved to catch onto the fur of passing animals—but clothing, a hiking boot, or skin serves just as well. The teddy bear cholla, also known as the jumping cholla, gets its primary name from its soft, fuzzy appearance. It is a nice illusion, but the "hairy" covering is, in reality, sharp, minutely barbed, painful spines. *April 1998. Linhof 4x5 camera, 210mm medium telephoto lens, Fujichrome Velvia film.*

Page 135: **Teardrop Arch, Monument Valley Navajo Tribal Park, Arizona, USA**
Photograph by David Muench
Eroded by wind and rain, sandstone is sculpted into extraordinary shapes. Here, the sun streams through Teardrop Arch. While deserts are typically viewed as perpetually hot, they turn frigid at night; lack of cloud cover means that rocks lose heat rapidly when the sun sets. Temperatures can reach 100°F (38°C) or higher in the daytime and 32°F (0°C) or lower at night. Moisture penetrates rock cracks, and if it freezes at night, the water expands, forcing cracks wider and breaking the rock into pieces. *June 1983. Linhof 4x5 camera, 210mm medium telephoto lens, Kodak Ektachrome Daylight film.*

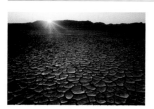

Pages 136–37: **Black Rock Desert, Nevada, USA**
Photograph by David Muench
One thousand square miles (2,600 square kilometers) of lava beds and alkali flats make up the Black Rock Desert—the result of volcanic activity 2.5 million years ago. This area, once Lake Lahontan, is now North America's largest perfectly flat landscape. At times, a few inches of water covers the ancient lake bed. Evaporation is rapid, and with 100°F (38°C) temperatures, mud cracks form mathematically perfect patterns as the sun bakes the ground. Dust storms sometimes sweep across the playa, blocking out the sun and covering everything with harsh, stinging grit. *July 1985. Linhof 4x5 camera, 75mm wide-angle lens, Kodak Ektachrome Daylight film.*

Page 137 (inset): **Pictograph, Cataviña, Baja California, Mexico**
Photograph by David Muench
A carefully rendered image of the sun colors a granite boulder in Baja California Norte. Rock art has been practiced for thousands of years by indigenous peoples around the world. Through these images it is possible to catch a glimpse of how ancient peoples saw their world at the dawn of civilization. Images immortalized on stone may have been used to invoke deities, to tell stories, or simply to create an aesthetically pleasing picture. Petroglyphs were either carved into the rock or painted with natural dyes gathered from plants or minerals. Thousands of petroglyphs have been discovered in canyons, caves, and escarpments. *February 1992. Linhof 4x5 camera, 75mm wide-angle lens, CC10R red filter, Fujichrome Velvia film.*

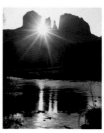

Page 138: **Red Rock Crossing, Oak Creek Canyon, Arizona, USA**
Photograph by David Muench
Sinagua and Yavapai Native peoples once called this region home. Manzanita *(Arctostaphylos sp.)* and juniper *(Juniperus sp.)* are found on the valley floor and along waterways, while green meadows provide habitat for a variety of birds. The area has been shaped by deserts, rivers and river deltas, oceans and lakes, and volcanoes. Fossils reveal horn corals, bryozoans, brachiopods, and ammonites, which flourished here in a time when waves lapped a now-vanished shoreline. Other fossils point to life that lived in lush river valleys and deltas, before the desert encroached once again. *November 1999. Linhof 4x5 camera, 300mm telephoto lens, Fujichrome Velvia film.*

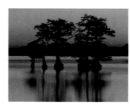

Page 139: **Bald Cypress *(Taxodium distichum),* Reelfoot Lake, Reelfoot National Wildlife Refuge, Kentucky, USA**
Photograph by David Muench
Dawn glow highlights a grove of bald cypress trees in this 20-second exposure. Often called swamp cypress, bald cypress is an aquatic species that thrives in wetland habitats. The tree evolved to fill an aquatic niche that few other trees can exploit. They have tapering trunks that enlarge at the base to form broad buttresses, giving them a pyramidal shape. The trees have horizontal roots that send out conical, woody projections, called "knees," above the waterline. These "knees" allow the roots to breathe even when inundated. *October 1988. Linhof 4x5 camera, 500mm telephoto lens, CC10R red filter, Fujichrome Velvia film.*

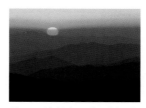

Pages 140–41: **Clingmans Dome, Great Smoky Mountains National Park, North Carolina, USA**
Photograph by David Muench
Shadowed planes reveal the heavily eroded Appalachians. One of the oldest ranges on Earth, these mountains were born out of the collision of Laurasia and Gondwana 390 million years ago. They show what happens when time meets rock. Along with high peaks of the Great Smoky Mountains, 6,684-foot (2,037-meter) Mount Mitchell is the high point of the 1,180-mile (1,900-kilometer) Appalachian mountain chain. Time has made changes (the Appalachians once rivaled the Himalayas in grandeur), but it has not lessened the beauty of this range. *May 1991. Linhof 4x5 camera, 300mm telephoto lens, Fujichrome Velvia film.*

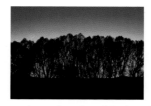

Page 142: **Trembling Aspen *(Populus tremuloides),* Brazos Mountains, New Mexico, USA**
Photograph by Marc Muench
A crescent moon sets at dusk in northern New Mexico. Though less than one-third the size of Earth, the moon has significant impact on terrestrial life. It is a source of navigation for birds and insects. Corals spawn in tune with the waxing and waning of the lunar body; marine organisms shift with the tides, feeling the pull of a body 239,900 miles (384,400 kilometers) distant. The origin of the moon is still subject to debate. But whatever its origins, the moon is a part of our daily life. *October 1999. Canon EOS-1N camera, 100-400mm zoom lens, Fujichrome Velvia film.*

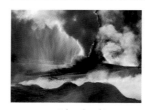

Page 143: **Castle Geyser, Yellowstone National Park, Wyoming, USA**
Photograph by David Muench
Castle Geyser, in Upper Geyser Basin, was named for the castle-like mound of minerals that has precipitated around its mouth. As the boiling water spurts out, it cools rapidly, depositing silica. Geysers need water, a heat source (from volcanic activity), a pressure-tight plumbing system, and constriction in that system to allow the geyser to build up pressure (resulting from deposits of silica that seal gaps between the rocks below ground). It is rare that are all factors are met. Here, Castle Geyser's eruption is backlit to enhance the primordial drama. *June 1999. Canon EOS-3 camera, 100-400mm zoom lens, Fujichrome Provia film.*

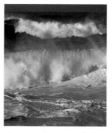

Page 144: **Montaña de Oro State Park, California, USA**
Photograph by David Muench
Although oceans cover 71 percent of our planet, parts of the moon are better known than the ocean depths. The voyages we make into this alien, liquid world are tentative and confined. It is an ever-changing landscape in which we are unlikely ever to feel at home. Whereas every continent is now inhabited, the oceans draw us mainly for what we can take from them: fish, minerals, petroleum, gas. But there is so much more to discover and appreciate, including intelligences that may be a match for our own; forms of life that rely on the upwellings of volcanoes, not on the energy of the sun; and vast mountain ranges that rival, and even dwarf, those that sit atop continents. *March 1985. Linhof 4x5 camera, 500mm telephoto lens, Kodak Ektachrome Daylight film.*

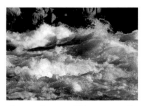

Pages 152–53: **Granite Rapids, Colorado River, Grand Canyon National Park, Arizona, USA**
Photograph by David Muench
John Wesley Powell named Granite Gorge and rapids during his 1869 exploration. He eloquently described them in *The Exploration of the Colorado River and its Canyons:* "We can see but a little way into the granite gorge, but it looks threatening. . . . The canyon is narrower than we have ever before seen it; the water is swifter; there are but few broken rocks in the channel; but the walls are set, on either side, with pinnacles and crags; and sharp, angular buttresses, bristling with wind- and wave-polished spires, extend far out into the river." *August 1997. Canon EOS-1N camera, 135mm lens, Fujichrome Provia film.*

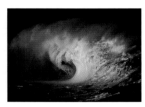

Page 154: **Waimea Bay, Oahu, Hawaiian Islands, USA**
Photograph by G. Brad Lewis
Lit by first light, a 30-foot (9-meter) wave breaks on Oahu's north shore. Waves result from interaction of atmosphere and ocean. Wind washes over the ocean, pushing denser water ahead and transfering energy to the water, building a wave. The wave's height is proportional to the wind's speed. Breaking waves also play a role in the hydrological cycle. A crashing wave traps air bubbles, facilitating absorption of oxygen and other gases into the water. The activity also throws salt into the air, allowing the wind to carry it aloft; salt molecules often serve as nuclei around which raindrops form. *February 1996. Nikon N90S camera, 500mm telephoto lens, Fujichrome Velvia film.*

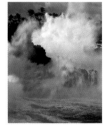

Page 155: **Nevada Falls, Yosemite National Park, California, USA**
Photograph by David Muench
The Merced River descends toward Nevada Falls. The Sierra Nevada, of which Yosemite is a part, began rising about 100 million years ago. The ancestral Merced River eroded downward as the mountains around it were uplifted. Before the Ice Age, about 3 million years ago, the Merced had cut a V-shaped canyon along its course. But when glaciers grew in the mountains, the flowing, liquid river was replaced by a massive plough of ice, and the V-shaped valley gave way to the U-shaped valley of today. Now that the ice has gone, the Merced is once again cutting a V-shaped valley for its waters. *May 1999. Linhof 4x5 camera, 300mm telephoto lens, Fujichrome Velvia film.*

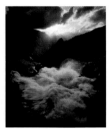

Page 156: **Kalapana Coastline, Hawaii Volcanoes National Park, Hawaii, Hawaiian Islands, USA**
Photograph by David Muench
Hawaii is a growing land. Volcanoes spew out liquid rock that spreads and creates new land. But the sea is not passive, and what volcanoes seek to create, the ocean works to erode away. As the Pacific Plate shifts, and with it the "hot spot" that has given birth to each volcano, the supply of magma will vanish and the volcanoes will be declared extinct. Erosion will claim the inactive peaks. Isolated in the midst of a great ocean, the Hawaiian Islands are equal parts fire and water—born of one and shaped and hewn by the other. *April 1978. Linhof 4x5 camera, 300mm telephoto lens, Kodak Ektachrome Daylight film.*

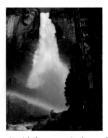

Page 157: **Nevada Falls, Yosemite National Park, California, USA**
Photograph by David Muench
Rainlike spray rises from Nevada Falls' plunge basin. In Yosemite, hanging valleys left by long-vanished glaciers present sudden drops for the rivers, sending them into oblivion for a few glorious moments where air and water intertwine. However, Nevada Falls does not cascade over a hanging valley; it and Vernal Falls, just below, descend giant steps carved into the granite cliffs by the Merced Glacier. The Merced River tumbles 2,000 feet (600 meters) in just 1.5 miles (2.4 kilometers) along this part of its course, with nearly half of that descent achieved by these two falls. *May 1999. Linhof 4x5 camera, 210mm medium telephoto lens, Fujichrome Velvia film.*

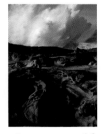

Page 158: **Cape Arago State Park, Oregon, USA**
Photograph by David Muench
Just south of Coos Bay lies Cape Arago. The thick layers of sand and mud that form the cape were deposited during the Eocene Epoch, 57 million to 36 million years ago. When these rocks were laid down, the Earth was in the midst of the "dawn" of recent life. The Eocene marked the emergence of many animals we would recognize today, including hoofed animals such as Eohippus, the "dawn horse," and marine mammals such as whales and manatees. In this image, huge winter waves send forth a dramatic display of swirling spray and foam. The rock formations are so tilted that the waves are hurled back seaward on impact, creating cacophonous fanlike displays. *January 1992. Linhof 4x5 camera, 300mm telephoto lens, Fujichrome Velvia film.*

Page 159: **Steller Sea Lions *(Eumetopias jubatus)*, Princess Royal Island, British Columbia, Canada**
Photograph by Marc Muench
Male Steller, or northern, sea lions are much larger than females and weigh in excess of 2,200 pounds (1,000 kilograms); females average 600 pounds (270 kilograms). Sea lions favor rocky coasts and islands, where they hunt fish, octopus, squid, and crustaceans. During the breeding season, males guard 10 to 30 females. In the 1960s, the estimated Steller sea lion population was 240,000 to 300,000. By 1989, the worldwide population was just 116,000. The reason for the decline is unknown but may be linked to disease, competition with fishing fleets, and deliberate killing. *October 1999. Canon EOS-1N camera, 100-400mm zoom lens, Fujichrome Provia film.*

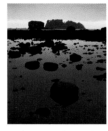

Page 160: **Ozette Coast Village, Olympic National Park, Washington, USA**
Photograph by David Muench
A deceptively calm moment marks low tide along the coast of Washington State. In actuality, the intertidal zone is one of the harshest environments on Earth, for here organisms must cope with a variety of environmental conditions, from complete inundation by seawater to being left high and dry when the tide is out. Seaweeds, mollusks, crustaceans, and fish here must endure being covered with sand and constantly moving pebbles and rocks, as well as being exposed to the hot, desiccating sun. *July 1991. Linhof 4x5 camera, 75mm wide-angle lens, Fujichrome Velvia film.*

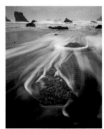

Page 161: **Bandon Beach, Oregon, USA**
Photograph by David Muench
A vigorous tidal outflow washes back toward the Pacific. A winter storm pounded this beach for several days prior to David's visit, redesigning the landscape. The shoreline experiences 2 high tides and 2 low tides during every 25-hour period. This regular influx of the tide combines the sea's productivity with that of the land. The rush of water, however, can create problems for local wildlife. In places, the sea level may change by as much as 6 feet (2 meters) in a single day and as much as 15 feet (4.5 meters) over the course of a year. Coastal species must adapt, move, or perish. *January 1995. Linhof 4x5 camera, 75mm wide-angle lens, Fujichrome Velvia film.*

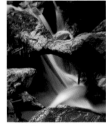

Page 162: **Roaring Fork River, Collegiate Peaks Wilderness, Sawatch Range, Colorado, USA**
Photograph by David Muench
Water cascades down the Roaring Fork River, its movement blurred in this 5-second exposure. The Roaring Fork River is just 60 miles (96 kilometers) long, rising near 12,093-foot (3,628-meter) Independence Pass and joining the Colorado River in Glenwood Springs. Along its short route, the river is transformed from a meandering stream to a raging river. The upper river in particular tumbles over rocks and fallen trees, fighting its way downhill under natural bridges of its own making. *July 1991. Linhof 4x5, 90mm wide-angle lens, Fujichrome Velvia film.*

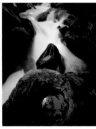

Page 163: **Avalanche Creek, Glacier National Park, Montana, USA**
Photograph by David Muench
A 3-second exposure blurs the lines between rock and water in this image of water flowing across glacially polished rocks. Located in the central portion of the park, along the Going-to-the-Sun Road, Avalanche Creek flows from Avalanche Lake, which is fed by runoff from Sperry Glacier. Flow during the summer is further supplemented by the 2 to 3 inches (50 to 76 millimeters) of rainfall the park receives each month. David waited until there was a break in the clouds and clicked the shutter: the reflection of trees and blue sky in the lower pool was the successful result. *June 1999. Linhof 4x5 camera, 75mm wide-angle lens, Fujichrome Velvia film.*

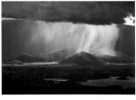

Pages 164–65: **Cascade Range, California, USA**
Photograph by Marc Muench
A fast-moving spring rainstorm casts a misty curtain over the northern California section of the Cascade Range. Parts of the western slopes of the Cascades receive as much as 100 inches (2,500 millimeters) of precipitation annually. The north-south orientation of the mountains blocks storm systems moving inland from the Pacific Ocean, forcing the moist air to rise upward and dump its load before passing over or along the mountains; a distinct dry zone, or rain shadow, is present on the mountains' eastern slopes. The ample rainfall feeds a large number of rivers and streams that cut into the landscape, carving V-shaped valleys within those already shaped by glaciers. *May 1997. Pentax 6x4.5 camera, 400mm telephoto lens, Fujichrome Velvia film.*

PRIMAL FORCES

Page 166: **Yellow Water Lily** *(Nuphar lutea),* **San Juan Mountains, Colorado, USA**
Photograph by Marc Muench
The saucer-shaped green leaves of the water lily are supported by the water beneath them. Water, one of the most plentiful substances on Earth, is also the most vital. It functions as a near-universal solvent—from oxygen and carbon dioxide in the world's oceans to the numerous substances dissolved in our own bodily fluids. Its high boiling point and high viscosity, its high density when liquid and low density when solid, and its surface tension (as evidenced by the water drops on the lily pads), all illustrate the nature of water. *August 1997. Zone VI 4x5 camera, 450mm telephoto lens, Fujichrome Velvia film.*

Page 167: **Cattail Falls, Chisos Mountains, Big Bend National Park, Texas, USA**
Photograph by David Muench
A spring-soaked canyon wall reflects a blue desert sky into a glass-calm pool. Located in a remote corner of southwestern Texas, Big Bend National Park encompasses the "big bend" of the Rio Grande. The entire Chisos Mountain Range, rising to 7,800 feet (2,340 meters), lies in Big Bend. This is a land in which volcanism, mountain building, earthquakes, oceans, and rivers have all combined to create a region with a surprisingly diverse ecology; more than 1,000 plant species are found here. *September 1996. Linhof 4x5 camera, 65mm ultra-wide-angle lens, Fujichrome Velvia film.*

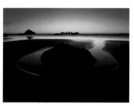

Pages 168–69: **Oregon Islands National Wildlife Refuge, Oregon, USA**
Photograph by David Muench
A magenta filter adds an impressionistic touch to a landscape of still water, sand, and distant sea stacks. Oregon Islands National Wildlife Refuge is a collection of rocky outcrops, islets, and islands along 300 miles (480 kilometers) of the Oregon coastline. Largely inaccessible (with public access prohibited), the islands are home to hundreds of thousands of seabirds. Marine mammals such as California sea lions *(Zalophus californianus)* and harbor seals *(Phoca vitulina)* also use the islands. *February 1996. Linhof 4x5 camera, 75mm wide-angle lens, CC10M magenta filter, Fujichrome Velvia film.*

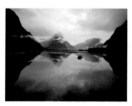

Page 170: **Milford Sound, Fiordland National Park, New Zealand**
Photograph by David Muench
New Zealand's largest national park, Fiordland encompasses 14 fjords within its 4,834 square miles (12,519 square kilometers). Along with its cliffs, waterfalls, and waterways, Milford Sound is also renowned for its rain. The region gets more than 20 feet (6 meters) of rain a year, making it one of the wettest places on Earth (the wettest place, Mount Waialeale on Kauai in the Hawaiian Islands, gets more than 33 feet [10 meters] of rain a year). Some parts of Fiordland are so inaccessible that they may never have been seen by humans. *April 1998. Canon EOS-3 camera, 14mm ultra-wide-angle lens, Fujichrome Provia film.*

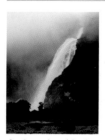

Page 171: **Bowen Falls, Milford Sound, Fiordland National Park, New Zealand**
Photograph by David Muench
In Milford Sound, heavy rains feed torrents that cascade over great cliffs, creating incredible waterfalls, including Bowen Falls, an impressive 531 feet (162 meters) high. In addition, the world's fourth-highest waterfall (after Venezuela's Angel Falls, Tugela Falls in South Africa, and Cuquenán, also in Venezuela) is found here—Sutherland Falls, at 1,873 feet (571 meters). Once filled with glacial ice, this land is now finely sculpted by liquid water. It is a thundering place, simultaneously serene and filled with noise—white noise. *April 1998. Canon EOS-3, 100-400mm zoom lens, Fujichrome Provia film.*

Pages 172–73: **Franz Josef Glacier, Westland National Park, New Zealand**
Photograph by David Muench
Like most of the world's glaciers, the Franz Josef Glacier was in rapid retreat over the past few thousand years (save for an advance during the "mini-Ice Age" that cooled the global climate between the fourteenth and eighteenth centuries). Then, from 1965 to 1968, both the Franz Josef and Fox Glaciers began to advance, moving about 600 feet (180 meters) farther down the valley. The advance stopped, only to start up again in 1985, and the glacier is currently moving forward at a rate of about 17 feet (5 meters) a week. Here, the glacier's snout lies over metamorphic rocks exposed by a previous ice advance. *April 1998. Canon EOS-1N camera, 14mm ultra-wide-angle lens, Fujichrome Provia film.*

Page 174: **Kermode Bear** *(Ursus americanus kermodei),* **Princess Royal Island, British Columbia, Canada**
Photograph by Marc Muench
Kermode bears, found only in areas of coastal British Columbia, are a rare color form of American black bear. Named for a former director of the Royal British Columbia Museum, the Kermode is also known as the "spirit bear" or "ghost bear." The creamy white Kermode results from a double recessive gene. When an animal has two recessive "white" genes, it is white. Animals with only a single recessive gene are black, but if they mate with another "carrier," 25 percent of their offspring will be Kermode bears. *October 1999. Canon EOS-1N camera, 100-400mm zoom lens, Fujichrome Velvia film.*

Page 175: **Tongass National Forest, Douglas Island, Alaska, USA**
Photograph by David Muench
About 90 percent of Southeast Alaska lies within Tongass National Forest, the largest publicly owned forest in the United States at 16.8 million acres (6.8 million hectares). With its 2,000 islands, high mountains, fjords, and glaciers, Tongass contains the most extensive areas of virgin temperate rain forest left in North America. In places, more than 200 inches (5,000 millimeters) of annual precipitation fosters a forest that has a greater biomass than that of tropical rain forests. In 1980 about a third of Tongass was designated a National Wilderness Area. *July 1996. Linhof 4x5 camera, 75mm wide-angle lens, 81EF warm filter, Fujichrome Velvia film.*

Page 176: **Hawksnest Beach, Virgin Islands National Park, St. John, Virgin Islands, USA**
Photograph by Marc Muench
A pristine white-sand beach wraps around Hawksnest Bay. Covering 14,696 acres (5,947 hectares), the national park takes up nearly two-thirds of St. John, the most undeveloped of the U.S. Virgin Islands. Primary forest once covered the island, but beginning in the seventeenth century, settlers felled the trees. Secondary forest has since reestablished itself. St John's highest point is Bordeaux Mountain at 1,088 feet (332 meters). Isolated from other land, the Virgin Islands' only native land mammal is a species of bat. *August 1998. Nikon F4 camera, Aquatica housing, 16mm wide-angle lens, Fujichrome Velvia film.*

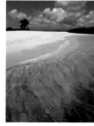

Page 177: **Sandy Cay, British Virgin Islands, United Kingdom**
Photograph by Marc Muench
Originally named *Santa Ursula y las Once Mil Virgenes* (St. Ursula and the Eleven Thousand Virgins) by Columbus in 1493, the British Virgin Islands consist of 4 main islands (Jost Van Dyke, Tortola, Anegada, and Virgin Gorda) and 32 smaller islands or islets, of which about 20 are uninhabited. One of those is Sandy Cay, located just east of Jost Van Dyke. The tiny, privately owned islet is rimmed by a coral reef made up of both hard and soft corals. The warm, calm waters support a diverse array of marine life, including the endangered hawksbill sea turtle *(Eretmochelys imbricata). August 1998. Nikon F4 camera, 20mm wide-angle lens, Fujichrome Velvia film.*

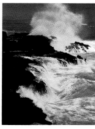

Page 178: **Koko Head, Koko Head Regional Park, Oahu, Hawaiian Islands, USA**
Photograph by David Muench
Waves pushed by strong trade winds pound Oahu's windward coast. East of Diamond Head, Koko Head is an extinct volcano that rises 642 feet (192 meters) above sea level. The coastline is black and jagged, the result of water cutting into basalt lava. Nearby Koko Crater, 1,200 feet (360 meters) high, is another extinct volcano. Koko Head experiences such strong currents and riptides, as well as hazardous shore breaks and submerged rocks, that it is the most dangerous body-surfing beach in the Hawaiian Islands. *April 1978. Linhof 4x5 camera, 500mm telephoto lens, Kodak Ektachrome Daylight film.*

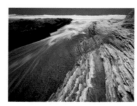

Page 179: **Montaña de Oro State Park, California, USA**
Photograph by Marc Muench
Encompassing more than 8,000 acres (3,200 hectares) of cliffs, beaches, coastal plains, streams, canyons, and hills—including 1,347-foot (404-meter) Valencia Peak—Montaña de Oro State Park is an idyllic point on California's golden coast. Black oystercatchers *(Haematopus bachmani),* killdeer *(Charadrius vociferus),* and greater yellowlegs *(Tringa melanoleuca)* ply the surf line; inshore, mule deer *(Odocoileus hemionus)* browse the vegetation. Winter storms pound these headlands, whereas the summer surf can appear quite benign. Rock formations reveal mud and sandstone strata that were laid down horizontally but have since been warped and lifted to stand nearly vertically. *April 1999. Zone VI 4x5 camera, 75mm wide-angle lens, Fujichrome Velvia film.*

Pages 180–81: Mount Hood, Cascade Range, Oregon, USA
Photograph by David Muench
Marc and David spent the night scrambling up 11,235-foot (3,424-meter) Mount Hood, Oregon's highest peak, so they would be at the top for sunrise. This mass of ice welcomed them. Far to the south stands 10,497-foot (3,150-meter) Mount Jefferson. The Cascade Range extends for 700 miles (1,100 kilometers) from northern California to southern British Columbia. When Lewis and Clark passed through the Columbia River Gorge they saw countless waterfalls, so they named the mountains that surrounded them the Cascades. *April 1995. Canon EOS-1N camera, 135mm medium telephoto lens, polarizer, Fujichrome Provia film.*

Page 182: Frozen Spring, Snake Range, Nevada, USA
Photograph by David Muench
The interior of a frozen spring takes the observer inside an icy world: cool, clean, silent. The spring appears motionless, quite literally frozen in time, quiescent and inert. Diffused white light reflects from the ice, the spectrum scattered to create a soft, gentle image. The ice allures; it transforms the familiar into something quite different and offers a chance of discovery and renewal. So much of our world has been shaped by ice. Though widespread glaciation is now 10,000 years distant, three-quarters of our planet's freshwater is icebound. *February 1998. Canon EOS-1N camera, 100-400mm zoom lens, Fujichrome Provia film.*

Page 183: Cape Hatteras National Seashore, North Carolina
Photograph by David Muench
Quiet Atlantic surf greets a new day in this long exposure taken just north of the Cape. Hurricanes are not common along this stretch of coast, but when they do hit—at any time between June and November—they bring winds in excess of 74 miles per hour (120 kilometers per hour), storm surges that can completely engulf the Outer Banks, flash floods, and torrential downpours. Even winter storms—known as nor'easters due to the northeasterly winds that cause them—can hit with an intensity that redesigns beaches, topples trees, and floods areas far inland. *May 1992. Linhof 4x5 camera, 210mm medium telephoto lens, Fujichrome Velvia film.*

Pages 184–85: Makena Beach, Maui, Hawaiian Islands, USA
Photograph by David Muench
Kahoolawe Island rises from the water across Alalakeiki Channel as a gentle surf washes up on Makena Beach. With its sweeping white sands, Makena Beach is often called the most beautiful beach on Maui; it has long been visited by surfers, snorkelers, and shell seekers. Kahoolawe Island, the eighth largest of Hawaii's major islands, is the only one not inhabited; the 45-square-mile (117-square-kilometer) island is used as a bombing range by the U.S. Navy, despite the fact that it is considered sacred by many Hawaiians. *May 1994. Canon EOS-1N camera, 20-35mm zoom lens, Fujichrome Provia film.*

Page 184 (left inset): Hawksbill Sea Turtle *(Eretmochelys imbricata)*, Virgin Islands National Park, St. John, Virgin Islands, USA
Photograph by Marc Muench
Classified as critically endangered, the hawksbill sea turtle's range is more than 150 million square miles (390 million square kilometers). Named for its hooked beak, the turtle reaches 2 feet (0.6 meters) in length and weighs about 100 pounds (45 kilograms). Long hunted for their tortoiseshell, used in jewelry and other ornaments, these long-lived animals are slow to recover from exploitation. Trade in tortoiseshell is now prohibited, but an illegal market still exists. *July 1998. Nikon F4 camera, Aquatica housing, 20mm wide-angle lens, Fujichrome Provia film.*

Page 184 (right inset): Magnificent Frigatebird *(Fregata magnificens)*, Isla Seymour, Galápagos Islands, Ecuador
Photograph by David Muench
With its range generally confined to coastal tropical America, the frigatebird is a large seafarer, 38 to 40 inches (97 to 100 centimeters) in length, with a 95-inch (241-centimeter) wingspan. The birds were named for frigate warships due to their penchant for harassing other birds and forcing them to disgorge their catches, which the frigatebirds then consume. Frigatebirds are mainly black, and males have an orange-red throat pouch that is conspicuously inflated during courtship displays. Juveniles have a white breast and neck; females sport a white breast. *September 1996. Canon EOS-1N camera, 135-350mm zoom lens, Fujichrome Provia film.*

Page 185 (left inset): Dry Tortugas National Park, Florida, USA
Photograph by Marc Muench
Yellow goatfish *(Mulloidichthys martinicus)* swim past a variety of soft corals 20 feet (6 meters) below the water's surface of Dry Tortugas National Park. Accessible only by boat or seaplane, the Dry Tortugas lie 70 miles (112 kilometers) west of Key West. The park consists of eight coral reefs covering 64,700 acres (25,880 hectares). Originally named Las Tortugas (The Turtles) by Ponce de León in 1513, they were renamed the Dry Tortugas to reflect the absence of fresh water. *July 1998. Nikon F4 camera, Aquatica housing, 20mm wide-angle lens, Fujichrome Provia film.*

Page 185 (right inset): Sally Lightfoot Crab *(Grapsus grapsus)*, Isla Bartolomé, Galápagos Islands, Ecuador
Photograph by David Muench
Found from Baja California to Chile, the Sally lightfoot crab contrasts dramatically with the black lava of these volcanic islands. Its carapace—2 to 3.5 inches (50 to 87 millimeters) wide—is vivid. John Steinbeck wrote in *The Log from the Sea of Cortez:* "They have remarkable eyes and an extremely fast reaction time.... They seem to run in any one of four directions.... If you walk slowly, they move slowly ahead of you in droves. If you hurry, they hurry. When you plunge at them . . . they disappear." *September 1996. Canon EOS-1N camera, 20-35mm wide-angle lens, Fujichrome Provia film.*

Page 186: Aialik Bay, Kenai Fjords National Park, Alaska, USA
Photograph by Marc Muench
Water clings to a blade of grass in Southcentral Alaska's Kenai Fjords. Located to the west of Resurrection Bay, Aialik Bay was, like the vast majority of bays in this region, carved by a glacier. The Harding Icefield covers 1,100 square miles (2,860 square kilometers) and spawns more than 35 glaciers, 3 of which—Holgate, Aialik, and Pederson—flow to Aialik Bay. Average summer precipitation often exceeds 9 inches (230 millimeters) in a single month; June tends to be the driest month, September the wettest. *August 1999. Contax 6x4.5 camera, 120mm lens, Fujichrome Velvia film.*

Page 187: Matanuska Glacier, Alaska, USA
Photograph by Marc Muench
The Matanuska glacier flows from Southcentral Alaska's Chugach Mountains; its meltwater flows into the Matanuska River. The glacier is 27 miles (43.5 kilometers) long, has an average width of 2 miles (3.2 kilometers), and has been in its present position for the last 7,000 years. Glacial ice often appears white or blue—sometimes a brilliant blue. Ice appears white where it is rich in air bubbles that reflect the entire light spectrum; where the ice is dense, without air bubbles, it often appears blue, because the red portion of the spectrum is absorbed, leaving blue to dominate. *August 1999. Contax 6x4.5 camera, 35mm wide-angle lens, Fujichrome Provia film.*

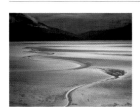

Pages 188–89: Turnagain Arm, Alaska, USA
Photograph by Marc Muench
This waterway was named Turnagain River by Captain James Cook during his search for the Northwest Passage in 1778; he had to turn his ship around in it after failing to find a way through. It took Captain George Vancouver's survey of 1794 to ascertain that Turnagain was a narrow branch of Cook Inlet—about 5 miles (8 kilometers) across at its widest point. Once filled with glacial ice, Turnagain has one of the world's greatest tidal fluxes, ranging more than 33 feet (10 meters). The glacial silt and water creates quicksand-like mudflats that can become deadly quagmires for the unsuspecting. *August 1999. Contax 6x4.5 camera, 120mm lens, Fujichrome Velvia film.*

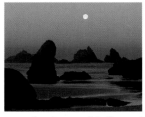

Page 189 (inset): Oregon Islands National Wildlife Refuge, Oregon, USA
Photograph by David Muench
A magenta filter enhances this impression of solitude along the Oregon coast. Sea stacks and islets are silhouetted as evening tide retreats, revealing tide pools and meandering channels. Above, the moon rises, a distant sphere responsible for these tidal changes. Daily cycles, monthly cycles, and annual cycles are all influenced by this orb—and by the sun, which at times contributes to, and at others counters, the moon's gravitational pull. The sun is far larger than the moon, but the moon's proximity ensures that its gravitational force is more than twice that of the sun. *May 1998. Linhof 4x5 camera, 75mm lens, CC10M magenta filter, Fujichrome Velvia film.*

PRIMAL FORCES

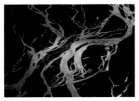

Page 190: **McKinley River, Denali National Park and Preserve, Alaska, USA**
Photograph by David Muench
An aerial view highlights meandering braids of the McKinley River, its entire length within the park's boundaries (where it joins the Kantishna River). The Muldrow Glacier flows from the flanks of Mount McKinley, moving gravel and debris toward its snout. When gravel is dumped at the front of the glacier, meltwater begins to move it. It is this meltwater that becomes the McKinley River. The river has no single, defined channel, flowing instead where the gravel allows. The braids shift regularly; where water flows one year may be dry the next. *July 1999. Canon EOS-3 camera, 100-400mm zoom lens, Fujichrome Provia film.*

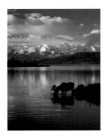

Page 191: **Moose *(Alces alces)*, Wonder Lake, Denali National Park and Preserve, Alaska, USA**
Photograph by Marc Muench
A moose grazes in Wonder Lake, backed by the immense Alaska Range. Moose are fairly common in the park's 7.9 million acres (3.2 million hectares), where they feed on willow, birch, aspen, and aquatic vegetation. Largest of the world's deer, they can reach 1,815 pounds (825 kilograms), and stand up to 7.6 feet (2.3 meters) at the shoulder. They can reach speeds of 35 miles (56 kilometers) per hour and are strong swimmers. At times, they submerge themselves completely to get at plants at the bottom of a lake. *August 1999. Contax 6x4.5 camera, 120mm lens, Fujichrome Velvia film.*

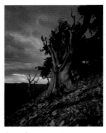

Page 192: **Bristlecone Pine *(Pinus aristata)*, Schulman Grove, White Mountains, California, USA**
Photograph by David Muench
The wind- and ice-carved trunk of a bristlecone pine endures all that the elements can throw at it at 11,500 feet (3,450 meters) above sea level. Bristlecones endure, in part, by having an extremely slow growth rate. The oldest-known bristlecone was called Prometheus; it lived for 4,950 years before it was cut down, in 1964, by a researcher, in an act that hopefully will never be repeated. Today, the oldest bristlecone pine, named Methuselah, is estimated to be 4,766 years old. *September 1975. Linhof 4x5 camera, 75mm wide-angle lens, Kodak Ektachrome Daylight film.*

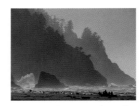

Page 208: **Neskowin Coastline, Oregon, USA**
Photograph by David Muench
People are dwarfed by dark basalt cliffs along Oregon's shore. Throughout its history, this coast has been sculpted by equal parts earth, air, fire, and water—it is the sum of all of these things. We are now able to influence many things in the natural world, mainly to our detriment, but we also have the ability to be inspired, awestruck, and moved by what we see. We are emotive creatures; we feel wonder and curiosity. We also feel responsibility, and it is the combination of all these emotions that drives us to protect the incredible places that the primal forces have crafted on our planet, Earth. *February 1999. Canon EOS-1N camera, 100-400mm zoom lens, Fujichrome Provia film.*

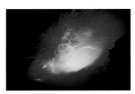

Endsheets: **Kalapana Coastline, Hawaii Volcanoes National Park, Hawaii, Hawaiian Islands, USA**
Photograph by David Muench
Molten lava, reaching temperatures greater than 2,000°F (1,100°C) spews forth in a breathtaking display of color and motion. Cooling rapidly in the air, thin pieces of silica hang like gossamer threads. Using an exposure of almost 1 second, David captures both the movement and fluidity of Kilauea's pyrotechnics. While lava epitomizes volcanoes to many people, only about 20 percent of the material ejected by volcanoes around the world is in the form of this exquisite liquid fire. *April 1985. Leicaflex camera, 50mm lens, Kodak Ektachrome Daylight film.*

Back Cover: **Mount Rainier, Mount Rainier National Park, Washington, USA**
Photograph by David Muench
Mount Rainier rises 14,410 feet (4,392 meters) high in this multiple exposure that combines a wide-angle image with a telephoto one. In total, 41 glaciers crowd the slopes of Mount Rainier. Part of the Pacific "Ring of Fire" that encompasses Alaska's Aleutian Islands, Japan, the Philippines, and the west coasts of North and South America, Rainier last erupted during the mid- to late-nineteenth century when 14 eruptions were recorded between 1820 and 1894. *July 1999. Linhof 4x5 camera, 75mm wide-angle lens (bottom) and 300mm telephoto lens (top), multiple exposure, Fujichrome Velvia film.*

RESOURCE LIST

Canadian Parks and Wilderness Society
880 Wellington Street, Suite 506
Ottawa, Ontario K1R 6K7 Canada
Tel: 1-800-333-WILD
Fax: 613-569-7098
Email: info@cpaws.org
Web: www.cpaws.org/

International Union for the Conservation of Nature and Natural Resources
IUCN-The World Conservation Union
Rue Mauverney 28
CH-1196 Gland Switzerland
Tel: 41-22-999-00-01
Fax: 41-22-999-00-02
Email: mail@hq.iucn.org
Web: www.iucn.org

National Parks Conservation Association
1300 Nineteenth Street, N.W., Suite 300
Washington, DC 20036 USA
Tel: 1-800-NAT-PARKS
Email: npca@npca.org
Web: www.npca.org/home/npca

The Nature Conservancy
4245 North Fairfax Drive, Suite 100
Arlington Virginia 22203-1606 USA
Tel: (703) 841-5300
Fax: 703-841-1283
Web: www.tnc.org

Sierra Club
85 Second Street, Second Floor
San Francisco, CA 94105-3441 USA
Tel: 415-977-5500
Fax: 415-977-5799
Email: information@sierraclub.org
Web: www.sierraclub.org

The Wilderness Society
900 17th Street, N.W.
Washington, D.C. 20006 USA
Tel: 1-800-THE-Wild (843-9453)
Fax: 202-429-2658
Web: www.wilderness.org

World Conservation Monitoring Centre
219 Huntingdon Road
Cambridge CB3 0DL United Kingdom
Tel: 44-1223-277314
Fax: 44-1223-277136.
Email: info@wcmc.org.uk
Web: www.wcmc.org.uk

World Wildlife Fund—U.S.
1250 Twenty-Fourth Street, N.W.
P.O. Box 97180
Washington, DC 20037 USA
Tel: 202-293-4800
Fax: 202-293-9211
Web: www.worldwildlife.org
Web: www.panda.org

For additional links to extensive wildlife and environmental internet resources, visit www.michellegilders.com

THANKS

This book draws on scientific knowledge that has been gained over centuries of study. The people who spent their lives trying to understand the intricacies of our planet's machinations are those who set the foundation for books such as this one—they have made my job so much easier, but no less fascinating.

Many people provided direct assistance as I worked on this book. In particular I would like to thank: Professor Andrew S. Goudie (School of Geography, Oxford University), Dr. Christopher Herlugson, Professor Douglas MacDougall (Director of Earth Sciences, University of California, San Diego), Jennifer Purl, Dr. Gary Stolz (U.S. Fish and Wildlife Service and Associate Professor, University of Idaho), and Claire Waddoup. They all provided invaluable comments and undoubtedly helped to improve the final product. As always, however, any errors remain my own. I would also like to thank the editorial team at Graphic Arts Center Publishing Company: Doug Pfeiffer, Tim Frew, Ellen Wheat, and Linda Gunnarson. Thanks also go to my family, especially my mother, who more often than not kept the tea flowing and food appearing at regular intervals as I pored over books and journals, oblivious to the passing time.

As I continue to travel the world, equally enthralled by mountains, coasts, rivers, deserts, and oceans, I am forever in awe of the photographers who can capture the grandeur and beauty of those landscapes. I feel privileged to have worked with some of those artists on this book.

—Michelle Gilders

We would like to acknowledge Dr. Tom G. Stockham Jr., a pioneer in the field of digital signal processing. His work and discoveries in the 1950s and 1960s led to much of the technology being used today, both in audio recording and visual imaging.

This technology has allowed Marc Muench and Tom Dietrich to control the color and contrast for the production of *Primal Forces*. The transparencies were scanned on the ICG Drum Scanner, retouched and editorialized in Adobe Photoshop™, and then proofed for the sheet-fed press on an Epson 5000 Printer. This digital darkroom optimized the pre-press workflow so that David and Marc were able to make critical decisions about their images in-house that were fulfilled later on the press.

A sincere thanks to Ken Kelley, a longtime aficionado of computer technology, who has kept David and Marc well informed of the possibilities in the continually changing computer industry.

Thanks to all at Graphic Arts Center Publishing Company for having the confidence in David and Marc to involve this rather new process among traditional standards. All of the good energy of Michelle Gilders' essay helps us to better understand the dynamics of primal forces.

—David Muench and Marc Muench

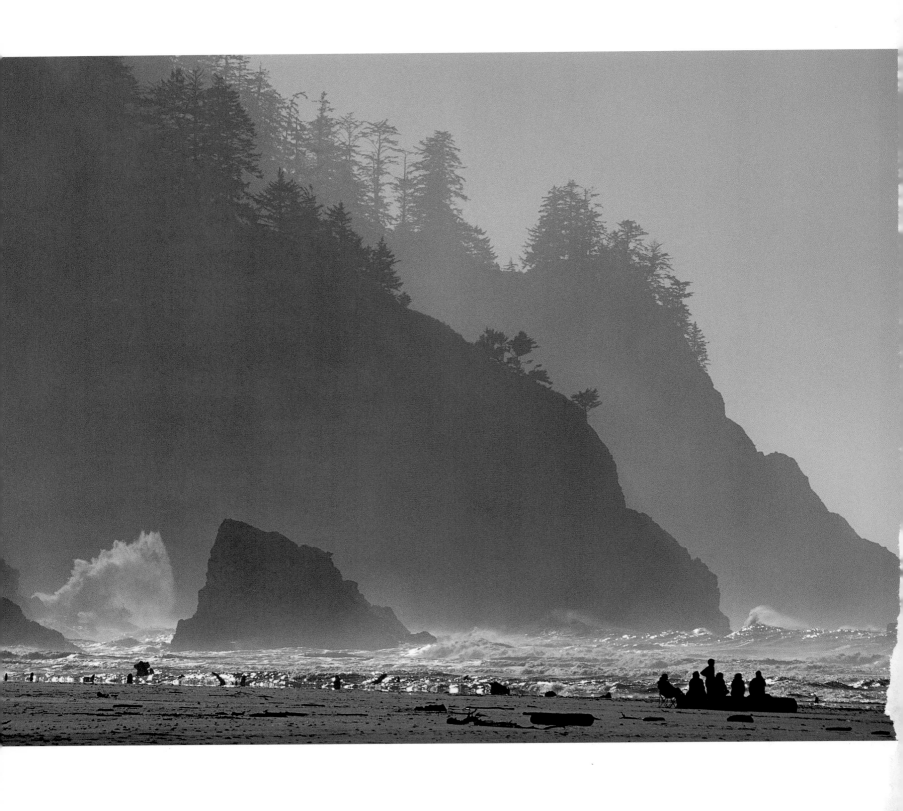

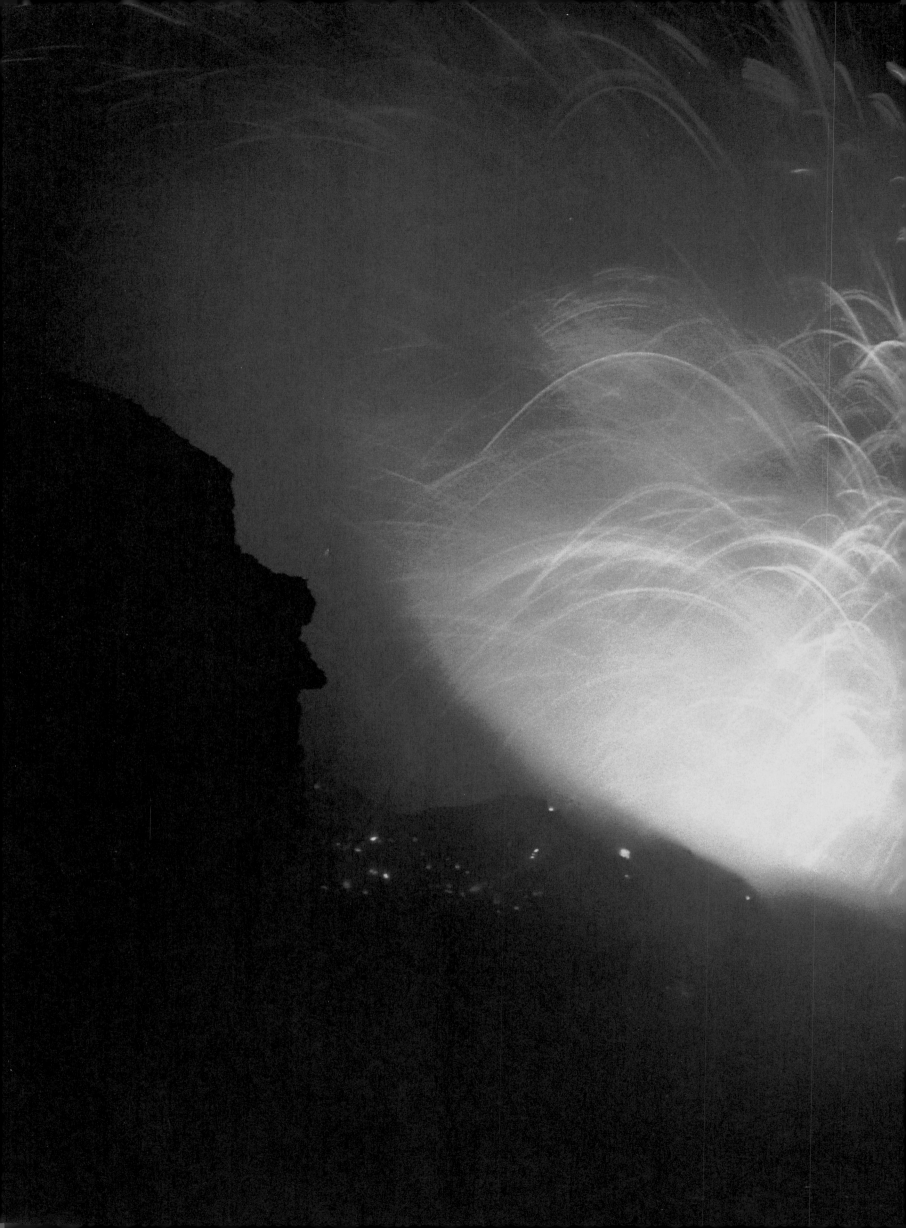